THE PRACTICAL HANDBOOK FOR THE EMERGING ARTIST

THE PRACTICAL HANDBOOK FOR THE EMERGING ARTIST

Margaret R. Lazzari
University of Southern California

Harcourt Brace College Publishers

Fort Worth Philadelphia San Diego New York Orlando Austin San Antonio
Toronto Montreal London Sydney Tokyo

Publisher Ted Buchholz
Editor in Chief Christopher P. Klein
Acquisitions Editor Barbara J. C. Rosenberg
Project Editor Laura J. Hanna
Production Manager Serena B. Manning
Art Director Vicki Whistler
Electronic Publishing Compositor Kim Standish

Cover Image: Photo by Kevin Tolman.

Address for Editorial Correspondence: Harcourt Brace College Publishers, 301 Commerce Street, Suite 3700, Fort Worth, TX 76102.

Address for Orders: Harcourt Brace & Company, 6277 Sea Harbor Drive, Orlando, Florida 32887. 1-800-782-4479, or 1-800-433-0001 (in Florida).

Printed in the United States of America

Library of Congress Catalog Card Number: 95-79646

ISBN: 0-15-501498-6

6 7 8 9 0 1 2 3 4 066 9 8 7 6 5 4 3 2

To my mentors, with thanks.

PREFACE

A multitude of practical concerns surrounds art making. They include negotiating art world structures, finding jobs, applying for grants, paying taxes, keeping records, drafting contracts, documenting artwork, securing copyright, and so on. These are enormous challenges for emerging artists. Most artists are a few years into their careers before they identify all the areas in which they need expertise, and how and where to get necessary information.

This book is the first to focus on issues concerning visual artists in the early years of their professional lives. It presents the career options and practical information they need in an organized, detailed manner. Reference books provide some of this information, but emerging artists would have to exert considerable effort to piece it together. Other books cover practical matters for artists, but address the established artist, or only those artists who show in commercial galleries. Much of the information that emerging artists need has not been published before. This book was written for graduating art majors preparing for graduate school, jobs, or the art world, and also all other emerging artists regardless of their education level. It addresses artists living both inside and outside major art centers. It covers the needs of artists working either in traditional media or new genres, as well as those making controversial or experimental work. It reflects the fact that the flush art market of the 1980s has given way to the much leaner 1990s, and that the careers of many artists will not depend upon regular sales of work.

The book is composed of sixteen chapters, divided into five sections:

Section One: Groundwork contains two chapters that focus on emerging artist's artwork, studio practice, and ways to develop ties with professionals in the art field.

The six chapters in **Section Two: Getting Your Work Out and Seen** cover the many options for showing work, including mainstream commercial galleries and museums, in addition to more unconventional sites. Included are detailed descriptions outlining how to produce visual and written documentation of artwork, how to package written proposals for showing work, and how to self-sponsor an exhibition or self-produce a performance in any kind of venue.

Section Three: Positions of Power describes how artists can function as art professionals while maintaining their own art production. The three chapters include art writing, curating, and creating an artist-run art space.

Section Four: Financial Concerns contains detailed information on the business, legal, and financial aspects of an art career. Chapter 12 deals with the kinds of jobs sought by artists and ways to find them. Chapter 13 covers grantwriting and artist residencies, while Chapter 14 describes other forms of funding, including commissions, public art programs, art organizations, and corporate support. Chapter 15 deals with health issues, insurance, record keeping, taxes, the legalities of copyright, and freedom of expression issues.

Section Five: Graduate School presents the benefits of pursuing a Master of Fine Arts degree, ways to research graduate schools, and criteria for choosing the best situation for each individual's circumstances.

Certain features make the information in this book particularly helpful and accessible. There are many "how-to" guides that give detailed instruction on writing resumes, preparing press releases, making slides, drafting contracts, etc. These instructions are supplemented by illustrations and sample documents for even greater clarity. The annotated bibliography gives the names of reference books and resource material, and brief descriptions of what each contains. The appendix lists organizations, agencies, and services of benefit to artists. And finally, each chapter concludes with an interview in which artists describe their career and personal experiences, to help "flesh out" the factual material in the book. These artists represent a wide range of backgrounds, working in different media, and at different stages of their professional lives.

There are no absolute answers in this book, but rather a range of options to help emerging artists situate themselves in the cultural field. Because there are far more options here than any one person could pursue, artists must decide for themselves which ones fit their own goals.

I am grateful to many for their help. Karen Atkinson, Virginia LeRossignol Blades, Cecelia Davidson, Lauren Evans, and Joyce Savio Herleth contributed substantially to my effort. I am also very grateful to all the artists interviewed for this book, who were generous with their insights and worked with me through the editing process.

The faculty and staff of USC's School of Fine Arts lent valuable assistance to this project, especially Debbie Barlow, librarian; Amy Navratile Ciccione, librarian; Robbert Flick, professor; Dr. Selma Holo, director of Fisher Gallery; Penelope Jones, admissions officer; Howard Smith, slide librarian; Ruth Weisberg, professor; Alana Williams, library staff; and Jay Willis, professor. Special thanks

go to my Senior Seminar students, whose feedback helped hone the presentation of this material. Thanks also to Kay Allen, Russell Barclay, Jan Blair, Dr. Richard Kaplan, Carol Levy, and Sherrie Ray.

Others who contributed advice, assistance, or information were Susan Brenner, University of North Carolina at Charlotte; Jack Buick, John Thomas Gallery, Santa Monica; Eva Cockcroft, University of California, Irvine; Frances Colpitt, University of Texas at San Antonio; Eleanor Dickinson, California College of Arts and Crafts; Thomas M. Goetzl, Golden Gate University School of Law; Joan Hugo, California Institute for the Arts; George Koch, President, National Artists Equity Association, Inc.; Steven Huss, Seattle Arts Commission; Gwenda Jay, Gwenda Jay Gallery, Chicago; Noel Korten, Los Angeles Municipal Art Gallery; Sharon Kopriva, artist; Nancy Loncke, California Lawyers for the Arts; Yvette Martini, artist; Mary McCleary, Stephen F. Austin State University; Karen Mueller, Minnesota State Arts Board; Pam Nelson, artist; Eve Reynolds, architect; Lisa Richmond, Southern Arts Federation; Sandra Rowe, California Polytechnic University, Pomona; and Laurie Ziegler, lawyer and writer.

I am indebted to the following reviewers: Bill Hoey, University of Texas at Austin; Ron Watson, Texas Christian University; Hylarie McMahon, Washington University; Phyllis Branson, University of Illinois; Lorraine Peltz, Northwestern University; Susan Rankaitis, Scripps College; Jerry Noe, University of North Carolina; Richard Long, University of Wisconsin; Beverly Naidus, California State University, Long Beach; Claudia DeMonte, University of Maryland; Kay Miller, University of Colorado; Linda Herritt, University of Colorado.

I was very fortunate to work with Harcourt Brace Acquisitions Editor Barbara Rosenberg and Editorial Assistant Kelly Whidbee. Their efforts and vision brought the project to fruition. Cindy Hoag, Harcourt Brace sales representative, advised on the preparation of the prospectus for this textbook.

Finally, my gratitude goes to my husband, Michael Dean, for all the large and small ways he helped, and for his practical advice and moral support. Thanks also to our daughter, Julia Rose, for being such a champ throughout this entire process.

CONTENTS

SECTION ONE

Groundwork

The bulk of this book is dedicated to presenting options for emerging artists starting their careers and to explaining structures and systems in the art world: the operation of art venues, funding, business issues, legal issues, and so on. Before addressing these topics, it is essential to give consideration to your art-work and your art-making practice, because they form the foundation for the rest of the discussion to follow. Because this book suggests many more options than any one person could possibly undertake, you decide for yourself which ones fit your goals as an artist.

Chapter 1 discusses ways to develop bodies of work, evaluate your results, and identify your audience.

The theme of Chapter 2 provides underlying message for the rest of the book: Don't go it alone. Build a strong network of friends who will be mutually supportive. Make alliances and work with others towards common goals.

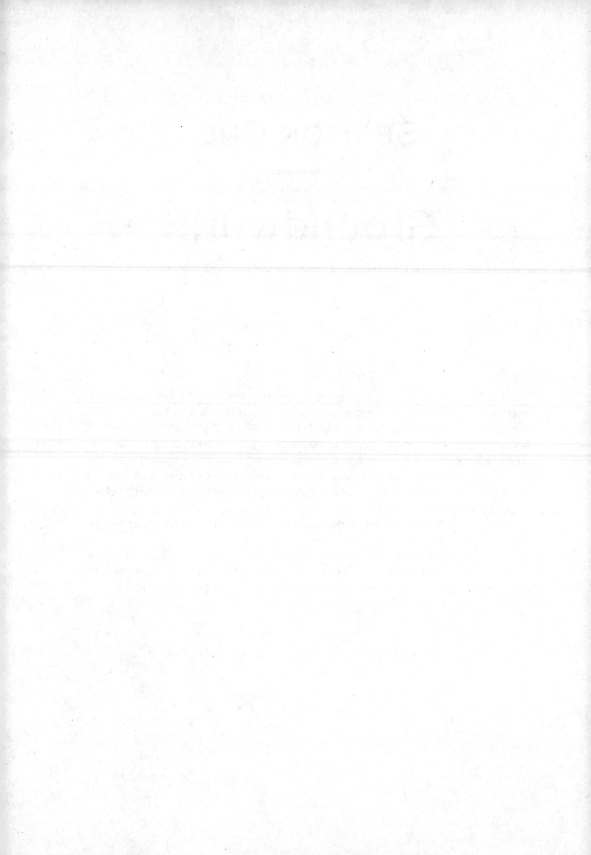

Chapter 1

THE ARTWORK IS MOST IMPORTANT

DEVELOPING YOUR ARTWORK

A body of work is a series of objects or performances that are visually related and deal with a consistent theme. Generally, you need a cohesive body of work before you begin to show, in order to communicate effectively with your audience and give curators and dealers confidence in your work. With some artists, a body of work is very regularized, for example, a group of paintings that are the same size, same media, similar imagery, and perhaps even similar coloring. For others, a body of work may include very different objects, media, and techniques to address a specific idea.

Concentrated practice is usually necessary to build a body of work. Many artists use something like the following procedures when beginning a new series or reinvigorating works in progress:

- Review work you have already done. Study particularly the pieces that still draw your attention.
- Discuss the concepts you want to incorporate into your artwork with people who are knowledgeable about art.
- Go to galleries and museums and read art magazines to see others whose work has some conceptual or formal tie to your own. Get recommendations from other artists or reference librarians.
- Envision new pieces based on previous ideas that still seem vital. Or, remake or adapt an old work you still like.

Set aside sufficient time and a place for working. Many artists need either the discipline of regular working hours or the incentive of an immediate deadline before they give adequate time to their art-making practice. Concerning a place to work, start on your art as soon as you have a reasonably usable space. While the separate studio with high ceiling, white walls, and skylight is the assumed traditional work space, some artists such as René Magritte and Joseph Cornell worked in their homes. What kind of

workplace is absolutely necessary for you? Can you be productive in your garage, in a spare room, or on your kitchen table?

Getting feedback is essential in the art-making process. Until others see your work and understand your ideas, your job as an artist is only half completed. Artwork is both an object and an activity; art exists between its maker and its audience. As your work progresses, you should evaluate how well the content is coming through. In school, you had a built-in community for this purpose—your teachers and the other students. Out of school, you need to develop a regular group of intelligent, perceptive people who spend time with your work and listen to your ideas as you refine them. Have these people come in often to see your work.

EVALUATING YOUR PRODUCTION

As your artwork progresses and bodies of work develop, you will need a conceptual overview of what you are doing and the ability to communicate that overview to others. Your overview should include the theme of your work, identify your audience, and describe the kind of work you do.

Articulating the themes behind your work is of primary importance. This includes describing the content bases of your work, how a piece embodies and communicates them, and the larger cultural milieu that provides the context for understanding them. This task may be difficult if your bodies of work and their associated themes do not develop in a clear, linear manner. The following steps may help you identify major themes within your work:

- Take a long view of your work rather than focus exclusively on the pieces just finished. Looking back on old work, most artists can see persistent themes emerge.
- Read artist statements, catalog essays, and reviews of artwork that are closely related to yours. In these, how are the ideas behind the work discussed?
- Have people familiar with your work describe what it is about and how you successfully communicate those ideas.

Your overview should also identify your intended audience and how it encounters your artwork. Audiences are usually grouped by some identifying factor, such as age, gender, economic class, ethnic origin, level of education, or geographic location. Examples of audiences might include young professionals, college communities, or senior citizens. While most artists might wish ideally for an unlimited audience for their work, in fact, artwork exists within time and space constraints that determine to a great extent who will be able to see it. For many artists, the default audience and method of encounter are those people who go to galleries and museums. However,

some artists seek other venues for their work, such as mural making and other forms of public art. Artists working in new technologies may submit their videos for public access cable television broadcast, or distribute their computer-based work over Internet. Others interact with their specific audiences while using art as a tool for healing or for social change.

In addition to themes and audiences, you will need to categorize certain aspects of your work, including: 1) the type of artwork you make; 2) the scale of your product; and 3) the cost of your art making in time and materials. In reference to type, your artwork probably falls roughly into one of the following four categories:

- Visual arts done in traditional media such as paint, photo processes, printmaking, sculptural material, etc.
- Media arts, encompassing artists' film, video, multimedia works, computer and projected imagery and any other new technology media. Bookworks and guerrilla art that rely on techology may also fall in this category.
- Site-specific installation and public art, covering both temporary and permanent artworks that are incorporated into the design or history of a particular place.
- Performance, where the human body is the vehicle for artistic expression. There is no permanent art object created, only the performance itself, although performance artists may videotape or photograph their work, and may make objects for use in it.

Another way to categorize artwork is by considering whether an object is produced or not. Traditional visual arts are considered to be "object-oriented," because often they are unique, permanent aesthetic objects. Performance and media arts are often called "nonobject-oriented," because there is no single unique object for sale and there may or may not be market motivation for artists making such work. While these distinctions are simplistic, artwork does fall along a continuum between more- and less-physical manifestations.

Scale is an important factor for describing your artwork. If you want to work on a monumental scale, such as in murals, large-scale sculpture, or elaborate performance pieces, then much of your art making may be devoted to developing models, maquettes, or detailed written proposals, since such work cannot be made without first having a site or funding. On the other hand, if the scale of your work is smaller, you probably work on speculation. You complete the work first, and then hope to interest others in it.

The amount of time and the cost of materials required to produce your art affects the nature of your output and how others perceive it. Costly or labor-intensive work is usually valued, distributed, and marketed differently from work that is quickly produced, mass-produced, or mechanically reproduced. Labor-intensive work may be made by the artist or fabricated by others according to the artist's plans and designs.

These thematic, formal, and functional descriptions of your artwork give others a clearer picture of what you are doing and help you make intelligent choices about where and how to show your work. A more significant consequence to thinking through them is that you will likely come to a deeper understanding of your own involvement and commitment to making art. Then your own art making becomes a solid foundation upon which to build the rest of your art activities.

The following interview with Leon Golub reiterates the need for artists to grasp the significance of their work. He places in perspective the shifting trends in the art world, the fluctuations in the art market, and the demands of surviving, and reemphasizes that the artwork is most important.

Leon Golub. 1989.
(Photo © Abe Frajndlich.)

ARTIST INTERVIEW: LEON GOLUB

Leon Golub is a painter in New York whose work has exposed the darker sides of contemporary life and the abuses of power at the margins of society. His work has been exhibited extensively in the United States and Europe.

Where do artists get the sense that they're doing something worthwhile? Neither art theory nor the art market seems to provide it because they can be so changeable.

You have to have belief. Artists are sufficiently obsessive or self-convinced about what they're doing and maybe they get an occasional intangible reward. They get into an exhibition or somebody likes their work or they get their name listed somewhere. There's a prestige to being an artist—well, society has both an unsure-of-itself contempt for the artist and grants them prestige as well. Most younger artists have decided, at some point, to step out of the conventional ways of earning a living, like joining a firm and working one's way up or becoming a doctor, an accountant, or some other damned thing. Consciously or unconsciously they decided to trade off the insecurity of the art game

(continued)

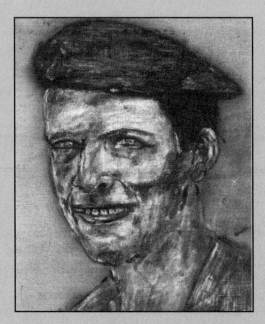

Leon Golub. Mercenaries I *(detail). 1979.*
Acrylic on canvas, 120" × 166". Saatchi
Collection. Photo by David Reynolds.

(continued from previous page)

for the sense of self, even the sense of possibly glory, that they might
get for daring to be an artist! And the fact that it may be difficult for oth-
ers to comprehend what they make, at times, can be thrilling to them.
They feel that what they are doing is not the same old dead thing, but
that they are really moving it ahead. Even at my age—I'm seventy-two—
I still get that kind of pleasure.

Your energy and involvement in your work seems undulled over the years.

One hopes so. Most artists need to feel that their work still has an edge,
an artistic tension. I've never wanted to, nor would even know how to
do relatively placid meditative work. I don't have it in me. Artists have to
pick out those ideas, themes, subjects, techniques—whatever it is—that
excite them, incite them, demand their attention. They have to have a
sustaining belief. It doesn't mean an artist can't change. Artists change
whenever the balance of forces within them push them to change,
sometimes quite radically. And when they do, they are often accused of

(continued)

(continued from previous page)

cheating on themselves or of being influenced by someone else. But often theses changes come from a very deep desire on the part of the artist. The thing that gets in the way, of course, is surviving economically.

Maybe you have some comments about that.

Surviving? There used to be an old joke that one third of the artists lived off their work, one third live off their spouses, and the other third, no-body knows how they live. That's not a real statistic but it implies the kind of difficulty of surviving through art. It gets very tough. If you have to be a construction worker or waiter or clean houses, as you get older it becomes extraordinarily onerous. There's only a small number of artists who live totally off their work. Most supplement it, part-time teaching, other things. And all this stuff you hear about money in the art world, it applies to an infinitesimally small percentage of artists.

How do you organize the demands on your time?

There are two careers in this studio: my wife, Nancy Spero, who has been very successful the last number of years, and myself. We have three assistants; one works four days a week and two work three days a week. They handle paperwork and slides, which are time-consuming jobs. They go on installations with Nancy, print images under her direction, set up canvases for me, run all kinds of errands, repair all kinds of materials, and things of this kind. They are continuously busy. We try to delegate as much as possible. Neither my wife nor I necessarily do a project from the beginning to the end ourselves. For example, in the course of working I used to scrape my paintings down, which was very laborious. Then I got assistants to help. I came to the conclusion that what counted was that I controlled the beginning of a painting and the ending of a painting. The intermediate stages someone else could assist on, because I could follow up and correct or change. It's a noisy place and can drive you nuts, but we try to keep three days a week without people around, Saturday, Sunday and Monday.

The first thing an artist does ordinarily when he or she starts to get success—if they have any brains at all—they do not go out and buy a house. They may get a loft or something. But they get an assistant, somebody to take over the more onerous tasks. And that permits them to expand their range of activities and actions. Perhaps they travel more, perhaps innovate more. We get a lot of applications for such jobs because it's one of the more attractive ways that younger artists can survive. Assistants often become well-known artists in turn, partly because the artists they work for often push their work.

(continued)

(continued from previous page)

Your general perception is that an artist's life is difficult.

I don't want to be negative about this, because basically I really believe that the art world is a great open space in which one can wander, demonstrate, conjecture, and cause trouble! Even when things are really tough, there can be a great pleasure in developing sufficient belief in what you're doing and making it work. To define yourself, that's an extraordinary thing to be able to pull off.

Compare this to mass industries, big offices where you have a hundred or two hundred people, and none of whom even have a cubicle of their own. And even when you have a cubicle, the partition is typically about chest high.

So artists who can find some hole in the wall where they can work, even if they have a lousy job to get by, they have a freedom that some of these others hardly know exists.

This is one of my theories, okay? One of the reasons it's so tough on artists is because society says you're one of these wise guys, huh? You're one of these people who are going to go off and make some smears on a canvas or throw some mud around and claim you deserve a living for doing so. Well, we don't fall for this so easily. We're only going to pick a couple of you guys. We're not going to let everybody who throws paint on a canvas make a good living, because otherwise everybody would leave those offices and nobody will do anything else. So society says maybe there is something in this, maybe it is important culturally, but you all can't be right so you have to be punished. You'll not be able to eat well, you won't have health insurance because you don't have the money. We're going to make it tough for you. And then if you prove yourself, okay, we'll reward you. But only a couple of you.

But at the same time the art world can be a terrific place. And artists have to be resistant. What if you work for years to get an exhibition and nobody reviews it, or worse—well, it may be worse or better— they review it as a negative? So what do you do then? Go shoot yourself? Become so depressed you torture yourself for months? Nobody likes put-downs, artists or nonartists. The point is that you have to have enough will or courage to just say, "Okay, everybody says this work stinks but I know different," and you stick by your guns. And the crazy part of it is that most artists have this will. They're very tough about it and they make it work. Not necessarily financially or prestige-wise, but they do what they have to do. And that's the game. I'm still romantic about it.

Chapter 2

MAKING CONNECTIONS

Making it as an artist is a two-part problem. Part one is creating work that is important to you personally. Part two is showing your work, getting the audience you want to see it, and getting your work validated. Validation means that your work is acknowledged by others to be significant and meaningful, whether aesthetically, conceptually, socially, or politically. While most artists realize that hard work and dedication are needed to create artwork, fewer anticipate the amount of social interaction required to complete the act of art making.

VALIDATION

To simplify, there are two ways to have your artwork validated, that is, recognized as signficant and meaningful by others. One way, the "mainstream" method, is to have your work recognized by people within the museum/gallery system, such as curators, dealers, and critics. These people are art professionals, who are entrusted by society at large with evaluating, displaying, buying, selling, and preserving artwork. Artists attempting mainstream success configure into a pyramid, with many struggling at the bottom and only a few reaching the top. Success is ultimately measured financially and positionally—what sells, to whom, and where the work is placed. In this system, artists expect eventually to live off the sale of their work and to see it collected by museums and wealthy individuals. For a few, this happens, but many more compete in this sphere because this is where the money is.

The mainstream art world purports to recognize artists of "genius" and artwork of "quality" regardless of its style or content. However, a brief look at recent history shows that mainstream art has been dominated by a series of styles: in the 1950s abstract expressionism, the 1960s pop art, the 1970s minimalism, and the 1980s, neo-Expressionist painting and text-and-image photography. Mainstream success may come more easily for those working in the current styles, and more slowly for those who do not.

Artists seeking mainstream success often send slides, résumés and other supporting materials to art professionals, hoping for a positive response to their overture. These artists try to have their work shown in the most prestigious galleries and museums, reviewed in prominent publications and collected by well-known

collectors. Second-tier galleries or publications are seen as stepping-stones to better places.

Some artists do not seek validations from the mainstream art world. They may want a different audience for their work from those who go to galleries and museums. Some do art that is not particularly marketable through galleries, such as mass-produced art, video art, or performance. Others make site-specific or monumental work, such as murals or art for public places, which physically does not fit into the gallery. Others may deal with content that might be considered unacceptable.

Validations for these artists cannot come through the traditional gallery-museum system, but through alternative means. Artists must identify the audience who is interested in what they make, and find ways to bring the work to them. To reach audiences, artists are usually more flexible about where they show their work than the image-conscious mainstream artists. In addition to galleries, they may exhibit in community centers or storefronts, print their images in newsletters, or project slides on the sides of buildings at night. For these artists, an exhibit is usually not merely a stepping-stone to something better, because of the emphasis on communicating issues rather than achieving sales. In fact, they rarely expect to make a living ever from the sale of their work. Alternative systems of validation deemphasize the buying and selling of artwork, so the esteem attained by artists through their work is not founded in financial success.

The dividing line between mainstream and alternative methods of validation is fuzzy. There are mainstream art professionals who are very interested in artwork done outside their sphere. And some artists make work for both mainstream and alternative sites. Some artists begin working in alternative modes but are eventually absorbed into the mainstream art world. For example, Cindy Sherman exhibited her photographic self-portraits at Hallwalls, an alternative space in Buffalo, New York, before her string of successful exhibits in high-profile galleries. She worked as a secretary at Artists Space in New York City, where she wore the outfits that she used in her early photographs. After a few years of daily "performing" at Artists Space, she was given a show there.

Either mode of validation, alternative or mainstream, involves the participation of others. In this part of art making, getting the work seen and evaluated is not something an artist can do alone. You work within systems and need the assistance of others to reach your goals.

SOURCES OF INFORMATION

Being connected on the most basic level means having access to information about career opportunities, such as upcoming exhibitions, competitions, grants, jobs, lectures, artist residencies, available studios, and so on. Much of this information can be acquired by reading national, regional and local art

publications that help artists keep up with critical theory, news, and current exhibitions. In addition to their articles, many artists find useful information in the announcements and classified ads sections. These publications are available at large newstands, university libraries, art supply stores, and by subscription. Also available is Arts Wire, a computer-based network, where artists can read news, participate in discussions, send and receive electronic mail, and retrieve information. Special services include "Hotwire," a summary of art-related news, and "Money," a searchable resource of grants and other opportunities for individual artists and art organizations. Another resource is the Visual Artist Information Hotline, a toll-free information and referral service concerning organizations and their programs that benefit artists. Topics include funding, health and safety, insurance, artist communities, international opportunities, legal information, public art, and so on.

Although these information sources are helpful, you need to supplement them with the information you get by word of mouth while keeping in touch with other artists and art professionals. The information you get this way is usually more timely and tailored to your individual situation, and therefore ultimately more likely to benefit you. Also, you may hear about many funding and job opportunities that are never broadly advertised, or are not posted in the particular publications you happen to read. But keeping in touch socially and professionally not only enables you to pick up passing information, you also become known as a person to others, who then might actively send opportunities your way.

ARTIST ALLIANCES

Whatever art path you take, find people to help you in your work. This means building for yourself a cooperative network of artists, art professionals, and ordinary intelligent, perceptive people. You can begin making these connections by going to art events, receptions, openings, and lectures. However, you can more quickly build an effective network by consciously developing a tighter group of people with whom you will work. You ask these people for help when you need it, give help back to them when asked, and share information with them about career opportunities, such as jobs, exhibitions, contacts, and so on. By building these alliances, you work for your success and the success of others at the same time, and help each other achieve common goals. The following are suggestions for different kinds of alliances that other artists have tried with success.

The simplest kind of alliance is an *informal alliance*, where you cooperate with the friends immediately surrounding you on regular tasks and current projects. For example, exchanging mailing lists, jointly maintaining equipment such as computers or shop tools, or regularly sharing information about shows and jobs can be mutually beneficial to members of a small group. In some cases, these groups critique each other's work and help hone ideas. If you are in charge of some project, you might be able to delegate

some work to others, and credit them publicly for their contribution when the project is complete.

Make your circle of friends broad and diverse as it can be, including people older and younger than you; of different economic, racial and cultural backgrounds; and of different gender and sexual orientation. Include not only artists but writers, arts professionals, business people, and perceptive people from any profession, as well. For example, choreographers, audio technicians, construction workers, and psychologists may be very helpful groups if you are planning a performance, installation, or video. Given their diverse backgrounds, these people will provide you with help and feedback from many different points of view. Note the people with whom you work well, with whom you have some kind of common goal, or whom you enjoy as individuals. Find people who can reciprocate when you give them help. If you are still in school, note the students you admire, trust, and find reliable, and keep working with them after graduation.

Collaborations are more complex forms of alliance. A one-time collaboration consists of two or more artists jointly producing a work that both own and for which both receive equal credit. In ongoing collaborations, the participants produce a series of works, forge a collective artistic identity, and become known under the collaborative name.

Artists are drawn to working collaboratively because the ideas generated may be richer and the work attempted more ambitious than one person could do alone. If you are considering working in a collaboration, let the nature of your group develop organically. Attempt one project and evaluate the results. If there is a second project, try to avoid some of the pitfalls you discovered in the first. After that, you may consider some long-term commitments together. From the very beginning, however, you and your collaborators need to come to an understanding on the following points:

- How does the group come to critical decisions? How are ideas proposed and developed? Who makes visual decisions?
- Who does the labor? Who builds a piece, transports and installs it, and stores it for future exhibits?
- Who funds the project?
- Who does the clerical work? Who is responsible for paying bills, keeping slides of the group's work, maintaining the group's résumé, and sending out proposals?
- Who owns the actual objects created? Are the works for sale? For how much? How are proceeds divided?
- Who owns ideas proposed by the group but never actually realized? Can individuals unilaterally use these ideas if the group is temporarily inactive or disbanded?

Collaborations come into being for many reasons and in many forms. While some long-term collaborations have fixed members, others operate

around a small core that is joined by outsiders on a project-by-project basis. Some are casual collectives, while others are much more formalized, like Art Attack, the New York- and Washington, D.C.-based public installation group with nonprofit, tax-exempt status. The collaborative identity in some cases is very strong, as is the case with the Guerrilla Girls, a group of anonymous artists/art professionals that create posters, videos, and performances criticizing the art world's unfair treatment of women and ethnic minorities. Far from keeping their members anonymous, other collaborations are called by the names of their members, such as Komar & Melamid, Russian emigrés painting in the social realist style. Many collaborations were formed for social or political action, such as Gran Fury and Powers of Desire, that deal with AIDS issues. Long-term collaborations are intense relationships, involving not only working together, but also requiring trust, similar work habits, mutual respect, a similar vision for the future of the group, and so on.

Artists' organizations are another form of alliance. In some respects, they are like extensions of informal alliances. Organizations can provide artists with a community, give support and advice, and pass on information about jobs, exhibition opportunities, and so on. Most cities and towns have local art discussion groups that can be found by asking other artists or by inquiring at galleries, libraries, or art supply stores.

Major artists' organizations are listed in the *American Art Directory*. For a listing of more than 300 nonprofit artist organizations and over seventy service and advocacy organizations, consult *Organizing Artists: A Document and Directory of the National Association of Artists' Organizations*. The listed organizations run the gamut in terms of their missions. Some package exhibitions or promote more exhibition opportunities for their members. Others are organizations for political action. Some are media based, for example, ceramic societies. The larger organizations produce publications with educational and networking information, provide access to group health insurance for their members and offer discounts for magazine subscriptions. Some of the most prominent are listed below.

The College Art Association is a national organization that furthers scholarship and excellence in art and art history, both in teaching and in practice. The organization publishes educational materials, job listings, and guides to graduate schools. It provides benefits to artists-members, whether they teach or not, including access to health insurance and an annual conference for the exchange of art and art historical ideas, trends, and research.

National Artists Equity Association works for social, economic, and legislative change for all visual artists. NAEA focuses on the artist's career and profession, much like a trade association. Recently, NAEA has pushed for passage of national legislation to protect artists—specifically, 1) Health Hazard Labeling, which provides for the review of all art material and the appropriate label warnings for chronic toxicity; and 2) Visual Artists Rights Act of 1990, which amended the copyright law to give artists greater protection for their work,

and contained an arts preservation act, limiting the destruction of artwork in public buildings. NAEA is an all-volunteer organization with chapters in various U.S. cities.

A loose network of more than forty independent organizations of Volunteer Lawyers for the Arts provides its members with legal advice at greatly reduced cost or for free. They also sponsor workshops on artists' issues with legal ramifications, such as information on the copyright laws, gallery-artist legislation, contracts, working with agents, and so on. They assist organizations in filing for nonprofit status. Similarly, the Accountants for the Public Interest provides professional accounting services to individuals and nonprofit organizations.

Women's Caucus for Art is a nonprofit women's professional and service organization for the visual arts. WCA seeks to undo the gender bias in museums, galleries, art education, and art literature. The national office sponsors an annual conference and publishes a quarterly newsletter, while chapters sponsor their own activities, such as meetings, seminars, and exhibitions.

Thus, in addition to providing artists with practical assistance, large artists' organizations can alter the art world, bring about legislation more favorable to artists, create more exhibition possibilities and provide beneficial services to artists. Artists face many difficulties. Exhibition opportunities may be difficult to get. Health care can be a problem. Just getting by can be hard. Very few earn anything close to a living wage from art, and most have other jobs to make ends meet. Laws may not protect artists, as in some states creditors can seize the work they left at a gallery if the dealer goes bankrupt. Other laws are unfair to artists, for example, the current tax law that allows collectors to deduct from their gross income the full market value of an artwork they donate, whereas artists donating their own work can only deduct the cost of raw materials. The collector profits from a hefty tax break, while the artist can claim only pennies on the value of the work.

All artists can exert informed and persistent pressure through organizations to bring about change in areas of concern to them. The power of organizations can be profound. For example, studies show that women and minorities in the art world, with fewer exhibition opportunities, less pay for their work, and less print coverage, have seen improvements in the situation only after these groups and their supporters have applied protest and pressure.

Artists can make connections also while working with agencies and organizations that are not necessarily artist-run. You can become involved in city, county, or state arts agencies or cultural affairs departments. These government offices in charge of tax-based cultural support often use advisory committees composed of artists, collectors, and art professionals to supervise their programs, which may include exhibitions, grants, scholarship competitions, and educational seminars. States and some larger cities operate their public arts programs through these departments. Serving on committees for these departments gives you an excellent education in public support for the arts, and enables you to make contacts with art professionals. By calling the offices of

these agencies and departments, you can find out the roles that artists play in their operations. Other places to work for change are artist committees in museums or private arts councils, or the board of a museum.

You might consider working with political activist groups that support causes you care about. For example, if you are concerned about pollution, your contribution as an artist to an environmental group may be invaluable. You are building a community of people who may support other aspects of your art career, and at the same time effecting needed change.

GROUP SKILLS

A few skills are helpful if you become involved in organizations: The ability to listen is the fundamental skill needed when working with someone else or a group. To ensure understanding, paraphrase or repeat important points when talking to another person. When you speak, have a firm grasp of your own ideas and use language that the other persons can understand. If you use speech to intimidate others, you may have positioned yourself on a level different from them, but you will not have gained allies.

Break down major goals into intermediate steps and set deadlines for completing each step. All involved group members should develop and agree on the working plan and timeline. The plans should be flexible and periodically revised as the group moves closer to its goal.

Negotiate for what you want. Your sense of your own power is essential in negotiation. Power resides in every individual, in personal conviction, in the justness of a cause, in financial resources, in persuasive ability, and in persistence. Also, you gain credibility and strength when supported by others. Information is also essential in helping you to frame arguments and propose solutions. Ask your friends and supporters to help supply you with information in any difficult situation. Finally, time: if you are willing to put in enough time, talking to people, clarifying what you want, trying to convince them, tying up their time, and in some cases simply outlasting them, you will often be successful in negotiation.

Another important component in negotiation, however, is compromise. To come to an agreement, both sides must gain something. But before compromising, mentally establish your bottom line, where you are actually willing to settle as distinct from your initial bargaining position. If you are negotiating on behalf of a group of people, you need to know what the entire group considers the bottom line.

In organizations, some people avoid leadership positions, fearing the exposure, responsibility, and demands on their time. However, effective leaders do not make all the decisions and do all the work themselves. Rather, they oversee the group as it reaches its goals. The one task that does fall to group leaders is running meetings. Leaders must ensure that when the group meets, it sticks to achieving its stated goals and moves forward on its timetable to accomplish intermediate steps, or else people will feel as if their time is wasted.

At your meetings, everyone should know beforehand what you intend to accomplish and remain focused during the time together. For large groups, you usually circulate an agenda beforehand. Agendas usually deal with old business first, to keep track of work in progress and make sure it is completed in a timely manner, before proceeding to new items. Allowing for some flexibility, list who will speak on what topic, for how long, and in what order. However, do not let one person monopolize the meeting, especially if this keeps others from making reports that they have prepared. When a problem arises that cannot be resolved in a few minutes, ask a small group to work on it and report back at the next meeting. Respect other people's commitments and end your meetings on time.

Budget the time you are willing to devote to an organization and hold firmly to that limit.

MENTORS

One final kind of artist alliance or relationship must be mentioned. A *mentor* is a loyal tutor, advisor, or friend, who has your best interest at heart and is willing to help you in your art career. A mentor should genuinely respect you and your work, believe in you, your character and potential. Often mentors will be older and at a more advanced point in their careers, having achieved some success in the art world. They can help you through difficult problems, advise you on ways to approach your career, suggest contacts that you can make, introduce you to art professionals and recommend you for positions and exhibitions.

A mentor relationship might develop with a particularly helpful instructor, with other artists or with art professionals. This relationship can be formalized or very informal, depending upon you and your mentor. You might meet on a regular basis to discuss your work. Or you can meet as needed, when you want someone to help you with an application or to review materials you are sending to galleries. A mentoring relationship is invaluable to emerging artists, not only because it provides practical help, but also because it gives you emotional support and important insights into the more complex dimensions of being an artist. Thus, a mentor can act as a role model and lend moral support as emerging artists develop. Such a relationship cannot be forced into being or invented as needed. But you should be alert to the possibility of it developing when circumstances allow. You may have several mentors at different stages of your career.

Artist and art professor Ruth Weisberg comments on some aspects of the mentor relationship:

> If you have a mentor, the best thing you can do is be successful, because both you and your mentor are invested in your success. Never make your mentor look bad. Several years ago, I recommended someone for a job, who was rude at the interview. I never, never recommended that person again.

Keep in contact with your mentor, not necessarily demanding contact, but a note every once in a while, where you are, if you are searching for a job. It is good to know that! Recently I wanted to pass information on to someone terrific, but was frustrated because I didn't have her phone number. Well, I'll send her a note, but that is creating work for me, so I am just somewhat less likely to do it. You must always assume your mentors are very busy, so you want to make it easy for them. If you want a letter of recommendation, always send a résumé. And it also feels real good to be thanked.

The mentoring relationship may gradually become a two-way street, with you eventually becoming a peer to your mentor, giving help and support back to that person. Also, you should be aware at any stage of your career of the possibility of your acting as a mentor. You already have more experience than others who are just starting. You could be a great help to them if you choose to be.

In the following interview, artist Rupert Garcia describes mentors who assisted him early in his career. He also discusses situations in which he informally acted as a mentor for other artists and also his participation in formal mentoring programs.

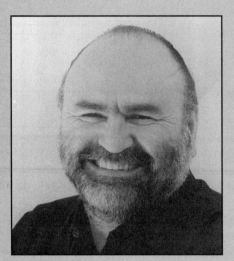

Rupert Garcia. 1993.
(Photo © Bob Hsiang.)

ARTIST INTERVIEW: RUPERT GARCIA

Rupert Garcia is a painter who lives in Oakland, California, and teaches at San Jose State University. His exhibitions include a travelling solo exhibition, "Aspects of Resistance," organized by the Alternative Museum of New York and a twenty-three-year retrospective of prints and posters that travelled in the United States and Mexico City. He received the 1992 Distinguished Award for Lifetime Achievement from the College Art Association.

You had some teachers who were very important to your development?

In the mid- to late 1960s one of my studio art professors at San Francisco State University, John Guttman, cleverly demonstrated to me the importance of art making, and integrated the intellectual aspect into it. It was very important for me as a young man looking to become an artist. He did not set out to be a mentor but the relationship was such that it became that. This went on for a few years, even into graduate school and after that as friends.

Later, from 1979 to 1981, I got a graduate degree in art history at UC Berkeley. I worked with Peter Selz, who took to me and I to him. He

(continued)

(continued from previous page)

was important to me in that he made clear in how art is interactive with society. He wasn't interested in keeping them separate. I knew that before experientially; in the 1960s and 1970s I had been involved in the art and politics of everyday life: race, ethnicity, social and cultural justice, identity, and direct action. But he was very important in terms of an intellectual mentor and in terms of the rigor required to make clear those kinds of relationships. I respected him as an art historian and critic. And he also supported my art production. He wrote major essays for catalogs and for arts magazines and reflected on my work as something that should be taken seriously. So both of these teachers functioned as mentors, although we never called it that.

What has been your experience as a mentor to other artists?

I began to really know mentoring for what it is when I cofounded the Galeria de la Raza in San Francisco in 1970. It began as an artists' collective gallery of Chicanos and Latinos who saw themselves as forming a part of the social and political movements of the late 1960s and 1970s. We were very concerned with the local nonresponse of the museums and mainstream galleries to our work. So we developed our own venue and developed our own way of organizing shows and had an internal dialogue with ourselves about, among other things, art and politics and their connection with the Mission District, with the people who lived there. The founding of the Galeria happened in the context of the antiwar, the Chicano, the Black Power, and the women's movements—what I like to call the international Grand Critique of the way things were, and to a large degree still are.

At the Galeria de la Raza, I became a mentor to other artists and I became conscious of that occurring. I helped these other artists with their work, wrote recommendations and tried to find opportunities for them. And I wrote catalog essays, brochure essays, and for the first year and a half or so I did mostly all the silkscreen posters for the art exhibitions. I didn't flaunt that I knew I was a mentor. I kept a very low profile because I wanted to continue the sense of friendship and not have people respect me too much. That creates too much of a distance and I didn't want that to happen. This kind of mentoring is something I got from the way in which my mother interacted with her friends and really helped other people figure things out. That unpretentious model made total sense to me.

(continued)

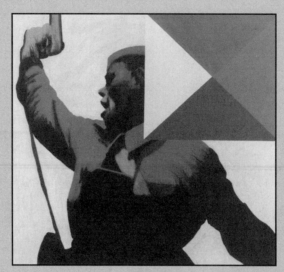

Rupert Garcia. N.E.W.S. to All. Oil on linen, 72" x 72".
(Photo by M. Lee Fatherree)

(continued from previous page)

In more recent years, I've also been mentoring Latino and other artists outside the academy, as well as with students at San Jose State University.

You participate in formal mentoring programs, don't you?

Yes. The College Art Association has a mentor program sponsored by the Rockefeller Foundation where an artist is asked to function as a mentor and to select a student or former student as a protégé to bring to the CAA Annual Meeting in New York. The students would make a presentation about their work. I would go along with my student, suggest important meetings to go to and introduce him to museum people, other artists and historians in attendance. It was really wonderful to go to this meeting where each protégé discussed their work. The energy was intense and just incredible. And it allowed these young people to experience that they were being taken seriously, and to meet young artists from around the country and an art historian from Mexico.

More recently, I formally participated as a mentor for two young artists for the mentor-selected protégé group exhibition of MACLA, Movimiento de Arte y Cultura Latino Americana, based in San Jose,

(continued)

(continued from previous page)

California. MACLA's guest curators, Pilar Aguero and Erin Goodwin-Guerrero, asked mentor artists to select protégé artists to "support and showcase Latino artists and continue the work the mentor artists began some twenty years ago."

Beside practical matters, what else might you discuss with those you are helping?

We deal with many issues. I tell them, in order to survive as an artist, you have to be involved in art as necessity—if you don't continue making art, you feel you are going to die. If you make art mainly to sell or to be in fashion, then you can be easily swayed into confusion. If you don't make it in the fickle art world, what are you going to stand on for support? It has to be, it must be, that you are making art because you have to, not because you want to become rich and famous, although that might happen, too! Generally speaking, the art market is about selling, it's about moving things that can be sold. It's not primarily about moving what is important. Compare what it means to be an artist and what it means to be an art dealer. Oftentimes they don't mesh; oftentimes art and commerce are adversarial.

I also try to help them get perspectives on political controversies that might affect them within the art world. For example, there was a multicultural movement in this country long before the current controversy. The attempt now to assert that multiculturalism is the vulgarization of 'American culture' is ludicrous and unfounded and is based on myopic points of view of art and culture and quality and how quality is achieved. It's a reactionary response from those in conservative political, economical, and cultural spheres of influence. The anti-PC movement is an in-your-face kind of meanness. Discussions on the quality of work versus what the work is about oftentimes denigrate the spiritual issues in works of art. To say something is not put together well as a painting and therefore it cannot be important often dismisses the ideas in the painting! Even though I say that, I do not support works of art that are poorly constructed formally. So to a certain degree there is something that needs to be said about works of art that pretend to be politically correct but are aesthetically incorrect. My students may argue, 'Oh, this is my feeling and so the painting is good.' Well, that may be your feeling, but as painting it all falls apart and that's *not* good!

(continued)

(continued from previous page)

How does this fit with your own artwork?

I approach art making, teaching, and mentoring in a holistic way: everything counts, meaning time in the studio counts as well as time outside the studio. How you negotiate that depends on who you are, what your priorities are and what your insight is. It is also helpful for me as a mentor to talk about the factors that go into my art making. On one level, it is the practice of thinking and feeling about the present moment in which I live as it is connected to the past and touches on the future. On another level, my work is concerned with critiquing certain aspects of the mass media and also issues of racism and war, based in part on my experiences of racial discrimination going as far back as my childhood in Stockton, California, and when I was in the Air Force serving in Indochina. The art-making process is the best way for me to negotiate these issues and others, a way of figuring them out, of feeling more deeply, hopefully to enlighten me both intellectually and emotionally. My background gave me a sensibility of fragmentation and juxtaposition, so my images seem to collide in a certain space, within diptychs and triptychs that bring disparate elements together.

What is in mentoring for you?

I do mentoring because this is what wasn't there for me in college, except for the people I mentioned. I believe in myself, I believe in my work and what I am doing as an artist is as right as it could possibly be. And I would like, in some way, to share that with other people and, in particular, younger artists. What I get out of it is simply the joy of seeing young people grow, and I really mean that in the profound sense of the word. Not only aesthetically, but intellectually. These young people mature and change, sometimes extremely rapidly, sometimes it scares the hell out of them. But being alive, to me, is simultaneously frightening and wonderful.

SECTION TWO

Getting Your Work Out and Seen

The chapters in this section contain practical information on showing your work in many different circumstances. Chapter 3 talks about showing your work outside of galleries and museums, whether you are an emerging artist just starting out or an established artist with a long record of shows. Chapter 4 tells you how to produce or put together your own exhibition or performance, including compiling mailing lists, designing announcements, and developing press material. Chapter 5 explains the operations of various established art spaces, who makes decisions within them, how they are funded, and what kind of work they are likely to show. Chapters 6 and 7 cover how to approach the administrators or owners of these spaces, and describe the preparation and packaging of the verbal and visual materials necessary to document your work and your career. In Chapter 8, the services provided by each kind of established art venue are described. The "rules" in these chapters are merely the conventions by which the art world currently operates. While you should know them, you have the option to follow or break them.

Your mentors, friends, and allies can shorten the time it takes you to get exhibitions and performances by suggesting likely sites or by introducing you to curators, dealers, and program coordinators.

Chapter 3

TAKING CONTROL OF SHOWING YOUR WORK

OPTIONS FOR ARTISTS IN MAJOR ART CENTERS

Artists often exhibit, place, or perform their work in many places besides galleries and museums. These sites are attractive to emerging artists for their first exhibitions or performances because the spaces are accessible to them. Since these sites are not typical galleries, but have other commercial or social purpose, they are attractive to established artists as well, because their work becomes site-specific and enriched in these places.

An example of artists taking control of exhibiting their work was L. A. Place Project, in which five artists organized and directed site-responsive shows of installation work in historic buildings under restoration. L. A. Place Project had no office, no bureaucracy and operated on intermittent grants and donations, but it attracted a considerable audience and critical attention. Its first project was the "Bradbury Building Show" in 1990, with sixteen artists creating installations among the marble, glazed brick, and cast iron of a lavish old office building. In 1991, thirteen artists created installations in a gutted interior with the "Chapman Market Show." Many of the artists who participated in L. A. Place Project installations were already integrated into the gallery system. They were attracted to working in venues and styles very different from what they could do in the gallery. They especially enjoyed the sense of community and spirit of cooperation among the participating artists.

Exhibition and performance opportunities are available in everyday circumstances, but they must be tailored to your own work and used imaginatively. Some projects may cost money to realize, while others could be relatively inexpensive or free. For example, if you consider a house as a potential exhibition or performance site, there are different ways that might actually be implemented, such as:

- Artists can rent an inexpensive apartment and turn it into a gallery. A basement exhibition space called MOAT, the Museum of Agenda and Transgression, in the house of Dallas artist Chris Hogg, held occasional and temporary exhibitions of unusual work.

■ Temporary site-specific exhibitions and installations can be done simultaneously in a number of homes and be open to the public at certain hours.

Other artists have used commercial sites, such as store windows and vacant stores in malls, for artwork. It is sometimes possible to get funding and recognition in the art world for these activities. Established art venues, nonprofit organizations and even museums may sponsor artist-initiated public projects. A group of Houston sculptors organize an annual outdoor exhibition of sculpture called "Watermelon Flats" in open spaces near the bayou. San Diego artists in "Projection Trilogy: Performance in the Neighborhoods" were sponsored by a nonprofit organization to show film, performance, slides, and video in public spaces and parking lots. Commercial movie houses have hung artists' posters on AIDS in their lobbies. In addition to office buildings, homes and parking lots, the following sites could also be used by artists:

Government buildings

Malls and empty stores in malls

Public buildings, including libraries, schools, and train stations

Commercial sites such as cafes, hair salons, bookstores, furniture stores, and so on

Yards, parks, beaches or empty fields

Rooftops

Storage spaces in storage buildings

Loft spaces

Concert hall walls and performance spaces

Slide projections on billboards, walls or other sites

Swap meet rental spaces

Newspaper advertising space

Vehicles as exhibition sites, such as your car, or flatbed truck exhibitions

Evaluate these ideas to see which are available to you and enhance your artwork. In some cases, you must consider factors such as security, adequacy of utilities, lighting needs, accessibility, condition of walls, restrooms, and so on, to make sure that a space will actually support the kinds of work you wish to do in it. Consider your potential audience: Who lives or works in the surrounding areas who will see the art? Visibility may be important: Will people coming specifically to see your work be able to find the place?

Performance artists can also use unconventional sites for performances. In her book, *Doing It Right in L. A.*, media and performance artist Jacki Apple states that self-producing a performance is "a given—the way things happen, not a stigma suggesting a last resort for rejectees. Quite the opposite—self-producing is admirable." Many previously listed sites work well for self-produced

performances, including government buildings, malls, public buildings, commercial sites, parks, beaches, and lofts. Other possibilites are:

Community centers or recreation centers

Privately owned art galleries

Churches

Clubs

Theaters

Dance studios

Broadcast media, such as public access Cable-TV and public radio

Not all these venues may be appropriate for the performance you might do, but some may provide for your basic needs. Evaluate the potential performance sites, deciding what qualities are essential for you. Some spaces may charge fees or require insurance.

Physical space: Are ceilings, floors, seating, exits, and sight lines adequate?

Lighting: Can you sufficiently control lighting with existing windows and light fixtures?

Sound: Are the acoustics and sound systems adequate?

Utilities: Are electricity, heat/air conditioning, water, and restrooms sufficient?

Personnel: Are there any maintenance persons, technical or clerical staff, security guards or other people you might need?

Availability: Check for both rehearsal and performance times.

If you are looking at theaters or auditoriums, see if the stage and tech booth meet your needs. Ask if other equipment is available, such as video or audio decks, slide projectors, film projectors, ladders, extension cords, and such.

Some performances in unconventional sites may have completely different sets of needs. In "Swimmin' the River," an ongoing performance dealing with humans' strained relation with nature, artist Billy Curmano is swimming the Mississippi in stages from its source to the Gulf of Mexico. His equipment needs have included such diverse items as boats, marine radios, water snake repellent, and barrier cream to protect himself from water pollution. He has been assisted by forty volunteer crews who have become part of the piece.

GUERRILLA ART

Guerrilla activity is an option open to artists who want their work to have a public impact. Generally, guerrilla art is nonsanctioned artwork that is done anonymously and appears without warning in public places. Its purpose may be political protest, social critique, or subversion. It may or may not obviously be artwork (Figure 3.1). It almost always addresses a particular audience in a

'Repent/Sin' is new option at crosswalks

NEW YORK (AP) – to the befuddlement and amusement of New York pedestrians, someone is doctoring electric crosswalk signs to flash commands such as REPENT/SIN and CONFORM/CONSUME instead of WALK/DON'T WALK.

Traffic officials have two questions — WHO? and WHY? — and a direction of their own: STOP.

"This could be dangerous," said Lisa Daglian, Transportation Department spokeswoman. "Someone could get hurt if they're looking at one of those signs while trying to cross the street.

"It's not a good message to tourists either," she added.

No, this isn't Kansas. Not with someone — guerrilla artist? prankster? urban terrorist? — climbing up light poles, unscrewing the grille on the light, removing the lens stenciled WALK and DON'T WALK, and replacing it with one bearing an ambiguous message.

Although Daglian said it was unclear how many lights had been tampered with, she cited three cases.

She was insistent: "This is not a creative outlet. It's confusing people."

FIGURE 3.1

An article from *The Outlook*, October 5, 1993, page 4C.

specific site. There is no formula for making guerrilla art, which by definition falls outside the status quo. It sometimes falls outside the law: Be aware of local regulations on trespassing and vandalism. The 1980s saw an explosion of guerrilla art that has continued into the 1990s.

Some guerrilla art is done on a grand scale. Gordon Matta-Clark cut large L shapes, rectangles and circles out of abandoned New York buildings in the 1970s. The cuts created new passages and light shafts through floors, ceilings and walls, opening up the buildings and making visible their structures. The first cuttings were made in abandoned buildings without the owners' permission, with Matta-Clark running the danger of possible police and gang confrontations. Later, Matta-Clark moved into the mainstream art world, and cut buildings under the auspices of gallery director Holly Solomon, the Paris Biennale, and the Museum of Contemporary Art in Chicago. The large chunks of walls and floors that Matta-Clark cut away were often displayed in commercial galleries, as were the photographs documenting the cuts that pierced the buildings.

Guerrilla art frequently has taken the form of posters, signs, drawings, or graffiti. For example, the Guerrilla Girls produced a number of famous posters, billboards, magazine ads, bumper stickers, slides, videotapes and performances documenting the art world's poor record in showing the work of women and ethnic minorities (Figure 3.2). In guerrilla fashion, the

Q. HOW MANY WORKS BY WOMEN ARTISTS WERE IN THE ANDY WARHOL* AND TREMAINE AUCTIONS AT SOTHEBY'S?

A.

Please send $ and comments to: **GUERRILLA GIRLS** CONSCIENCE OF THE ART WORLD
Box 1056 Cooper Sta. NY, NY 10276

*The Contemporary Art Auction

FIGURE 3.2
Guerrilla Girls Poster

works would appear or the performances occur at discriminatory art events and openings.

The relationship of successful or prominent guerrilla artists to society is complex. At the same time as they question or challenge the status quo, the works of the better-known guerrilla artists are being absorbed into the mainstream. Guerrilla art satisfies the official art world's constant thirst for the new or its desire to appear politically liberal. Robbie Conal is a Los Angeles artist responsible for a number of posters protesting the conservative politics of the late 1980s and early 1990s, targeting individuals such as Senator Jesse Helms, Presidents Ronald Reagan and George Bush, and members of the Supreme Court. Conal's large thickly painted oil portraits, the bases for the poster images, were displayed and sold in commercial galleries at the same time as his nocturnal volunteers plastered the posters on walls, fences, and construction sites. As an art student, Keith Haring anonymously produced a number of colored-chalk graffiti drawings in the New York subway. Many drawings were lost, but as the fame of his graffiti images spread, Haring moved into mainstream art and executed his imagery with paint on canvas.

Successful guerrilla artists may find themselves becoming increasingly "respectable," like Art Attack, a guerrilla art group (at its founding) that became a nonprofit corporation in the late 1980s in order to deal with its tax responsibili-

ties. Art Attack now focuses on public art, applying for permits to work legally at its selected sites.

Some guerrilla art remains relatively obscure or is not easily appropriated into the system. It may address audiences without ties to the world of fine art. Some guerrilla artists purposely downplay public relations. In some cases, the viewers may not know for sure whether or not they have encountered guerrilla art (Figure 3.1). Artist Jill D'Agnenica surreptitiously placed 4,687 small pink plaster cupids, ten per square mile, on street corners, bus shelters, in yards and freeway ramps in Los Angeles, photographing each angel where it was placed. She sees her work as a gift to the city and to those who happen to find the work, and as a photographic documentation of the city as it existed in 1993–1994.

EXHIBITING IN SMALL CITIES AND RURAL AREAS

Artists living in small cities or rural areas have a different kind of challenge in exhibiting their work. These areas lack the critical mass of people to provide many established venues for displaying art. Galleries and museums are few and far between. Guerrilla art is more difficult where everyone knows everyone else's business. In very small towns, there may not be many commercial establishments or public institutions with high public exposure.

Like emerging artists, artists in these areas have to be inventive in finding an audience and venues for their work. Of course, small town- or rural-based artists may still exhibit in galleries in large urban areas, like photographer Joel Peter Witkin who lives far from the East and West Coast galleries that show his work. But many artists find resources and venues closer to home, which emerging artists may also use.

A remote location might be an important condition or even an asset for the work you could produce. Site-specific works and earthworks are examples of this. Walter de Maria's "Lightning Field," constructed from 1971 to 1977, with a grid of 400 stainless steel poles each 20'7'' high and 220' apart in a large open field in New Mexico, is a moving and spectacular work that takes advantage of the frequent summertime afternoon electrical storms in the area. Local controversies may be an impetus for works of art, a strategy sometimes used by environmental artists. Dominique Mazeaud pulled trash out of the polluted Rio Grande every day for one year as a performance art piece and a way to bring attention to the river's dreadful condition. Ciel Bergman collected nonbiodegradable material from the Santa Barbara coastline for her 1987 installation, "Sea of Clouds What Can I Do."

Regional and state art agencies promote the proliferation of art in areas other than the major art centers like New York, Los Angeles, Chicago, and other large U.S. cities. The National Endowment for the Arts works in cooperation with seven regional organizations to award fellowships to artists living in specific areas that cover the entire United States. Check for other outlets for your work in the community where you live. Commissions for artwork may be offered by regional museums, city governments, local businesses and local institutions.

Karen Atkinson with Joe Luttrell.
(Photo courtesy of artist.)

ARTIST INTERVIEW: KAREN ATKINSON

Karen Atkinson is an artist, art activist, and independent curator living in Los Angeles. She currently teaches at California Institute of the Arts. She is a former director of Programs and Exhibitions at the nonprofit art space, Installation, and is the founder and director of Side Street Projects, a nonprofit workshop/gallery in Santa Monica, California.

In the course of your career, you have taken advantage of a wide range of options for getting your work out.

In the late 1970s, I started a slide exhibition project called "Projections in Public" that showed in storefront windows after-hours. I am still doing this and often curate slide projects with other artists. I founded a group called the ARTtorneys at Work to fight for the reauthorization of the National Endowment for the Arts. I did a project where I turned a gallery into a lawyer's office to deal with this issue. In addition, the ARTtorneys distribute the Alternatives List, a description of projects that artists have either thought of or executed that exist outside the commercial gallery scene or outside the traditional ways artists are validated. These projects occur in parking lots, storefront windows, and so on. The Alternatives List has made its way around the country in some form

(continued)

Karen Atkinson. fenestrae reliquian (in memory). 1994. A site-specific installation of 300 handkerchiefs. Window size: 64' X 12'. Viewers added white ribbons with names of those who have died of AIDS. (Photo courtesy of artist.)

(continued from previous page)

or another and a lot of teachers have used it in their classes. "Ra-Decals" for the Angry Consumer, for Pro-Choice, for Environmental Concerns, for Freedom of Expression, are stickers designed and distributed by the ARTtorneys (in this case, Beverly Naidus and myself). They can go on all your bills and correspondence, doctors' office magazines, grocery items, and so on. Anywhere that is legal, and then some.

For me personally, it is not a question of access, because I have shown in galleries and museums, but a question of context. Artwork can be landscapes, abstractions, or doing highly charged political work, or talking about whatever issue you want. But I describe art making as a contract with someone who will see it, a contract with the viewer. You put energy and commitment into work that ultimately goes into a public space as a form of communication. You

(continued)

(continued from previous page)

have a language to speak to your audience, and the viewer has another way of perceiving it. The job for the artists is to make a connection in the way they intended the work to be read.

Context changes the way the audience perceives your work. If you hang your work in a gallery, it could be read in a certain way, or if you hang it in a hospital, it could have a completely different reading, or in a furniture store, another reading still. Depending on the context, a work can be really funky or boring, or challenging and interesting. Not all work makes sense in a museum setting, and not all work makes sense in a parking lot or on a billboard. You need to figure out where your work fits.

When I talk about this in lectures all over the country, artists ask how they will be paid for such work. My response is "Well, are you getting paid now?" What does an artist do whose work does not sell, or who is not interested in making work to fit the commercial market? The artists participating in "Projections in Public" have received a fee every time the project has been shown, and that project exists outside the marketplace.

Many of your projects described on your Alternatives List require that artists get involved with local communities.

Getting permission involves a community effort. Even with a project in a storefront window, you have to deal with the owner of the building, unless you find an abandoned structure. I have curated or produced slide projects in offices and commercial spaces by day, that then shut down and become art spaces from dusk to midnight. The collaborative element educates people who know nothing about art. There is something interesting in the way artists have been separated from the rest of society. The critique of elitism has its pros and cons, but art is not a part of our cultural lives anymore. People don't understand what we do. Some artists think that you have to become simple when you speak to the public, but I think that it is unnecessary and dangerous to talk down to your audience. The idea of sharing what we do is a completely different strategy.

This approach to art can be attractive to both emerging artists and established artists.

In the early 1990s, with the art market collapsing, artists are definitely looking for more options. And it all depends upon how you contextualize things. If you added "museum" and "commercial gallery" to our

(continued)

(continued from previous page)

list, and just called it "places to do work," then we wouldn't be talking about "alternatives."

In L. A. alone, there are probably ten new spaces started by artists. They may not be permanent, but there is work being produced that never would have happened in the 1980s. In the 1980s, artists expected that they would follow a sort of traditional linear trajectory, that their work would be shown in "hottest" galleries and that they would live off their work and be "art stars." A few years ago, my students' work looked exactly like what was showing in the commercial galleries. If they did not have a gallery before they graduated, they were devastated. Now things have shifted. Fewer artists are making artwork for the galleries. More are making work by their own definition, for their own spaces, not just for themselves only but in contract with the audience. In general it is much more interesting work than what we saw in the 1980s.

Artists are also becoming more savvy about technology, about video, computers and computer networks. I recently became involved in a computer network, called Nomad Web, linking people all over the globe through the Banff Center for the Arts. Discussions about art have traditionally appeared only in the print media, which doesn't allow access by people who aren't writers, who aren't somehow "on the list." Print media is more like preaching because the audience can't answer back. On the network, you have access to talk to each other and write your own ideas, and participate, so it is another art form that I think has tremendous potential for the future, although it still has class boundaries.

Why have you founded a nonprofit organization?

There seemed to be a hole that needed to be filled, so, in my delirium, I decided to fill it! I started Side Street Projects for artists' projects and installation work that get less attention in the validated venues. It is another option for artists.

I actually support showing in commercial spaces and museums, and alternative spaces. But, with so many friends of mine, their work changes once they get a commercial gallery. Or they become known for certain work, and if it sells the gallery director is always saying, "I want more of that kind of work!" It isn't easy for their work to change or grow. What if the artist wants to do something else? Commercial galleries have to

(continued)

(continued from previous page)

survive by the sales of works, and it sometimes puts pressure on everyone.

Well, Side Street Projects exists for artists who can't show in a commercial gallery or for someone who is highly successful in a gallery but wants to do something different. Look at Felix Gonzales-Torres, who not only exhibits in museums, but does books, billboards, and public art projects, situating his practice wherever it makes sense. There are some artists and arts professionals who look down on showing in certain cities or in certain spaces. Their choice is valid, but looking down on what other people are doing or closing off possibilities perpetuates the old system.

Side Street Projects also has a workshop space. After graduate school, how do artists get things made? Who has a table saw in their living room? Lumberyards do not guarantee the accuracy of their cuts and a fabricator may charge a minimum rate of $45 an hour. Artists usually can't spend that kind of money, so they just don't make certain kinds of work. At Side Street Projects, artists can get things cut, drilled or sanded at half the rate of most fabricators. We keep lists of people who have other skills, like welding, and who will give discounts to artists if they come to them through our organization. We also hire artists to help us with the production and offer fabrication and skills workshops. Side Street Projects helps many artists in a circular kind of way.

You are encouraging artists to be cooperative among themselves, not competitive.

I think in this particular time, it is the only way to survive. But it goes beyond artists. Side Street Projects is located in an arts complex where several arts organizations share a number of buildings, fax machine, and copiers. It is a very collaborative situation, and that is probably the way of the future, and the way artists and arts organizations are going to prosper.

Chapter 4

YOUR SHOW

This chapter describes putting together an exhibit or producing a performance, including compiling mailing lists, designing and sending announcements, writing press releases, preparing the exhibition site, organizing the performance, and/or installing the show.

You can use this information in three circumstances: 1) when you have a show with a commercial gallery, to be certain your work is properly handled and publicized, and to make your contributions to the effort; 2) when you are curating an exhibit of other artists' works (see Chapter 10); and 3) when you decide to organize, publicize and fund your own exhibition or performance. In the latter two cases, you take on some of the work and expense normally borne by a gallery, museum, or other institution, in order to exhibit artwork that otherwise might not be seen.

The following are examples of circumstances when artists might be partially or totally self-sponsored.

- Artists who make work for the general public and want to show at public sites, community centers, or other places that lack an art budget or staff.
- Artists whose works are either unmarketable or not politically mainstream, requiring venues other than established commercial galleries that deal only in marketable work.
- Artists working in experimental or new technologies.
- Performance artists for whom venues are limited.
- Artists who are members of a cooperative gallery.
- Emerging artists without an exhibition or performance record.
- New commercial galleries, which will more readily take chances on new artists and often show the most exciting artwork, may pass some responsibility for the exhibit on to the artist, due to limited budget and staff.

Before you jump into a self-sponsored show or self-produced performance, find out how much money and time will be required. Artists frequently make their artwork without sufficient pay for time, talent, effort, materials and other expenses. If at all possible, avoid having to pay to show your work as well. Before you commit, ask your mentors if you are likely to incur more hidden

costs than what appear at first, and whether the exhibit is really worth it. To reduce your cost and effort, consider a group rather than solo exhibition, having all the participating artists share the work. Fortunately, such a group show is likely to attract more art professionals and a bigger audience.

EXHIBITION CALENDAR

The calendar below outlines what you need to do for your self-sponsored exhibit or self-produced performance, and when, relative to your opening, you need to do it. Ideally, you have several months to prepare for a show. Often, however, opportunities for emerging artists come with only a few weeks' warning; for example, you may get a chance for a show due to a last-minute cancellation. In such a case, obviously, your timetable is compressed.

The list below contains many tasks, and the sheer volume of things that need to be done may seem daunting. Ask for help or to trade services as a way to accomplish them.

When you first consider a possible exhibition or performance:
Work out an agreement with the space's owner or staff on all essential points, especially concerning expenses. If possible, get a written contract or letter confirming the agreement.

- Establish whether the event is solo or group, and who is participating.
- Set the dates.
- Will the artists be reimbursed for any expenses, such as printing and mailing announcements, shipping, press releases, or reception? If not, are there some businesses that have donated money or services in the past, and that can be approached for this event?
- Who writes and sends press releases and handles publicity?
- At what times is the gallery open?
- What staff is available? Preparators, clerical help, gallery attendants?
- Who restores the space and walls before and after an exhibition?
- How much time is available to install the work?
- Is insurance needed if showing at an unconventional site?
- What audiovisual equipment is available for video or performance?
- Is any technical assistance available for video or performance?
- Is the electrical service sufficient for all artwork, lighting, and equipment needs?
- When are available rehearsal times, performance times?

Several months before your exhibition:
Begin to develop your mailing lists, if you do not already have them.
Traditional Visual Art: plan the exhibit.

- Acquire a map of the gallery.
- Draw to scale how you will place existing work in the gallery.
- Plan new pieces for the exhibit, if needed.

Performance: begin scripting, casting, and developing audiovisual materials.

Six weeks before:
Prepare your announcements:

- Design the announcement and prepare camera-ready artwork.
- Make price comparisons on printers.
- Have the announcement printed.

Recruit people to be gallery attendants if showing in an unconventional site.

Five weeks before:
Preparation for publicity:

- Photograph your work, both with slides and black-and-white prints (see Chapter 6).
- Make all black-and-white prints to be mailed with press releases.
- Write the press release.

Four weeks before:
Distributing publicity materials and announcements:

- Duplicate and mail press releases to the print media. Use first-class mail.
- Mail your announcements if using bulk mail.

Three weeks before:
Prepare artwork to be installed:

- Frame works if necessary.

Arrange for a photographer to document your performance.

Two weeks to ten days before:
More publicity:

- Send press releases to broadcast media. Use first-class mail.
- Send follow-up press releases to print media.
- Make phone calls to art writers.
- Mail your announcements, if using first-class mail.
- Assemble press kits.

Performance:

- Set the schedule for performance rehearsals.
- Design and duplicate a simple program.

One week before:
Evaluate the condition of the exhibition site.
Traditional Visual Art: prepare supplementary material for the exhibition:

- Update your resume (see Chapter 6).
- Write an artist's statement to be placed at the exhibition (see Chapter 6).
- Photocopy past reviews of your work.
- Prepare the exhibition list, with titles, dates, media, and prices.
- Prepare signage for show.

Two to four days before the opening:
Traditional Visual Art installation:

- Paint and patch gallery walls.
- Acquire necessary hardware for installing exhibit.
- Install the exhibit.
- Set lights.
- Prepare artwork labels.
- Purchase a guest book for names and addresses.
- Acquire reception supplies.

Performance:

- Do tech rehearsal, coordinating performers with sound and light.

Opening day:
Performance:

- Do sound and light checks.
- Check the condition of the stage and the audience areas.

MAILING LISTS

You need to build and maintain your own mailing list, for both self-sponsored work and for exhibits at established galleries and institutions. It is key to getting a good audience turnout. With group shows, combine the mailing lists of all participating artists to attract a larger audience. For shows at galleries and institutions, your mailing list is perhaps not as essential, because these spaces maintain their own lists of supporters and press people. However, supplementing their lists with yours is surely worthwhile, because most people are interested in artists and artwork rather than the art space, per se.

In order to target particular groups with your publicity, you need to create a mailing list that is subdivided into useful categories. The first category in your mailing list is the *press list*, the people who receive press releases. The following are the broadcast and print media that should receive press releases from you:

National art magazines

Regional and local art magazines

Metropolitan daily newspapers

Alternative press and free weekly papers

Neighborhood newspapers

College newspapers

Radio stations

Television stations

While it is beneficial to include national publications in your press list, you should concentrate on local magazines and newspapers that are more likely to review emerging artists.

For print media, press releases should be sent to the appropriate editors. Some big daily newspapers have both citywide editions and also local editions with special sections covering particular neighborhoods. If so, send press releases to the citywide art editor and to the arts/culture editors in local editions. Do some research before your exhibition to find the alternative, free weekly newspapers and small local newspapers that cover art events in the area of your exhibition. If you are exhibiting at a university, send a press release to the university newspaper.

Many local and regional publications also have calendar listings of art exhibitions. To be listed, send a separate press release specifically to the calendar editor at these publications. Most publications post the deadlines for submissions at the beginning or end of their calendar sections.

Address press releases to the art and the calendar editors by name, not simply to "Editor," and mail them to their publication. The publisher's address and editors' names are located in the masthead, which usually can be found near the front of the publication.

Press releases should also be sent to individual writers. As you read art reviews over time, you will recognize that certain writers may be sympathetic to your work and should be put on your mailing list. Also add any writers you have personally met or who have already reviewed your work. Send press releases to writers at their publications only if they are regular writers. If they contribute articles irregularly, try to discover their home address and send materials there, since publications may or may not forward mail to them.

Writers and editors should also receive your show announcement, especially if it has an image and your press release did not.

The second category on the mailing list is *art professionals,* to whom you send announcements of your exhibition. It includes:

Museum directors

Curators, both independent and institutional

Commercial gallery dealers

Academics

Other artists

Keep these people apprised of your work, so that they may include you in a future show they curate. Announcements should be sent to all commercial galleries in the area. Send announcements also to galleries in other cities if you would like to show with them. Local and out-of-town curators should receive announcements if you know them to be interested in your kind of artwork.

The last category on the mailing list is *personal supporters*, to whom you send announcements. This includes friends, family, and collectors who are interested in you and in your work. You especially want to include those who have purchased your work in the past. They may be interested in further supporting your career. Even if they are not, the fact that you continue to be an active artist is heartening to them.

To be the most efficient and cost-effective, delete from your mailing list the names of people who have moved or who are no longer interested in your work. At the same time, always plan to expand your list by trading lists with other artists whose work is related to yours, and by adding the names and addresses of people who have signed your exhibition guest book.

As you accumulate names and addresses, you need to deal with the problem of maintaining your mailing list. While building, outputting, and updating mailing lists is time-consuming, using a database program on a home computer makes the task manageable. Database programs allow you to make a separate entry for each person's name, address, and phone number, and to specify to which category of mailing list each belongs. You can also add nonprinting information and notes about persons on your list, such as past reviews they have written, or works they have collected. The database program can sort and print out your mailing list in different ways:

alphabetically, for easier address changes and deletions

by ZIP Code, if you are sending announcements via bulk mail

by category, if you wish to send out only part of your list; for example, sending releases to the press.

You can update your computer-based mailing list by adding new addresses, deleting expired ones and making address changes, leaving the rest of your entries undisturbed. Most computer printers can print your mailing list directly onto self-stick labels, which are easily affixed to envelopes or postcards.

There are many different kinds of database software available through retail computer stores or mail order outlets. You can also use hypertext software for mailing lists, although database programs can store more information per entry and have more sorting capability.

Before home computers were so common, mailing list were kept on index cards or in address books. Addresses on announcements were handwritten, or typed onto standard sheets of paper and then photocopied onto self-stick labels. All these methods are terribly labor-intensive. While you might have to invest

some time to put your mailing list on computer in the beginning, you can quickly generate your list every time you subsequently need it. If you do not have a computer, and do not know how to use database software, make an alliance and trade work with someone who can provide you with computer access.

ANNOUNCEMENTS

Show announcements and press releases are your most important publicity. Sending a well-designed announcement to everyone on an extensive mailing list is an excellent way to get your work known to arts professionals. As a form of advertisement, your announcement communicates information about your work, specifically in words, and more subtly through images, typeface and the composition.

Your announcement must cover the following key points, including:

Artist(s)' name(s)

Name of exhibit or performance

Dates

Name of gallery or site

Address, with a map if the site is difficult to find

Phone number

Regular gallery hours for exhibitions

Reception date and time, if any

Cost, of course, is especially important for a self-sponsored project. Fortunately, you can design great announcements that are also inexpensive to print and mail. The following guidelines will help you make effective, economical announcements. You can supplement the material presented here with any one of the many excellent books available on graphic design. Consult the bibliography at the end of this book, or visit a library or bookstore for more information.

Four basic factors affect the cost of announcements.

- Design costs
- Production costs, which are the expenses incurred to properly prepare a design so it can be printed
- Printing costs, including printing, paper, and labor
- Mailing costs

A good design is the first and most essential aspect of your announcement, if it is to be effective publicity. Further, a good design can save you production and printing costs because no special effects or exotic printing methods are needed to make it work; conversely, no amount of splurging on printing will save a poorly designed announcement.

Times
Century Old Style Bold
Memphis Extrabold
Univers
Bodoni

Helvetica
Helvetica Condensed
Helvetica Condensed Bold
Helvetica Condensed Oblique
Helvetica Condensed Light
Helvetica Condensed Light Oblique
Helvetica Black
Helvetica Black Oblique

FIGURE 4.1
At the top are examples of different typefaces. At the bottom are examples of variations within a single typeface, Helvetica.

You can avoid *design costs* if you design your own announcement. Attempt it only if you are good at graphics, which is not necessarily the same as being a competent artist. With the proliferation of computers and desktop publishing programs, some people may think that good designs are easy to do. While desktop publishing programs do reduce production costs, they no more ensure your producing a good design than any pencil will. While this text cannot cover how your announcement should look, you can develop a successful design by adapting other announcements that you like, sketching several possible designs and asking other artists and mentors to review your ideas.

Another option is to pay or trade with a graphic artist to design your announcement. Before someone else designs your announcement, communicate clearly to them what you want.

- Use visuals rather than words as much as possible to describe what you want.
- Show examples of other graphic works you admire.
- Have a sample of the type font you want used. Keep the type simple. Use only one typeface, with variations if needed, unless using several fonts is essential to your design (see Figure 4.1).
- Show color samples if you will be printing in color; asking for green when there are olive, teal, mint, forest, lime, and many other greens is not sufficiently specific.
- Make thumbnail sketches if you want a particular layout.

Finally, have your designer make a detailed drawing of the final design for you to approve, before any type is set, images are shot, or any other production

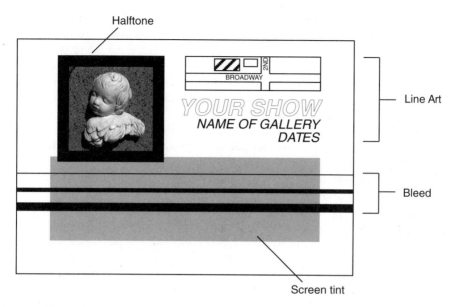

Halftone

Line Art

Bleed

Screen tint

FIGURE 4.2
Examples of line art, halftone, screen tint, and bleed

costs incurred. If you are paying for the design, you may be billed for both materials and labor.

Production costs vary with a number of factors. The kind of art in your announcement affects the cost you will incur. *Line art* consists of type, line drawing, and any graphic elements that can be rendered as black lines on a white background (Figure 4.2). Line art represents the least expense in production and later also in printing. *Continuous-tone art* is any image or graphic containing gray tones, of which photographs are the most common example. In order to be printed on an announcement, continuous-tone art must be screened or scanned to render it as a pattern of dots, called a *halftone* (Figure 4.2). An announcement containing continuous-tone art has higher production costs than one with line art only.

Type is another production expense. *Computer-generated type* is the most common type source now. You can design your type with a home computer, using commonly available word-processing programs, desktop publishing programs, or some more sophisticated drawing programs. Any of these can give you a wide range of fonts, sizes, and styles, and allow you to format your type, which means to align and place it exactly as you would want it to appear on your final announcement. The computer printer used drastically affects the look of the type. A dot matrix printer usually does not give acceptable results unless you want a computer "look" to your type. A 300 dots-per-inch laser printer generates higher-resolution and minimally acceptable type, but still has discernable "jaggies," or rough edges on the letters' curves. *Linotronic* output

has far better resolution than laser printer output, and is available at service bureaus, which are businesses that provide photocopying, color copying, hourly computer renting, offset-litho printing, and fax services. An 8.5'' × 11'' sheet of lino-output type generally costs less than $10. You can have a "lino" made by bringing your formatted text file on disk to a service bureau. Before bringing a disk to a service bureau, first find out what computer systems and software they support, and what format they need in order to produce a lino from your file.

In addition to computer-generated type, you can also use distinctive *hand printing* or *calligraphy* for an announcement. Of course, either of these poorly done will degrade the overall impression of your announcement and by extension your exhibition. Also, you can use *transfer letters* for limited amounts of type. Transfer letters are vinyl letters on clear plastic sheets that you rub and thereby transfer, character by character, onto a sheet of paper to spell out whatever you have to say. Transfer letters are available by the sheet in a variety of type styles and sizes at most art supply stores. If your announcement has much text or uses several type sizes or fonts, transfer letters will probably be too time-consuming and expensive to use, as they cost in the range of $3 to $7 per sheet. Finally, you can pay to have your text *typeset* at most printers and service bureaus, but given the proliferation of computers and the availability of other sources of type, typesetting seems like an unnecessary expense you could avoid.

The number of printed colors in your announcement affects the production costs, and later on also the printing costs. *One-color printing*, the least expensive, refers to any one color of ink on any one color of paper. Thus, black ink on white paper, blue ink on yellow paper, or purple on orange are all examples of one-color printing. One-color printing, with line art only, is the least expensive announcement to produce, and with a good design, such an announcement can be distinctive and effective. One-color printing combined with screened tints or halftone images gives the illusion of more colors, with that one color used both full strength and also its paler tints. *Two-color printing* refers to printing any two colors of ink, their combinations, and screen tints of one or both, onto any one color of paper. Two-color printing can appear to be quite colorful. It has, however, higher production costs and higher printing costs than one-color printing. Likewise, every additional color will increase overall costs. *Four-color printing*, sometimes also called full color printing, refers to printing cyan, yellow, magenta and black inks to reproduce color photographs. These four inks are called the *process colors*. Four-color printing has high production and printing costs and may require using more expensive paper for good results. In addition, you usually must approve a press proof for color accuracy.

Any *special effect*, such as embossing, die cutting, perforation, inserts, gluing, or varnishing, will increase production and printing costs of your announcement.

Production involves making the *camera-ready* art for your announcement. This entails assembling all the finished-quality type, images, and graphics. In traditional production work, a final version of the type is generated and

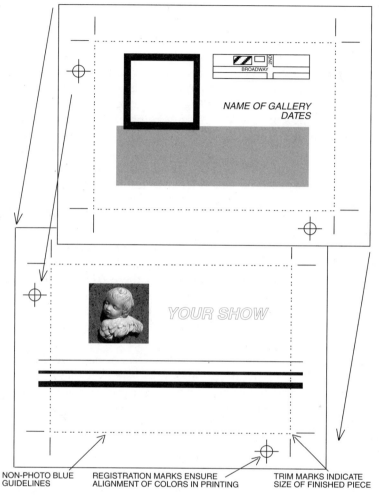

NON-PHOTO BLUE
GUIDELINES

REGISTRATION MARKS ENSURE
ALIGNMENT OF COLORS IN PRINTING

TRIM MARKS INDICATE
SIZE OF FINISHED PIECE

FIGURE 4.3

A pasteup with one overlay for two-color printing

any graphic or photograph is prepared, and all are then glued to clean illustra-
tion board in their proper place. This camera-ready art is sometimes called a
"pasteup." The elements in a pasteup are usually the same size as those in the
final printed announcement. Guidelines are usually drawn with nonphoto blue
pencils, and ample space is left around the edges of the pasteup for handling
the work and for instructions to the printer (Figure 4.3). Traditional production
work takes time to do, and thus labor represents most of the production costs.

With the recent proliferation of home computers and desktop publishing
programs, there is less need to make the traditional pasteup. Type, graphics,

and images are generated and manipulated in digital form and saved as files on computer disks. At some service bureaus, the finished announcements may be printed directly from the computer file. Conventional printers still print with plates prepared from a laser printout or lino. Generally, desktop publishing reduces production costs.

Some factors that affect *printing costs* have already been listed above, such as printing in multiple colors or using special effects. In addition, using a *bleed* increases printing costs. A bleed is any graphic or text that appears to run off the edge of your announcement (Figure 4.2). Since all printed material with bleeds must be trimmed after printing is completed, bleeds increase labor cost and paper cost in trimmed and wasted paper. In addition, with a bleed you may need to use a more expensive printer for your announcement, because many inexpensive "quick printers" do not have the equipment to print bleeds. Check prices before you decide whether a bleed is worth the extra cost and whether your design really depends on it.

The price of paper can add considerably to your overall printing cost. *Stock* is the paper used to print your announcement. Factors affecting cost are weight, content, finish, and special qualities, but these factors also affect the look and feel of your announcement, and therefore how it is perceived. Selecting paper is an aesthetic choice, and the tactile and visual qualities of the paper should be an appropriate reflection of your work.

Weight: the heavier the paper, the more expensive it is. Weight is given as the weight in pounds of a ream, which is 500 sheets of paper in a basic size. Bond papers, also called writing or business stock, are available in weights of 20 or 24 pounds. You may choose heavier paper for postcard announcements, or for announcements that feel and look more substantial. For example, cover stock generally comes in 50- and 80-pound weights.

Content: rag papers are more expensive than wood pulp papers. Again, you may choose to use rag paper if its feel or tactile sensation is important.

Finish: coated stock tends to be costlier than uncoated stock. However, you probably need to use coated stock if your announcement has four-color process printing, if you want to retain color brightness, or if your design has fine detail that needs to be crisp and sharp. Conversely, if you want lower contrast, softer edges and somewhat duller colors, uncoated stock will give those effects due to a greater absorption of ink. Other available paper finishes include enamel, linen, and laid. In addition, paper may be cold-pressed for an open finish and feel, or hot-pressed for a smoother, harder finish. Specialty papers, such as metallics, are more expensive than plain paper.

You can select and purchase the paper for your announcement at the printer, as most printers carry a limited amount of stock on hand. To choose from a greater variety, and probably pay less, purchase stock directly from a paper supplier and bring it with you to the printer.

Finally, the type of printer you choose for reproducing your announcement will affect printing costs. If you need only a small number of announcements, and your design calls for black only, consider photocopying

your announcement, using a good photocopier that gives strong, solid blacks.

Use an inexpensive "quick printer," if your announcement meets all the following criteria:

The announcement is printed in black only.

There are no bleeds.

The design is relatively bold, without fine details.

You need 100 to 500 copies.

Quick printers use small offset-litho printers with paper or plastic "plates." These inexpensive plates are not durable enough for very large runs and do not hold fine detail. Turnaround time is usually one or two days on most jobs. Quality varies greatly from one quick printer to the next, so ask to see samples of finished work before leaving your job anywhere.

For color printing, bleeds, or special effects, use large commercial printers. They offer either offset litho with durable metal plates, or a variety of special printing processes. They carry a wide range of stock. While expensive for small orders, their cost per piece on runs of 500 or more becomes reasonable. Larger printers are usually higher quality and slower to complete jobs than quick printers.

To contain *mailing costs*, you must know how your announcements will be mailed as you begin to design them. You can use bulk, presorted first-class, first-class and postcard mailing, and your cost, size limitations, weight limitations and format requirements vary greatly for each. Check with the U.S. Postal Service for current postal rates and regulations. The following are some general rules of which you should be aware:

Bulk mail rates are the least expensive of all options offered by the U.S. Postal Service. However, bulk mail must conform to a list of criteria, or the special rate cannot be used.

- Bulk mail postcards must be rectangular, at least 3.5″ × 5″ and no more than 4″ × 6″ in size. They must be at least 0.007″ thick, printed on minimum 60-pound paper stock.
- Maximum size for bulk mail letters is 6.125″ × 11.5.″
- Each item must display the bulk mail permit, or indicia, in the upper right corner, and the return address of the holder of the permit in the upper left corner (Figure 4.4). The post office prefers that the indicia be printed in black. The address area must be 3.5″ × 3.5″ and must be blank except for the address and the indicia.
- You must have at least 200 identical items to qualify to do a bulk mailing. No personalized notes may be written on any items.
- Bulk mail must be presorted, bundled, and color coded according to U.S. Postal Service regulations. The Postal Service supplies written instructions, and sometimes classes, on bulk mail procedures.
- Bulk mail must be delivered to special post office locations.

NAME OF BULK
PERMIT HOLDER
ADDRESS
CITY, STATE ZIP

NON-PROFIT ORG.
U.S. POSTAGE
PAID
LOS ANGELES
PERMIT 0000

3.5"

3.5"

Leave blank for address.

FIGURE 4.4
Postcard format for bulk mailing

Bulk mailing can be done only with a bulk mail permit. Individuals must pay $50 per year for a permit. Nonprofit tax-exempt organizations have even lower bulk mail rates. Check to see whether the gallery or institution where you are showing already has a permit. With bulk mail, it is impossible to predict exact delivery date, which may take two days or up to one month. Also, while bulk mailing costs the least amount in postage per item, a lot of labor and knowledge is required to do a bulk mailing. If done improperly, the Postal Service may refuse to deliver the announcements. If you have to learn postal procedures, or have to pay someone else to prepare the bulk mailing for you, then evaluate whether first-class mail may be cheaper and easier after all.

First-class presorted is a less expensive rate than regular first class. You must have at least 500 pieces, sorted by ZIP Code with at least ten pieces per ZIP Code, and sent with precanceled stamps or endorsed "Presorted First Class." Again, check with the Postal Service for current rates and regulations.

Postcards no larger than 4.25'' × 6'' in size can be mailed first class at a reduced rate. Larger postcards mailed first class must carry regular letter postage.

PRESS RELEASE AND PRESS KIT

Press releases notify the press about upcoming art exhibits and events. For print media, they provide information to arts calendars and entice critics to write about your work. For broadcast media, they are used for announcements of upcoming events, or perhaps to instigate an on-air interview. Press kits are more detailed documentation of your work, which are given to writers when they come to review your exhibition or performance.

A *press release* begins with factual information, answering the questions, "who?", "what?", "where?", and "when?" The following belongs at the top of the press release in the order given:

Date of the press release

Name of the exhibit or performance

Name(s) of the artists(s), if less than four are exhibiting; otherwise, something like "a group show of eight artists"

Exhibition curator, if any

Name of the gallery

Dates of the exhibit or performance

Reception time and date, if any

When writing a press release for a solo performance or exhibit, the first paragraph of the text should summarize the event. The next paragraph should flesh out the important aspects of your artwork; this part can be condensed from your artist's statement (see Chapter 6). You may also include other paragraphs with the following optional information: listings of your professional accomplishments, your other important exhibits or performances, major collections in which your work is included, comparisons of your work to other artists, or quotes from published reviews, catalog essays, or remarks by noted curators about your work.

A press release for a group show or series of performances begins also with factual information followed by the short, summary paragraph, with the names of participating artists and the curator, if applicable. Following paragraphs should discuss the exhibition theme, including a short quote stating the curator's point of view. If possible, the work of each artist should be covered in one or two sentences. When there are simply too many artists to do so, then lengthen the discussion of the theme and describe some examples. If you have planned any related events, such as workshops or artists' talks, list time, date, place, and participants. Also, acknowledge any group, individual, business or foundation that provided support.

For all press releases, a final paragraph lists supplementary factual information:

The address or location, with directions and parking information if needed

Regular gallery hours, for exhibitions

Name and telephone number of a person to contact for more information

Ticket prices and reservations telephone number for panel discussions, performances, or other art events with admission charge

Telephone number for complimentary press tickets for events

Figure 4.5 shows an example of a standard press release, printed on gallery letterhead. A press release is one or two pages in length, with all text double-spaced. Make sure your layout has ample spacing and short paragraphs for easy reading. The factual information at the beginning of the press release should be readable at a glance. Use outline form, large-size type, capital letters, bold letters or underlining to emphasize this information. Whether it was written by you or by gallery personnel, the press release should appear on gallery or institutional stationery. Use a high-quality photocopier to get clean, sharp results, and copy the body of the press release directly on extra sheets of letterhead, rather than photocopying the gallery logo also. Send it in a regular business envelope with the gallery's return address. However, press releases for self-sponsored exhibitions or self-produced performances at unconventional sites should have no letterhead at all.

Remember that the press release is a not a personal statement. Whether you write it or not, the press release always refers to you in the third person, calling you "the artist, Catherine Liu," or "Ms. Liu" or "Liu's work. . . ." The language in the press releases should be readable and informative, without esoteric terms or references. However, what you do write should be complete and reflect the essential qualities of your work. Sometimes the language in a press release later appears verbatim in a review or article about the work.

Some artists include an image of their work with their press release, in order to better convey an impression of its qualities. Some send photocopies of their work, but even the best photocopier does an inferior job reproducing photographs. Others send 8″ × 10″ glossy black-and-white photographs of their work, suitable for reproduction and properly labeled on the back with name of artist, name of work, media, date, and size. Distribute photographic reproductions only to those likely to use them, to avoid extra expense. If your exhibition announcements have an image and are available already, send one with each press release.

Technically, the gallery or institution's staff is responsible for writing and sending press releases for you. About six to eight weeks before your exhibit or performance opens, ask to review a draft of the press release, in order to have some input on the description of your work. However, you cannot always count on galleries or institutions to prepare press releases, as they may lack the staff or budget to do so. And if you are showing at an unconventional site, of course no one will be there to write press releases for you. In either case, you should be ready to write and send them yourself.

The artist interview with Steven Forster at the end of this chapter provides more information on preparing and distributing a press release.

FIGURE 4.5
Sample press release

FOR IMMEDIATE RELEASE:

EXHIBITION: HUBERTUS VON DER GOLTZ, "Sculptures: In Balance"
 TIN LY, "Dimensional Paintings"

DATES: November 20–December 19, 1992
OPENING: Friday, November 20, 5:30–7:30pm
HOURS: Tuesday–Friday 10:30–5:30, Saturday 11–5

"Sculptures: In Balance" by German artist HUBERTUS VON DER GOLTZ can be seen around the world atop buildings, bridges and the Berlin wall. There are also intimate versions that fit into corners and cast playful shadows onto the supporting walls. The figures are on the verge of toppling off the skinny beam that supports them, and there is uncertainty whether or not they will remain in balance. A specially designed selection will be exhibited at the Gwenda Jay Gallery during November and December.

Hubertus von der Goltz is an artist who himself experienced relocation from his native Prussia at an early age, and lived in Berlin faced with everpresent political uncertainty. He has built his artistic expression around the important personal, political and philosophical issues facing people everywhere. At Documenta this year, Jonathan Borofsky showed a sculpture very similar to the image von der Goltz has used for years to express man's precarious imbalance.

Von der Goltz's work has been shown throughout Europe and collected by several museums. In 1991, his work was shown at The University of Wisconsin-Milwaukee Art Museum. He is also working on an outdoor sculpture installation in Art Park this year.

Paintings by Vietnamese-American TIN LY provide the viewer with a graceful and romantic synthesis of two distinctly different worlds of East and West societies. The beautiful, atmospheric paintings present mystical sitings and organic forms, symbolic of spiritual rejuvenation, rebirth and the origination of life, reminiscent of Eastern thought. They are encased in a cold steel framework which boldly defines its boundaries and contains its vision, grounding it in a more American ideology. In a visual parody, Mr. Ly's contradictions parallel the contrasts between Eastern and Western thought.

Tin Ly has shown his work throughout Southwestern United States, and has participated in many competitions and group exhibitions. This is his first exhibition in Chicago.

For more information, please contact Raquel Chapin at 664-3406.

301 W. Superior • 2nd Floor
Chicago • IL 60610 • USA
312 • 664 • 3406

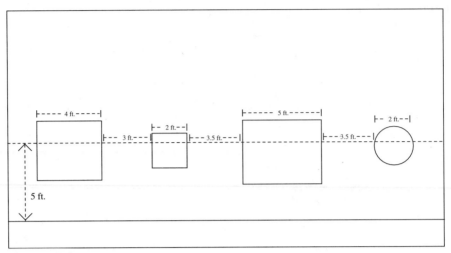

FIGURE 4.6
Conventional style of installing flat artwork

A *press kit* is a packet of information and images that is given to an art writer or critic who is writing a review of your work. You should have press kits ready that contain the following:

A copy of your press release

An announcement

An artist's statement

Copies of past reviews of your work

Copies of programs from past performances

Artist(s'), resume(s), for solo or small group exhibitions

A sheet with brief biographies of all participating artists, for large group exhibitions or performances.

A black-and-white glossy photograph documenting your work

These items should be arranged in a large envelope or folder, with the name and number of yourself or a contact person on the outside.

INSTALLING AN EXHIBITION

This section presents current conventions for displaying traditional visual art-work or video in a gallery-like setting. Feel free to vary these general rules, should you wish a different effect from your show.

Evaluate the condition of the exhibition site a week or so before your show. Nonconventional sites may require a great deal of work. The condition of the walls is critical for most traditional visual work. In extreme cases, you

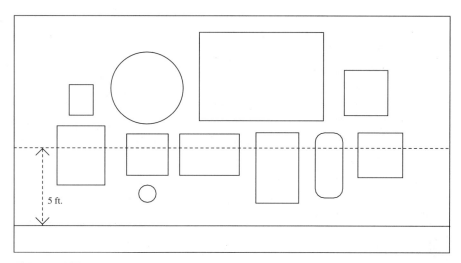

5 ft.

FIGURE 4.7
Salon-style installation

actually may have to build walls to finish a "raw" space, or build partitions to divide a large space. If so, you need wood (1″ × 2″ and 2″ × 4″) or metal wall studs for framing, drywall (4′ × 8′ sheets) for the wall surfaces, drywall nails, tape and mud for smoothing over the seams, and paint for the finished surface. Building walls is costly, takes a great deal of time, and requires some experience to get a good finish. Get help if you do not know what you are doing. Hopefully, your exhibition site needs only a cosmetic touch-up. Patch any nail holes or small wall tears from previous exhibits with Spackle, using a putty knife to apply it and sandpaper to smooth it once it is dry. Conventionally, the walls in galleries are painted cool white.

Check the lighting. Ideally, the site will have track lighting, with plenty of fixtures to illuminate as many pieces as you want to include in your exhibit. Unconventional spaces, however, may only have incandescent bulbs or fluorescent light. In these cases, the lighting may be bright, harsh, and utterly flood the room, or conversely may be so sparse and dim as to barely illuminate the place. You may need supplementary lighting to illuminate the artwork. Artificial illumination should be a constant, balanced white light or slightly warm light; the greenish tint and flickering of most fluorescent lighting is generally considered undesirable for viewing artwork. Check hardware stores for fixtures that can be temporarily installed in your space.

When installing artwork, you need a hammer, nails, long ruler, tape measure, and stud finder. While lightweight works can be hung almost anywhere on the wall, heavy works must be supported on substantial nails driven into studs. For hanging framed work, screwdrivers, screws and picture-hanging wire may also be needed, plus a plumb bob or level to help hang pictures evenly on

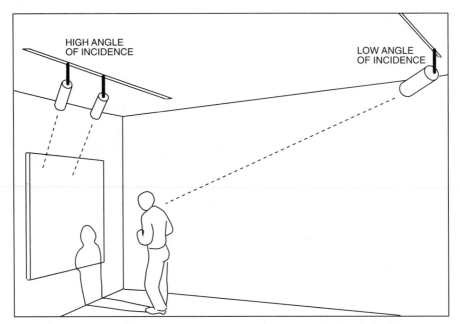

FIGURE 4.8

To avoid glare and cast shadows, light artwork on the wall from a high angle of incidence.

the wall. The conventional rules for spacing artwork on walls is to leave as much space to each side of a work as the work is wide, and to hang all works in a horizontal line around the room. Thus, a three-foot-wide painting would have three feet of space on either side between it and its neighbors. For pieces of varying size, average the width of the works to determine spacing (Figure 4.6). Conventionally, paintings are hung with their centers slightly below five feet from the floor. Alternatively, artwork may be hung salon style, in which case pieces can be stacked vertically and horizontally (Figure 4.7).

When everything is in place, set lights to illuminate each work. With works on the wall, watch for glare off shiny or glass surfaces. Illuminating wall works from a high angle of incidence usually eliminates most glare, while lighting across the room at a low angle of incidence increases it (Figure 4.8). In addition, a low angle of incidence will likely result in spectators casting their own shadows on works they are trying to view. Illuminate sculpture from several sides, so all parts are visible and the work does not cast a single long dark shadow. While each sculptural piece must be evaluated separately for best illumination, lights on sculpture often should be from both high and low angles of incidence (Figure 4.9).

For video, room illumination should be kept relatively low so that the images on the monitor can be seen more easily. Seating of some sort is usually

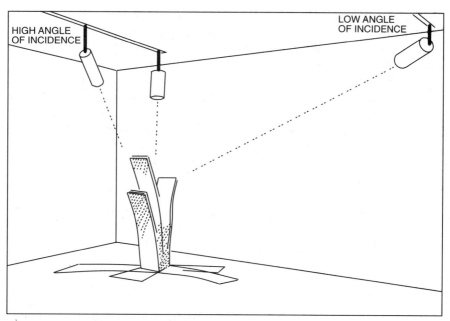

FIGURE 4.9
Light sculpture from both high and low angles of incidence.

provided for video viewing, unless the video is part of an installation that is meant to be seen from many angles.

Generally, artists provide a variety of written material at the exhibit, including a resume, artist statement, copies of past reviews, exhibition list, and acknowledgements. These materials should be clearly reproduced and placed in a binder on a front table or reception desk. Sometimes, the artist statement is enlarged and displayed on the wall. If you choose to do that, make sure the statement is printed on a quality printer, with clear, well-aligned type large enough to read from a few feet away, and displayed on mat board or under glass. Your exhibition list should number each work, and include the name, date, size, medium, and optionally the price. Corresponding numbers are placed on the wall to the right side of each work, usually three or so feet from the floor. Or you may use wall labels with the name of the work, and optionally the date and medium. Size and price are omitted usually on wall labels. The type again should look sharp and the labels mounted on mat board or under Plexiglas. If any persons, organizations, or businesses assisted you in making the work or sponsoring the exhibition, acknowledge them on a separate card displayed somewhere in the exhibition, perhaps near your artist's statement or your name at the entry.

Signage is important. External signage should be plentiful, especially if your exhibit is in an unusual site. Make it easy for the public to find your work. Inside, the artist's name and/or the name of the exhibit usually appear in large type at the front of the exhibit. Custom-made large vinyl letters are available through specialty printers for this purpose. Or you can use an opaque projector for projecting words onto the wall and then tracing and painting them by hand. This time-consuming and tedious work requires a steady hand to give professional results.

Minimal refreshment at a reception is a beverage served in plastic cups. It can escalate from there to an elaborate spread with snacks, finger foods, cut vegetables, hors d'oeuvres, and desserts. If you plan to serve alcoholic beverages, check first with your site. Many colleges, community centers, and churches have restrictions. If outdoors, check local ordinances about serving and consuming alcohol in public. Arrange for someone else to be in charge of the refreshments. You should not be tending the cheese dip while the work you have made or the show you have curated is on display.

Have a guest book available for the entire run of the show for signatures and addresses of those who attended.

PREPARING FOR A PERFORMANCE

Performance may be as simple as one person speaking or as elaborate as a full-blown theatrical piece. Either way, the element of staging—where, when, and how the audience meets the performer—is critical and requires preparations very different from those of traditional art exhibitions.

All performances, simple or elaborate, are group efforts. In addition to performers, you may need technical personnel to operate sound and lighting equipment, artistic personnel, such as composers or perhaps even a director, and often house personnel to manage the audience. Getting everyone to work together requires time, practice, and social skills: listening, communicating, building group consensus, getting help, and delegating tasks. Your rehearsals should be organized, not waste people's time, and start and stop on time.

You may be able to pull together a simple performance in a few weeks, but long-range planning is necessary for elaborate performances, when you may have to contend with script-writing, casting, choreography, recording audiotapes, and preparing written and visual materials. In her book, *Doing It Right in L. A.*, Jacki Apple outlines procedures for all these tasks. While some information in the book is Los Angeles–specific, the bulk of the text is applicable to anyone working in performance in the United States.

If you are performing at an unconventional site, you need to be certain that the space will be usable for your rehearsals and performances.

Coordinate with whomever is responsible for opening and cleaning the space.

Clear any changes you wish to make to the space, such as covering windows.

Arrange for seating, if necessary.

During the two weeks preceding the self-produced performance, plan on dealing with programs, audiovisual equipment, rehearsals, space preparation, and a host of other challenges. Your performance could conceivably use an array of equipment, from theater lights, microphones, speakers, tape decks, and slide projectors, to video decks and monitors, and so on. Be sure to have personnel competent to operate and do quick fixes on the equipment. Have backup equipment if possible. A host of other handy items might help, for example, a well-stocked tool box, extension cords, plug adaptors, extra tapes, a ladder, and so on. Try to anticipate every need, and provide for it.

Rehearsals:

Distribute the rehearsal and performance schedule to all participants.

Have scripts ready.

Coordinate audiovisuals and lighting with performers.

Have a photographer document your performance at a rehearsal, to avoid disrupting the actual performance.

Make video documentation during two rehearsals.

Programs: You should provide programs for your audience. Credits should include the following.

Name of the performance

Performers

Authors

Artistic personnel

Technical personnel

Acknowledgement of any person, business, or organization that provided support

Brief artist statement, if possible

Short biographies of the performers, if possible

By making up your program a few days before the performance, you can reflect last-minute changes. If you include performers' biographies, having them write their own, within a specific word limit, is preferable to your writing them. Then they can present themselves as they choose. Programs can be quite simple, and can be printed or photocopied on regular bond paper. Make and keep extra programs for future press kits or grant proposals.

Steven Forster. 1994

Photo © Owen Murphy

ARTIST INTERVIEW: STEVEN FORSTER

Steven Forster is a photographer who has exhibited at the New Orleans Museum of Art, the Contemporary Art Center, and the Mario Villa Gallery in New Orleans and Chicago. His work has also been seen in a wide variety of nontraditional exhibition sites.

Where do you show your work?

I am affiliated with a gallery. I love galleries and still do things there and I am planning a show there now. But I try to keep the contract loose with them. The gallery is only going to do so much for you. They are interested in what you can do for them, and then probably only one or two times a year. That's fine, but I also want to show more often and in other spaces where a good volume of people will see the work. I recently put some strong pieces together—3′ × 5′ photographs—in the window of a major men's department store in downtown New Orleans, on a wonderful corner on Canal Street where the streetcar turns and there is a lot of traffic. I was going for a bigger audience, and a place where kids would see it.

You have to convince the gallery owner that doing things in other places keeps you in the spotlight, and when you go back to the

(continued)

Steven Forster. The Prince of Bucktown. 1992.
Silver gelatin print, 9.5" X 14"
Photo courtesy of artist

(continued from previous page)

gallery people recognize your name. Pricing can be tricky. Galleries want 50 percent, but some nongallery sites don't ask for any commission. But you don't want to undersell the gallery. And your contract may still require that you give something to the gallery—like 20 percent of what you sell in other places.

Do you put the whole thing together when you show outside a gallery?

In the first part of my career, no. I had a friend who produced plays, and when I had an idea I would go to him, and he would figure out a way to write a proposal and he would help things out. It was great. But then he moved, and I was out of luck. And then I went through a period where I would put a show someplace, and other people would approach me that they wanted the show. So then the show would move around.

When I first started organizing my own shows, I would put the work together first and then go looking for locations. Now that I am more confident, I will find an accessible, exciting space months in advance, and then it gives me a deadline. I'll have to put other things on the back burner and really work on the art for a few

(continued)

(continued from previous page)

months. And work on promotion, because I realize when I promote my work and when I push it, then others get excited about it.

So getting good publicity is really key to your shows?

The press release is a major tool that is extremely important. The first two sentences of the press release are the killers. That's what they're going to pick up from, and that's how they're going to decide whether to read the rest of the thing or not. The press release should not be longer than one page. I've worked for publications, and after being on the other side of the desk, if it goes on too long, there is a chance they are not going to read it. So just make it quick, blunt, and powerful. You write it so that basically they can take stuff right from it, so that they can use the press release verbatim in their article. Because they are not likely to call you and ask you further about it. You've got to make it easy for them.

Early in the career, if you don't have quotes from reviews, you can quote yourself in the press release. Even at the entry level, you can self-describe your work: what is it about, who your influences are, what your inspiration is. Later on, when you have a couple of mentions, you can take bits and pieces out of other reviews. Keep it positive. Don't go on about the past. Be focused on the future. I send out press releases with no logo on them, just from me. Or I've gotten a sheet of stationery from the place where I was showing and used that for the press release. It is kind of helpful if there is a contact person's name who is associated with the place where you are showing. You don't want to be too accessible, and you also don't want to seem as if you are too aloof, either.

I used to just send invitations and press releases to critics. But now I also send them to writers, which is sometimes better than a critic, who may go off on strange tangents at times. Writers will ask you about your work and your point of view. They may do a story on both you and your work. And it is easy enough to look through a paper to figure out which writers in which newspaper sections may be interested in your work. And don't be afraid to call the publication and ask, "Who wants this information? To whom should I send it?"

I hand-deliver the press releases. Even if it means waiting until the writers or editors come back from lunch or whatever. Because if you do, then they meet you. And you may end up going for a cup of coffee, and

(continued)

(continued from previous page)

you may end up getting an interview out of it. You are offering them something that you are excited about, and it is not going to cost them anything, and it is something they really need. If you are up against something that was just sent in the mail, and something you hand-delivered, you are going to win.

Magazines need the press release about three months in advance, because they are working way ahead of schedule. At this time, if you finish a piece you really like, one that you might use on the invitation, you get some photographs of that and you get it to the magazines. Closer to the show, about a month before, send out press releases to weekly publications and dailies. You've got to have black-and-whites of your work ready for newspapers, and transparencies for magazines, because they want color.

When it gets close to the show, then fax another press release to them. Later, you can call them up and tell them you've got an invitation for them. You want to drop it by and hope they will come and see the show. You can hit them two or three times—the press release, the fax, the invitation. The opening is something that is related to work but they can go and have a good time.

The opening becomes a party, then?

When I have an opening I invite a hilarious array of people—businesspeople, friends of friends, other artists, anyone!—and I would try to keep a pretty hysterical, diverse group. People who would like meeting other people. Fun people. New Orleans is a very warm town.

You shouldn't get drunk at your opening. A lot of people who are coming will not be drinking, and they may be interested in buying something, but they like to meet the artist. And if you're a waste, then it turns them off. And other artists come to shows and openings, and I do a lot of networking there. I used to drink a lot, and I used to drink before I went to the openings. I think a lot of artists do it to escape. But there is a great line from Ethel Merman. She was standing on the side of a stage, waiting to go on, next to a dancer who was sweating and shaking, and she said, "What is the matter with you?" The dancer said, "I am nervous. I am scared of the audience." And she said, "Listen, if anybody out there was any better than you, they'd be here." Some people are going to like the work, and some people are not. And for me, some people still always like the one photograph I almost didn't put in the show.

(continued)

(continued from previous page)

Can you recommend any other ways to increase publicity for self-produced exhibitions or performances?

I've gotten more press out of the radio than I thought I ever would. Every station has to fill spaces with public service announcements. If you frame a press release like a public service announcement and send it to radio stations, you have a wild chance that they might do it. You don't want to push the place where you are showing, because the press doesn't want to give free advertisement. Emphasize that the exhibit is free and open to the public. You can also get PSAs (public service announcements) out if your show benefits some kind of charity.

Your shows are sometimes benefits?

Yes. But I could see this backfiring for someone who just wanted to do it for the disease of the month. The person who had recommended that I do this was a phony PR person—you can get a whole new group of people who are excited about your work and a lot of publicity out of it too. But I chose a charity that I had wanted to help anyway. My mother had gone through breast cancer, and I had been wanting to do something, but did not know what I could do. If you are at the point where you can give a percentage of your sales to a charity, you can help somebody with your art, and they are also getting a lot of publicity for the cause. You can get recognition for it and you draw a nice blend of people. If you do it for the right reasons, I think it will work. It is good karma if it is sincere. But you know, you can get depressed once these self-produced exhibitions are done. Even though they seem maddening when you do them, you miss having that sense of purpose and concentration when they are over.

Oh, and one other thing—getting involved with public auctions, like PBS auctions, is great. You are in this big gumbo of artists and you meet a lot of people.

Chapter 5

ESTABLISHED ART VENUES

You expect to hear classical music at a symphony hall and contemporary music at a dance club. Sometimes the opposite may be true, but usually your expectations would be met. Similarly for art, there are different sites for different kinds of exhibitions, events and performances. This chapter outlines the various kinds of existing sites for these art activities. You can be actively pursuing shows in these venues, while at the same time self-producing exhibitions or performances.

The following alphabetical listing includes the established art venues discussed in this chapter:

Alternative spaces

Businesses

College galleries

Commercial galleries

Community centers

Cooperative galleries

Museums

Municipal galleries

Vanity galleries

For each, there is a description of: 1) the type of exhibition sites; 2) the type of artwork displayed and the artists shown; 3) the operation of the site; 4) the audience attracted; 5) funding; 6) the role the site plays in the art world; and 7) the relative prestige of each site. Juried exhibitions and video festivals are also discussed, and the chapter concludes with brief comments on art consultants and artists' representatives.

Which exhibition and performance sites interest you? And how can you determine which spaces are most likely to show your work? The recommendations of mentors and other artists are very helpful. If they know your work well, and are already familiar with the existing sites in the area, they can recommend suitable places. They may even provide you with an introduction to the curator, gallery director, or exhibitions coordinator, thus giving you a great advantage when you approach them about your work. Even without recommendations,

however, this chapter gives you criteria for evaluating the exhibition and performance possibilities in your area or in another city. Once you have a grasp of the kinds of sites available to you, and how they work, you can begin to approach them for a show.

KINDS OF ART VENUES

Alternative spaces are venues for art that push the boundaries of established genres, by being controversial, experimental, or difficult to market. Some alternative spaces promote work dealing with political and social issues. Alternative spaces show installation work, performance, and art based on new technologies, in addition to work in traditional media. These venues also are generally conscientious about equal opportunity for the work of women and members of ethnic minorities.

Some alternative spaces boast a large staff, while others are small, with one permanent person plus non-paid interns and volunteers. Exhibition spaces, performance spaces, and/or video screening rooms can vary greatly. Alternative spaces often maintain a slide registry, which is a collection of slides sent by artists to represent their work. Curators, critics, and other artists may review the registry to select artists for shows at other sites.

Shows are organized by committees of artists and art professionals, either from the slide registry or from proposals sent in by artists. For example, artists wanting to exhibit or perform at C.A.G.E., Cinncinati Artists' Group Effort, must take the initiative to submit slides, videos, or written proposals, which committees then review. Blue Star Art Space in San Antonio operates similarly, but also occasionally invites a guest curator to put together a show. Hallwalls in Buffalo has an extensive staff of curators of visual arts who not only review slide submissions but also visit studios, solicit work from artists who have not submitted slides, and invite guest curators to organize exhibitions and performances.

Alternative spaces may also sponsor large group shows based on a particular theme. Some are juried, where artists are invited through advertisements to submit slides of their work around the show's stated theme, and a juror selects the show from the work submitted. Others are open exhibitions, where any artist who wishes can simply bring work to the gallery at a designated time, and the work is hung on a first-come-first-served basis until the gallery walls and floor space are filled. No curator or juror judges which pieces should be included in the show.

Shows at alternative spaces attract critical attention and a broad art audience, including artists, museum personnel, collectors, and so on, who expect to see something unusual, controversial, or shocking. Critics frequently review these shows. Alternative spaces may attract special interest groups, such as a site dedicated to Latino artwork. The general public usually does not attend in large numbers.

The funding for alternative spaces varies. Almost all are nonprofit. They do not depend upon sales of work. Many are supported substantially through membership dues and fund raisers, such as art auctions, parties, and events. Alternative spaces may also receive funding through government agencies, private foundations or corporate donations. Those with less governmental and corporate funding are more autonomous regarding what they show; those with more are vulnerable to outside influences. Almost every space is supported through a combination of sources; for example, Hallwalls operates on funds acquired through all the above sources, plus earned revenue from admissions to events and sales from its bookstore.

Alternative spaces are part of both the art world mainstream and alternative systems of validation. They serve as a testing ground for very new or very controversial work, but such work sometimes ends up in commercial galleries or museums. While some alternative spaces receive a lot of respect and others are less well known, generally they enjoy a high degree of prestige in the art community.

To research what alternative spaces are available in a particular area, you can refer to *Organizing Artists*, the directory of the National Association of Artists' Organizations, listing over three hundred artists' spaces, their mission, their operation, and a brief description of the art disciplines they support. All the artists' spaces listed in the NAAO directory pay fees to artists who exhibit with them. In addition, the directory lists over 120 spaces that are part of the National Alliance of Media Arts Centers (NAMAC), which promote artists' films, videos, and multimedia productions, and approximately fifty sponsors in the National Performance Network (NPN). The *Art in America Annual Guide to Museums, Galleries and Artists*, published every August, lists the names, addresses, and telephone numbers for over two hundred nonprofit exhibition spaces across the country. Check the index for the listing of nonprofit spaces. Also, large cities often have monthly gallery guides listing current exhibitions, usually with alternative spaces included in the list. These guides are free and available at commercial galleries. Finally, you can check the calendar section in any large daily or alternative weekly newspaper that covers the local cultural scene. The current exhibitions at the alternative spaces, galleries, and museums are listed. Unfortunately, since calendar listings and gallery guides mix together all kinds of exhibition sites, you may have difficulty picking out the alternative spaces from other art venues.

To find out if you wish to show in a particular alternative space, you may have to visit it a few times to grasp the range of work shown, because the work can vary dramatically from month to month. Ask whether there is a printed policy about the exhibitions, video events, or performances. Examine the space to see if your work will fit and if the space is well maintained. Does the attendant seem competent? Add your name to the mailing list or join as a supporting member to receive all announcements and publications about the space, especially announcements about group exhibits. If you have time, volunteer to help at an event sponsored by operators of the space, to learn its operations from the inside. Of course, ask other artists and your mentors their opinions of the space.

Some *businesses* sponsor art exhibitions. At the high end are a few large corporations that both collect and exhibit art, that hire an art professional to oversee exhibits and collections, and that fund their exhibition sites from business revenue. Such corporations operate their art enterprises very much like small museums.

However, the vast majority are restaurants, banks, and furniture stores that simply hang art on their walls. These businesses hope to raise their stature and prestige by association with fine art. While some display kitsch or touristy work, others exhibit art dealing with the same themes, media, and styles as galleries and museums. Rarely, however, will businesses show controversial, shocking, or experimental art. Wall space tends to be available while floor space is often needed for the operation of the business. Therefore businesses often favor art that hangs, seldom showing space-demanding sculpture, installation, or performance art. Artists usually have to display their work around the businesses' furniture and decor.

The person who determines the exhibitions at the business varies. In some cases the owners exhibit whatever they like. Or the owners may ask artists they know to recommend other artists to show their work. Most businesses spend no money on exhibitions. The artist usually is responsible for delivering and hanging the work, and for printing and mailing any announcements for the show. Thus, geography tends to be a factor determining whose work is displayed, because there are too many expenses and not enough return to make it a worthwhile venture for artists living far away from a business.

Exhibitions at businesses rarely carry much prestige or give the artist visibility in the mainstream or in the alternative art world. Critics generally will not review these shows, except at the large corporations that maintain a collection and a regular gallery. Despite the lack of art world recognition for most exhibitions in businesses, there are some benefits. More of the public sees the work in these locations than at commercial galleries or alternative spaces, providing artists with a much broader audience for their work. Also, the artist might generate some income by selling work from businesses frequented by the wealthy—for example, upscale restaurants. Finally, a successful exhibit at these sites may build the confidence of emerging artists.

There are no listings of businesses that sponsor exhibitions. Most artists find out about these places by word of mouth. Consider whether the business displays almost any kind of artwork indiscriminately for decoration, or if the work is selected thoughtfully. Evaluate the exhibition area. Are the walls clear, or are you competing against the decor? How effective is the lighting? Is the artwork handled carefully or does it seem endangered by the operation of the business? Do the people there constitute an audience you want to reach? Ask to speak to whomever is in charge of exhibitions. Do they carry insurance on your work while it is on display? Do they take a commission on works that sell, and if so how much? Cleaner, clearer, and more flexible spaces are usually more desirable as exhibition sites.

A final note about exhibitions at businesses: Recently, some artists have approached malls and businesses for permission to mount exhibitions in empty stores and in storefront windows. With these business-sponsored exhibits, the artists have been able to take over the entire space for both traditional and innovative work. These sites are very attractive to artists who seek a broad audience, and may attract critical attention.

Universities, colleges, and junior colleges often sponsor exhibition spaces. While all have an educational function, *college galleries* differ from each other in their operations and in the artwork shown. Some large universities maintain galleries like small museums, showing high-profile exhibits by well-known artists or important traveling exhibits. Some are dedicated to displaying the university's permanent collection, which often consists of valuable items or artwork given by trustees or other major donors. Such museumlike galleries only occasionally show works of emerging artists.

However, most large universities also have other spaces that are open to emerging artists, as do most colleges and junior colleges. These venues often function pedagogically as extensions of the school's art curriculum. Most college galleries show traditional art, unusual or experimental art, performance, installation, and work in new media. Most show a broad spectrum of work by artists of diverse backgrounds.

The audience for these exhibitions and performances consists mostly of the faculty, staff, and students of the institution. Members of the outside art world attend college art events in fewer numbers, although a publicized show at a prominent institution may attract many people.

College galleries are answerable to the college administration and to those who provide its financial backing, whether governmental, religious, or private. Some may be reluctant to show openly controversial work. However, those with a strong tradition of academic freedom will likely respect freedom of expression in the visual arts.

Large university galleries have their own staffs, each with a director who makes the decisions about what work will be shown. Other college galleries usually are run through the art department. At some institutions, a great deal of care goes into deciding who exhibits or performs and the quality of the work. At these institutions, one or more faculty members oversee the gallery, with the help of work-study students. Other college galleries are run by a single faculty member heavily burdened with teaching and other committee responsibilities, or by a staff person responsible for office matters. In these cases, very little thought may be put into what will be shown. This affects how the gallery is perceived by the art public. Ask your mentor to name college galleries that are well curated and well run.

Like researching an alternative space, you may have to visit a college gallery a few times to get a feel for the work shown, because again the variation from one show to the next can be great. Is the space well maintained? Is there an attendant watching the space? Will your work fit well physically in the space? If one is available, add your name to the mailing list.

When talking about art galleries, most people are referring to *commercial galleries*. Commercial galleries promote the display and appreciation of art through marketing—the buying, selling, and collecting of art objects.

Since most commercial galleries must sell artwork to survive, they tend to show traditional visual artwork such as ceramics, painting, photographs, prints, sculptures, and so on, where discrete objects are produced. Few commercial galleries deal with video, computer art, or performance, and not many will take on installations. Also, many commercial galleries avoid work that is too controversial, too political, too raw, or too shocking.

Unlike alternative spaces and college galleries that show a wide range of work, commercial galleries often specialize in a particular style, medium, or look. They become known for a specific type of art, such as figurative painting, ceramics, or contemporary Asian artwork.

While some galleries show work by diverse artists, well-established commercial galleries have been notorious for showing almost exclusively the work of white male artists. Several surveys have pointed out this embarrassing fact (see Bibliography for Pindell and Dickinson), and artists from neglected groups have demanded proper attention. In response, some well-established galleries have expanded coverage, but rarely sufficiently to represent the ethnic and gender breakdown of artists in the population. Ageism can also be a problem at some commercial galleries that dump mid-career artists who no longer reflect new trends.

Commercial galleries attract an audience of artists and art professionals, and the segment of the general public that follows art events. However, commercial galleries rarely draw the public in large numbers.

Large commercial galleries may have an array of persons running them, including backers, gallery owners, directors, attendants, and preparators. Backers are usually silent partners who contribute financially to the gallery but take no part in running it. The gallery owner, also called a dealer, makes long-term decisions about the direction of the gallery and works with major collectors. Generally, gallery owners decide what gets exhibited. They consider taking on new artists primarily on the recommendations of other artists and, to a lesser extent, on the slides artists send to the gallery. The director is in charge of the day-to-day operation of the gallery, and oversees the employees, maintenance, and so on. Directors sometimes also review artwork and make visits to artists' studios to see new work. The attendants handle reception and clerical duties. The preparator is responsible for all physical labor associated with running the gallery: hanging shows, crating, shipping, patching walls, painting, and so on. In smaller galleries, these positions are conflated into one or two positions; in a very small gallery, there may be no backers, and one person does everything.

For most commercial galleries, the main or only source of funding is sales, although those with private backers have financial support in lean times. Other galleries are combined with related side businesses, such as framing services or fine art prints. In these cases, the side businesses subsidize the gallery, while the fine art association gives them added stature and prestige.

Commercial galleries are the bottom tier of the mainstream art world pyramid. Gallery owners and directors do the work of sifting through the slides and visiting the studios of available artists to select work to show. They are a kind of clearinghouse for critics, collectors, and curators who frequent commercial galleries to selectively review, collect, or acquire art. As part of the mainstream, commercial galleries enjoy prestige in the art world, but the level of prestige varies from gallery to gallery. To be considered first rank, a gallery must have a "stable" of well-established artists and sell works from their exhibitions to prominent collectors.

For artists, a show at a commercial gallery represents the best way for their work to be seen by these critics, curators, and collectors. Shows at commercial galleries often provide artists the best format for selling their work and the connections to arrange subsequent shows. In addition, association with a commercial gallery often facilitates some business transactions for artists; for example, it is easier to get work shipped from a business location such as the gallery.

Artists often believe that they will begin their careers at second-rank galleries, then will be "picked up" by first-rank galleries where major collectors will acquire their work, and then on to museum shows. In the money-flush 1980s, some very high-profile galleries, almost all in New York City, were able to make superstars of a few relatively young artists, selling their work for prices never seen before. However, some artists may find that getting shows at commercial galleries is difficult, or impossible. There are more artists wanting shows than this system can absorb, especially after so many commercial galleries closed in the early 1990s.

For state-by-state listings of commercial galleries across the country, refer to the *Art in America Annual Guide to Museums, Galleries and Artists*. Locally, consult the free gallery guides, newspaper calendar listings, and yellow pages. Research commercial galleries both for the artwork shown and also for the look and style of the gallery itself. Your first visit should be for gathering information, before approaching them about your work. If possible, see a summer group show, which should reflect the range of work for which the gallery is known. Does your work seem to fit in? Specifically, is it stylistically and conceptually compatible? Are at least some emerging artists, or are they all well known and well established? What is the price range of the work shown? Is the space suitable for your work: large enough if your work is large, or intimate for small pieces? Is the gallery well maintained (exterior, interior, furniture, walls, floor)? How is the lighting? Is the gallery attendant attentive and well informed, or passive, distracted, and ignorant about the work being shown?

When at the gallery, add your name to its mailing list. Receiving announcements with art reproductions is extremely beneficial when researching galleries in other cities.

Community centers are multi-use spaces designed to meet the recreational, educational, and social needs of a particular group. In some cases, geography determines the group, like neighborhood-based community centers. In other

cases, the center serves a special interest population—for example, senior citizens, women, Japanese Americans, and so on. These centers sometimes have art galleries, theaters, or other areas used to display art.

These centers tend to show very diverse artists and artists who are of the community. The work shown can run the gamut of art styles and subjects in traditional visual art, and also include performance, experimental, and new technology work. While very partisan or political work may be shown, sexual or violent subject matter is often avoided because the audience may be mixed, and frequently includes children. However, the fact that these spaces are used by a very broad audience, much broader than those frequenting commercial art galleries, may be attractive to some artists.

The director of the center may decide what gets shown, or it may be a director of programs or cultural events, if there is one. In some rare cases, the center may have a budget for art exhibits, for invitations and receptions, and so on, but more often artists are responsible for hanging and publicizing their own exhibitions. Community centers themselves are funded either by local government or by the special interest group that the center serves. They are susceptible to those opinions regarding the artwork they show.

Most community center galleries are outside the mainstream and alternative art world. These venues are not visited by critics, nor by many art professionals. The exceptions are those community centers that have a history of mounting interesting exhibitions, or when the community served by the center has been in the news. For example, a center-sponsored exhibit dealing with the World War II internment of Japanese Americans may draw attention. For the artist, the benefits of showing at community centers are similar to those at businesses, although the audience might differ greatly from the clientele of upscale restaurants.

To research a community center as a possible exhibition site, evaluate the physical condition of the gallery, the competence of the staff, and the kind of artwork they show. Are the persons attending the center an audience you want to reach?

Cooperative galleries are exhibition spaces funded by a small group of artists, usually between eighteen and thirty-six artists, primarily for the purpose of showing their own work. These artists become members of the cooperative and financially support the gallery by paying a fee, ranging from several hundred to several thousand dollars a year, depending upon rent and other gallery expenses. Artist-members must work a certain number of hours per week toward running the gallery. One member usually acts as director of the gallery, organizing the efforts of the group and overseeing day-to-day operations. Sometimes members remain constant at a space, while at others, artists rotate out after a specified period, for example, three years and two solo exhibitions.

While some cooperative galleries show only member work, others dedicate a percentage of their shows to nonmembers. The work shown can encompass the entire range of art. Since the galleries are artist-funded and artist-operated, the only limitations are those imposed by the supporting members themselves.

Some have explicit exhibition policies and philosophies, while others do not. The diversity of artists shown varies from one cooperative to the next. But because of the fee, membership is difficult for low-income artists. The audience for these spaces is the regular art crowd and arts professionals.

While cooperative galleries may resemble vanity galleries in a few superficial ways, the differences are extremely important. Cooperative galleries have set standards for artists and artwork shown there, whereas anyone with money can show at a vanity gallery. Cooperative galleries are great laboratories for artists, educating them on the gallery operations, on exhibition procedures and perhaps even on curating shows. Artists assume control for exhibiting artwork, a role otherwise reserved for art professionals.

Cooperative galleries are part of alternative systems of validation. Historically, those limited to showing only members' work have relatively low status in the art world. Cooperatives enjoy a better reputation when they regularly include the work of nonmember artists, are community- or service-oriented, and have nonprofit status and grant funding. However, perception of cooperative galleries in general is changing as artists need more exhibition options now with fewer commercial galleries operating.

To evaluate a cooperative gallery, visit the space to make the usual judgments on the physical aspects of the gallery, the staff, and the artwork shown. Get explicit answers to the following questions:

What are the minimum and maximum periods of membership?

What does membership cost?

How long must artists be members before receiving their first show?

What is the time interval between shows for each member?

How many hours per week must members work at the gallery?

Do members have the opportunity to curate exhibitions?

What exhibits in the past have been reviewed by critics?

How often are nonmembers included in exhibitions?

Ask for the exhibitions policy and procedures for selecting new members.

Municipal galleries are city-run exhibition sites, often part of a complex for other cultural events as well. They differ from city-run museums in that the museum houses a permanent art collection owned by the city. Municipal galleries only host exhibitions, promoting the work of the area's emerging and established artists, and perhaps also displaying traveling exhibits from other areas. The artists shown tend to be as diverse as the population of the city itself, as the gallery is charged with the mission to represent its citizens. Municipal galleries are funded from city tax revenues, often supplemented by donations from local businesses. As a result, the type of artwork shown is dependent upon the overall attitudes of the city itself. Conservative areas may restrict subject matter, while cities with more liberal politics may support a gallery showing unusual, experimental, or controversial work.

Shows at municipal galleries may attract a higher percentage of the general public than shows at commercial galleries, partly because of their commitment to local artists, partly because they often sponsor other cultural events on the site, and partly because these galleries may offer educational programming that attracts student groups.

Municipal galleries have regular paid staffs. The director runs the gallery, overseeing personnel, setting the budget and maintaining the physical plant. The curator is usually concerned with programming and with art issues only. Curators put together exhibitions and performances, visit artists' studios, write about exhibits at the gallery, and plan related events. In some cases, curators make all decisions unilaterally, or they may work with an advisory committee of art professionals who review slides and proposals from artists. At large galleries, the director and curator are two separate positions; at small galleries, one person may do both jobs.

Municipal galleries can have one foot in the mainstream art world and the other in the alterative system. While they show established artists, their interest in local, emerging, diverse, or experimental artists may lead them outside the mainstream. Generally a show at a municipal gallery is considered advantageous for an artist, especially if the gallery is in a major city. Those in very small cities or ones dedicated to local history or pandering to tourists may have less art world stature.

Visit the municipal gallery, evaluating the site, adding your name to the mailing list, and inquiring about the procedures for reviewing artists' work. If researching municipal galleries in other cities, find out if they are restricted to area artists only.

By definition, a *museum* preserves and exhibits objects of historic, artistic, or cultural significance. But generalizations about museums are difficult because the name is used for many different kinds of institutions. Many museums maintain a permanent collection, devoting the bulk of their annual budget to acquiring, maintaining, storing, and displaying art objects. Some museums do not have a permanent collection, only rotating exhibitions much like a commercial gallery. The focuses of museums vary, from historic to contemporary, from fine art to decorative arts to cultural artifacts. Any or all may display contemporary art, either on an occasional basis or as their sole mission.

Different museums show different kinds of work, but museums are not generally cutting edge or avant garde. They are institutions at the top level of the mainstream art world, and thus exhibit work that has been already shown and validated by other means, often through commercial galleries or alternative spaces. Museums often will show work in a variety of media, including traditional, new, high-tech, and experimental. Some will also support installation and performance art.

Solo museum exhibitions are often retrospectives, where the best works from an artist's entire career are displayed. Museums usually do not show the

work of emerging artists, unless they sponsor a special series specifically for such work. Call the museum's curatorial office to find out.

Over the past several decades, museums' shows were mostly given to white male artists. Male artists are still shown in museums in percentages far greater than they figure in the population of artists as a whole. This is not surprising since museums mostly show established artists. Because of recent surveys, adverse publicity, and pressure from disenfranchised groups, museums have made some efforts to include more diverse artists. At some institutions, the change has been profound; other museums have resorted to tokenism.

Museums attract a broad spectrum of the population, and often host special groups and students.

Curators decide whose work will be shown, and they find art through a number of channels, for example, alternative spaces, commercial galleries, and art critics. Some curators look at slides sent in by artists and make studio visits to look at work. By telephoning the museums' offices, artists can discover which ones are interested in contemporary work and their procedures for reviewing it.

Funding for most museums comes from foundations, private donations and/or tax revenue, including federal, state, county, or city. The private donations are usually sizable bequests from wealthy persons, either monies or art objects, or both. Other lesser sources of revenue are business donations, grants, fund raisers, member dues, admission fees, and gift shop profits. Recently, some museums in redevelopment areas have received substantial funding from surrounding businesses under the umbrella of public art programs.

Regarding prestige, major museums represent the pinnacle of the mainstream art world, with small municipal museums and regional museums falling behind them in the pecking order. Small museums dedicated to local history have little status. Showing at a prominent fine arts museum is advantageous, prestigious, and desirable for artists.

Visit the museum, evaluate the site and inquire about procedures for reviewing artists' work.

In outward appearance, a *vanity gallery* resembles a commercial gallery, with its white windowless walls, track lighting, and exhibitions that change every month. However, anyone with money can have a show at a vanity gallery. Like guns for hire, the staffs at vanity galleries have no philosophy about art and no point of view about what they show. They do not serve the interests of any particular community or artistic group. Shows at vanity galleries have no prestige in the art world, rarely result in substantial sales, and generally afford the artist no benefit while costing a great deal of money.

You can tell if a space is a vanity gallery if you are offered a show without any kind of review of your work and if you must pay all expenses, including one month's rent, staff salaries, utilities, printing and mailing costs, and any other overhead.

JURIED EXHIBITIONS

Juried exhibitions are art contests based on a particular theme and/or a specific medium, resulting in a group exhibition. Artists are invited to submit slides of work that explores the stated theme for the show. A juror, often a prominent artist or art professional, then reviews the slides, either accepting or rejecting each work. Juried exhibitions are usually sponsored by universities, regional museums, and art organizations and have a defined geographic scope, which may be local, regional, national, or international.

Entering juried exhibits offers some advantages to artists. Juried exhibits are a good way to get your work seen by a prominent arts professional and by the public, if it is accepted into the show. The exhibit can be added to your résumé, giving your work more credibility and boosting your confidence if you are just beginning to show your work. Because the theme is often topical or even controversial, juried exhibits give exposure to work dealing with strong political and social themes that might not be seen in commercial galleries. Such thematic exhibits allow artists to see many works dealing with the same subject. Some artists may be given cash prizes for excellence and/or purchase awards for the acquisition of their artworks. Catalogs are published for some juried exhibits, listing all accepted work, sometimes with images.

There are drawbacks to juried exhibits. Many artists object to the cost of such competitions. Most juried exhibitions charge entry fees, usually between $15 and $30 per entry. This forces the artists to subsidize the exhibition, which many see as unfair and as comparable to charging musicians to perform a symphony for a nonpaying audience. Artists subsidize the exhibit whether they have been accepted or rejected, so you might be in the unhappy position of paying so that others can show their work. Artists also have to pay for crating and for shipping both ways, if their work is accepted in a juried exhibit in another city. Such costs may be prohibitive. Sales out of juried exhibits are rare. Finally, juried exhibitions are not necessarily stepping-stones toward exhibiting your work in commercial galleries or alternative spaces. Success here does not guarantee you any advantage in other venues.

If you choose to enter juried exhibitions, select only those juried by an artist or arts professional you respect and whom you want to see your work. If possible, enter only competitions in your area, so that you can hand-deliver work rather than pay for shipping and crating. Otherwise, submit slides of pieces that will be inexpensive to ship. Enter only those exhibits that will be in reputable, high-profile and well-maintained gallery spaces.

To submit slides, you need a prospectus with essential information: the theme of the show, if any; awards, if any; the juror's name; deadline for the submission of slides; fees; size and media limitations; location of exhibition; dates; procedures for delivering accepted work; and an application form. You can find out about juried exhibits and send off for a prospectus by checking classified ads and display advertisements in the backs of art magazines. Also,

the *American Art Directory* has a limited listing of national, regional, and statewide juried exhibitions. You can also find prospectuses for many juried exhibitions posted on art department bulletin boards at colleges and universities in your area.

Art fairs and street fairs are other kinds of juried competitions. In these cases, artists submit slides to be considered for one of the available spaces from which they display and sell their work during the fair. Because the main purpose of these fairs is to give artists an opportunity to sell their work, most art fairs have no stated theme to follow, although some are limited to only certain media, such as craft media. Many art fairs charge the participating artists a space rental fee, once they have been accepted. The advantage of participating in art fairs is the opportunity to display and sell work to a broad segment of the general population. Some artists whose work sells well are regular participants in art fairs. Since each art fair promotes different levels and kinds of work, you should research a fair before entering to see if you wish to participate.

Art fairs are outside mainstream and alternative art communities, and thus, your participation in art fairs is highly unlikely to lead to exhibitions in alternative spaces, galleries, or museums. Because art professionals rarely attend art fairs, they will not see your work there. A listing of art fairs on your résumé will not carry weight with curators or dealers.

Video Festivals

An important way for artists to get their work out in the video arena is through video festivals. Video festivals are often sponsored by media arts centers, usually in big cities. Media centers in Seattle, San Francisco, Chicago, New York, and other cities help artists produce as well as exhibit and package video work.

You can find out about video festivals in the *AIVF Festival Guide*, published by the Association of Independent Video and Filmmakers (AIVF). This book describes in detail available national and international festivals, their focus, guidelines, and deadlines. You can also research the listings in media magazines publications, for example, *Afterimage* and AIVF's *Independent*. You can join the National Alliance of Media Arts Centers (NAMAC) to receive their newsletter that lists all the festivals, jobs, and other information artists need within this network of support.

Art Consultants and Artists' Representatives

Like any other area of cultural or commercial life, the art world has intermediaries and facilitators.

Art consultants are buyers' agents, assisting businesses that are acquiring art. For example, art consultants may collect a range of artwork to be placed in a new office building or hotel lobby. They might also assist a business located in a redevelopment area that must acquire art as part of a public art program.

Art consultants do not operate an exhibition space, and therefore are not a "venue" per se. However, consultants keep slides and a large number of traditional art objects in inventory for the convenience of business clients who want to purchase art, but are uninterested or unable to search it out for themselves. Art consultants receive a commission from each sale.

Working with art consultants is pretty much an all-business proposition for artists, in that consultants do not give you an exhibition of your work or access to art critics. The clients are the only people who will see your work while it is in the hands of the consultants, who might, nonetheless, arrange many sales. Some artists mass-produce the kind of work that a particular consultant can easily sell, and are able to make a substantial amount of money.

The relationship between art consultants and the art world is complex. For artists, however, your business with art consultants is generally separate from your stature in the art world, which is dependent upon your exhibitions and critical reviews. One caveat: If you are known to work with a number of consultants, many commercial galleries will not show your work because of overexposure and difficulties in establishing standard prices.

Artists' representatives are agents for artists, helping them promote themselves. Among other services, they advise artists on ways to present their work, approach galleries, and become known to critics. They charge fees that can be as high as several thousand dollars, which is generally a waste of money for artists. Most established art venues want to deal directly with the artist and will not work through a representative. You do not need someone else to promote your work. This book, your mentors, and your friends can tell you how to do it yourself.

Carole Ann Klonarides. 1994
Photo by Myrel Chernick

ARTIST INTERVIEW:
CAROLE ANN KLONARIDES

Carole Ann Klonarides is a media artist and curator from New York. She has programmed artists' videos for the Artist Television Network in New York City and for large-scale public presentations of video in major cities in Spain, Portugal, and the United States. As a video artist, she collaborates with Michael Owen under the name of MICA-TV. They have been commissioned to produce videos on art and architecture by the Museum of Modern Art in New York and the Wexner Center in Columbus, Ohio. Since 1991, she has been Curator of Media Arts at the Long Beach Museum of Art.

When artists approach you as a curator, do they send you clips or do they send you the entire video they worked on? Do they send VHS cassettes?

Let me speak first as a person who makes videotapes, because I've had a lot of experience trying to get my own work out. The first thing I try to do is make my work seen as much as possible. I started showing it in my New York loft, inviting curators and critics over to see it. I also mail out compilation tapes on VHS cassettes because the universal

(continued)

Carole Ann Klonarides/Michael Owen (MICA-TV). The In-Between. 1990. Still image from video.
Photo by MICA-TV

(continued from previous page)

standard is VHS-NTSC, even in Europe. On this format, almost any-body can see it. It is preferred for viewing only, because there is a breakdown of image on VHS. But if you have mastered your work in very high format and copy from one-inch to VHS, it is not so bad.

Unfortunately most artists don't do the one-inch mastering. For exam-ple, an artist may be appropriating Hollywood film and re-editing it along with shot material; if they are taking already a VHS copy off their TV set, and then editing it, transferring it, then re-editing it to VHS, they're going to have a real breakdown of image. It is going to look pretty bad. And artists do that all the time.

But, surely, artists integrate that look into their aesthetic. Or is there a value system associated with quality in terms of the in-dustry—you know, we have to have good resolution, good color saturation, and so forth?

(continued)

(continued from previous page)

Initially, a broadcast professional wouldn't even look at that kind of degraded image. Now advertising mimics it, they have appropriated it. It is respected as an aesthetic, an acquired taste.

Artists who are purists want to have the best representation of their work. They master it on a higher format and make VHS copies from that. They are concerned with the archiving of their work.

As a curator, what do you want the artist to send you?

I am interested mainly in ideas. Along with the tape, I like to receive a proposal and some supplementary material—a description or review written on the tape, or a paragraph where the ideas behind the work are articulated. If the artist hasn't previously written a statement, include in the body of the letter some sort of description of what I am about to see. I am usually looking at a lot of tapes at once, so if within two minutes I don't get the idea of the tape and it has a slow beginning, I fast forward!

I think all artists should know that their work may be viewed on the "Search" mode. In this job, I am not supported enough to handle the amount of work I receive. I have more tapes than I can view, so initially I put the tape on search and get a sense of what it is I am about to see. If it is really low end and not an interesting image, I read the description and see if that is part of the concept. If the concept is really interesting and it makes sense with the images viewed, I will go back and look at it in real time and sit through the piece. But the more information that can be included with the video, there is a better chance of understanding the work.

Sending still photography isn't necessary, and résumés only help to recall if the work was seen previously in a festival or programmed exhibition.

In what form are video works acquired by a museum?

There are several: the museum can acquire the rights to an image and acquire a drawing and videotape to represent the work with the understanding that the work may be transferred to an upgraded mode of technology in the future. Many institutions have bought the equipment separately. Some artists like Bill Viola package the whole thing, including

(continued)

(continued from previous page)

the equipment, and it becomes a very high-priced investment initially. Some artists like Bruce Nauman sell the drawing and the tape and that is it—depending upon the equipment needs, this can be an even greater outlay of money.

How is video used to document performance, installations, and other artwork?

I have sat as a panelist on NEA grant panels and viewed whole exhibitions of traditional art on tape, with explanations by the artist on camera. And in some cases they were funded because their presentation on tape was so good! The artists were speaking for themselves and presenting the work in many views, which is better seen than with slides. For example, showing book art on video, you can turn the pages, and you can actually see a person interacting with the work. And since more people are making nonstatic work that involves viewer participation or interactiveness, it's seen clearer on video.

Now almost every performance artist submits videotapes of their work. Young performers just starting out may only have a friend come in and document their performance, and if the quality of the tape is bad, it is hard to get a good sense of the work. But that is true of all photographic documentation; quality is important. People view artists with poor slides as not being professional.

The Long Beach Musuem has a collection of over two thousand tapes, and housed within that collection are several early documentations of performance art. The tapes have increased in value tremendously—for example, the documentation of Joseph Beuys. The museum now has a responsibility of preserving this work and making it more accessible to the public. In some cases, the museum has the only copy of the work of deceased artists.

Distribution is a big issue for museums with video collections and also for individual video artists, isn't it?

The museum's collection of videotapes is not accessible for viewing except by request and appointment. How am I going to get these works out to the people? I am not going to get the public to a theater to see them. I am not going to get the public to a little room with gray chairs and a TV set. Alternative film, underground film, had the same problem. I think the answer is to be inventive with distribution.

(continued)

(continued from previous page)

An artist should think about all the new possibilities for distribution. The greatest support of art video has been the public library. Libraries buy tapes by artists as well as art school libraries. A lot of MICA-TV tapes were bought by libraries.

I see future potential in packaging videotapes and selling them on the home market. More than exhibiting in festivals or being broadcast, home marketing could greatly impact the future of video art. I don't think video is ever going to be seen as a collectible, in the sense of a multiple art form with limited editions, like photography and print-making. I think it is much better as an accessible kind of art form, available to all. Possibly if artists are clever, they can package their work and make it thematic, working for a large or a smaller audience.

Are you able to do your own work, with the demands of the job? Have you found that your work has become curating?

This is a difficult question to answer only because of how one is de-fined. I see everything that I do as an extension of my creative think-ing. I see curating as producing. I see producing as curating. To me, it is all interchangeable. Because I work collaboratively, my own art form is very akin to what I do as a curator. Many people can't get to the point of seeing critical writing, producing, film, video or curating art exhibitions as creative art forms. But they definitely are. Since I have been here I have done two video catalogs for the museum, col-laborating with the other curator and artists in the exhibitions. To me they are totally unique and creative and I see them as productions that I have done.

My video partner is still in New York. We have two projects in grant form and since I have been here, we have shot one piece and we're in close contact with our subject for the next piece.

Chapter 6

Documenting Your Work

Resumes, artists' statements, and visual documentation are the primary ways that artists keep records of their past accomplishments and the artwork they have created. This material can then be used to secure future exhibitions or performances, or to apply for grants, residencies, jobs, or graduate school.

Resumes

Your resume is an essential document summarizing your professional art activities and past accomplishments. It represents you to the public. Often, art professionals see it before they ever meet you and decide from it whether they want to pursue further contact.

While your resume is the list of your professional art activities, you should not think of it as one single document. It should be a flexible mass of information, which you can condense to one page if necessary, or make longer if need be, or custom-edit for a job application or an exhibition proposal.

The following list contains major areas that you should include on your first resume, when you have just finished school or have just begun your professional career:

Name

Address

Telephone number

Education: List the name of your university, your degree, and area of specialization (for example, B.A., Painting; or B.F.A., Sculpture), and year received. If you graduated with honors, include that here.

Exhibitions or *Performances*: Organize your exhibitions or performances according to year, listing the most recent year first. Then put the name of the exhibit or performance, followed by the name of the site and the city where it is located. Indicate whether your exhibitions were solo, group, or juried.

A solo exhibit can be either an exhibit you had by yourself, or one with no more than two other artists, each exhibiting in separate areas of

the gallery. In a group exhibit, a curator invites you to show a few pieces with several other artists, usually with all works intermingled and exploring a single theme. A juried exhibit is a publicized competition, in which a juror selects work from slides submitted by artists, accompanied by an application form and usually an entry fee. If the exhibit was juried or curated by a prominent art professional, list the name of that person.

If you have recently graduated or are still in school, include college- and graduate-level student exhibits in this list. You should also list exhibitions scheduled in the near future. Your first resume might also include exhibits in nongallery public spaces, such as libraries, community centers and government buildings. Do not list exhibits in restaurants or other commercial ventures that indiscriminately use any artwork solely for decoration.

Awards and Grants: Include academic scholarships or awards received in juried exhibitions.

Exhibition Reviews and Articles: Reviews and articles should be listed in alphabetical order by author, or by title when no author is given. Use correct bibliographic form, including page number, section, volume, number, and indicate whether illustrations of your work were used. The following fictitious examples show the correct form for articles with one author, two authors, and no listed author:

> Fujito, Shellany. "Exchange Shows with Japan." *Artweek*, May 1, 1992, pp. 2–3.
> Lister, Josine A., and Javier Cruz. "New Shows at the Forum." *Washington Post*, April 10, 1994, Sec. E, p. 4, col. 2. (Reproduction)
> "Two Performances of Exceptional Impact." *St. Louis Riverfront Times*, August, 19, 1995, p. 18, col. 3.

Do not limit yourself to articles that were written exclusively about your work. You can list any published writing that includes your name, for example, if your name was mentioned in a review of a group show. Include articles that appeared in your college paper or in alternative or free publications, in addition to reviews in daily papers.

Collections: Include any museum or corporate collection that has purchased your work, and any prominent private collections. List the city and state where these collections are located. Include other private collections sparingly, and avoid listing your relatives as collectors.

Work and Other Professional Experience: Include all jobs of more than four month length that show you to be hardworking, responsible, experienced, or skilled. List the dates of employment. List any unpaid activity or experience that may show you to be unusually sophisticated or knowledgeable. Examples might include internships, travel, research, volunteer work, or creative ventures.

This category belongs on a job application resume, but not necessarily on a resume you send out in packets to curators and dealers, unless your current employment is relevant for some reason.

References: List three or four individuals who have agreed to serve as references on your artwork, background, or character. After the name and title/position of each reference, put the person's institution/business, address, and phone number.

If you must send out a resume but as yet have asked no one to be a reference, simply write "References Available on Request" at the bottom of your resume. This gives you about one week's time to line up people to be references for you.

Include this category when applying for jobs, grants, or graduate school, but not on a resume you send to a gallery or museum about your artwork.

Figures 6.1, 6.2, and 6.3 show examples of standard art resumes, in these cases for a fictional artist with a few years professional experience. Such resumes will probably have more entries than your first one. As you gain experience in the art world and have more exhibitions or other accomplishments, you will need to add categories, such as these listed below:

Current Position: If you work as an art professional, include this immediately after your name and address. List your position, the name of the institution, and how long you have worked there.

Exhibitions: After you have at least six listings in this category, you may want to break it into these separate subheadings: 1) Recent Solo Exhibitions; 2) Recent Group Exhibitions; and 3) Recent Juried Exhibitions. As implied in these subheadings, when your resume gets longer and your exhibition record becomes more impressive, you may drop very old listings from your working resume. For example, you may want to list only exhibits from the past five or ten years, or only exhibits in museums and galleries. Also, when your exhibition record becomes quite lengthy, you can drop the category of Juried Exhibitions altogether.

However, keep track of all your exhibitions even if they do not appear in your working resume, because you may need to supply your complete list on some occasions. For example, academic resumes are generally expected to be quite long, and you may need a complete list of your exhibits if you want to be promoted as a teacher.

Gallery Representation: List the names and addresses of galleries that represent your work. "Representation" indicates a long-term relation with a commercial gallery, where you regularly exhibit your work and where they keep on file a complete set of your slides, resume, and reviews. Being included in one group show at a particular place does not necessarily constitute representation.

Published Books, Catalog Essays, and Reviews: List in bibliographic form everything you have written.

MARIA APARICIO 6935 Figueroa Street
 Houston, Texas 77027
 (713) 555-5555

CURRENT POSITION:
Instructor, Part-time (1994-), Art Department, Rice University, Houston.
 Courses taught: Painting I, Drawing I, Drawing II

EDUCATION:
M. F. A., Painting, University of Texas, Austin. 1993
B. A., Art, with emphasis in Painting and Drawing, Trinity College, San Antonio. 1989
 Magna Cum Laude.

RECENT SOLO EXHIBITIONS:
"New Paintings," Mazon-Winter Gallery, Houston. (scheduled for November 1996)
"Figure and the Ground," Burroughs Institute, Houston. 1995
"New Figurative Works," Bluestein Gallery, University of Texas, Austin. 1993

RECENT GROUP EXHIBITIONS:
"Earth Works," Fontbonne College, St. Louis. 1996
"Painting and Drawing in Texas," Owen Mills Gallery, San Antonio. 1995
"Summer Group Show," Mazon-Winter Gallery, Houston. 1994
"Summer Group Show," Mazon-Winter Gallery, Houston. 1993
"Small Works," Fontbonne College, St. Louis. 1993

RECENT JURIED EXHIBITIONS:
"Acid + Rain: Artists Respond to the Environmental Crisis," University of Arizona,
 Tempe. 1994. Juror: Hilda Mayer, Curator, Atlanta Museum. Catalog.
"Power," Dallas Art Space. 1993. Juror: William Kozak, Critic, Dallas Report.
"Survey of American Oil Painting," Houston Contemporary Art Center. 1993. Juror:
 Marin Mazon, Director, Mazon-Winter Gallery, Houston.

AWARDS AND GRANTS:
Ann Stinson Award for Outstanding Arts Graduate. University of Texas. 1992

COLLECTIONS:
Venus Corporation, San Antonio.
Western Bank Corporation, Houston.
Fontbonne College, St. Louis.

WORK AND OTHER PROFESSIONAL EXPERIENCE:
Preparator, Central Texas Regional Museum, Austin. 1992-1993
Art Instructor, San Antonio Teen Camp. 1988-1989
Gallery Attendant, Heckal Gallery, San Antonio. 1987

GALLERY REPRESENTATION:
Mazon-Winter Gallery, 9975 Westheimer, Houston, Texas 77038

FIGURE 6.1

An example of a complete, detailed resume for a fictional artist a few years out of graduate school

REVIEWS OF EXHIBITIONS:
Birdsong, Eleana. "'Acid + Rain' Etched in Souls," University of Arizona University
 Chronicle, April 19, 1994, p. 12. Reproduction.
Hart, Mi-Lin. "Overview of Gallery Group Shows," Houston Times, Calendar Section,
 August 2, 1994, p. E4.

PUBLISHED ARTICLES:
"New at the Contemporary," Houston Weekly Underground, May 4, 1995, p. 38.
"Survey of Still Life: Review of the Scot Smithson Exhibition," Houston Weekly Under-
 ground, March 18, 1995, p. 37.
"Where is Painting within the Austin City Limits?" Austin ArtsMagazine, Vol. 3, No. 1,
 January 1993, p. 14..

PROFESSIONAL ACTIVITIES:
Exhibitions Chair, League of Arts, Houston. 1995-96
Publicity Committee Co-Chair, Southern Environmental Action, Houston. 1995

PROFESSIONAL OR ACADEMIC CONFERENCES:
Panelist: "Artists Speak Out on the Environment"
1996 Annual Conference of Environmental Organizations, Washington, DC.

REFERENCES:
David Wong, Chair (713) 555-5555
Art Department
Rice University
Linyard Hall Room 302
Houston, Texas 77123

Linette Marguer, Professor of Painting (512) 555-5555
Department of Art
University of Texas
1350 Crockett Drive
Austin, Texas 78792

Lucius Long, Director (512) 555-5555
Central Texas Regional Museum
1881 Farm Road
Austin, Texas 78740

Marin Mazon, Director (713) 555-5555
Mazon-Winter Gallery
9975 Westheimer
Houston, Texas 77038

Luther Bill, Associate Professor (210) 555-5555
Art Department
Trinity College
6600 City Line
San Antonio, Texas 78110

MARIA APARICIO 6935 Figueroa Street
Houston, Texas 77027
(713) 555-5555

WORK EXPERIENCE:
Instructor, Art Department, Rice University, Houston. 1994-
Preparator, Central Texas Regional Museum, Austin. 1992-1993
Art Instructor, San Antonio Teen Camp. 1988-1989
Gallery Attendant, Heckal Gallery, San Antonio. 1987

EDUCATION:
M. F. A., Painting, University of Texas, Austin. 1993
Ann Stinson Award for Outstanding Arts Graduate. 1992

RECENT EXHIBITIONS:
"New Paintings," (Solo), Mazon-Winter Gallery, Houston. 1996
"Figure and the Ground," (Solo), Burroughs Institute, Houston. 1995
"Earth Works," (Group), Fontbonne College, St. Louis. 1996
"Painting and Drawing in Texas," (Group), Owen Mills Gallery, San Antonio. 1995
"Summer Group Show," (Group), Mazon-Winter Gallery, Houston. 1994 (Review)

PUBLISHED ARTICLES:
"New at the Contemporary," Houston Weekly Underground, May 4, 1995, p. 38.
"Survey of Still Life: Review of the Scot Smithson Exhibition," Houston Weekly Under-
 ground, March 18, 1995, p. 37.
"Where is Painting within the Austin City Limits?" Austin ArtsMagazine, Vol. 3, No. 1,
 January 1993, p. 14.

PROFESSIONAL ACTIVITIES:
Exhibitions Chair, League of Arts, Houston. 1995-96
Publicity Committee Co-Chair, Southern Environmental Action, Houston. 1995.

REFERENCES:
David Wong, Chair (713) 555-5555 Lucius Long, Director (512) 555-5555
Art Department Central Texas Regional Museum
Rice University 1881 Farm Road
Linyard Hall Room 302 Austin, Texas 78740
Houston, Texas 77123

Linette Marguer, Professor of Painting (512) 555-5555
Department of Art
University of Texas
1350 Crockett Drive
Austin, Texas 78792

FIGURE 6.2

**A resume for a job application,
edited down from the complete resume in Figure 6.1**

MARIA APARICIO 6935 Figueroa Street
 Houston, Texas 77027
 (713) 555-5555

Instructor, Art Department, Rice University, Houston.
M. F. A., Painting, University of Texas, Austin. 1993

RECENT SOLO EXHIBITIONS:
"New Paintings," Mazon-Winter Gallery, Houston. (scheduled for November 1996)
"Figure and the Ground," Burroughs Institute, Houston. 1995
"New Figurative Works," Bluestein Gallery, University of Texas, Austin. 1993

RECENT GROUP EXHIBITIONS:
"Earth Works," Fontbonne, St. Louis. 1996
"Painting and Drawing in Texas," Owen Mills Gallery, San Antonio. 1995
"Summer Group Show," Mazon-Winter Gallery, Houston. 1994
"Summer Group Show," Mazon-Winter Gallery, Houston. 1993
"Small Works," Fontbonne, St. Louis. 1993

RECENT JURIED EXHIBITIONS:
"Acid + Rain: Artists Respond to the Environmental Crisis," University of Arizona,
 Tempe. 1994. Juror: Hilda Mayer, Curator, Atlanta Museum. Catalog.
"Power," Dallas Art Space. 1993. Juror: William Kozak, Critic, Dallas Report.
"Survey of American Oil Painting," Houston Contemporary Art Center. 1993. Juror: Marin
 Mazon. Director, Mazon-Winter Gallery, Houston.

COLLECTIONS: GALLERY REPRESENTATION:
Venus Corporation, San Antonio. Mazon-Winter Gallery
Western Bank Corporation, Houston. 9975 Westheimer
Fontbonne, St. Louis. Houston, Texas 77038

REVIEWS OF EXHIBITIONS:
Birdsong, Eleana. "'Acid + Rain' Etched in Souls," University of Arizona University
 Chronicle, April 19, 1994, p. 12. Reproduction.
Hart, Mi-Lin. "Overview of Gallery Group Shows," Houston Times, Calendar Section,
 August 2, 1994, p. E4.

PUBLISHED ARTICLES:
"New Show at the Contemporary," Houston Weekly Underground, May 4, 1995, p. 38.
"Survey of Still Life: Review of the Scot Smithson Exhibition," Houston Weekly Under-
 ground, March 18, 1995, p. 37.
"Where is Painting within the Austin City Limits?" Austin ArtsMagazine, Vol. 3, No. 1,
 January 1993, p. 14.

FIGURE 6.3

**A resume for sending to curators and
dealers, edited down from the complete resume in Figure 6.1**

Professional Activities: Include here all arts organizations in which you have been an officer, all arts events that you have organized, and professional committees of which you have been a member. Mention any exhibits you juried, with name of exhibit, gallery name and location.

Professional or Academic Conferences: If you were a speaker, moderator, or panelist at any local, regional, or national art conference, include that here.

When compiling your resume, enter all the above details of your professional art accomplishments onto a word processor or computer with a word-processing program. Computers are more efficient than typewriters for developing and maintaining your resume, because corrections and updates are easily made on the computer. With the typewriter, you start from scratch every time you make a change or add new information to your resume. Also, with a computer, you can easily edit down the complete, detailed resume to make a shorter one that is specifically directed to a particular job or grant application. Therefore, always enter the data in their complete form, and update them every six months or so to keep the resume current. Custom-edit the resume for each kind of application you make.

Your art resume can be as long as necessary to convey all pertinent information. In this respect, an art resume differs from a standard business resume that is usually only one or two pages in length. On the other hand, never pad your resume, nor give people more information than they want. Business resumes often list your age and marital status, but these items are rarely put on art resumes. Also, business resumes often list an objective directly under your name, saying something like "to work as a marketing consultant for a large manufacturing company," or "to become a land surveyor supervisor." This form is almost never used on art resumes.

The most recent information is placed first under each resume heading. In bibliographic listings, periods and commas precede quotation marks at the ends of article titles. Avoid spelling, grammar, and punctuation errors by using the computer spell-checker or the services of a proofreader. Do not abbreviate on your complete, formal resume, except in bibliographic areas. If on shorter resumes you do abbreviate to save space, then abbreviate consistently.

Design your resume so that the headings are emphasized and the information is contained in several blocks, with space between headings. Do not let your resume look like a solid mass of text. Use at the most two different type fonts within the same resume; one type font is even better. Boldface text, italics, capital letters or underlining create distinct headings within the same font.

Your resume should be as clean, sharp, and readable as possible. Therefore, print your resume on a laser printer or on a dot matrix printer that produces "near letter quality" type. When making copies, use a good photocopy machine with a clean glass plate and plenty of toner. Copy onto paper with some rag content so that the paper has a distinct weight and feel. Standard resumes are copied onto white paper. If you wish, you may use a neutral or pastel paper with a distinct finish, such as linen. Resumes on fluorescent or bright papers may be considered silly.

If you wish, you may disregard the above "rules" for resumes and represent yourself with something less conventional. Then you are using the resume as an expressive tool for yourself, with a distinctive style and content meant to reflect your personality or artwork. Your resume may then stand out from the rest, but there is a risk that you will be perceived as unprofessional or unsophisticated. If you decide to use a nonstandard resume, make sure it works well for you by showing it to a few knowledgeable art people, some with daring and some with conventional personalities, and listen to their reactions.

ARTIST STATEMENT AND CONCEPT STATEMENT

The ideas behind artists' work are sometimes misunderstood, occasionally by persons from the general public, but even at times by art professionals. Especially troubling would be inaccurate statements about your work made by an employee of a gallery or a misleading article a reviewer wrote about your work. However, gallery directors do not always hire persons with great aesthetic discernment, and the art reviewers in your local paper may also cover theater, music, movies, and perhaps even dining out. What do they know about your art?

The *artist statement* is your best defense against visual illiteracy. Writing about your work gives you the first say about it. The general public will seek out such material for a frame of reference for unfamiliar imagery. But also you will find that many gallery directors, gallery employees, reviewers, teachers and curators will rely on your statements to understand and evaluate your work. Some artists do not write statements, believing that the work "speaks for itself." Others find statements to be pretentious or superfluous. Not writing a statement is always an option for artists. However, statements may be required for some job, grant, and graduate school applications. And many artists make their statements available at their exhibitions or include them in performance programs.

The artist statement is a general introduction to your work. It should open with the work's basic themes, briefly explained in two or three sentences in the first paragraph. The second paragraph should discuss how your themes are embodied in a few of your pieces. Succeeding paragraphs may cover some of the following points, if they are important in your work:

- Why you created this work
- How you expect the audience to react to your work
- How this work differs or grows from your previous work
- Where your work fits in with current contemporary art
- How your work fits in with other art in a particular group show or series of performances
- Sources for your imagery
- Artists whom you admire or artists working with similar themes
- Whether this is a finite series of works or an ongoing body of work

A final, summary paragraph should recapitulate the most important points. At the bottom, separate from the body of the statement, you may include quotes about your work from published reviews, from catalog essays, or from curators' statements.

The tone of your statement should be expressive of your work. If appropriate to your work, you may choose a personal style, using the emotional tone as a hook to grab your audience. Many people are not interested in simply seeing a performance or purchasing an object, but also want to know the artist's state of mind. The following excerpt is emotional in tone:

> My figures confront you with sullen stares of disenchantment, alienation, and fear. Harsh bloody marks line their faces, like war paint, wounds, or self-inflicted scarring.

Or you may choose to write in a more reserved style, with a theoretical, academic, or analytic tone, if it is an accurate reflection of your work.

> A recent *Art in America* article by Hal Foster reflects some of the conceptual basis of my work. Examining the current resurgence of abstract painting, Foster found that it functions as simulation, and as such, recalls a style of art without engaging in the ideas and conflicts inherent in that style. I am interested in positioning my work as both painting and as signifier of style.

You might also write humorous, antagonistic, or political statements. Choose the best vehicle for the understanding of your work. In any case, refer to yourself in the first person, not as "the artist." The artist statement should feel as if it comes from you.

Use a word processor or a computer when you compose your statement to make revisions and updates easy. You should save previous statements on disk to use when referring to older work.

Most artist statements are not more than one page in length. The statement is usually single-spaced, in ten- or twelve-point type, printed on plain paper, with your name and date at the bottom. There is no need for fancy fonts or elaborate formatting. If your statement is available at your exhibition, you should place it in a binder at the desk with the list of works in the exhibit, your resume and copies of reviews. Or you might enlarge the statement and place it on the wall, usually mounted on mat board. For performance, a short version of your statement could appear in the program.

Statements can be expanded into multi-page essays for someone doing research on your work, for background information for a catalog essay, or for academic documentation for tenure or promotion. Frequently, such documents cover your work over a period of years, and may be a compilation of old statements that you have used in the past.

Some artists experience writer's block when composing an artist statement, in some cases because they are so close to the work that they cannot summarize their thoughts in a few paragraphs. You can avoid such blocks by tape-recording a conversation as you and a colleague talk about your work, and transcribing excerpts. Another antiblock strategy is to jot down quickly everything possible

about your work. Then organize and edit (or find someone else to edit) your rough remarks, filling in details as needed. Here again, use a word processor so you can easily rearrange your ramblings.

Once finished, check that you have written an effective statement by having it reviewed by a mentor, fellow artist, or art reviewer who knows your work. Or, have a professional writer or editor review it with you. Proofread for grammar, spelling, and punctuation errors.

A *concept statement* is related to the artist statement in that both deal with formal and conceptual aspects of your work. A concept statement, however, describes work that you plan to do, versus what you already have done. A concept statement is frequently required for grant applications and proposals for exhibitions in alternative spaces, museums, or university galleries. It is often needed for first-round proposals for public art projects. In the concept statement, you apply your work to a particular situation; in other words, you do not simply discuss your work, but also how you will address a given theme, project, or agenda.

The degree of specificity required in concept statements varies with different situations. Read the application guidelines carefully to ascertain the questions you need to answer and the information to provide. In case of doubt, ask the curator or project supervisor for instructions on what is needed. All concept statements, even the most general, should give a sense of the themes you will explore, the kind of artwork you will do (e.g., a series of paintings, an installation), the way the work fits in with the given theme or site, the media you will use and a rough idea of any unusual requirements in terms of the space (e.g., temporary walls, electrical needs, lighting, etc.). The tone of concept statements should be unembellished, straightforward, and explanatory. For more information on concept statements, see the interview with Kim Yasuda at the end of this chapter.

Conceptual proposals for public art projects and commissions are covered in Chapter 14.

Visual Documentation

Over the years, it is likely that more art professionals will see documentation of your artwork than will see your artwork in person. Curators, jurors, and collectors usually review slides, still photographs, or videos before seeing actual work. Therefore, you need high quality reproductions because artists are responsible for providing these images to those who may request them. In addition, you will need reproductions for announcements and for critics who will review your work and thus need an image for publication.

There are five basic formats for documenting your artwork: 35mm slides, black-and-white prints, 4" × 5" transparencies, color prints, and video. The 35mm slide is the most commonly used format for traditional visual artwork, and is backup documentation for performance. If you document your work in

only one way, that way should be 35mm slides. Use 35mm slides when sending packets about your work to galleries or museums, when entering juried exhibits, when applying for grants, or when applying for teaching jobs.

The second most common format is the black-and-white print, which can be used to reproduce your work on announcements, in magazines, or in newspapers. Another format is the 4″ × 5″ transparency, which shows off your work beautifully, but is expensive to produce and generally not needed by artists as they start their professional careers. Color prints are not often used to document your artwork, but they can be used occasionally for display or publicity purposes, and sometimes for reproductions on announcements when you only need a few. For more announcements, commercially printed color reproductions would be more economical.

If you are a video artist or animator, then video is naturally the primary and necessary format through which to present your work. For performance, video is necessary documentation, with slides as supplements. Video can also be used to document any artwork that has sequential elements, sound, movement, or is time/space based, for example, artists' books, installations, kinetic sculptures, or large earthworks. Video is becoming more common and more accessible as documentation, while video's drawbacks include the expense of editing equipment, loss of quality with each video generation, and the rapidly changing technological developments that can make some equipment obsolete.

Many artists successfully make their own 35mm slides and black-and-white reproductions of their artwork. It is not hard to learn, and can save you money, since most professional photographers charge $30 to $50 per hour, plus film costs, to do this for you. Even so, you may want a professional photographer to document your work in special cases, for example, when 1) the work is extremely large and hard to light evenly, 2) the work is very shiny, and difficult to light without glare, 3) the space where the work is located is very small and you may need special lenses to capture the image, or 4) for 4″ × 5″ transparences, which require a costly camera and special knowledge.

Detailed instruction follows on how to make your own 35mm slides and black-and-white reproductions, and more limited information on the other formats. You need to be already familiar with 35mm cameras and basic photographic terms and procedures. At every step, try to get the highest quality results possible. Carelessness usually means inferior results, which make your work look bad, regardless how wonderful it may actually be. And that is bad for you.

Here are a few notes on photographic film, before you begin:

1. For all color reproductions of your work, whether 35mm slides, transparencies, or color prints, it is absolutely essential to use film balanced to the kind of lighting you will have. The wrong combination of lighting and film will result in unusable color reproductions, either too yellow or too blue.

2. When you buy film, always check expiration dates on the box and only use fresh film.
3. Black-and-white film, professional film, and tungsten-balanced films are available at photographic supply shops. Daylight-balanced films are available at a number of locations, including discount stores, drugstores, grocery stores, and photographic supply shops.
4. Use the slowest film possible (with low ISO numbers) to photograph traditional visual artwork. Slow film is the most stable, generally has the least grain, reproduces the most detail with the greatest sharpness and, in the case of color film, gives truest color reproduction. For performance, you may need to use a faster film to capture images in low-light situations.
5. You can use either professional or nonprofessional film. Professional film gives better color results, but must be used shortly after purchase and must be kept in the refrigerator until two hours before use. Nonprofessional film gives satisfactory results, has a longer shelf life, and does not require refrigeration.
6. To cut costs, you may want to buy film in bulk and store it in the refrigerator at low humidity to prolong its usefulness. Store all professional grade films in the refrigerator before use. In any instance when you photograph with refrigerated film, allow the film to warm up a few hours before opening its plastic container and shooting.
7. The first few times you photograph your artwork or performance, take notes on each exposure and critically evaluate your results after developing. Then adjust your procedures to give you the best results possible.
8. Always photograph unframed artwork, unless the frame is an integral part of the idea behind your work. Frames are usually unnecessary distractions. Also, plexiglass or glass coverings may cause glare that obscures your work.

35MM SLIDES

What you need:

- Camera: 35mm or Single Lens Reflex Camera with light meter, manual override, and 50 or 55mm lens
- Hand-held incident light meter (optional)
- Tripod
- Cable release
- Neutral gray card (Figure 6.4)
- Lights for indoor shooting (Figure 6.5):

 Sylvania 500-watt ECT 3200K Photofloods

 Reflectors (with metal clamps or light stands, rated for 500-watt lamps)

 2 or more lights for flat artwork

 3 or more lights for sculptural artwork

- Film (numbers indicate film speed, or ISO):

 Ektachrome Professional 64, 160, 320 Tungsten

 Fujichrome 64T Tungsten

 Ektachrome 100, 200, or 400 (Daylight) Professional and Non-Professional Grade

 Fujichrome 100, 400 (Daylight)

 AGFA Agfachrome 100, 200, 400 (Daylight)

 Kodachrome 25, 64 (Daylight)

Photographing Traditional Visual Work

These directions are intended as general guidelines. Try variations to see what shows your work best. Photographing flat artwork will be covered first, and then photographing sculptures and installations.

Photographing artwork indoors, with controlled lighting, is the method preferred by most artists and professional photographers. For indoor photography, you need photoflood lights and film that is balanced for tungsten lights. You also need a clean black, white, or gray wall, or a clean cloth or roll of paper you have pinned to the wall. Any artwork, flat or sculptural, is hard to see against a cluttered background (Figure 6.6). Stay away from brightly colored walls or objects that may reflect unwanted colors onto your artwork.

Place your camera on a sturdy tripod pointing directly to the center of your flat artwork. Make sure the back plane of your camera is parallel to the front plane of your artwork (Figures 6.7 and 6.8). Look carefully through your viewfinder to see if the artwork is well framed and properly aligned with the camera (Figure 6.9). If your artwork is rectangular, you can easily see if the edges of the art are parallel to the edges of the viewfinder, indicating correct alignment.

To light your work, use photoflood lamps in aluminum reflectors. While professional photographers may use quartz lamps for indoor lighting, these lights are too expensive for occasional use. Never use ordinary household bulbs, floodlamps, or fluorescent lights when photographing your work in color, because they will cause a perceptible color shift to yellow or blue. Photoflood lamps give off a tremendous amount of heat and can melt or short the socket. Therefore, make sure you are using fixtures rated durable enough for 500-watt bulbs. Mount the light fixtures on light stands, or use the clamps to secure them to chair backs or some other convenient furniture.

Photoflood lamps emit more light when fresh than after they have been used for even a few hours. In addition, the light emitted by photoflood bulbs becomes increasingly yellow with use. You will have difficulty lighting your work evenly if you use one fresh photoflood with an old one. Use pairs of photofloods together until the color shift makes them unusable. Photoflood bulbs last 5 to 15 hours.

Light your artwork carefully, because this radically affects the quality of the slides. Block off from your artwork any strong light source other than

photofloods. However, it is not necessary to eliminate low-level ambient light where you are working, because photofloods are powerful enough to overcome the color-altering effects of low-level, indirect light from other sources.

You can use two photoflood lamps for flat artwork less than four feet in either dimension. For larger work, use four lamps to illuminate your artwork evenly. First, you must roughly place your lamps, locating them at a 45-degree angle to the picture surface. Place them far enough back that you avoid obvious "hot spots" or bright areas on your work. One rule of thumb is to position each light a picture's-width away from the center of the artwork. Make sure your lights are placed even with the camera; you should not be able to see either lamp through the viewfinder of your camera (Figure 6.10).

After your lights are placed properly, then cross-aim them to evenly distribute the light across the surface of the artwork. Aim the right lamp towards the left edge of the artwork, and the left lamp towards the right edge (Figure 6.11).

Check the surface of your work for glare while looking through the camera's viewfinder. If glare is minimal, you are ready to proceed. However, if your work is very large, with a very shiny surface, you may still have distracting glare or bright reflecting spots. Try moving the lights to an angle less than 45 degrees to see if glare is reduced. If not, you may need to illuminate your work indirectly. You can bounce light off a white ceiling or off large sheets of white mat board to create indirect lighting (Figure 6.12). It may be more difficult to light your work evenly and sufficiently by bouncing.

Whether you use direct lighting or bounce lighting, it is important to make sure your artwork is evenly lit, without bright and dark areas. Use a hand-held incident light meter to take a light reading at all four corners and at the center of your work (Figure 6.13). An incident meter measures light falling on a subject. Make sure your own shadow does not interfere with your readings. If you do not have an incident light meter, however, you can use your camera's light meter. Cameras are equipped with reflective meters, which measure light reflected from a surface. Hold a neutral gray card at all four corners and at the center of your work, and at each location place the camera so that the gray card fills the camera's viewfinder. Then take a reading. Again, keep your own shadow out of the way.

Note the f-stop reading for each location. If all your readings are within one-quarter f-stop of each other, you are ready to begin shooting. If not, adjust the lights to provide more illumination to darker areas (Figure 6.14). Make your gray card readings again, until the lighting is even.

Do not photograph your work on the lowest f-stop, with the camera aperture wide open. You will get better results with at least a mid-range f-stop because depth of field will be improved and the resulting image will be sharper; f-5.6 or f-8 are good settings to use. Then set your shutter speed wherever necessary to give the proper exposure with your chosen f-stop. Since you will be using a tripod and cable release when you photograph, you can shoot at any shutter speed, fast or slow.

Now you are ready to begin photographing your work. Load the film into the camera, and carefully replace the camera on the tripod. Set your f-stop. Focus

carefully. If your artwork lacks strong tonal contrasts and edges, you may find it difficult to focus. If so, simply draw a pencil line on a piece of paper, place it on the surface of the work, and focus on that.

Bracket your exposures. To bracket, shoot several additional exposures above and below the f-stop indicated with the light meter and the gray card. For example, if your meter readings call for an f-stop of 5.6, Figure 6.15 indicates how much you should bracket.

You must bracket because it is impossible to exactly predict what exposure will give good results for any particular artwork. You may need to compensate if you have a dark work with important details in shadows, or conversely if your artwork is very pale with subtle shifts in the light tones. In addition, there are other variables beyond your control that affect how your slides look, such as variations in film speed, processing, camera inaccuracies, and your own occasional errors. Bracketing ensures that you will have good results and will not have to shoot the entire batch of slides again (Figure 6.16).

Take detail shots if your artwork has some important textural or narrative details not apparent in an overall shot (Figure 6.17).

When photographing objects that do not hang on the wall (for simplicity, called "sculpture"), you again need a clean, uncluttered space that shows the work clearly. Sculpture is not only hard to see against a cluttered background, but also masking around the image may be impossible, resulting in an unsatisfactory slide. Consider the color, texture, and tone of the sculpture, and place it against a contrasting background (Figure 6.18).

The minimal requirement for successfully lighting sculpture is two photofloods; three lamps give better results (Figure 6.19). Unlike flat artwork, which you try to light as evenly as possible, it is important to light sculpture unevenly in order to show its volume. The main light, placed closest to the artwork, provides primary illumination. It is set to one side of the sculpture to emphasize the dimensionality of the work; facets facing toward it are most brightly lit. The fill light is placed opposite the main light and farther away from the artwork, in order to subtly illuminate shadow areas to show some detail. You may be able to bounce light onto the sculpture instead of using a fill light. The ratio of illumination between bright and dark surfaces should be at least 1:2 and no more than 1:4. Thus, the main light should illuminate the sculpture at least two times (one f-stop) and no more that four times (two f-stops) as brightly as the fill light.

If you have a third photoflood, use it as a back light to create depth by shining it down from the rear (Figure 6.20). This highlights the artwork's shape and distinguishes it from the background. Experiment with its exact placement to find what effects you like best. Check the viewfinder carefully before photographing to make sure the stand and cord from the back light do not show up in the slide. If using only two lights, eliminate the back light and place the work near a clean, white background, which will provide some bounce light on the work (Figure 6.21).

FIGURE 6.4

Cable release and neutral gray card

FIGURE 6.5

Photofloods, reflectors and a light stand

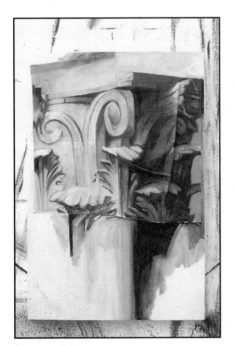

FIGURE 6.6

Cluttered or messy backgrounds are distracting in slides. While you can later mask around the edges of flat artwork to eliminate the background, you cannot mask around images of most sculptural work.

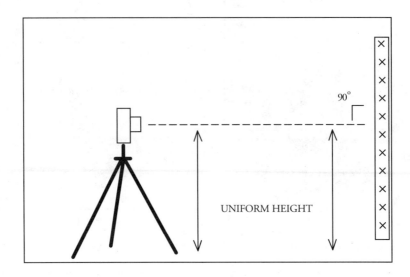

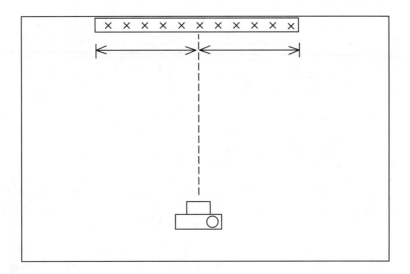

FIGURE 6.7

Correct camera alignment. At the top of the page, the side-view diagram shows correct alignment of artwork with the camera. The bottom diagram shows a top view of the camera centered on the artwork.

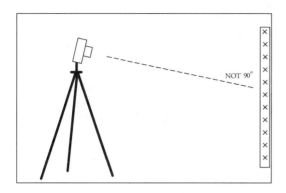

FIGURE 6.8
**Incorrect camera alignment.
The artwork is not parallel
to the camera back.**

FIGURE 6.9
**Look carefully through the viewfinder to see if your artwork is properly
aligned with the camera. None of these examples is aligned.**

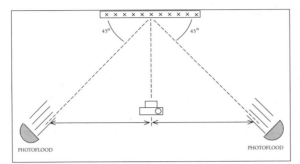

FIGURE 6.10
Top view diagram showing rough placement of photoflood lamps for making slides of artwork. Place your lamps at a 45-degree angle from the surface of flat artwork. Make sure the lamps are two artwork-widths apart.

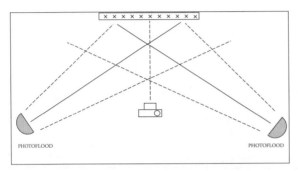

FIGURE 6.11
Diagram, showing how to aim the photoflood lamps on flat artwork. By aiming across the center of the artwork, you light it more evenly. Check your work carefully through the camera's view-finder, and readjust the lights if you see glare or hot spots.

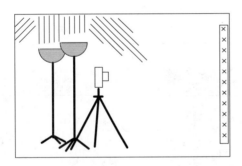

FIGURE 6.12
Two ways to bounce light to illuminate your artwork. The diagram at top shows a side view of flat artwork on a wall. Light is bounced off a white ceiling to softly illuminate the entire room. Below is a top view of flat artwork lit by bouncing light off white surfaces.

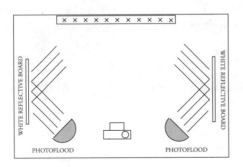

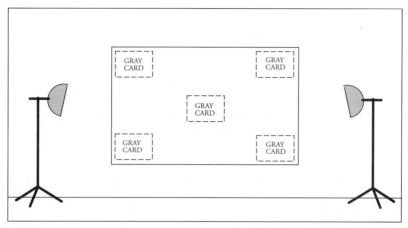

FIGURE 6.13

Front view of large artwork on a wall, showing where to place the gray card for reading light levels to ensure the artwork is evenly lit

FIGURE 6.14

The artwork on the left is unevenly lit, while on the right, the lighting is much better. Look for even tone in the background to help you properly light your work.

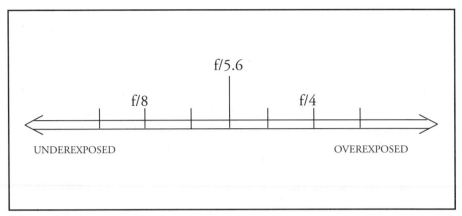

FIGURE 6.15

Bracket your exposure by first photographing your artwork at the f-stop indicated by the gray card reading, and then making exposures at three half-stops above and below the original reading. Thus you will make seven exposures at half-stop intervals.

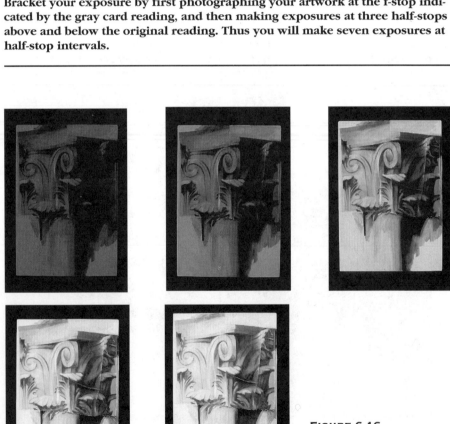

FIGURE 6.16

A group of reproductions that show bracketing

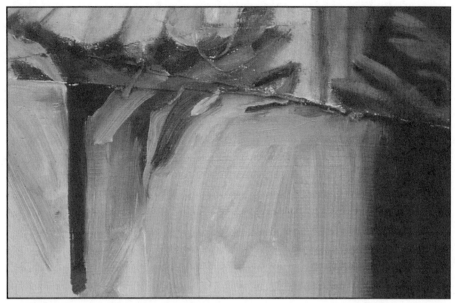

FIGURE 6.17
Detail shots can reveal texture qualities not visible in an overall shot.

FIGURE 6.18
Place your object where it shows up against the background.

FIGURE 6.19
An example of lighting an object with three photofloods

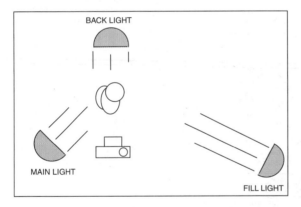

FIGURE 6.20
Lighting sculpture with three photofloods, shown from a top view and a side view

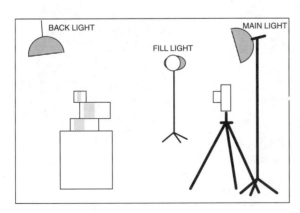

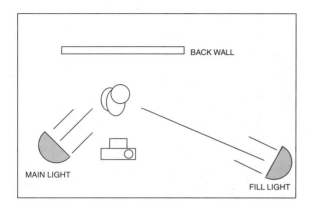

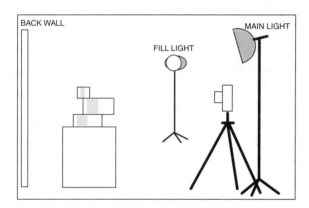

FIGURE 6.21
Lighting sculpture with two photo-floods, shown from a top view and a side view. Light bouncing off the back wall replaces the back light in Figure 6.20.

FIGURE 6.22
Avoid overly long, dark shadows in the background.

FIGURE 6.23

The scale of the object you photograph appears to change when you raise or lower the camera's point of view. Try to photograph your work at the angle at which it usually will be seen.

FIGURE 6.24
This image was shot with the aperture wide open while focusing on the closest area of the chair. As a result, the back edges are out of focus. Therefore, you should shoot with the smallest possible aperture to keep the entire image in focus.

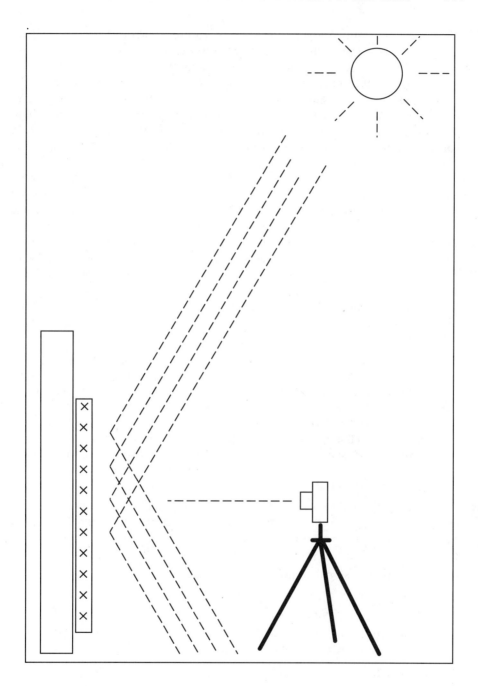

FIGURE 6.25
Side view of flat artwork on an outdoor wall, with the sun over your
shoulder and high enough to avoid glare, as you photograph your work

Keep your lights fairly close to the sculpture, to avoid overly long shadows showing up in the slide. Place the sculpture away from the background wall to avoid distracting shadows looming behind it (Figure 6.22).

You can make the same object look large or small in a photograph, depending on the placement of the camera relative to the object. A low camera angle will make your object appear larger, while shooting down from a high position will seem to shrink the same object. When photographing artwork, you should position your camera to most accurately reflect how people view the work when it is displayed (Figure 6.23).

With the incident meter, or with gray card and the camera's light meter, check light levels for consistency on the illuminated side of your sculpture. Of course, the shadow side will be darker. The correct exposure will be the average of the light-side and dark-side readings, but you should also bracket your exposure. Use a slow shutter speed and the smallest possible aperture for maximum depth of field, for example, f-16 (Figure 6.24). Focus at a point about one-third of the way into the work, to ensure that both close and far surfaces are in focus. Take detail shots to show surface texture and various views.

Photographing installations incorporates the principles of photographing flat artwork and sculpture. However, there are a few added considerations to remember:

- Take several shots in sequence to establish how the viewer encounters and moves through the installation. Thus, you should photograph the installation at its entrance and at various points as the viewer would see it.
- Take both distant shots to record overall impressions and detail shots to highlight particularly effective areas.
- Consider making a video of your installation, especially if you incorporated sound (see video below). Video is not a substitute for your 35mm slides, however. Generally, you send slides to curators, jurors, and gallery directors.

Photographing artwork outdoors means that you do not need photofloods and that you use the more easily available daylight balanced film. Remember to photograph between 10 a.m. and 2 p.m. for proper light balance. There are a variety of disadvantages to photographing outdoors:

- Haze or occasional clouds will affect your light levels.
- Wind can wreak havoc on your setup and make paintings fly away.
- Glare is more common on painting or sculpture surfaces.
- Glare from adjoining surfaces is harder to avoid.
- You must mask the resulting slides to eliminate background clutter.

When photographing outdoors, keep the sun over your shoulder. (Figure 6.25). Do not shoot in the shade, which may result in a distinct blue cast on your slide. Place a nonreflective gray or black dropcloth around the work to avoid glare and color reflections from surrounding surfaces. Illuminate shadow areas of sculpture with bounce light. Use a gray card to read light levels.

Photographing Performances

Documenting performances is a very different task from documenting traditional visual work. With traditional work, you control the lighting environment so that every slide or photograph has been exposed consistently and the colors are balanced. You set up your work, frame it and focus with care. In contrast, performance presents a moving target for the photographer, and may be dramatically lit. You may be photographing bright sequences, dark sequences, and situations with colored lighting. The subjects, rather than being inanimate, are living persons with their own ideas, schedules, and willingness to cooperate. Control is much harder to maintain. When you document a performance, or someone else documents your performance for you, here are some important points to work out before shooting.

First, decide when the photographing will be done. If possible, do not photograph during an actual performance, because the photographer distracts the audience. Photograph during the first full dress rehearsal, when all lights are in place. If something goes wrong, then you may have a chance to shoot again during subsequent rehearsals. If you want both slides and black-and-white photographs, make both at the same time by using two cameras, one loaded with each kind of film. This is more efficient than running through two rehearsals or setting up each shot twice.

Next, decide what specific shots you want. If someone is photographing for you, provide her or him with a script or explain which shots are important. Indicate from what angle the photograph or slide should be made, when you want close-ups, whether you generally want tight framing or whether you prefer to see the background surrounding the performer.

Next, decide how you want to stage each shot. If you photograph a rehearsal in progress, you may get more dynamic results. On the downside, some images may be blurred, poorly framed, and an occasional hand or head cut off. In addition, photographing this way means that you cannot make exposure readings before shots and you cannot bracket shots. If there are great variations in lighting in the performance, you could miss some shots and make exposure mistakes on others. Your other option is to simulate particular moments in the performance and then have the performers freeze, allowing the photographer time to frame, take meter readings, and take a few bracketing shots. The disadvantage is that the images may look more stilted, a little less animated. Most importantly, your documentation should adequately convey the look and feel of the performance. Therefore two things to avoid are artistic but misleading shots, and promotional, portrait-like, overly staged shots.

Color balance can be tricky, especially if special effect lighting or theatrical lighting is used in the performance. There may be dramatic color effects at times when the light should appear colored and not balanced, whereas with photographing traditional visual work, balanced white light has become the convention and standard, and what art professionals expect. Documentation of performances should convey planned color effects. On the other hand, you

want to avoid documentation that is tainted because of color imbalance in the general lighting used for the performance. In other words, photographic film is sensitive to light shifts caused by artificial lights, while human vision compensates for these shifts. For example, although humans can see a fairly full range of color under warm lights, the photographic film will record that warm shift, giving everything a distinct yellow cast. In such cases, blues may appear as either green or black. If you are photographing a performance in unknown circumstances or have not worked under particular lights before, try two test rolls of film, one daylight-balanced and the other tungsten-balanced. Compare the result these two types of film give, and choose the better.

Light levels are as challenging to photograph in performance as color shifts. Some sequences may be dark, and some brightly lit. Again, the consistent lighting used for photographing traditional work would interfere with the integrity of the performance, so the varying light levels should be maintained. Thus, do not try to adjust the lights or the f-stop so that the exposures are the same from image to image. However, you must take care that the lighting is not so dramatic that your photographs or slides are all blackened in or washed out. The human eye can see a much wider range of light levels than any photographic film can record. Thus, where the eye can see detail in shadows and features in bright lights, the film may totally lose them. Therefore, try to stop down somewhat to avoid burning out a brightly lit area. And try to even out drastic contrasts between light and dark areas, by bouncing light to illuminate shadows. Use a hand-held or camera light meter for readings in both light and dark areas. If the light and dark areas differ by three or more f-stops, you need to even out the illumination. If that cannot be done, decide which area is most significant, and expose for that. For difficult shots, try bracketing.

Photographing a performance cannot be as controlled as photographing traditional visual artwork. You will try the patience of the performers if you are slow in setting up your camera, slow in making meter readings, and insist on long freezes. If you can get good effects with a hand-held camera and your performers are impatient, then forget the tripod. You may have to use a faster film if you are hand-holding the camera and shooting under a wide range of light levels. While slower film has better color saturation and less grain and is preferred for traditional visual work, you will probably use film with an ISO of 400 or higher for performance.

Communication is essential in this process, whether you are the photographer explaining what you want from the performers, or the performer trying to direct the photographer to get certain effects. Talk through everything thoroughly and clearly.

Editing, Masking, and Storing Slides

After your slides are processed, edit the results. Use a projector or light table to see if each slide is in sharp focus and to check the color balance. Look at the overall color. But also carefully examine white areas where subtle red or green tints may be more apparent, indicating an undesired color shift. Compare your

bracketed shots for the best exposure. Check for detail in the shadows and highlights. The best f-stop may vary from artwork to artwork.

Pick the best slide and get ten or so duplicates made for each artwork, in order to have extra sets of slides. Do not mail out your original slides to anyone, because they may never be returned. Always make duplicate slides from original slides. Duplicate slides are usually somewhat less satisfactory than original slides in terms of graininess, color accuracy and color saturation. Duplicates made from duplicates are even worse.

Having duplicate slides made can be expensive, and as mentioned, degraded from the originals. An alternative to duplicating slides is taking several slides at the proper exposure as you shoot your work, so that you immediately have several slides of each piece. While it is difficult to predict exact exposures at first, with experience you will find that you can guess pretty well which exposure settings will work best for an individual artwork and take several slides at that setting. Even so, bracket your exposures! You never know when you or the lab may make a mistake. The bracketed slides are your insurance that you will have at least one good reproduction of your work.

If there is distracting background behind your artwork, you may need to mask the slide. To mask a slide, remove it from its mount. If the slide has a plastic mount, check to see if it is reusable. If the slide is in a cardboard mount, remove it and discard the mount.

Place your slide on a light table, where you can see the image clearly. Avoid getting fingerprints on the emulsion. Affix pieces of slide masking tape (e.g., Leitz Special Silver Tape) over background areas on the nonemulsion side. Use only slide masking tape, as other tapes damage film and melt under the heat of the slide projector. Remount slides in reusable plastic mounts, which are available at photographic supply shops. When masking, you may be tempted to try to save time by simply placing the tape over the mount. This does not work well because the tape may come off or get stuck in a slide projector and because the mount interferes with placing the tape on the film.

Label your slides as follows (Figure 6.26):

- your name
- the name of the artwork
- the medium/media used
- the date completed
- the size of the work, listing height, width and depth in that order
- slide orientation: Indicate "top" with words and an arrow, or place a colored dot in the extreme lower left of the slide as you hold it in your hand, viewing it correctly.

Your collection of slides can grow amazingly large. In a few short years, you may feel as if you are about to be suffocated by the mountains of unorganized slides that you have accumulated. Or you may search for hours through piles of loose slides for images you know you have, but cannot find.

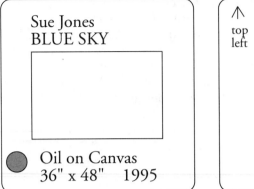
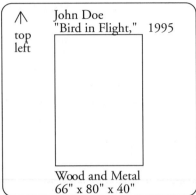

FIGURE 6.26
Two possible ways to label slides

When these unfortunate events happen, buy metal slide cases or archival storage boxes and use a filing system to organize your slides by date, media, or subject matter. These cases or boxes are widely available through mail-order catalogs or local photographic supply firms. Organizing your slides makes them easier to find and helps you avoid running out of slides of a particular work.

Store your slides in archival containers, which will ensure that the slides last as long as possible. If you store or send out slides in plastic slide sheets, avoid the nonarchival polyvinylchloride (PVC) sheets, which become brittle, sticky, and discolored in time. Use either polyethylene or polypropylene sheets.

BLACK-AND-WHITE PRINTS

Film (numbers indicate film speed, or ISO):

AGFA Pan-Professional 100, 400

Ilford FP4 (64), HP5 (400)

Kodak Plus-X 125, Tri-X 400

Kodak T-Max 100, 400

You need the same equipment for shooting black-and-white film as you need for 35mm slides, and follow similar procedures.

Color balancing is not critical for black-and-white photography, but it is still important to read light levels off your gray card in order to get a good exposure. For black-and-white reproductions, therefore, just as with color slides, set up your work against an appropriate background and read several light levels off the gray card. Bracket your exposures, because once again, you cannot always predict the proper exposure for each work of art, and you need to check for detail in shadows and in highlights.

At the lab, request that your film be developed and a proof sheet made. Store your negatives and proof sheets together, so that it is very easy to have enlargements made as you need them.

Most black-and-white prints of your artwork are made to be reproduced in some commercial print media, either in a newspaper, on an invitation, or in a catalog. In order to get the best final printed results, your print should be low contrast and on glossy paper. If a commercial lab is making your black-and-white prints for you, specify "for reproduction" to get desired results.

If you have a photographer document your performance or artwork for you, make sure you get both the negatives and a proof sheet. Some photographers give a proof sheet only and keep the negatives, so that you have to pay them for every print you want made from that roll.

4" X 5" TRANSPARENCIES

With their large size, good color saturation, fine grain, and abundant detail, 4" × 5" transparencies are a pleasure to view. Announcements with images that are made from 4" × 5" transparencies are usually sharper, brighter in color, and generally superior to printed images made from 35mm slides.

Unfortunately, 4" × 5" transparencies are expensive to produce. You need to have a view camera to make them, and you need to know how to use that camera. Knowledge of 35mm photography is not sufficient. Film and processing costs are higher for transparencies than for 35mm slides. And transparencies are less forgiving than 35mm slides. Uneven lighting, glare, sloppy framing, and even slightly off exposures show up more in the larger-size transparency than in the small slide.

Generally, artists just beginning their careers do not need 4" × 5" transparencies of their work. Transparencies are rarely used to document performance. More established artists usually hire professional photographers to make their transparencies, and usually only of selected artwork, reserving the 35mm format for documenting all of their work. However, if you have access to a view camera and enjoy photography, you may want to try producing your own 4" × 5" transparencies. Good introductory books to the view camera are available in large photographic equipment stores, art libraries, and art bookstores.

COLOR PRINTS

Films:

AGFA Agfacolor 100, 200 (Daylight or Flash)

Vericolor VPL 160 Tungsten

Vericolor Professional 160 (Daylight or Flash)

Kodacolor Gold 100, 200, 400, or 1000 (Daylight or Flash)

Color prints are of limited use in documenting your artwork. Color shifts are more common in color prints than in color slides, due to the extra processing steps of first developing the negatives and then printing color prints from them. Color is usually less saturated in prints than in slides. However, you may want color prints for display or as an inexpensive alternative to commercial color printing, if you are producing only a few announcements of an exhibition. Simply glue color prints onto announcements that are already printed with the necessary information. Also, some artists use color print enlargements in portfolios to show their work to the general public, who are not as accustomed as art professionals to reviewing work in slide or transparency formats.

You can also make color photocopies of your work from either color slides or color prints. Color photocopies are low-quality reproduction and grainy, with poor color accuracy. However, they give a rough idea of your work when a slide does not seem adequate, and may be useful at times.

VIDEO

Video is both the working medium and the documentation format for video art. Video has been available in many formats, including one-inch, three-quarter inch, and half-inch, which indicate the width of the actual videotape, and also in VHS, S-VHS, 8mm, and Hi8. Most commonly used for high-end archival presentation of work is the one-inch format. In popular formats, Hi8 is currently of interest to artists as an image-capture medium, because its imagery can be transferred to one-inch tape without generational loss of quality. VHS is the standard format for presentation of your work, for sending the edited and finished versions out for others to see.

Video artists must take care that their video copies maintain the resolution and color saturation of the original work. The VHS copy you send to curators and festivals should not be seriously degraded from the best copy of your work. The professional way to maintain quality would be to make from the original tape you shot, called your resource material master, a "windowed up" copy of your work on three-quarter-inch tape with digital time code on the bottom for off-line editing. Off-line editing is sketching out your takes and putting together a rough edit to see how the piece works. Your final on-line edit would be done on one-inch format directly from your resource master for

high-quality archival preservation. Subsequent copies would be made from that. These formats and the editing equipment for them are not always accessible to artists; however, whatever format they use, artists should avoid the copy-of-a-copy-of-a-copy tape with a badly degraded image.

Making visual documentation of video art is usually the same as presenting the work itself. However, because video takes so much time to watch, many art professionals preview only the first few minutes of artists' submitted videos, and then in "Search" mode, which is fast-forward viewing without sound, before deciding whether to view the entire work. Therefore, your video needs effective visuals in the beginning minutes, and should be supplemented with a cogent, enticing written description or artist statement.

Many artists make video installations, where the video is incorporated within a larger artwork that provides a context for understanding the video imagery shown. Other artists envision the video as simply shown on a monitor without a constructed setting. When submitting a tape of your video work for review, indicate how the work should be presented, either with written description, slides, or drawings.

Video is important documentation for performance work and sometimes used for time-based art and installation. In both cases, 35mm slides are a substitute form of documentation and in fact may be necessary to submit your work for certain grants or shows, or for giving an oral presentation on your work. But video gives a better sense of performance work than any other documentation medium.

The least expensive and easiest way to video-document a performance is to put one video camera on a tripod and let it run through the whole performance. Unfortunately, the tapes made with this method look extremely boring to viewers used to seeing panning, dramatic cuts, close-ups and distant shots in television programming. You should use two cameras to give different points of view and to vary the shots. This requires you to script or organize your video shoot beforehand, and afterwards edit the takes into one final version. You have to be a video artist of sorts if you are a performance artist doing your own documentation.

Artists who make traditional visual work sometimes use video in addition to slides to document it, especially if there is a time-based, sequential, kinetic, or sound element to the work. For book art, kinetic sculpture, sound pieces, or installation, video communicates more about the work and shows how the viewer would actually encounter the piece. The quality of video images is generally lower than that of 35mm slides, with more grain and less color accuracy and saturation than slides. Video does have an advantage in that video images can be "grabbed," digitized, and made accessible to a computer, where stills can be stored or manipulated. Artists applying for New Genres grants with the National Endowment for the Arts may submit documentation that they believe best represents their work. There is no one way to do it.

Whether you do your actual work on videotape, or simply use it to document your work, you should be aware that equipment in early video formats,

such as half-inch reel-to-reel, is no longer available. Do not use this format even if you have access to the equipment. Another problem that exists even with current video formats is that images on videotape can degrade over time. You should check old tapes periodically, store them at a constant moderate temperature, and copy them to newer, more archival formats as they become available. In addition, you will probably be affected by the current turnover in video technology. Videotapes are expected to be replaced by digital video, where video images will be stored on disk and edited by computer. Videotape will likely become obsolete. If you have any work done or documented in a format that is being replaced by a new technology, you should plan to copy the old work to the new standard format.

Getting access to video equipment and instruction on using it may be difficult and costly. However, the National Alliance of Media Arts Centers (NAMAC) lists organizations and individuals committed to further diversity and participation in video and multimedia production. The more than 120 members of the organization, many of them museums or alternative spaces, can assist you in finding access to video equipment. NAMAC members are listed in *Organizing Artists*, the directory of the National Association of Artists' Organizations. Other possibilities are community colleges or junior colleges offering video courses for a reasonable fee. And cable television companies offer filming and editing instruction through their community access facilities, as they are obliged by law to provide studios for public access programming. You can learn how to operate editing equipment and learn editing procedures.

If you don't have a video background and all this seems daunting, possibly the best way to get video documentation for your performance or other artwork is by forming an alliance with someone who owns video equipment and trade some sort of work with them.

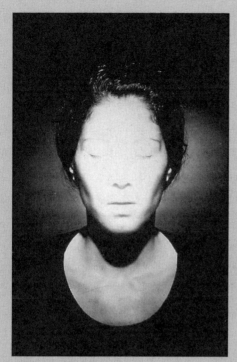

Kim Yasuda
Photo by Courtney Gregg

ARTIST INTERVIEW: KIM YASUDA

Kim Yasuda is an installation artist whose work is site-specific and historically grounded. She also works on public art projects with teams of other artists and architects. She teaches at the University of California at Santa Barbara. In the following interview, she recounts some of the instances when she has used concept statements as part of applications and proposals.

You have had experience showing in many different kinds of spaces. How were you able to get these opportunities? Do you write proposals?

Primarily the exhibition opportunities I've had for my installations have been based on past work and on very general conceptual proposals. The institutions where I have shown have had a certain amount of good faith towards the way I work, which is very site-specific, context-specific, and

(continued)

Kim Yasuda. Unspoken. *1994. Detail of a multimedia installation, Total environment: 15' X 25'. Ansel Adams Center for Photography, San Francisco.*
Photo by Andy Grunberg

(continued from previous page)

time-specific. To have a highly detailed proposal ahead of the actual exhibition is not possible. For example, at the alternative space, Cameraworks, in San Francisco, the exhibition committee asked for a fairly specific proposal with a fairly strong conceptual foundation. In other words, they want to know how I am thinking, how I regard their institution and my ideas. They expect a pretty strong conceptual statement, but not a detailed description of the actual exhibition. The final work was a variation of my initial proposal, but that was fine with them.

What would a proposal entail, even one from which the final installation might vary?

Well, I will be doing a project for the Ansel Adams Center, which is part of their Open Space series, promoting alterative photo-related projects under no curatorial direction. You can do whatever you want. I sent slides of past work and briefly told how my work

(continued)

(continued from previous page)

would address certain issues. In this case, what became interesting for me was that Ansel Adams himself was at one time hired by the War Relocation Authority to document the Japanese-American internment camp during World War II, while the internees had no ability to do so for themselves. They were denied cameras and any kind of visual record unless it was under the approval of the War Relocation Authority. The notion of an "open space" for me, and the idea of the Japanese-American internment for my parents, became a personal point of departure. It was the foundation to respond critically to the normalcy in which Adams chose to document these people and the reality of my family's memories of the internment. This is my initial concept, and that's all I had to tell them. They still don't know what I am actually going to do, and the exhibition is two weeks away. How the proposal translates physically in the space will be ultimately determined during the installation.

How do you approach writing a concept statement or conceptual proposal?

One of my problems is that I write too poetically. In any proposal or grant writing, I have to remind myself that I am just trying to articulate an idea, not make art. Keep it clear and simple, not necessarily too explicit and not necessarily too general.

I think it is important to remember that the work is critical, though, foremost in our entire discussion. I think that that is where the proposal has to be most effective—the work has to do it all. It has to be the prime mover before all other things happen.

Are there any specific details about your installation that you might include in your preliminary proposal to an institution?

If I need equipment or if I need installation support, that needs to be arranged. I need to have enough planning to allow them to do that. Often I need a commitment for people capable of helping with the kind of installations I am doing, which are labor intensive. It's not enough that they know how to hang pictures on a wall. Otherwise, with a complicated installation, I may end up having to hire and pay for the help myself.

Are there other instances when you have needed proposal statements or concept statements?

I am going to do the Banff Artists in Canada residency; it's an international residency that will bring me into a new arena and geography. I

(continued)

(continued from previous page)

had to write a really specific proposal on what kind of research I would do related to their topic for this year, which was the "End of Nation-States" and the disintegration of a world order.

The grants that I've applied for are visually based, so the applications are fairly simple. I just got an Art Matters grant, and with them the priority is your work, not an elaborate proposal. I just recently got a Little Tokyo Trust grant for $5,000 to do a project related to the commemoration of the Japanese-American internment, a theme I was already working on, and I wrote a conceptual proposal for that.

And then there are the public art projects. . . .

Would you describe your approach for them?

With them, you start with the initial proposal describing your idea or you show images of past work. If you are chosen as one of the finalists, you do elaborate plans, models, and drawings to show your proposal in detail. Your original conceptual proposal serves as a framework for those plans, which of course must be much more involved and complete.

For public art projects, I highly recommend to not think you can do it yourself. It is a misleading and frustrating experience if you are not trained in the field. The reason why we had substantial models for the proposals was because I collaborated with someone who was an architect. Not to say that you couldn't come up with an incredible idea, but to actualize and argue your idea through the entire bureacracy and be convincing and be respected, you really need support, you need to know this is a team effort. For example, in one project we have to work with state architects, and it was very difficult to argue with them for the added cost, time, or skill it may take to make something relevant and aesthetic, in addition to functional.

These public art projects can be like balls-and-chains on your ankles. You are bound to these things until they're done. Two projects are in their third year and they are still in my face 100 percent. There are approvals, plan checks, engineers, and a million different bodies that have to review things. For one of them, our proposal was chosen over three years ago, but because the supervisors of the district want to make some radical changes to the site, I have had to present this proposal over and over again to the community and to the supervisors!

(continued)

(continued from previous page)

Are you still interested in working in the public realm?

Yes, with a certain proper pacing. It is something I am attracted to, but to a point. Public art has made me realize the range of audience and the range of means and scale of the built environment that we can operate in, versus these enclosed, institutionalized, very elite spaces of the art world. The external projects for the public are good complements for my very personal installation work.

Chapter 7

PROPOSAL PACKETS

After having researched established art venues, and having prepared your resume, artist statement and visual documentation, you are ready to send packets to inform art professionals about your work. The following items constitute an adequate description of your work, and would be included in an average packet:

Cover letter

Resume

Visual documentation

Artist statement or concept statement

Copies of reviews of past exhibits, if any

COVER LETTERS

The cover letter in your packet introduces you. It is your chance to "talk to" a certain curator or dealer in a direct way. Your letter should clearly state what you want, present you in the best light and highlight your achievements. The first paragraph can be quite short, perhaps one or two sentences, and should explain why you are writing. For example, you are requesting funding for a project, or you would like your work to be considered for future exhibitions at that site.

In the paragraphs that follow, summarize the content of your work and its physical attributes, such as size and medium. If applicable, describe qualitative attributes, such as mood conveyed or audiences' reactions to your work.

Then your letter should explain why you are approaching this particular site for an exhibition. Possible reasons include:

Recommendation ("So-and-so recommended I write to you")

Reputation ("Because your gallery is known for showing video work . . .")

Past Exhibitions ("I was very impressed with your recent exhibit of Chicano painters . . .")

Location ("I have a body of work that I want to show in the area where your center is located.")

3398 Schuylkill Road
Ardmore, Pennsylvania 19167

12 July 1995

Levering Stern, Director
Helen Warrent Gallery
3235 North Locust Drive
Seattle, Washington 98104

Dear Mr. Stern:

Please review the enclosed slides and written material. I would appreciate your considering my work in a future exhibition at your gallery.

For the past few years, I have been working on human-scale sculptures that deal with issues of body and modern medicine. While this topic could conceivably be very emotional or sensational, I have chosen to focus instead on the increased reliance on machines to augment or sustain the human body. I am interested in reflecting the odd inventiveness of the medical world that hybridizes the body with artificial hearts, joints, and prosthetics. Thus, my sculptures combine organic-looking elements with mechanical devices, some medically authentic and others taken from engines, home appliances, or other such objects. I showed my work a few months ago at the Mazon-Winter Gallery in Houston. Viewers found it to be fantastic, playful, absurd or chillingly real, all of which are readings that I want the work to have.

The critic Hugh Medton recommended that I send slides to you because of the gallery's reputation for figurative sculpture. If you are interested in my work, I would be happy to discuss it with you when I will be in Seattle at the end of September. Also, if you are ever in the Philadelphia area, please consider making a studio visit to see the work in person. My studio telephone number is (215) 555-5555 or you can reach me at home in the evening at (215) 555-5556.

If you wish any more materials or have any questions, please call, or I will be calling at the end of July to make sure you have received this packet. I am looking forward to hearing your reaction to my work. Thank you.

Sincerely,

Lani Chodeesingh

FIGURE 7.1
Sample cover letter

When you know the location and history of the space and its operators, or have a particular reason for approaching them, you are much more likely to be successful with them. Avoid writing generic cover letters that sound as if they could have been sent to anyone, and in all likelihood were. Then you appear to be taking the shotgun approach to getting a show, blanketing the city by sending packets to every exhibition space possible while putting in the least amount of effort in the process. While this might be efficient, your cover letter must give a better impression.

If they are relevant, highlight your major accomplishments, such as video festivals in which you have participated, collections of which you are part, or awards or grants you have received.

Request a meeting with the dealers, curators, or exhibition coordinators to further discuss your work. Urge them to retain the visual documentation for future consideration. For alternative spaces, request they add your slides to their slide registry if there is one. Also ask to be considered for an appropriate group exhibit, or to be sent a prospectus for any future open or juried exhibitions.

Conclude your letter with your telephone number and the best time to reach you. Inform them that you will make a follow-up telephone call in one or two weeks, and then do so, to find out if they have received the packet, if they have any questions, or if they would like to see more work. Close your letter by thanking the arts professional.

The conventional cover letter (Figure 7.1) is one page long, which should be sufficient if you are terse. Long, rambling letters simply irritate people. Use standard business letter format: your address and date at the top, followed by the name, title, and address of the person to whom you are writing. Use the person's name, not simply "Dear Curator," or "To whom it may concern," which indicates that you have no idea to whom you are writing nor any knowledge of the exhibition space. Of course, you should use "Mr." or "Ms." in the salutation, so check whether the art professional named "Jean," "Mallory," or "Pat" is a man or a woman. You will look bad if you guess wrong.

Most artists type or computer-output their letters to arts professionals, with clear dark type for legibility. There is no need for personal stationery; white bond with a 20 percent rag content is fine. If you use a word processor, then you only need to write your letter once, and then modify it for each place you send your packet. This represents a tremendous time savings over starting from scratch for each letter.

While the standard letter format works most often for most people, you may wish to vary it, doing something more florid, funky, or colorful. Or you may want to write handwritten notes, which seem less formal and more familiar. Then, you must consider style issues. Is your handwriting distinctive, legible, and mature-looking? What is the best way to present yourself to someone you do not know? The form, look, and details of your cover letter convey subtle hints about you and your work. It may be more worthwhile to devote time to content aspects of your packet rather than reinvent the form of a cover letter.

OTHER MATERIALS

Along with your cover letter, you need to send visual documentation of your work. Video artists should send VHS *videotapes* of their work. Performance artists should also send VHS video documentation and slides. Most artists doing traditional visual work should send eight to twenty 35mm *slides* of artwork; ten usually gives sufficient indication of your work. Sometimes book artists and installation artists also use video documentation to show how the viewer progresses through the work. For more information on the particular problems of artists working in computers and new technologies, see the artist interview with Paul Berger at the end of this chapter.

Make your visual documentation well-focused. If you include too many works or too many series, you merely confuse the person trying to grasp the concepts behind your work. Do not show work that is unfinished, already sold, or totally different from your current work.

Your slides should be high quality and properly labeled. They should be presented in a fresh archival plastic sheet, with your name and address on the edge if the work is to be added to a slide registry. Do not send loose slides or slides in small boxes, where they cannot be easily seen.

Include in your packet copies of your *resume* and *artist statement*. If you have any, include copies of past *reviews* and *articles* about your work with the name of the publication, volume number, date, and page typed at the bottom. All copied material should be clear and easily readable. Also enclose a *self-addressed, stamped envelope* for the return of materials, because without that, many curators and gallery directors will simply discard the slides in which they are not interested.

If you are proposing a project, include a *concept statement*, and a one-page summary that covers the following points:

The name of the project

The medium/media and size

Proposed dates of exhibition

Time frame for the creation of the work

Amount needed, if you are asking for funding

Save more detailed descriptions and complete budget breakdown until someone has expressed interest and wants to see more.

The presentation of your packet is important. All material should be enclosed in a folder or envelope, or clipped together. Little bits of things should not fall out when someone looks through your material. As long as you are collecting all this material, prepare several packets at once, enough to send to several established art venues.

Before sending a packet, call the art venues first to find out if they are reviewing work, if there is any particular time when they would prefer to receive packets, and any special materials they want. Sometimes commercial

galleries will refuse to review any packets at all, because they cannot take on another artist. If you feel very strongly that your work would be of great interest to them, you might send one anyway. They may look at the slides, or they may return the packet unopened.

Over the next several weeks, you might receive several rejections before there is any positive response to your work, because there are many artists vying for few exhibition opportunities. And there are fewer still for emerging artists. You may find, however, that after your first positive response, the next comes more quickly, and the next even more quickly still. As you build your exhibition record, more opportunities present themselves than when you are just beginning.

Therefore, when a packet comes back with a negative response, do not become disheartened. Rewrite your cover letter and send the packet out to the next venue on your list. Keep your packets circulating, and you will find places to show your work. Remember also that a negative response from someone may merely mean "no for right now." If you think there is a possibility for a connection, then send a packet again in a year or two, when you have new work and have more entries on your resume.

MEETING WITH CURATORS, DEALERS, AND EXHIBITION COORDINATORS

When you receive a positive response to your packet, a curator, gallery director or exhibitions coordinator is interested in the materials you sent and wants to learn more about you and your work.

If you do traditional visual artwork, invite the art professionals to come for a studio visit. There, you can control the environment and set up your work as it would best be displayed. If you do not have a studio, try to borrow someone else's. If you work out of your home and have to show your work there, clear out a room for your work. Viewing artwork leaning against the living room sofa or the dinner table is distracting. A separate space, even within your home or apartment, gives a greater impression of professionalism. Offer your guests coffee or tea while they look at your work.

A less desirable alternative is taking your art to the art professionals where they work. You will not be able to take very large or very delicate pieces, are limited to showing fewer objects, and cannot set up the work to show it to its best advantage. You may have to crawl around the floor to spread out the work, putting you in an undignified position while talking to someone you wish to impress.

If you do performance, installations, or monumental-size artwork, or want to discuss a proposal for a future project, then you may be able to meet art professionals at a restaurant or art event, and the problems associated with showing work do not exist. Visuals are still very helpful, such as slides, working drawings or other documentation of past work.

Have an extra copy of your resume and statement and copies of any previous reviews handy, even if you have already sent this material to your visitors, because they may not have that material with them at the meeting. Also, have ready slides of other work which is not available at the moment, because the work is sold, on consignment, or being shown elsewhere. Be prepared to talk about personal motivation, content, and the technical issues associated with your work and your direction for the future. At this time, art professionals are interested in hearing you talk about your work rather than discussing items of business.

Studio visits usually last thirty minutes to an hour. At the end, your guests may want to show your work, may express the desire to visit again in six months or so, or indicate that they will not show the work at this time. Or the visit may end inconclusively from your point of view. Be sure to do whatever follow-up is required, whether delivering work now, sending more slides later, or simply writing a thank-you note expressing appreciation for the visit. Regardless of the outcome of the visit, keep in touch with them. Once even mildly interested, they are likely to remain interested in future work.

ALTERNATIVES TO SENDING PACKETS

You may want to try an alternative to the conventional packet sent to dealers and curators. Some artists seek other approaches because many galleries, alternative spaces, and museums receive several such packets a week, if not several a day.

Some artists hand-deliver their packets, and try to engage the dealer or curator in conversation at the time of delivery in order to distinguish their work from the mailed packets. This method may work if the art professional is there, unoccupied, and feels like talking. Otherwise, you may find that you spent a lot of time driving all over town, doing nothing more than the postal service does. Some artists call to set up an appointment, but in all likelihood, the curator or dealer will request that you send a packet for review before making an appointment. Other artists have brought the actual work into the gallery with them without an appointment, hoping to get the dealer's attention. You may be occasionally successful with this approach, but art professionals have experience in avoiding artists determined to see them.

Curators, gallery directors, and exhibitions coordinators might be more receptive to your work if they have met you first when you are not seeking a show. Attending art parties, events and receptions may put you in contact with these people, giving you a chance to become acquainted socially. Writing reviews for the art press (see Chapter 9) or curating group shows (see Chapter 10) gives you a chance to meet gallery directors under different circumstances.

The best alternative to sending packets to commercial galleries is to get recommendations from other artists who are already represented by that gallery. Many dealers pay a great deal of attention to the enthusiastic reports of artists they already know and respect. You can make yourself known to these artists by going to receptions for their shows, attending art events, becoming involved in organized activities around artist-sensitive issues, belonging to artist organizations, or participating in conferences or seminars where they are speaking. Put yourself forward and make yourself known to them.

Paul Berger
Photo courtesy of artist

ARTIST INTERVIEW: PAUL BERGER

Paul Berger's work deals with measurements, models, and notations as systems for structuring knowledge, including earlier series in photography and later computer-based work. He is a professor at the University of Washington at Seattle.

How does an artist develop and maintain a professional profile when the work is digital?

While slides are the standard when walking into a gallery, their equivalent in electronic imaging is not yet clear. You may not have a venue for seeing multimedia or purely digital work. There is not yet the digital equivalent to a 35mm slide projector. Even if the work is output on paper, it is no more inherently one kind of print than another kind of print. It is information, and the output is negotiable.

There are multiple standards for storing and displaying electronic work, and they are changing all the time. At the moment, Syquest drives and removable cartridges are relatively standard among service bureaus— places where you would get output done—but not necessarily

(continued)

Paul Berger. FACE-08. 1993 Iris Print on BFK paper, 24" X 30"
Photo courtesy of artist

(continued from previous page)

something a gallery would have. With floppy or optical disks you run into problems of format. You can always call ahead to avoid compatibility problems.

One needs multiple storage of one's work, if it is purely digital. It is worth having a couple of different copies in different formats and forms, as well as traditional slides if you are producing something that can be seen outside the computer.

So computer artists who output their work to hard copy can present it with slides, like artists who use traditional media?

Yes. But every form of documentation is a flawed representation. In reality, people usually view slides by holding them up to fluorescent lights or to their desk lamps. The number of times that artists' slides are projected in a carefully darkened room is actually fairly rare. Video is problematic, too, for representing flat static work. You can't be sure that someone will have a video system set up and plugged in to

(continued)

(continued from previous page)

see the work. And because video resolution is so low, you are not going to get a sense of the detail that exists. For traditional media, we will be seeing a transition period from the standard slide presentation of work to some electronic version.

For a purely digital work, you run into an interesting set of problems when you use electronic media rather than slides to present your work. Like videotape and slides, will you have a good presentation system available to the person reviewing the work? Can you count on a curator or dealer having the platform and program to read your file? Of course, the way the industry is going, we are probably looking at a time frame fairly soon when there will be a platform-free standard whereby you could show some relatively high-resolution, if not "final," versions of your image. But once that happens, there is the strange paradox in giving someone digital work to review, because you have essentially given them the work itself. Once they have the encoded color and resolution of the image, that is it. They have it as much as you do. Not to say that they would sell it or give it to someone else, but you have given them the work itself.

Right now, many software companies are working with ways that you can download and review their new programs, to try out an essentially functional program but with some crippling limitations. If you like the program, you pay for a secret number that gives you a complete working copy and documentation. Or you might get a version that works only for a certain amount of time, like three weeks, just long enough for you to try it. In the same way, say, the Washington State Arts Commission, which has an artists' slide bank that people can consult, could have an electronic version that could be downloaded by category or whatever. For interactive pieces, there could be demo versions that people could review, or other ways you can get a sense of the program without giving you the program, or for still images, ways to show the work without having given it away.

You mentioned that artists working even in traditional media are beginning to move to digital media when making proposals for showing their work.

Oh, absolutely. You can have digital copies of your work made and show them in ten minutes. Presentation software can be used to develop, say, five different prepackaged presentations of your work. Of

(continued)

(continued from previous page)

course, you have to deal with both the advantages and inherent difficulties of temporal-based presentations. You have to art-direct the presentation of the work—zooming in, sequencing, voice-over. But you have much more control than simply labelling slides one through twenty and hoping that people will look at the slides in order, instead of just holding them up to a light and looking at whatever catches their eye.

Artists can already do this with video. I've seen tapes of artists applying for jobs or showing their work. But the culture already has sets of traditions and expectation levels for this media, and a really bad videotape may give you a worse opinion of an artist than if you had merely seen slides.

What visual documentation for interactive pieces should be included in proposal packets?

Some interactive pieces use existing software that runs on standard equipment. For these pieces, you can send something very close to the actual work.

On the other hand, some computer-based interactive pieces are very unique objects, with complex machinery electronically driven, that demand that you are really in their presence. The interactivity is both body-based and conceptual. These are essentially sculptural pieces even though they are electronic. You need some standard camera documentation, either stills or videotape, to suggest what it is like as the viewer physically encounters these pieces.

When artists who do interactive pieces write proposals for showing their work, do they have to deal not only with the merits of their work, but also with equipment issues?

Yes, but there is a big range within that. For works using standard equipment and software, you merely specify the IBM or Mac platform. At the other end, for the more sculptural electronic pieces, the artist will have to provide the platform and any other specific objects.

Should artists making exhibition proposals consider asking computer manufacturing companies to lend equipment for a one- or two-month exhibition, in cases when the space does not have computers and the artists do not want to lend their own? Will the companies see this as a PR opportunity?

(continued)

(continued from previous page)

I think that is a lot harder now than in 1989 when the computer manufacturers were making tons of money. But I think there is a second tier that is a good source for asking. For example, there are a lot of small companies in CD production that have that equipment. They might be interested in helping with a certain kind of project if there is some sort of trade-off or collaboration possible.

But the wave right now is networks and big servers. Seeing a work is no longer necessarily tied to your physical presence with it. Artists could perhaps find creative ways to piggyback off someone else's server or use it in off-hours, to dish out information to other places for short periods of time. For example, you could simultaneously send your work over a network to terminals in several alternative spaces.

So the field is really open in terms of computer-based artwork and digital documentation.

A lot of artists are beginning to investigate the operating structures and factors in the delivery of information on the computer. With cinema and photography these things are worked out, but for the computer these conventions for communication are still very open, and that is why so many people are interested in interface design. Are there other ways we don't know about yet? It is a perfect thing for artists to plunge into—it is still possible to do almost first-generation work because there is really not very much yet for comparison.

Because computer-based work is still relatively new, you may have to be a little more nimble and maybe have to do more reading, because linkages and conceptual breakthroughs could pop up in very strange places for strange reasons. People get hung up about having the latest equipment, but computer speed is not really the major consideration. People need to think a little more about what this machine lets them do. Think about doing the wrong thing, in the broadest sense. How else can you use these things or put things together in odd ways? What is possible?

Chapter 8

WHAT TO EXPECT FROM PLACES SHOWING YOUR WORK

After sending out many slide packets, your hard work has paid off. A gallery, alternative space, or institution has expressed interest in showing your work. This chapter covers what you might expect in ideal circumstances from galleries and institutions, and also what to expect in the less-than-ideal, "real world" circumstances.

Exhibitions at alternative spaces, college galleries, and museums are generally one-time-only opportunities at each institution. A second or third show at the same place will come only after a good span of time has passed. Showing in these spaces does not involve the potential for building a long-term business relationship, and is therefore fundamentally different from the commercial gallery show that may represent the first step toward the gallery handling your work on an ongoing basis.

This chapter covers first the concerns for the artist showing at alternative and institutional spaces. Discussed later are your first show with a commercial gallery and what to expect in subsequent association with them.

ALTERNATIVE SPACES

Your experience at an alternative space may be hard to predict, because different alternative spaces vary in funding, in gallery conditions, and in staff support. Some spaces provide an entire range of support for the artist, including designing, printing and mailing announcements, hanging the show, preparing advance publicity and press releases, shipping work, and in some cases even paying a stipend to the artist for showing the work. Such spaces tend to be well-staffed, and their galleries in good condition. Some alternative spaces support a variety of cultural arts in addition to the visual arts, with numerous activities occurring each month, bringing in many people. They may publish newsletters that feature the current exhibition and events. On the other hand, other alternative spaces have very little money, a small staff, and thus provide fewer services and fewer programs.

Before showing at an alternative space, you and the staff person should work out all details in the following areas, deciding what is to be done and who is responsible for doing it:

Exhibition and performance dates

Exhibition installation and rehearsal times

Publicity

Equipment and/or technical support

Expenses, such as shipping, reception costs, insurance, and announcements (designing, printing, and mailing)

Stipends or honoraria for artists, commissions retained by the space for sold work

Try to negotiate with the exhibitions coordinator if you are not getting the deal you would like. Once you have settled on all points, ask for a contract, or at least a letter of confirmation, which most alternative spaces will readily provide. If not, write a letter to the exhibitions, video, or performance coordinator spelling out the agreement as you understand it, and ask for confirmation.

Commissions charged by alternative spaces may vary from nothing to 50 percent. Remember, though, that if you have an exclusivity agreement with a commercial gallery (see below), the gallery may also take a commission on works sold outside its space, usually between 20 and 40 percent.

Most alternative spaces have a very liberal policy about artwork shown, and will make no attempt to limit the content. However, the survival of some alternative spaces may be dependent upon funding from the government, businesses, or a special interest group. Therefore, tell the space's staff what your work in their space will be, especially if it is likely to be controversial. If they have a chance to prepare their backers and instruct them on the overall content of your work, the backers are less likely to dispute the work or withdraw support.

COLLEGE GALLERIES

While exhibitions at college galleries almost always serve a pedagogical function, the college galleries themselves vary tremendously in the funding, staffing, and artist support they provide. One may be simply a space with no gallery attendant and no insurance for your work. The walls may need patching and painting. The artist may have to do all the work and cover all expenses. Another may have a first-rate, well-maintained space, and may provide an announcement, mailing, press releases, publicity, delivery of artwork, hanging, and reception for the artist. When showing at a college gallery, you must work out all the details with the person in charge. Use the checklist above. College galleries often request a minimal commission on sold works, usually 10 to 20 percent. Also, inquire about

the hours of the gallery, as some spaces are open on a very irregular schedule, depending upon student help. Some institutions will send letters of intent to exhibiting artists. For those that do not, write a letter to the staff recapping your agreement, specifying the date of the show, the general theme or content of work to be exhibited, and the technical, financial, and staff support that you understand the school will be providing. Ask for confirmation in response.

Inquire about other obligations associated with your exhibition. Sometimes artists are asked to conduct educational talks or workshops. While college galleries usually do not provide a stipend to the artist for exhibiting, they should pay you an honorarium for a talk or workshop.

MUSEUMS AND MUNICIPAL GALLERIES

Museum and municipal gallery shows usually provide the most services and represent the least cost to artists. Whether large or small, these spaces usually handle all press, invitations, shipping, and installing work. Neither space regularly provides artist stipends, but museums may purchase one piece from the show for their permanent collections. Sometimes museums will commission a new work to be made based on a detailed proposal submitted by the artist, in which case the artist is paid for the work when completed. Because they are the least experimental type of art venue, these spaces usually show work that has been shown elsewhere before, and is selected for this exhibit through slides or studio visits. The artist does not have the final decision about what work is included and the way the work is displayed. Many museum curators, however, are very willing to work with artists so that all parties are satisfied.

The artist may be asked to participate in extra programming, for example, in artist talks, seminars, or panel discussions. Artists should be paid an honorarium for such events.

Museums and municipal galleries will provide contracts or letters of intent spelling out the details of the agreement. Because they plan so far in advance, they want their schedule locked in and all details ironed out.

BUSINESSES AND COMMUNITY CENTERS

With no exhibition staff and rarely any budget for exhibitions, these spaces provide few services to those who show there. Artists often must do almost all the work for shows in these spaces, including writing press releases, designing and mailing announcements, hanging the show, and providing for a reception. See Chapter 4 for information about putting together such an exhibition. There are some exceptions to this: A few community centers have exhibition staffs and budgets, and a few large corporations maintain a gallery staff. Inquire before committing to an exhibition.

COMMERCIAL GALLERIES

The dealings between artists and commercial galleries are full of unwritten customs and codes of behavior, which will be discussed in this section. First, however, artists need to be aware that, like other business affairs, there are laws regulating some aspects of artist-gallery relationship in Alaska, Arizona, Arkansas, California, Colorado, Idaho, Illinois, Iowa, Kentucky, Massachusetts, Minnesota, Missouri, Montana, New Hampshire, New Jersey, Ohio, Oregon, Pennsylvania, Tennessee, Washington, and Wisconsin. Called Artist-Dealer Relations Laws, they regulate consignment, which is the delivery of artwork to a dealer who will pay artists only for what works sell, and who may return what is unsold. The following points are covered in most of the states' laws:

- The artist retains ownership of works on consignment, despite the fact that they are in the dealer's possession and the dealer has the right to sell them.
- The dealer is responsible for all loss or damage to the artwork while on consignment.
- Artists receive their share of the proceeds of a consignment sale first, before the dealer receives any monies, unless the artist otherwise agrees in writing.
- Artwork left on consignment cannot be claimed by creditors in the case of the dealer's bankruptcy.

In addition approximately twenty-four states have Fine Print Acts, which require artists, dealers, and auctioneers to disclose the status of limited editions, including a print, photograph, or sculpture cast, to protect the purchaser of artwork. Thus, it is illegal for anyone to sell a print at a certain price based on a misrepresentation of its rarity. California is the only state with a Resale Royalty Act, which legislates that artists should receive 5 percent of the sale price when their work is resold for $1,000 or more. Resale royalty legislation is more common in Europe.

While this summarizes existing state laws on the artist-gallery relationship, the unwritten conventions and customs in the art world are more complex and even more important. All commercial galleries are not alike. Well-established galleries operate differently and relate differently to artists than do new, experimental, or underfunded galleries. In addition, your early shows with a gallery are like a trial period, and the customs and expectations of that period change when artists become "represented" by a gallery, or develop a long-term relationship with the space.

First Shows at Commercial Galleries

If you are offered a show at a well-established commercial gallery, the following is likely to be what you will encounter. Generally, well-established commercial galleries are financially sound, have contact with prominent critics and

curators, show the work of recognized artists, and have a number of collectors who make regular purchases.

Your first exposure in a well-established commercial gallery will probably be in a group exhibition, usually during the summer or December holiday "off" seasons. You can expect that the dealer will pay for all exhibition, publicity, and reception costs. The well-established gallery should generate all publicity for shows, including writing and sending press releases, making follow-up calls to the press, and paying for the printing and mailing of well-designed exhibition announcements. The gallery should carry insurance covering all work on its premises. The dealer sets the retail price of your work, and has control over how your work is presented, where it is hung in the gallery, and what other work is next to it, although often artists can make suggestions on these points. Usually, the artist receives 50 percent for all work sold through the gallery, while the gallery retains 50 percent for its profit and to cover its expenses and overhead. Galleries should remit to artists their percentage of sales once a month, so you should expect to be paid for sold work within thirty days. Artists should be paid in full for all installment sales before the gallery receives its cut. The dealer should inform you immediately of all sales and give you the name and address of collectors who purchase your work.

There is almost never a contract between artist and gallery on commissions, payments, and so on, because the relationship between the artist and the dealer is seen as being "sensitive," based on mutual admiration and trust. In fact, however, galleries more easily profit in situations where there is no contract. While artists would benefit from contracts, they rarely have the bargaining power to insist on them because there are too many artists vying for too few exhibition opportunities. Nevertheless, you and the dealer should review all of the above business matters and have at least a verbal understanding concerning commissions, insurance, timetables for payments, names of collectors, and so on, before any solo or group exhibition. Make sure you thoroughly but tactfully cover all points in conversation. After your conversations, if you feel there may still be some gray areas, send the dealer a letter explaining your understanding of these matters, and ask for confirmation. Be aware that you may encounter a peculiar stigma associated with the artist's being businesslike when dealing with galleries. You can be wrongfully labeled as "difficult," or caring more about business than art, when in fact you are only trying to take care of yourself. (See Chapter 15 for more on artist-dealer contracts.)

Although dealers at well-established galleries may be loath to sign contracts, they should agree to produce two written documents for you: 1) an end-of-the-year accounting of the sales of your work; and 2) a consignment agreement for all works left with the gallery. The end-of-the-year accounting may be simply the 1099 form prepared for tax purposes that lists the sum total of payments the artist received from the gallery that year. To develop this form, the galleries must review their records for all sold work. Therefore at this time, you might request a list of the titles and prices of each piece of yours that sold over the past year, if you want it.

FIGURE 8.1
The basic consignment form

The consignment agreement is your receipt proving that you lent work for a particular show, for a specified period of time, or until sold. Never leave a work with any gallery or exhibition space without receiving a consignment agreement for it. Consignment forms vary from gallery to gallery, but even the most brief should clearly identify each individual piece, listing title, media, size, date when the gallery received your work, and the agreed retail price (Figure 8.1). Such forms may also list information about the condition of the work, whether it is part of a series, and whether it is framed. All consignment forms should be signed by a representative of the gallery; some are signed by both the gallery and the artist. Some gallery consignment forms add other clauses about the period of consignment, insurance, slides,

SPRING LAMB
GALLERY

Name _____ Margaret Lazzari _____ Address _ 641 Ocean Park #4 _____
Telephone _ (213) 450-5750 _____ City, Zip _ Santa Monica, CA 90405 _
 Date _ June 8, 1990 _____

This letter is to confirm that the listed below was left on consignment withe Spring Lamb Gallery. All works on paper are framed unless otherwise stated. Any wall pieces must be wired. Retail prices are listed and the galery may reduce the retail price within 10% for selected collectors or institutions. The terms of this agreement are _50_ % Consignee; _50_ % Gallery which applies to art in clud- ing framing. If work is purchased with a Master Card, Visa or American Express, it is agreed that the merchant charge rate will be taken off the top and then profit split according to the terms above. Artist may receive names of collectors from Gallery with the understanding that the artist will con- tact the collector only with Gallery approval and any sales to that collector will follwo the terms of this agreement.

Description/Title				Retail	Date RTD/Paid,	check # amount
Profile VII 1990 M/M 32x22						
Woman's Head X 1990 32x22						
Neck 1990 M/M 32/22						
Anguished III 1990 M/M 32x22						
Profile VI 1990 M/M 32x22						
Profile I 1990 M/M 32x22						
Anguished I 1990 M/M 32x22						
Male Head VIII 1990 32x22						
Physical Presence	60x44	1990	M/M	1800.00	returned	
Manipulated	60x44	1990	M/M	1800.00	?	
Sleeping	60x44	1989	M/M	1800.00	?	
Leo Series #2	60x44	1989	M/M	1800.00	?	

Record of Gallery Expenditures:
All Works Unframed

Spring Lamb Gallery Artist-Consignee

102 WEST THIRD STREET • DOWNTOWN LONG BEACH, CA 90802 • 213-432-2291

FIGURE 8.2
The consignment form with added clauses

expenses, discounts on the retail price, whether the artist or the gallery ab- sorbs the discount, and the artists' dealings with collectors (Figure 8.2). If there are clauses to which you do not agree, have them struck before sign- ing. (See Chapter 15 more on consignment forms.)

In addition to these business matters associated with your first shows at a well-established commercial gallery, you and the dealer should be critically ex- amining each other's "operations." The dealer is getting feedback to determine whether your work can be successfully marketed through this gallery, which is not necessarily the same as the dealer admiring your work. In addition, the dealer is becoming more familiar with your current work, the direction you are heading, and your general business habits. During and after these early shows,

the dealer should have a complete set of your slides, resume, statement, and copies of previous reviews, and should be showing your work to collectors and critics.

For your part, you should evaluate whether the dealer understands your work, presents it well to collectors, and talks intelligently or passionately about it. Does the dealer seem conscientious in all business matters? Is the gallery well-maintained? Does your work look good hung on its walls? Do you respect the other work shown by the gallery, or are you embarrassed by other shows at this space? Is your work shown at every opportunity, and not simply relegated to the back room? The dealer should be interested in your new work as you produce it and respond attentively either when you show slides or when you request a studio visit.

To ascertain this information and to communicate your interest in the gallery, you should make occasional visits and attend as many gallery events as you can. In frequent conversations, find out the dealer's own goals and aspirations, and discuss your ideas and new work. Try to get to know the dealer very well.

Opportunities for artists to show with well-established galleries are rare. Many artists deal with new, experimental, or underfunded commercial galleries. These galleries are just starting out, or may operate on a shoestring budget. They may be run by artists or art professionals who have little business background. New or experimental galleries frequently lack collectors, backers, or other sources of funding. While less-established galleries manage to survive in flush economic times, many are forced to close in periods like the recession-ridden early 1990s. In actuality most commercial galleries fall somewhere between the well-established gallery and the struggling gallery, experiencing some business hardship yet providing some services.

When showing with less-established commercial gallerys, artists may have to contribute toward or pay totally for printing and mailing the announcements. Artists may be asked to subsidize exhibition advertisements in art magazines. The gallery may not carry insurance on your work. Payments to artists for sold works could often be delayed for weeks or months. Although payment within thirty days may be the law in some states, often artists agree to wait for payment if the dealer asks. Less-established galleries might discount prices to buyers, and you may receive less per sold work than you had hoped. These galleries usually do not enter into contracts with artists.

However, you can expect certain things from any gallery, regardless of its circumstances. All galleries should give you consignment forms for every work left with them. All should handle your work with great care while it is in their trust. If and when returned, your work should be in the same condition as when you lent it. In addition, even if you grant a delay, you have the right to be paid for all work sold.

Artists have more bargaining power with less-established galleries than with the well-established gallery, so you can negotiate to your best advantage on retail prices for work, and style of exhibition and presentation of your work. Furthermore, if there are clauses on consignment forms you do not like,

you can more easily have them removed. The amount of clout you have with the dealer depends on your negotiating skills, whether your work sells, and how many other options you have for showing your work. Conversely, the fewer options you have and the more desperate for any show you are, the less maneuvering room you have in any negotiation.

As with the well-established gallery, you and the dealer must have at least a verbal understanding on all business matters. Although you will not likely have a contract, your discussions can spell out terms of commission, payment schedule, and expenses. A follow-up letter from you can confirm the points of agreement. These verbal agreements are more important here than with well-established galleries, because you need to know up front if you have to settle for less-than-ideal terms in order to exhibit at a particular space. Ultimately, you decide how much you can compromise in order to have a show.

Long-Term Relations

After the trial period, you may move toward a long-term relationship with a well-established gallery, sometimes called "representation," where you and the dealer commit to working together for a number of years. Bear in mind that only a minority of all of artists have this kind of arrangement with a gallery. The exact terms of this representation can vary tremendously.

In long-term artist/gallery relationships, the artist generally grants the gallery some degree of exclusivity, making the gallery sole agent for the artist in some specified area. With exclusivity, the artist sells work only through that one gallery, not through any other and not directly from the studio. Exclusivity has definite geographic boundaries; thus, the gallery becomes the only outlet for the artist's work in the metropolitan area, the region, the nation, or in the world. This arrangement is advantageous to the gallery when an artist's work sells well. But exclusivity is a point of great concern to artists entering a long-term relationship with a gallery, because it limits other potential outlets for the work. In addition to discussing the geographic limits of exclusivity, the artist and dealer should specify exactly what each means by exclusivity. Some dealers are very loose, encouraging artists to show work at every available opportunity, and merely request with exclusivity that the artist notify the dealer of all exhibits outside the gallery. Other dealers are very restrictive with exclusivity, deciding for the artists if they can show elsewhere and severely restricting the artists' exposure. With exclusivity, the dealer can claim a commission on the work the artist shows and sells elsewhere. This applies whether that sale was made within the area of exclusivity while being exhibited with the dealer's permission, or outside the area of exclusivity. Usually, such a commission is less than that taken for work sold within the gallery.

In exchange for exclusivity, the dealer agrees to give the artist regular solo exhibitions, usually one every eighteen to thirty-six months, depending upon the artist's rate of output. The dealer also agrees to invest extra energy and funding into the artist's career. Thus, the gallery on occasion may publish a

color catalog of work from the artist's show, an important tool for attracting collectors and for interesting museum curators. The dealer should also promote the artist's work energetically and actively to collectors, critics, and museums and make contacts for the artist for shows with prominent galleries in other cities. The gallery should maintain complete documentation of the artist's work, with a complete slide set and all written material, including resume, statements and reviews, and should duplicate and mail complete packets whenever necessary to further the artist's career. The dealer also may try to "place" the artist's work with prominent collectors, rather than simply sell the work to anyone off the street. Thus, the best work should be reserved for important collections. With exclusivity, the dealer sometimes agrees to pay for some expenses that artists usually bear, such as framing, crating, and shipping costs. Commissions may remain the same whether you and the gallery have a long-term agreement or not.

All of the above points are negotiable, especially the area of exclusivity, frequency of solo exhibits, commissions, and covered expenses. Artists who sell more and who have other exhibition opportunities can ask for more concessions from the gallery, while those with limited sales and limited connections with critics and curators have little or no bargaining power. Many artists and galleries do not enter into contracts concerning their long-term relationship, again because of the belief that the underlying personal relationship and understanding would only be spoiled by a written contract. However, artists benefit when such a complex set of agreements is set down in a contract (see Chapter 15). Even without a contract, the artist and dealer must thoroughly cover and agree verbally on the points of their long-term relationship. Finally, the artist and dealer should establish the length of time for which this agreement is in force.

The artist-gallery relationship is a business partnership with the purpose of selling artwork. With money involved, the artist and the dealer must trust each other, keep good records, and be honest with each other in their business dealings. However, it is also a personal relationship between the artist and the dealer based on mutual artistic respect and perhaps also friendship. The dealer is entrusted with the important role of presenting the artist's work to the public, curators, collectors and the press. The artist's and dealer's success are interdependent; for one to prosper, both must do well. The dealer should be genuinely enthusiastic about the artwork, confident in the artist's worth, and able to convince curators, critics, and collectors of its importance. The dealer should understand the conceptual basis of the work and appreciate its finished form. Artists should respect the dealer's artistic taste, selling ability, and business acumen. Artists should honor the exclusivity agreement and inform the dealer of all activities outside the area of exclusivity. They should keep good records of all sales and consigned work and remain vigilant on all business matters. It is not unknown for even the most prominent galleries to experience cash shortages, and to pass the squeeze on to the artist by deferring payments or backing down on points of agreement.

Less-established galleries cannot offer artists the same benefits of a long-term relationship or representation. The lifespans of less-established galleries are too uncertain, their funding too shaky, and their relation with critics and curators too tenuous to make an extended commitment to furthering an artist's career. Many galleries do not expect more than the most basic exclusivity with artists, specifically, that you not show at another gallery in the immediate area while also showing with them, and that you keep them informed of your other exhibits. Hard-pressed for income, they will not reserve your best pieces in order to place them with important collectors. Often they are in no position to refuse any sales at all.

For your part, you should try to help the emerging dealer, making alliances there just as you would with emerging artists. Use whatever connections you have with press, museum personnel, or collectors to help establish the gallery and build its base of support. Keep your dealer informed of other shows and sales you have. If your work is showing and doing well in other regions, the gallery dealer may be more enthusiastic about your work, and perhaps better able to sell it to collectors.

You may think that artists deal on a long-term basis with less-established galleries simply because they have no other exhibition opportunities. However, there are many reasons on the positive side. The new, underfunded, and experimental galleries take more chances with artists, showing exciting, unusual, cutting-edge works that established galleries may avoid. Also, artists often develop great friendships with struggling dealers, admire their vision, have faith in them for the long haul and actually want to work with them. The personal relationship between artist and dealer may be very important. In these situations, the artist and dealer enjoy a more equal partnership, unlike at the well-established gallery, where the dealer is more likely to be controlling or perhaps even dictatorial. Also, with less-established galleries, artists avoid the restrictions of long-term commitments. They can negotiate a favorable exclusivity agreement, or avoid it altogether, and thus be free to approach anyone they wish about showing their work. They do not have to produce a consistent body of marketable work, but have greater flexibility and room to change without encountering the strong disapproval of a dealer who only wants to see work like that which has sold in the past.

Artists need ways to evaluate their experiences with less-established galleries to decide whether to continue a business relationship with them. First, keep excellent records of your dealings with the gallery, retaining consignment forms, copies of correspondence, and check stubs from work sold. Second, make frequent visits to the gallery. Check on the status of your work, its physical condition, whether the dealer is making efforts to show it or whether it is sold. One tactful way to check your art without appearing suspicious or offending the dealer is to bring in some new work to replace pieces the gallery has had for a while. The dealer will then indicate what work is already sold or will be retained because there is a potential buyer. Finally, insist on timely payment after a sale. If you are not being paid for work sold, negotiate for time

payments so you receive a percentage due per month. You are doing no one a favor when you let the gallery fall behind on payments for too many months. If you are not being paid, then probably other artists are not either and the gallery may quickly fall deeply into debt. While you might agree to deferred payments, you will likely resent never getting paid at all. You will have invested a lot of time and money, your best work will be gone, and you may never get anything for it!

Most gallery cash shortages are due to well-meaning but overextended dealers. However, there have been a few cases of dishonest dealers, both at well-established and less-established galleries, who have sold and sometimes double-sold works and never paid artists. A few dealers have stiffed both artists and collectors, kept all proceeds and closed down or skipped town. These situations are rare, but they represent another reason why you should be diligent in business matters when dealing with any commercial gallery. In a relatively short amount of time, you will be able to discriminate between the dishonest dealer and the one who is merely overextended.

Werner Hoeflich
Photo by Susan Unterberg

ARTIST INTERVIEW: WERNER HOEFLICH

Werner Hoeflich is a painter who lives in New York City. He has shown his work in galleries in New York and Los Angeles. His interview covers various aspects of an artist's relationship with commercial galleries.

You show with galleries, but you still do a lot of self-promotion, don't you?

Yes, I do. It's a mistake for any artist to think that once they get a gallery, the gallery's going to take care of everything. Showing through a gallery makes it easier to sell paintings and keep your prices going up, there's no two ways about it. But to me, a good gallery relationship is one in which you can work hand in hand with the gallery, and that means you continue to help promote yourself. I enjoy showing my work and I enjoy talking about it because it helps me as an artist, although that's not something I've always felt comfortable with. If the gallery can bring people into my studio, I can take it from there. And if I can sell a painting, I can keep on painting.

(continued)

Werner Hoeflich. Totems. 1993
Oil on linen, 66" X 48"
Photo by Jean Vong

(continued from previous page)

How did you get to be associated with galleries?

If you are able to connect with a gallery when it first opens, there is a better chance of being taken on. This is the way I've seen most artists become associated with galleries, and is what happened with my first two New York galleries. Once the gallery establishes itself, they are not looking for artists the way they were initially. They may start you out in a group show with their "stable" of artists and then possibly a solo show.

With my second New York gallery, I was introduced to the owner at her first opening through a friend. Then she came to my studio at a time when my work was going very well, and we had a great visit. She was very responsive to the work. After a month, the gallery director came

(continued)

(continued from previous page)

over, and I knew I had made a good impression, but several weeks passed before anything happened. Finally I was asked to be in a group show. The response was good, so after that she offered me a solo show.

As time passes and new pressures come on, the galleries cut some artists, and others are brought in to round out the original roster. Even after artists get solo exhibitions for one or two years, if the gallery owner feels that maybe their work isn't going anywhere, or they aren't excited by it, or they feel the artist isn't spending enough time in the studio, they may stop showing that artist or pass on the work for a while.

What has been your experience with written agreements with galleries?

The Los Angeles gallery I work with is very professional. You get written information from them laying out exactly what is expected of you and what they will provide, when work should be delivered, and who will pay for what. I really enjoy that. If they sell a piece of your work and they receive full or partial payment, the check is in the mail to you on the first or fifteenth of the month.

The New York galleries I've shown with haven't been quite like that. But among galleries there is a kind of understanding about who pays for what. The ones I have worked with in New York have all paid for standard things like the opening and the mailing, but there are idiosyncracies, such as who pays for photographing your work. Some New York galleries do not operate on that level. The artists are expected to pay for much more, and sometimes there are real complications. What I liked about the Los Angeles gallery was that it was all written out, and it just made things easier.

How did you know what you were going to encounter with galleries without written information?

You talk to your friends who have shown there, or you talk to the gallery directly.

You know, most artists desperately want to show and it puts the galleries in a very powerful position. This creates a situation in which artists can be taken advantage of very easily. Given that, artists have to make the gallery deal with them on the up and up and vice versa. An

(continued)

(continued from previous page)

artist needs to be straightforward, and the more you ask questions and keep the mystery out of things, the better relationship with the gallery. And if the gallery can't handle that, then my feeling is that you really don't want to be showing there.

How can artists pursue galleries where they are interested in showing?

Well, I have been pursuing a gallery in Oregon for the last four years. I first got introduced to the gallery director through a friend who had a studio next to mine, and has done well with them. Later, when I was back in Oregon visiting family, I went to the gallery and liked their aesthetic and the way they did shows. So after that, when the gallery director was back visiting my friend, I would say hello if I was around, and if the opportunity presented itself I would get him to look at my work which was right next door. I've sent them my slides every year and my friend who shows with them always puts in a good word for me. They took a few pieces a year and a half ago, so I feel things are slowly developing and I try to be patient.

Whenever I am back in Oregon, I stop in and spend some time to try to establish a personal and professional relationship with the gallery director. Once we just talked about art in general, which is very important. You have to see if you are in sync with the thinking of the gallery. You may be a realist, and they may be showing all conceptualists, but if you are a conceptual realist, then you are going to fit in.

So you are not looking so much for superficial likenesses as a similar basic philosophy?

Exactly. A gallery has to be able to convey what your artwork is about, because that is a very big part of selling artwork. Major art dealers are incredibly intelligent and incredibly well-spoken about their artists. They have to represent you articulately, or they have to be able to bring people into your studio so you can present yourself articulately. This is as important as the work itself sometimes to make a sale, so it can't be underestimated. To have this kind of relationship with a gallery, you have to be in sync with them.

(continued)

(continued from previous page)

So it really is important for an artist to be discriminating in selecting galleries.

Yes of course. Artists may not appear to be in positions of power. But from my experience, I've seen so many galleries come and go, and even a whole gallery district in New York City come and go, that I finally realized I have as much or more staying power as a lot of galleries. Artists make art, and because of that, have more power than they think they do. It is just not necessarily immediate power.

Whatever you do as an artist relative to promotion, you have to feel comfortable with it. This lets you pursue your career in a way that has personal integrity. Otherwise you come off as someone really hungry, and people sense it and don't respond to it. You have to put in the time to get to know the people involved with galleries. Over a couple of years, you will find people in the art world you really like and can work with.

Do you have an income-producing job, even though you show your work with galleries?

Yes, I work freelance a couple nights a week for caterers to supplement my income. I'm making approximately half my living with my artwork now.

A pragmatic piece of advice I would give would be to learn some skill or job that will allow you to have some time on your hands— one you can tolerate doing both on a daily basis and in terms of years. I think it really takes a long time to become a good artist. I've been in New York fourteen years, and I feel like I'm just hitting my stride. That job or skill is going to take pressure off your having to "make it overnight" which I'm not sure I even believe in.

SECTION THREE

Positions of Power

Many artists occasionally take on the role of art professionals, even as they continue their artwork. They write for the art press, curate, or operate art spaces in order to influence the kinds of work shown and the discussion of related ideas. These activities are all within the capabilities of emerging artists. While they require time and energy, many artists see them as extensions of their art making. Then these activities become not distractions but important parts of their creative work.

The following chapters cover art writing, curating, and operating art spaces. They are presented in order of difficulty, with writing being the least time-consuming and least costly activity, and operating an art space as the most labor-, time-, and cost-intensive. Each section is intended to cover expenses and difficulties realistically in order that you will be well-informed before embarking on any of these activities.

Chapter 9

WRITING FOR THE ART PRESS

BENEFITS AND DISADVANTAGES

Many artists have written reviews and articles for the art press. Art writing requires sophistication; good writing skills, research skills, and a strong foundation in contemporary art criticism. Graduate-level education may be necessary to provide sufficient theoretical background. To build on that knowledge base, and to keep current on the development of ideas, writers should regularly read respected art magazines, or anthologies of particularly significant articles. When writing, you should be able to analyze a work of art, articulate its major themes, and evaluate how effectively those themes are communicated. You should be able to compare a piece to related work and place it within the larger cultural and social trends.

The major benefits of art writing are the following:

- The ability to influence the dialog surrounding art, to help shape opinions and to act as an advocate on particular issues.
- Increased visibility in the art community, access to dealers and curators, and contacts with exhibiting artists.
- Firsthand experience with dealers, curators, and staff, their particular interests, knowledge about contemporary art issues, and manner of dealing with the press. You can make better choices for a venue for your own work.

There are also drawbacks, difficulties, and potential pitfalls in writing for the art press. Some of them are listed below:

- Art writing is time-consuming, requiring attention and research. To gather sufficient information before you write, you need to study the work; talk to the curator, dealer, or artist; and/or read past reviews in an art library. You have to write at least two drafts of the article or review, and then perhaps revisions after the editor has seen it.
- Entry-level art writing does not pay well, usually ten to twenty cents per word, which generally does not cover the time and effort you expend. Some publications may not pay you at all.

- The art press is full of potential conflicts of interest. Two possible conflicts are: 1) As art writers, artists may be tempted to slant reviews in order to gain the favor of a particular dealer or curator; and 2) to meet expenses, art publications depend upon advertising from galleries in addition to subscriptions, unless they are supported by grant money. Some publications may review the shows of their advertisers more than the shows of nonadvertising galleries.
- A negative review may cause hard feelings toward the writer.

APPROACHING EDITORS

There are two kinds of art writing: 1) articles, and 2) reviews. Articles are longer pieces, requiring the writer to develop a thesis and use various works of art to "illustrate" the idea. Considerable research is often required for articles. Reviews are descriptions and evaluations of current art events. They usually are timely, short (400–700 words), easier to write than articles, and more often assigned to entry-level writers. Most publications pay fixed amounts for writing reviews, but compensation may be negotiated for longer articles or "think" pieces.

The following kinds of publications publish art reviews or articles. Some are exclusively devoted to art news, while others run an occasional art piece among their many other articles. The publications at the top of the list tend to have less prestige in the art world, while those at the bottom are more respected, with more writers competing to write for them. Opportunities for emerging writers can be quite common in low-profile publications, and almost nonexistent in high-profile ones.

University newspapers. These represent an opportunity for you to gain experience as an art writer while still a student. Your audience will be limited to the university community, and you will not be paid.

Neighborhood and community publications. These newspapers often cover art events in their areas. These publications offer definite possibilities for entry-level art writers. However, the pay may be minimal or nothing and the readership may be limited.

Urban weeklies. In large cities, these free papers often have a very wide following. Pay for writers varies, depending upon the health of the publication and its degree of interest in the arts. The best-known large metropolitan weeklies can be very high-profile and respected and are unlikely to use entry-level writers for their art writing. In mid-sized cities, weeklies using freelance writers represent opportunities for entry-level writers, while those using only regular writers do not.

Daily newspapers. These cover the arts as part of the area's cultural news. Writers' pay may range from respectable at papers with large circulations, to

very low at others. Entry-level writers may find opportunities in daily newspapers in smaller cities, but will likely be closed out by the competition if trying to write for the most prominent paper in the largest cities.

Regional art magazines. These magazines concentrate on art in a particular region, for example, the Southwest or the Midwest. Some also have limited national coverage. Most of these publications work with a regular set of writers. However, because of the number of articles and reviews they run, these publications often need new writers and will consider submissions from entry-level writers.

National art magazines. These are high-profile publications, often printed in full color. Despite their category, most of their coverage is not national, but limited to New York, and secondarily international, West Coast, or other major art centers. Their articles are by their regular writers and by prominent freelancers. While they will review unsolicited articles, they treat them as writing samples and almost never publish them. Because of their prestige and the competition to write for these publications, they rarely give writing assignments to entry-level writers.

Research some publications by reading them on a regular basis. Find a few you respect. Are your interests and writing style comparable to other articles published? Is your experience commensurate with those of other writers? Determine for yourself how important payment is, and whether the experience of writing will be sufficiently valuable to you if you are underpaid or not paid at all.

Select a few publications to approach. Try a range from high-profile to more accessible publications. If you know writers at particular publications, ask them to recommend you to the editors and call directly to inquire about the possibility of your writing for them. If not, find the editors' names and the publications' addresses and telephone numbers on the publications' mastheads. Send cover letters explaining your interest in writing and any past experience. Include copies of any past articles and your resume. You might also want to send an unpublished manuscript, an article or review, which you wrote specifically to attract the editor of a certain publication. The manuscript should fall within the publication's area of interest and match the approximate word length of its articles or reviews. Of course, presentation is important: Your material should be clean, legible, and well-organized.

If a publication is interested in your writing, the editor will probably assign you an art event to review. You will be given a word length for the piece, the number of images to be used, and a deadline. The editor will probably offer you a fixed compensation that is paid for all reviews of a certain length. Often your first assignment with a publication will be on speculation, meaning that your completed piece will be printed and you will be paid only if the editor deems the writing to be usable.

When you attend a performance or art event as a reviewer, identify yourself and the publication for which you are writing. If attending an event with paid

(continued from previous page)

You are not writing for art magazines now. Why?

I stopped writing when one magazine wanted to know in advance who I was going to cover that year, and the woman who was new in New York inadvertently told me that they were using it as a lever to get publicity. The mechanism of the art press is very perverse. They are really a form of sophisticated PR for the galleries that pay for them through advertisements. A good magazine is allowed to be creative and write about other galleries. But when economic times get tough, you see funny things like a "Spotlight on Galleries" section, which is basically advertising, and you see frequent reviews of shows at Gallery X, one of their regular advertisers.

Some publications that get grants are more independent. And I am still interested in writing for academic journals funded by schools for educational purposes and about theoretical issues.

What motivated you when you did write for art magazines?

I think that writing is a form of advocacy that is really important. I consider it necessary to have more than one front—writing, teaching, producing events, in addition to making artwork—to develop your ideas.

You know, no one has really made a better stance for themselves in the art world solely by art writing. It is just not true. As self-promotion, it just doesn't work! Those who continue to write are not doing it to give their career a great big boost, but because they are still involved in the issues through writing.

Chapter 10

CURATING

BENEFITS AND DISADVANTAGES

Curators create groupings of artworks or performances around provocative ideas, where the juxtaposition of works is thoughtful and powerful. While those who do it full-time are art professionals, some artists curate occasionally while they continue their artwork. The major benefits for artists who curate are the following:

- With curating, artists play a part in determining what artwork will be seen in the art community.
- Curating enables artists to make connections with other artists, writers, and art space directors.
- Curators have the opportunity to deal with potent issues and promote the work of others.
- Curating is valuable experience that can lead to a job as an art professional.

A curating project is long-term, probably requiring a year or more to develop an idea, find artists and find a venue. However, you can develop curatorial projects in the course of your regular professional activities, such as going to art events, reading magazines, or talking with art professionals and artists. It does not require intense, focused effort in the formative stage.

Curating does require sophisticated knowledge of art issues. A graduate-level education would be helpful professional background to curating. Curators also need to be aware of national trends and of recent events and exhibitions in the local art community. Curating involves communication. You have to be articulate, persuasive, and committed as you repeatedly present your idea to artists and to directors of art spaces. In large cities, you may face stiff competition from other artists and art professionals to curate exhibitions for certain spaces. Once a project gets off the ground, curating is time-intensive with studio visits and reviewing work. Attention, acumen, and difficult decision making are necessary as you cull through work. As you approach the opening, your time commitment will increase if you are involved in physically gathering and installing the work. Curating involves writing skills. You have to develop a curatorial proposal; you may write a catalog essay; and you may have

to organize or oversee publicity. And possibly you may have to deal with anxious, unreliable, argumentative, or uncooperative people. Curating also requires persistence to see a long-term project through to completion. The demands of curating can erode the time you spend in art making; you may not be able maintain your position and your level of production in both fields. If you have the disposition for this kind of work, however, curating can be important creative work for your career.

Given all those caveats, it is still important to remember that curating projects come in all sizes and in all degrees of complexity. To a great extent, the artist-curator can determine the amount of time and involvement required while formulating the project. For example, the interview with Louis Cameron following this chapter recounts the experience of an undergraduate college student who undertook a successful curating project with very little experience, limited time, and no budget.

FORMULATING A CURATORIAL PROJECT

Strong artwork, a sound premise for grouping the art together, and an appropriate place to show the work are the essential ingredients for a successful curatorial project. You develop all three components simultaneously.

The curatorial premise or theme is the primary concern as you begin your project. Premises are generally based on one or perhaps a combination of the following:

Medium and/or style, for example, abstract oil painting

Geography, for example, artists from Georgia

Temporal limits, such as ceramic work from the 1960s, or figure painting from the last five years

Concept, when you are gathering disparate works in order to support a thesis concerning content, cultural movements, social trends, art-making practice, and so on

Curating according to the first three, medium/style, geography, and temporal limits, often will result in an overview of work, or presentation of the best of what is available in a particular category. In these cases, the successful curator is in a sense a diligent detective, who finds the best or most of one kind of work. Curating according to concept is often the more creative approach, where, like a writer or artist, you have an idea that you are trying to bring to life. With curating, however, your raw materials are not words or paint, but the finished artwork of others.

Initially, your curatorial premise may be vague. You develop and hone it by looking at other exhibitions or catalogs, by reading magazines for related work or articles, and by discussing your idea with mentors or close friends. What is the basic idea you want to communicate? How does your concept relate to national

trends? Locally and regionally, have there been other shows similar to yours? How does your idea differ? What audience are you addressing?

The artworks are critically important, because you are seeking interesting pieces in and of themselves, and also an interaction that makes the works more provocative together than viewed separately. You can start with artwork you know, and then look farther afield based on recommendations, or by researching exhibitions, catalogs, and publications. Once you can clearly and succinctly articulate your premise, you can begin to approach artists you do not know. Bear in mind that you need to make a good presentation of a strong idea before you can interest artists who are unfamiliar with you. Also, established artists with sufficient outlets for their work may not be as willing as emerging artists to participate in your project.

Be rigorous about selecting only the work fitting a premise that really makes sense. This is especially critical when reviewing the work of friends and associates. Including your own work in a project where you are the sole curator may be questioned by some artists and art professionals. If the project is co-curated or group-curated, your work might be included.

While developing your theme and selecting participating artists, start looking for possible venues for your project. Ask mentors and friends to suggest spaces they know. While well-established art spaces with full-time curatorial staff are unlikely to consider outside curatorial proposals, the following places might be receptive to your ideas:

- Alternative spaces regularly have shows with outside curators. Depending on the prestige of the space and strength of your curatorial theme, they may be more or less willing to consider proposals from emerging artists.
- College galleries and performing spaces may be receptive to your proposal.
- Commercial gallery dealers may consider your project if the theme fits in with work they generally promote, if the work is marketable and if they know you. However, if your idea is provocative enough, a commercial gallery may show the work even if it falls outside these parameters.
- Cooperative galleries may be interested in sponsoring group exhibitions or series of performances as a way of raising their stature in the art community and a means of attracting new members.
- Community galleries, especially those that are understaffed or underfunded during recessions, may welcome an outside curatorial project.

If you want to get the work out quickly, you could use someone's studio or a temporary site such as a vacant storefront or office building. Owners of empty buildings are willing to donate available space for one or two months for cultural events that are likely to draw attention to the site, but they may be conservative on content issues. In addition, you may encounter some hidden costs:

Insurance. Building owners may insist you find coverage to protect the building proper and legal liability insurance. While you may have trouble

finding any insurance carrier to cover you at a reasonable cost for such a short period of time, you can ask the building owners about a rider on their policy to cover your art event.

Security. You may be required to hire persons to protect the artwork or to prevent access to other parts of buildings.

Preparation. Unconventional sites rarely meet the wall and lighting needs for either performance or traditional visual art.

Visit and evaluate the possible venues. For existing art spaces, go to see a few shows in the spaces. Make a short list of spaces that meet the needs of the work you are selecting. Then call the persons in charge of the spaces and ask if they review outside curatorial proposals. Ask what considerations are important to them in the use of their spaces. What proposal format is appropriate? Should any special materials be included? During your telephone conversations, try to determine if you could work with these persons.

WRITING PROPOSALS

A basic packet for proposing exhibitions or series of performances includes the following:

Cover letter. Introduce yourself, summarize your curatorial theme, and explain why you want to use that particular space. Your cover letter should be customized for each venue, explaining how the work and the space are a good match, how it fits the space's agenda, and serves their constituency.

Concept page. Write a short document that explains fully the concept behind the exhibit or performances. List some or all of the artists involved, and the kind of work that will be included.

Your resume.

Slides and resumes of participating artists. Get a few slides and a one- to two-page resume from each artist to include in your packet.

Budget. List here all expenses that will be borne by you or the artists, all support that you will receive from donors, and all support you are requesting from the art space. Include printing, mailing, shipping, reception costs, and any special equipment or installation needs. For example, if special walls must be built or video equipment is required, indicate the costs or the source of a donation. For unconventional sites, list expenses that will be incurred for site preparation, insurance, and security, if needed. If at all possible, include the cost of a catalog, brochure, or some permanent document of the project.

Self-addressed stamped envelope, for return of materials.

Organize and package these materials with the cover letter on top, followed by the concept page. You can send proposal packets to more than one venue at once. Follow up with telephone calls to answer any questions.

Once the person responsible for a space is interested in your proposal, you need to work together on a list of responsibilities and deadlines. Produce a written document covering who will do what and when, covering:

Designing, printing, and mailing announcements

Press releases

Procuring special equipment

Delivery and installation of work

Preparing the site for the art event

Parking and security, if necessary

Staffing, such as gallery attendants or house personnel for performances

Restoring the site after the exhibit or performances

Reception

Keep documentation of all curatorial projects after you have completed them. The exhibition catalog and brochure are the best documents, if they exist. Keep past proposals, announcements, copies of any reviews, and installation photographs of exhibitions.

Louis Cameron
Photo courtesy of artist

ARTIST INTERVIEW: LOUIS CAMERON

When Louis Cameron curated the exhibit, "65/92: A Look at the Civil Unrest in Watts and Los Angeles," he was entering his junior year in undergraduate school at the University of Southern California. He is a painting student who intends to study for a Master of Fine Arts degree.

How did you start working at a gallery, and how did the exhibit, "65/92" come about?

What had happened was that I had gotten an internship at a photography gallery called Black Gallery in the Crenshaw district of Los Angeles. It was funded by one of the Getty grants where $3,000 is given to different organizations to have an intern paid for the summer. A friend of mine had told me about these grants, and I must have interviewed for at least five internships, and I was getting rejected right and left. You know, it was kind of disheartening until I finally got this internship.

The Black Gallery is a privately owned gallery, a commercial space. It deals with mainly black photographers. As an intern, I did the regular gallery-sitting and had to deal with different people on different levels. Plus, I got exposed to the grant process because the director of the gallery was constantly writing and reviewing grants. There was an exhibit coming in with images from New York or London, and we had to deal with the invoices and the faxes. And it was a good experience to work on that kind of scope, you know, being responsible for signing for these images, getting the faxes out, and making sure that the images get here.

There was a three-week space between exhibitions at the gallery, and M. B. Singley, the other intern, and I got the idea looking through the

(continued)

Louis Cameron. Untitled. 1992. Spray enamel on wall, 8' X 12'. Hunington Beach
Photo courtesy of artist

(continued from previous page)

archives in the gallery. They had some pictures of the 1965 Watts Rebellion. And we got the idea of having an exhibit comparing the two rebellions, the Watts rebellion and the 1992 L.A. rebellion. So, we pitched the idea towards the director of the gallery, and he gave his okay. And from there we started working on putting together this exhibit.

What was entailed in selecting work for the exhibition?

We had limited time to get the exhibit together. Usually, when you do an exhibit, it's planned a year in advance, but we had only weeks.

We called all these different people and looked for a whole bunch of different sources—the University of California at Irvine, UCLA, the *L.A. Times,* different newspapers. We were working on a shoestring budget, so we were calling around to see what we could get, if we could borrow images. But they were asking for $10 per print or something like that. Plus they were talking about us getting the photographs in a few weeks, where we didn't have that much time. So we ruled out newspapers. And I was working on getting some images from the California Afro-American Museum.

(continued)

(continued from previous page)

The director of the gallery told us of a few artists and one he recommended was Melvin Rogers, a local photographer. He had a whole series of images from '92. Once we decided we were going to use him, we had to go through the process of picking only fifteen images. He usually showed larger groups of them all together where the images had sort of a narrative to them. He didn't like us breaking them up, but thankfully he let us do it after we went through a process of deciding what we were trying to do.

What were your criteria for choosing images?

What we were trying to do was stimulating thought on what happened in the 1965 rebellion and in '92, what the similarities were and the differences, and why thirty years later the same thing was happening.

Melvin Rogers, the artist with the '92 images, had been in Vietnam. What he explained to us in his work was that the L.A. rebellion was like a military operation, that L.A. had come under martial law and that basically we were an occupied territory. And that's what most of his images dealt with. So we looked through the pictures of 1965 and chose images that showed those kinds of things. There were quite a few in the archive. So we were lucky in that respect, that we had those readily available to us. Most of them that we used were from an artist who was dead, so we didn't have too much trouble with getting permission. We called his wife to see if it was okay, but actually they are the property of the gallery.

What else did you do to get the show together?

M. B. wrote up the curatorial statement for the exhibit. So we had that available for information. I designed the announcements. We used a picture from Melvin Rogers of some burned-out trucks with a shrine on them—a picture of Malcolm X on the truck and some flowers, with a sign that said, "Here will be built a future Boys Club of America," or something like that. It was a really interesting image.

We didn't have money to hire a graphic designer. We had to take care of that ourselves. We scratched up the money from the director of the gallery to get the announcements made and we sent out stuff to the different black newspapers like the *Sentinel* and *Watts Times*, and also to the *L.A. Times*. Basically we had to do everything. It was a lot of hard work, but it came off well. And the experience was really valuable. We were at a very small gallery, so it wasn't like we were at

(continued)

(continued from previous page)

the Museum of Contemporary Art, where we were only interning for a certain department and that's all we got to see. We got to do the press, choose the images, get the images, prepare the gallery, hang the images. . . .

Basically it was like a team effort with myself and the other intern. We had to do decision making together. There were certain areas where we had to compromise, like in the whole process of thinking up names for the exhibit. I came up with the idea of "65/92" and we thought about it and we thought it sounds kinda good. Then we added on the "A look at the civil unrest of Watts and Los Angeles."

Are you interested in doing something like this again?

It was a good experience, but I don't think I'd really want to make a career out of it. I like to do a lot of things, but I think my emphasis is painting.

Chapter 11

CREATING A NEW ART SPACE

Artists have frequently begun new art spaces when they perceive the need for it. The benefits are similar to those already listed for writing and curating. You make important connections, raise your own visibility, and have some power in determining what artwork gets shown. In small cities, suburbs, or rural areas, you may provide the only viable site for artists' work.

Artists have begun many different kinds of spaces, and have invented as many different ways to support them. Each solution was the result of the unique factors and circumstances that faced the artists, coupled with their own creativity, tenacity, and resourcefulness. The discussion below describes some of the major issues entailed in starting an art space, to give you some guidance as you approach the problem.

ARTIST-RUN SPACES

Starting an art space should be undertaken with much more caution than writing or curating because it requires a greater investment in time and money. Running one is time-, labor-, and cost-intensive.

You should have some clear mission when starting an art space, or an articulated philosophy about the work you want to show. By doing so, your profile in the art world is higher, your audience can grasp what you are trying to do, and you simplify your selection process when looking for new work. The mission or philosophy may be media-determined; for example, you show video art. Or your gallery may be noted for art that is influenced by a certain style, look, or concept, such as trompe l'oeil realist painting. You may aim for a particular market or audience, or showcase a particular group of artists. As another option, you may select noted outside curators to make the choice of artwork shown.

The following are models artists have used for establishing artist-run spaces:

The "extra-space" space. Many artists have begun exhibition and performance spaces in their garages, in extra rooms in their home, or in partitioned areas of their studio. This represents the easiest and least expensive option for art spaces, but, as the most informal, it requires a strong concept and strong work to get respect and attention. The

month-to-month responsibilities continue to be costly in time and money even at these sites. On the other hand, there is no added rent, site preparation may be minimal, and you can tend the space while continuing with other living and working activities. In larger art markets, dealers sometimes operate out of their homes, both beginning dealers just starting up and seasoned dealers who downsize during recessions.

Temporary borrowed sites. Once you start, you do not have to run an art space for the rest of your life. In fact, it may be healthy to operate an art space for a fixed period, such as a year. With some searching and diligence, you may find someone to lend you a space or rent it to you at a reduced rate for a limited time, especially in commercial or industrial areas with high vacancy rates. The building owner might also pay for your renovation if the space is made more attractive and thus may be more easily rented in the future. The month-to-month responsibilities and expenses remain.

Permanent art space for which you are solely or partially responsible. In this situation, you, your backers, and/or a group of associates put down the rent on a space and renovate it to become a permanent exhibition or performance space. Permanent art spaces can be operated either as commercial galleries or as nonprofits. This type of art space is the most costly up front and requires that you make commitments such as signing leases. The month-to-month responsibilities and expenses continue, also.

Cooperative gallery. A group of artists, usually between eighteen and thirty-six in number, band together to create cooperative galleries primarily for the purpose of showing their own work, and secondarily for showing the works of other artists whom they respect or whom they feel are underrepresented. Membership rotates, with new artists coming in and others leaving as their interest in the space diminishes. With cooperative galleries, you have the satisfaction of seeing the space continue after you leave, and not simply fall apart and disappear into oblivion. Start-up costs, month-to-month expenses, ongoing responsibilities and decision making are shared among members. Cooperative galleries often receive less respect in the art world because of their self-promotional nature, but that can be offset by outstanding programming and exhibitions.

Consider how much money you could invest in the start-up and operations for the first year. While you might hope to make some money from sales, performance admissions, or donations, your planning should allow you to support the space even if you have no financial return for several months. To start a space, you may incur expenses in the following areas:

- Site selection, both because of your time invested, and also any fees you may have to pay to agents
- Legal advice on lease agreements
- Rent due after signing a lease, usually first and last month, and deposit
- Site preparation or renovation, for example, walls and lighting

- Utilities and telephone service, including deposits and hook-up fees
- Signage, stationery, consignment forms, and sale receipts

Your ongoing responsibilities, the ones that face you continually, include:

- Monthly costs, including rent, utilities, payroll for personnel if any, and so on
- Gallery maintenance
- Publicity and advertising
- Correspondence
- Bookkeeping and tax records
- Reviewing packets sent by emerging artists
- Selecting work for exhibition
- Gallery sitting during open hours
- Cost associated with exhibitions or performances, including printing announcements, installation of artwork, mailing, receptions, house expenses, and so on

OUTSIDE SUPPORT

You may need to offset your expenses and get assistance in running a new art space. Some possibilities are suggested below. Remember, however, that while these sources of assistance are extremely beneficial and important, they may not always be reliable. Volunteers may not be able to come when you need them, donations and grant sources may dry up during a recession, and your free space may disappear once a paying tenant comes along. Additionally, all these forms of assistance require your time to manage or pursue them. In the end, final responsibility for the space always falls to you.

Financial support:

Grants (see Chapter 13)

Corporate cash and in-kind donations (see Chapter 14)

Special Interest Groups. You may solicit help from organizations whose mission or philosophy match that of your art space.

Professional assistance:

Legal: Volunteer Lawyers for the Arts in New York, and related organizations throughout the United States, provide artists and art organizations with limited free legal assistance and educational materials. These organizations are most often consulted on contracts, agreements, rental disputes, and incorporation for nonprofit status.

Accounting: Accountants for the Public Interest provide free accounting services and professional assistance to individuals and organizations. API is most often consulted on tax returns, bookkeeping, and on the advisability of seeking nonprofit status.

Business Advice: The Business Volunteers for the Arts provide management consulting and business advisory councils for art organizations, plus sponsor educational programs and publish educational material.

Other help:

Ask the participating artists to help with various tasks, such as mailing, gallery sitting, installation, and take down. Or, ask participating artists to contribute toward expenses.

Arrange for college students to be interns on a semester-by-semester basis.

THE NONPROFIT ART SPACE

A permanent artist-run space created for public benefit may be established as a nonprofit, tax-exempt organization. Such entities are regulated by state and federal laws, and thus there are legal requirements concerning their formulation, and subsequently their annual operation. You cannot casually muddle your way through the arduous process and required paperwork. For assistance, you can 1) seek legal or professional advice; 2) follow the directions in handbooks, such as *How to Form a Nonprofit Corporation,* by Anthony Mancuso; or 3) follow closely the model of another similar art space that successfully completed all the paperwork and requirements.

This simplified description outlines the general process of applying for nonprofit, tax-exempt status. Your first step is to research whether or not this status is appropriate for your organization. While being a nonprofit may seem like an obvious plus to anyone, in fact there are advantages and disadvantages, depending upon each individual set of circumstances. Seminars given by Volunteer Lawyers for the Arts and *How to Form a Nonprofit Corporation* discuss the pros and cons of nonprofit tax-exempt status. In addition, your local VLA or API affiliate will give advice regarding your space. At this time, ask for an estimate on the amount in fees that will probably be levied in this process. Fees vary from state to state, but in some locations can be as high as several hundred dollars.

Nonprofit tax-exempt organizations can take several forms, but the most common for art-related operations is as a nonprofit corporation for public benefit. There are two distinct steps involved in establishing such an entity: 1) organizing the corporation; and 2) applying for tax-exempt status.

Incorporation is regulated by state law, usually through each state's Office of Secretary of State. Thus the legal requirements in forming a corporation vary, depending upon your location. Check the specific law for your state. Generally, the major tasks you must perform include:

Selecting and filing for a corporate name. A state office regulates filing procedures and name availability to determine if your proposed name can be used.

Preparing and filing articles of incorporation. This generally includes listing the name of your corporation, the form of your corporation, statement of corporate purpose, and the name of a person who will be the initial agent for service of process. Since you will also seek tax-exempt status for your corporation, you must use specific language in your articles of incorporation. Again, seek legal advice or consult a handbook.

Writing the corporate bylaws, which specify among other things the internal rules by which the corporation operates, the make-up of the board, the duties of officers, and the rights and duties of members, if any. State law places few requirements on what bylaws must actually contain, so there may be considerable leeway in what you write. The bylaws, however, should be appropriate for your particular corporation.

Organizational first meeting of the board of directors. Certain tasks necessary to begin corporate operations must be accomplished, such as naming the principal executive officer, authorization of the bank account and signatory power, and accounting procedures. Minutes for this meeting must be retained in a corporate record book.

Application for tax-exempt status must be made on both the federal level, to the Internal Revenue Service, and also on state level, generally to the state tax board. Each requires forms and paperwork, and copies of the corporation's articles of incorporation and bylaws. Again, legal advice or handbooks will step you through these procedures. The IRS and state boards will then accept or reject your application.

Even after nonprofit, tax-exempt status has been granted, your corporation must follow certain procedures to maintain its status, such as holding regular meetings, keeping separate bank accounts, filing necessary tax returns, having board ratification of significant changes, and documenting board proceedings with minutes that are retained in the corporate book. In addition, members of the board of directors must be attentive to their duties and avoid conflict of interest in their dealings with the corporation. Legal advice or handbooks will tell you how to proceed.

Suvan Geer
Photo by Dean Schonfeld

ARTIST INTERVIEW: SUVAN GEER

Suvan Geer is an installation artist whose work often deals with nature and transience. She is an art writer and arts organizer who discusses in this interview her experiences as a founding member of the Orange County Center for Contemporary Arts (OCCCA), an alternative gallery and artists' space established in 1981.

What made you as an artist decide to help establish a nonprofit alternative art space?

When I was in graduate school in Fullerton, in Orange County which is south of Los Angeles, the only places for an artist to show were at the one contemporary art gallery and the museums in Laguna and New-port, and that was it! There was nothing else! I was an emerging artist and no one was going to give me the time of day. You know, you walk out of graduate school and disappear off the face of the earth. Plus, my work is in installation, and at that point I was working mostly outdoors and needed a place that would be very forgiving, and a space that would let me work at a particular time of year when I could get and

(continued)

Suvan Geer. Timed Release/At the Speed of Sound. 1987. Mixed media installation with recorded sound, 16' X 16'.
Photo courtesy of artist

(continued from previous page)

use some specific natural materials. I knew that no commercial space or museum would do this!

A group of us realized we needed a venue, so five of us got together—Alhena Scott, Jenny Horstcotti, Carol Stella, Richard Aaron, and myself—and we started an alternative space for very self-serving reasons. We wanted a place to show. Everyone in graduate school was telling us that we had to go into L. A., but for some of us that just wasn't physically possible. Alternative spaces were okay at the time in New York but certainly not okay out here in California. In New York, it's like, sure, you open your own space and show your own work. Out here that would seem self-serving and the term "vanity gallery" was bandied around. So we did everything we could to counteract that image. You couldn't just come in, be a member, and have a show if you had a million bucks. Your work had to be reviewed and you were juried into membership. And also to make sure that we weren't just showing our own work, we had

(continued)

(continued from previous page)

one guest artist per show, and sponsored special theme shows that had nothing to do with membership.

When you say membership, you mean more than the original five, don't you?

When we first began the space, we determined it would take eighteen artists to fund and run the space, and so we started canvassing. We visited studios, called up people, saw work in galleries and went after them, that kind of thing. And because nobody knew who we were, and really didn't trust the idea of an alternative space in Orange County anyway, it was like pulling teeth. So we started I think with eight or nine and financed the whole thing ourselves. It took about $10,000 to start up in 1981, but that did not include the cost of the labor that we did ourselves or had friends do. Alhena's husband was in the electrical business so we were able to get a lot of the lighting at cost. We did the thing on a shoestring and got it up and running in six months.

Did the members then run the space once it opened?

Oh yeah. We had to. When you signed on to be member, you didn't just put down your bucks and walk away from the thing. You had to work on committees, spend your time babysitting the space, and you know it was really rocky at the beginning, because people would forget what day they were supposed to be at the space . . . you know, all the things that make an artist-run gallery a pain in the neck! We had to do all the clerical work and press releases ourselves, because we couldn't afford to have anyone do it for us.

After three or four years, we eventually got to eighteen members. But by that time, expenses had gone up and we needed more people. And so in the beginning we showed once a year, and then it got to be every eighteen months, and then we had to divide the space differently, and take out the office and put a gallery in the front—I mean, anything we could do to make the space more usable.

How else was OCCCA transformed?

Six months after we opened, I went to a backer who knew me and knew my work and I said, "Look, I am doing this, I think it is worthwhile, but we are having trouble becoming nonprofit." He had his own company and had a lawyer on retainer and said, "Oh, hey, my

(continued)

(continued from previous page)

lawyer just set up the nonprofit for Fedco. Go see him." So we did, and within six weeks, we had our nonprofit. He basically set us up to be a cathedral for art. We fit right in and have kept it ever since. Nonprofit status helps us when we want to solicit funds and ask people for donations. One of our biggest expenses was mailing, and the nonprofit helps us because you can mail in bulk at the nonprofit rate.

What is OCCCA's current structure?

Well, in some ways the structure is still the same. The members are called affiliates and there are about twenty-one. These are the people who are actively showing in the space. If a person wants to become an affiliate, they submit slides. A committee, which is pretty much the general membership, judges the work and reads their letter of application to see if the person has the understanding of what a membership gallery does. The status of affiliate lasts however long they want, unless it is pulled for nonperformance. But I don't know that that has ever been used. I would say that the average membership is two to three years, but some people last for only one year. They get in, wait their x number of months, have their one show and then they're out of there. That is probably less common than it used to be in the beginning, when OCCCA was a hell of a lot of work.

Affiliates contribute $40.00 every month, a very small sum, exactly the same amount as when we started thirteen years ago. But the rent has more than doubled.

So how does OCCCA make up the difference?

Fund-raising. Art auctions, juried exhibits, dinners, tours of collections in Orange County, all the usual stuff.

Is there a staff at OCCCA?

There is no staff. They've tried in the past to hire a staff, but that is a hell of a financial drain. The affiliates do all the work and there is a director, a member who is crazy enough to volunteer to be nominated and approved for one year at a time by the membership. There are also heads of each committee like exhibitions, public relations, community outreach, etc.

(continued)

(continued from previous page)

You really have benefited from your involvement with OCCCA.

Sure. I learned firsthand about the gallery market system. How to put a show together, how to write a grant proposal. I started art writing after my PR work for OCCCA made me more comfortable doing that kind of writing. From there I went to earning money for it with *Artweek* and the *Los Angeles Times,* and to teaching at the local colleges. Many people associated with the space have gone on and parlayed their experience into other positions.

You know that many people really disparage artists who are self-serving. There is something so ludicrous about that because, tell me, who in this world isn't self-serving? Others have benefited by what we have done. In some years, over half the shows we had at OCCCA were for nonmember artists. Artists are an economic force. We are in business (printers alone make a fortune off of us!). When you get a bunch of us together it is like unionizing. We are a much more organized force that can place pressure. We can actually demand that a community pay attention to a certain kind of art making, if we get together, organize, and do a series of shows showing how much work is being done out there around a certain theme.

It takes work, everything takes work. But you never know in what ways your efforts will pay off. OCCCA exists primarily for the art community and for its members, but we were also very aware that the only way OCCCA would grow was by reinforcing community ties. So a few years ago, OCCCA went into the schools, and got the schools to come to OCCCA, to make up for the fact that there was no art education. And after that, things really changed. Outside people got on the board, got involved, made us known to the city council, all from that simple connection. And since then, things have really taken off.

SECTION FOUR

——————

Financial Concerns

This section covers the very practical side of being an artist, including the financial, legal, and administrative aspects of your career. Chapters 12, 13, and 14 cover many ways to raise money to continue your artwork: jobs, grants, donations, public art projects, commissions, and artist residencies. Chapter 15 deals with the internal business of your career, including maintaining a studio, insurance, record keeping, billing, inventory, taxes, contracts, and copyright. For each topic, basic issues are discussed, and, where applicable, references for complete information are given.

No one very much likes this part of the profession.

Chapter 12

JOBS

While very few artists live off their artwork, many work creatively while holding other jobs. In all probability, you will have to supplement your art income with income from a "regular" job. The ideal job for an artist would have the following qualities:

- Adequate pay to cover living and studio expenses
- Benefits, including health insurance and savings plans
- Flexible working hours. A strict nine-to-five Monday-through-Friday job would make some aspects of your art career difficult, for example, meeting curators, soliciting corporate support, researching grant possibilities, seeing some exhibitions, or writing reviews. You can try to work an evening shift, a four-day/ten-hour schedule, or flexible or reduced hours. If your job has a slow season, you may request several weeks off without pay.
- Art-related work. Such a job may further your career while helping to pay the bills.
- Work that requires you to communicate visually

Very few jobs meet all the above criteria. Many jobs meet some of them. Before you take a less-than-ideal job, figure out what would make it more agreeable to you, and negotiate with your employer for some changes. You may be able to work out compromises that benefit you and still meet the needs of your employer.

Art-related work with high visibility and prestige in the art world are extremely desirable. The very nature of this work keeps you involved in the art world. Only some of the following positions are entry-level jobs, but all are available to artists who work through the ranks and gain appropriate experience.

- Museum and gallery personnel, including curator, director, fund-raiser, or education coordinator. Less prestigious positions are slide registrar, librarian, preparator, or gallery attendant.
- Arts administrator, including those who work for artists' organizations, nonprofit groups, public art programs, government art agencies, foundations, or state or local cultural affairs offices. Positions of responsibility, such as director, are most prestigious.

- University teaching. An M.F.A. is almost always required to get these jobs.

Universities hire many people in support positions. With these jobs, you often work only nine or ten months out of the year. You have the potential to build a strong network with faculty and graduating students.

- Lab and shop technicians, such as shop supervisors, darkroom supervisors and computer technicians
- Slide librarians and photographers
- Office staff, including counselors, admissions personnel, and office supervisors
- Art librarian. A Master of Library Science is often required.
- Fund-raisers

Other teaching jobs give you a flexible schedule and blocks of free time between teaching sessions. These positions in and of themselves bring you no added stature in the art world, but give you time to continue your work.

- Grade school or high school teaching. A teaching certificate is required.
- Substitute teaching. Your time is yours whenever you want it. Most states require a B.A. degree.
- Art instruction in prisons. Some states have fairly comprehensive programs.
- Continuing education courses. Educating adults can be very satisfying because you are working with interested, motivated students. There are teaching opportunities in art courses or in English as a Second Language (ESL) courses in areas with high immigrant populations.

Community outreach jobs are sponsored by museums, churches, special interest groups, universities, and local government. In these positions, artists develop art programming that benefit specific audiences. This programming varies, depending upon the audience and the agenda of the sponsoring institution. Community work may be satisfying and rewarding. Some positions may also advance your professional career, for example, if you were employed by a major museum to do community outreach programming.

Artists often hire assistants on an as-needed basis. If you do artist-support work, you should live in a major art center and build up a clientele that regularly uses your services.

- Writer for hire. There is a regular demand for persons who can write effective artists' statements, organize a resume, and write grant applications for institutions, organizations, and individuals.
- Photographer, documenting artists' work with slides or $4'' \times 5''$ transparencies. Galleries and museums also need this kind of work. Or you can do darkroom work for artists who use photographic images in their work.

- Printmaker, assisting artists in producing editions of prints, or operating a printshop that artists can rent for their own use for a day, week, or month.
- Art-making support jobs, including making custom-ordered canvases for other artists; fabrication work in plastic, wood, and metal; managing a colony of artists' studios or residences; or conducting how-to workshops on topics pertinent to artists.
- Art restoration work. Specialized training is required.

Design jobs entail visual communication. While these jobs may not increase your stature in the art world, they do allow you to hone your visual skills and become adept in working with a range of media.

- Graphic and commercial art work, including illustration, layout, and design. Illustration work requires a high degree of accomplishment in painting and drawing. With most graphic design work, you become very competent with computer applications.
- Design fabrication, making unique objects for upscale or trendy businesses, such as signage and fixed furnishings including entryways, bars, counters, and wall decor
- Decorative murals and custom painting work, such as faux finishes
- Display design, such as window displays for stores, and booth design for fairs, conventions, and "home shows"
- Interior design, both for offices and residences
- Prints, photographs, or watercolors produced in a large numbers for hotels or office buildings. This work is usually available through interior designers or art consultants hired by businesses.
- Commercial photographer for portraiture or commercial publications; or an in-house documentary photographer who photographs persons and events for magazines and annual reports produced by hospitals, corporations, universities, and so on
- Entertainment industry work. There are many peripheral jobs around movie, advertising, and television production, although special training may be required for some. Preproduction work includes set painting and prop construction. During shooting, script consultants check for continuity, and there is a range of go-for jobs. Editing jobs include both editing raw footage and post-production editing, where existing video or film are reedited for a general audience or for dubbing into another language. In television, cable-TV companies are required to staff and maintain public-access studios and programming.
- Computer/video work. Video editing for CD-ROM production, and illustrating and layout for CD-ROM texts

Jobs with flexible hours, reduced hours or seasonal work give you large blocks of time for pursuing your art career. Such jobs include:

- Housepainting
- Construction work
- Agricultural work
- Landscape design
- Food work, including catering, bartending, or waiting tables

FINDING A JOB

Information sometimes passes quickly by word-of-mouth in art communities, and asking friends and associates may be the best way to find out about art-related jobs in your area. In addition, you should monitor the following sources for potential jobs:

Newspaper want ads, listing jobs available in a certain metropolitan region

University career centers, where corporations and businesses interested in hiring college graduates can advertise openings

Personnel offices of government entities, corporations, universities, and cultural institutions, with listings of all current openings

Regional and local art publications often have jobs advertised in their classified ads

Publications of professional organizations. Members of these organizations receive newsletters and job bulletins as part of their membership. The College Art Association's *Careers* lists university-affiliated jobs, including teaching, administrative, technical support and university museum positions, from all over the United States and some international positions. The National Art Education Association's *National Arts Placement Affirmative Action Newsletter* lists a variety of arts-related jobs and internships; theater, music, and visual arts positions are all included. *Aviso,* the monthly newsletter of the American Association of Museums, lists entry-level and higher openings in museums. In its newsletter, the Art Libraries Society of North America (ARLIS) lists job openings in art libraries; usually a master's degree in library science is required.

Popular architectural magazines often feature the work of fabricators, decorative muralists, and custom interior painters. Through them, you can find who works in these fields in your area. Many of these painters and fabricators run large operations, and are looking for apprentices.

Apply for all jobs that may interest you. Give yourself as many options as possible. Wait until after an interview, when you have more information, to decide that something is not for you.

The interview process is a two-way street, with prospective employers deciding if they want to hire you, and you deciding if you want to work for them.

Monopolizing the conversation or waiting passively for each question make a poor interview as well as a poor conversation. When interviewing, try to meet not only with a personnel officer, but also with potential supervisors, co-workers, and subordinates.

By preparing for an interview, you can both learn more about your prospective employer and make a better impression.

- Research the organization or firm where you hope to work. Ask mentors and friends what they know about it. Ask corporations, educational institutions, museums, or cultural affairs departments to send you their publications explaining their mission, budget, organization, or programs before interviewing with them.
- Ask in advance for a complete job description. You need more information than what is provided in a two-line classified ad in the newspaper.
- When salary is advertised as "negotiable," find out from friends and mentors what salary range is likely.
- Practice interviewing with a mentor or someone with a similar job, to learn the questions you are likely to be asked.
- Prepare a list of questions. A pertinent and appropriate question not only reveals your intelligence, but also can be quite flattering.
- Presentation. Give some thought to your appearance. If you are showing visual materials, they should be compact, easily managed, and fit under your arm. All visual material should be absolutely professional looking.

LETTERS OF RECOMMENDATION

Letters of recommendation are supportive documents that others write about you when you apply for a job, for promotion, for graduate schools, for scholarships, and for some grants. Also called reference letters, they should describe your strengths in relation to a particular situation, and so may cover your artwork, academic record, job experience, professional involvement, and character.

There are different kinds of letters of recommedation. They may be confidential, meaning that you have waived the right to see them, or nonconfidential, in which case you may know what your reference wrote about you. While you may prefer the accessibility of nonconfidential letters, you may benefit in some cases from letting the letters remain confidential. For example, the employer, school, or granting agency requesting letters may place more weight on confidential recommendations than on nonconfidential ones. Or some potential references may not write on your behalf without confidentiality.

Letters of recommendation may be general or directed. Directed letters are written specifically to the person(s) who will be evaluating you for school, employment, or funding, and cover many of the concerns of that particular situation. These are one-of-a-kind letters, and as such, can be impressive testimonials because of the thought and effort the reference put into the writing. General letters

of recommendation are addressed to "Dear Colleague," or "To whom it may concern," and discuss your strong points more broadly. Your references then give you the letter, which you can photocopy and distribute as needed. The advantages of general letters are that you know exactly what the references say about you and you have the letters available when you need them, without having to contact your references and wait for results. They are beneficial if your references may be away for an extended period of time. Such letters carry less weight than directed letters, but may be used as preliminary references, especially if you are just beginning your professional career and sending out a large number of applications—that is, seven or more.

Letters in placement files are another kind of recommendation. Some universities offer placement services for their current students and recent graduates. Each teacher who recommends you may choose to write one general letter that is placed on file with the service. You then request copies of your file be sent wherever you need it. Such letters may be confidential or not.

You generate your own resume and cover letter, and thus have control over them. Because other people write letters of recommendation, you are somewhat at their mercy regarding what they say about you. However, there are ways you can help ensure that letters of recommendation present you in the best possible way. When soliciting letters of recommendation, first make a list of people whom you think would make good references. Select people who meet at least some of the following criteria:

Persons with status in the art world, whose opinions will be respected

Persons who regard you very favorably

Persons who know you in more than one area of your life

Persons who are familiar with the kind of situation to which you are applying

Persons who write well

Relatives and friends may like you and write enthusiastic letters for you, but letters from art professionals, such as former or current teachers, curators, writers, or other artists, have more clout. These people can validate you in the art world, and the greater their reputation, the more their letters will help you. In every case, remember to respectfully request a letter. Do not offend potential references by expecting them to write for you. Regardless of how long or how well you know someone, that person is under no obligation to recommend you for anything.

Secondly, try to determine what kind of recommendation your references will write for you. This situation requires tact, because the reference does not have to tell you what will be included in the letter, confidential or not. Ask potential references if they feel they know you well enough to write letters of recommendation that cover the range of your accomplishments. Mention how important strong recommendation letters are for you to achieve the situation you want. Be very attentive to their response. If they seem ambivalent or half-hearted about writing the letter, you may consider asking someone else.

Thirdly, provide your references with the necessary materials to write an excellent, detailed letter for you. Make an appointment to give them copies of your resume, artist statement, visual documentation, or academic transcripts. Include a description of the job, grant, or school to which you are applying. Ask if they are willing to discuss certain points that are most important to you. For example, you might tactfully point out your exhibition record, your reliable character, your high grade point average as a student, and so on. Your requests must come across as mild suggestions only, as you cannot demand anything. Provide them with stamped, addressed envelopes to send their letter to the appropriate party. Give your references plenty of time to write the letter, two weeks or longer if possible. Effective recommendations take time to compose, and some sought-after references have very busy schedules.

Ask your references to write directed letters. If they cannot because of time constraints or because you need many letters, suggest that they write one general letter that is reproduced directly onto letterhead and individually signed. These appear more impressive than a photocopied letter with a photocopied signature. There may be circumstances where you can envision requesting a letter every week over a period of a month or two. In such cases, as a courtesy, let your references know up front that this will be happening. Then they can prepare a basic letter on a word processor and customize it into several different directed letters.

After letters are written on your behalf, thank your references for their effort and support. When possible, save copies of the reference letters.

If you have a chance to see letters of recommendation written for you, evaluate them for their effectiveness. A good letter of recommendation should indicate how the reference knows you, speak of your past experience and/or your future potential, being detailed and specific on these points. The letter should address your merits as a person and qualities that make you particularly suited for the situation. Most letters are one to one-and-a-half pages in length, single spaced, and should look professional. Letters of recommendation are expected to be documents that support you, and therefore to be effective, need to be strong and enthusiastic. If the letter mentions too many of your weaknesses, even if accurately, or is lukewarm, consider getting another reference.

Kathy Vargas
Photo by Robert Maxham

ARTIST INTERVIEW: KATHY VARGAS

Kathy Vargas is a photographer whose work has been shown nationally and internationally; at the time of this interview, she was preparing for a show at the Corcoran Gallery of Art in Washington, DC, on the topic of hospices. She talks here about her employment background and her current job as the director of the Visual Arts Program of the Guadalupe Cultural Arts Center in San Antonio, Texas.

You worked many different jobs before you took your current position.

My first job was in animation for a man who eventually became a Hollywood animation supervisor. And then I photographed rock 'n roll bands. National people. I had a friend who had worked at a booking agency. If a band started a tour in Texas, they needed a fast turnaround on photos they could use for the whole tour. It was no big deal. I would go on the road for about three days or so and photograph the band and do commercial pictures. I was cheaper than the people in L.A. and I was available to travel.

Then I decided to go back to graduate school, and I became the research assistant for an art historian who was director of a research center, and that led to a lot of other things. I did research, writing,

(continued)

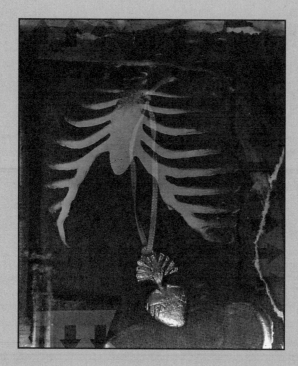

Kathy Vargas. From the Oracion series. 1989–1991. Hand-colored black and white photograph, 24" X 30".
Photo courtesy of artist

(continued from previous page)

copyediting for the newsletter, a little bit of budget, and a lot of photography. But the best thing for me was looking over the director's shoulder and learning from him. Certainly that helped me both want to apply for and get this job because I knew a little bit of what was involved. He was very good at grants, how grants work, and network building. While watching him raise money within a university is different from what I am doing now, it gave me a good background as far as funding sources.

I also did some art writing for one of the local papers, writing on photography and Latino art. The paper wanted the art historian to do some criticism, but he really didn't have the time and recommended that I do it because he liked the way I wrote. When the editor of the art section of the paper at that time asked for samples of my writing, I took him term papers from school! It was the only writing I'd ever done. He said, "Fine, you're hired," and I was a freelancer for a long time.

I worked for a commercial photographer doing different things, and in the course of that job I met a lot of people who eventually, some of them, have since become supportive of the Guadalupe Center.

(continued)

(continued from previous page)

What is entailed in being director of the Visual Arts program?

I curate a couple of shows every year, where I'll pick a theme and select artists. I have a Visual Arts Advisory Committee, mostly made up of local artists, that selects a lot of exhibits. I'll also book shows that are from touring exhibits. We have community-oriented things, some forums, symposia, and classes. I supervise classes and I teach a photography course a couple of times a year. We do grant writing, development, fund-raising, budgeting. So there's a lot going on. I work probably between forty-five and sixty hours depending on what's going on. Before a major fund-raiser, we might put in nearly one hundred hours a week.

Do you think that artists working in administrative jobs eventually get "used up," not only their own energy, but also the goodwill of the people they work with?

I think it's a balancing act between what you give and what you take away. How much you offer to a community at large, to a city, to a group of artists, so that they keep trusting you. And you keep finding different ways to do good things for people, so that gives you credit with people. And you also don't close any doors.

You just now talked about the word "trust," but I rarely read art books that talk about that.

I think that's what it comes down to. If you're trying to serve a community of artists or a public, they have to trust that you're not going to abuse them in some way. Artists want to know that they are not going to get taken advantage of, that their creative enterprise is going to be respected. The public wants to know that you are not pulling the wool over their eyes. They really are looking for a handle for understanding contemporary art, for dealing with it, so that it becomes relevant to their lives again.

And it's the center, too. When you talk about that sense of trust, I think people trust the Guadalupe Cultural Arts Center because they know the product that has come out of here. It makes it easier to network, it really does. If I was trying to do these projects on my own, I couldn't.

What else are you involved in?

I am chairing the Studio Sessions for the 1995 Annual Meeting of the College Art Association. I'm on the board of Art Matters, and I'm

(continued)

(continued from previous page)

doing a photo series, and I'm cocurating this other show for FotoFest. And you know, I'm thinking, am I nuts? But it keeps me more alert to have all these balls thrown at me at once, and it's more interesting, and it promotes more networking. And the key is that all the things I'm doing are very interesting to me and I want to be a part of them.

I think that when artists get bogged down, or when they get burned out, or whatever, it's because maybe they haven't done something to find trouble to get into, you know, something else to take on that's huge, impossible, unsurmountable, but that's really going to keep you on your toes and keep you alert, keep you excited. As director here, I hit the "seven-year itch" at six or six and a half years. I had gotten the job down pat, and all I was doing was recycling. Anybody in their right mind would have said, "Get another job!" But there were a lot of things that I saw that I wanted to change. We had a very small exhibit space and I thought I'd really like to do more for emerging artists. How could I do that?

Well, we got a warehouse—we got a great deal on the rent—and I'm going to get the center into massive debt taking on this giant building. We'll have art studios and we're going to build a new gallery and a residents' gallery, and we're going to have a visiting critics program . . . Maybe somebody in their right mind doesn't do that, but I really wanted this space, and it's really kept my life interesting.

What about your own work?

I'm a studio photographer. Thank God. It's super because I can work at night and have a whole other day with a whole other activity. I can go home and in two hours I can set up my studio props, shoot nonstop for two hours, go into the darkroom the next night, develop the same film and I can have at least two images that I know I want. After printing and culling, I would say that I average at least a couple of new pieces of artwork every two weeks to a month. Which means that at the end of every year, I have twenty-four to fifty new pieces of work, which is a show.

Chapter 13

GRANTS

Generally speaking, a grant is a gift for a particular purpose. Most grants are given either by government agencies or by foundations. Many granting agencies give only to organizations, usually nonprofit, tax-exempt, charitable, or service organizations. Some give to individuals only, or to both individuals and organizations. Grants are either "matching," meaning that the agency or foundation will match every dollar raised from other donors up to a certain amount, thus covering a maximum of one-half the cost of a project, or nonmatching, meaning that no extra fund-raising is required to receive the grant.

For artists, grants fall into one of two categories. The first is a fellowship or stipend grant, which gives an artist a sum of money in recognition of past accomplishment or future promise. No particular performance is required in exchange for an artist accepting a fellowship. Fellowships are given only to individuals. The second kind of grant, a project grant, is by far more common. Project grants provides money, service, or equipment for clearly specified purposes. These purposes can include individual endeavors, such as pursuing a research topic or creating a particular work of art. Or the project may be more socially oriented or function within an organization, such as a lecture or exhibition series. The specified purpose must be fulfilled if the grant is accepted, or else the granting agency may ask that the funds be returned. Project grants can be awarded to an individual, an organization, or an individual sponsored by an organization; however, the majority of these grants go to nonprofit organizations.

Grants are given in order to achieve the aims of the granting agency. You should apply for grants when your goals already match or nearly match those of a particular agency. Committing yourself to something outside your interests, simply in the hope of attracting a sum of money, is likely to be both a personal mistake and an unsuccessful gambit. Before you begin researching what funding sources for projects are available out there, you should have an idea or project. While your idea will naturally develop over time, you should be able to articulate what you want to do, where, when, for what audience, and approximately how much money you will need.

GRANTING AGENCIES

In the United States, various levels of government use tax revenues to support the arts through *governmental granting agencies*, specifically, through federal, state, and local art agencies. The federal program, National Endowment for the Arts, was established "to foster excellence, diversity and vitality in the arts." The *Guide to the National Endowment for the Arts* provides an overview of all NEA programs. The following is a summary of those programs that support artists or art organizations.

The NEA gives nonmatching fellowship grants to individual artists throughout the country. These cash awards encourage the "creative development of exceptionally talented professional artists by enabling them to set aside time to create new work, continue work in progress, acquire supplies and materials, do research, travel, etc." Competition for these grants can be intense. Students are not eligible to receive them. Grant programs are divided into broad media areas:

Design arts: architecture, landscape architecture, urban design and planning, historic preservation, interior design, industrial and product design, and graphic design

Media arts: film, radio, and television

Visual arts: crafts, painting, photography, sculpture, works on paper, and other genres including performance

In addition to fellowships to individuals, the NEA sponsors programs of "matching grants to non-profit, tax-exempt organizations and for projects of the highest artistic merit" for:

Design arts organizations

Media arts organizations

Visual arts organizations

Expansion art organizations, serving "specific communities, such as ethnically distinct neighborhoods, inner city barrios, rural hamlets, and Native-American tribes"

Folk art organizations, including those supporting visual, musical, and narrative arts

If your project falls within an area funded by the NEA and also is in line with the mission of a nonprofit, tax-exempt art organization in your area, consider asking the organization to sponsor your project so that you can apply for support through more programs. As these are matching grants, half of the needed funds must come from the organization's budget or from other fund-raising.

Down one level from the NEA are regional arts organizations. They sponsor Visual Arts regional fellowship programs similar to the NEA fellowship programs, matching grant programs for nonprofit arts organizations, and also some of their own unique programs. Similarly, various media arts centers administer regional fellowships in film and video. For example, the Southern Arts Federation oversees regional fellowship programs in Visual Arts for Alabama, Florida, Georgia, Kentucky, Louisiana, Mississippi, North Carolina, South Carolina, and Tennessee. Artists can apply for fellowships in artists' books, crafts, drawing, painting, photography, printmaking, or sculpture. The fellowships consist of a cash award and two years of promotional activities, including an exhibition and group catalog. Because each regional art agency structures its programs differently, with its own categories, deadlines, and application procedures, you should call or write your regional agency for complete information on their fellowship and grant programs. The addresses and telephone numbers of all regional arts organizations and regional media centers are listed in the *Guide to the National Endowment for the Arts* and in *Organizing Artists: A Document and Directory of the National Association of Artists' Organizations*.

On the next level, state art agencies or art councils provide various services and support for visual artists, such as grants, fellowships, commissions, residencies, information exchange, exhibition opportunities, and/or educational opportunities. Some programs are open only to residents of that state. As an example of programs offered by a state art agency, the Minnesota State Arts Board has a fellowship program for Minnesota artists in all stages of their careers, providing $6,000 to each recipient. In addition, they offer Career Opportunity Grants for state artists, ranging from $100 to $1,000, to allow artists to take advantage of impending opportunities to advance their careers, such as a first solo exhibition or the chance to study with a mentor. The Minnesota State Arts Board also administers the state's Percent for the Arts in Public Places Program, with competitions open to artists throughout the country (see Chapter 14, for further discussion of public art programs). Of course, programs and services vary from state to state. Call or write the individual state art agencies for brochures describing their programs. Listings for these agencies are also available in the *Guide to the National Endowment for the Arts* and in *Organizing Artists*.

Funding resources are available for artists on the local government level, but this support also varies from city to city. Artists in Seattle, Washington, for example, can find support through art agencies on both the county and city level. The King County Arts Commission, part of the King County Cultural Resources Division, supports visual artists in Seattle and the surrounding county through four programs: 1) 1% for the Arts for King County, which commissions new works for new public construction; 2) Special Project Program for New Works, where artists, writers, musicians, and other artists can receive support to create new works to present to the public, such as works of art, lectures, or workshops; for visual artists, this fund primarily supports temporary,

alternative works in unusual locations to complement the 1% for the Arts Program which usually funds permanent works of art; 3) the Permanent Art Collection of King County, where works by local artists are purchased and rotated throughout public buildings in King County; and 4) the gallery of the Cultural Resources Division, showing artwork of unrepresented artists. In addition, the city-run Seattle Arts Commission has its own Percent for the Arts Program, with open national competitions for art in city capital improvement projects, including new buildings, parks, sports facilities, and so on. It has a Portable Works Collection of 1,500 pieces by Northwest artists that circulate through city offices. It also sponsors the Seattle Artists Program, commissioning ten artists every year to do new works with size the only limitation. The Seattle Arts Commission publishes a newsletter listing their own and other national and regional competitions and opportunities for visual artists. Again, contact your area's agencies for particulars about programs in your district. For addresses and telephone numbers, call the NEA's Office of Public Partnership for Local Art Agencies or call the National Assembly of Local Art Agencies.

In addition to governmental agencies, *foundations* also support artists and art organizations through grants. A foundation is a nonprofit, nongovernmental organization whose purpose generally is dispersing funds for cultural, scientific, or social advancement. The foundation is usually started by an endowment fund, which is invested along with its other assets; the resulting income constitutes the funds for grants. Private independent foundations are usually started with the gift of a single individual or family. If still run by family members, it is considered a family foundation. Company-sponsored foundations are legally distinct entities funded through the profits of a parent company or corporation. However, the funding decisions of some such foundations are influenced by the general business interests of the parent corporation. Some corporations support both a separate foundation and also a corporate-giving program within the company. (See Chapter 14 for further discussion of soliciting support directly from businesses.)

Foundations tend to give project grants, either matching or nonmatching. As a group, foundations give the great majority of their grants to nonprofit, tax-exempt, charitable, or service organizations in part because of Internal Revenue Service and other government restrictions. Foundation grants to individuals can be given for study, travel, or similar purposes, but foundations are regulated on their application, screening, and follow-up procedures.

There are many, many different foundations, and only a small portion of them support the arts. Even among these, each foundation has a particular field of interest within the arts, specific types of support it gives, and guidelines determining to whom and where the funding goes. *Money to Work II: Funding for Visual Artists*, edited by Helen M. Brunner and Donald H. Russell, is probably the source for grant information that is most specifically directed to the individual visual artist. It lists 250+ sources of funding in all media areas, including foundations, government agencies, and residencies.

The name, address, telephone number, and contact person of each granting organization are listed, followed by the purpose and description of the award, application procedures, selection process, and other information. Three publications edited by Suzanne Niemeyer entitled *Money for Film and Video Artists*, *Money for Performing Artists*, and *Money for Visual Artists* list many support possibilities for artists, including project support and study and travel grants. The *Directory of Research Grants* lists more than six thousand private foundations and governmental agencies that give grants to both individuals and organizations in all fields. The subject index helps you identify foundations that give to the arts. Again, entries include names, addresses, brief descriptions of grant programs, and some application requirements.

Other resources to consult are the publications of the Foundation Center, an independent organization established by foundations to provide information on private philanthropic giving. The Foundation Center's *Foundation Grants to Individuals*, lists 2,300 foundations that make grants to individuals in all fields. A subject index helps you locate grants for the arts in general, including visual arts. Entries list names, addresses, brief descriptions of grant programs, and some application requirements. The bibliographic listings at the front of *Foundation Grants to Individuals* should also be helpful to emerging artists. *The Guide to U.S. Foundations, Their Trustees, Officers and Donors* contains brief information on more than thirty-four thousand large and small local foundations but does not necessarily identify which ones support the arts. At the front of the Guide, however, is a helpful listing of states' directories of foundations that operate within their borders; addresses and telephone numbers indicate where these directories can be acquired. The *Foundation Directory*, a guide to six thousand of the largest private foundations, is probably too general in its scope and too much oriented toward funding for nonprofit organizations to be immediately helpful to artists. Call the Foundation Center in New York for local libraries with these directories in their collections.

Collectively, these various publications and directories cover large foundations and a host of smaller ones. In addition, there are very small foundations that operate on a strictly local level, with little endowment, limited budgets, and no staff. These foundations represent a small percentage of the total philathropic giving for the arts, are not found in directories, and are simply known by word of mouth within certain communities.

The amount of money given in grants to individuals is small compared to grants given to established nonprofit organizations. If your project supports or complements the mission of a nonprofit arts organization in your area, consider asking them to sponsor your project. In this way, the credibility of your project is bolstered by association with the organization, and you can solicit funding from more sources (see Chapter 14 for more information on nonprofit organization sponsorship). If you do have organizational sponsorship, consult the *National Guide to Funding in Arts and*

Culture, also published by the Foundation Center, for foundations that have a proven history of giving to arts organizations. This guide is arranged by state, listing the foundation name and limitations on funding. Following that are the recent grants the foundation has made, including the organization funded, the amount given and a short description of the use of the grant money, which is helpful in targeting the foundations that are likely to support your project.

Once you have digested the overload of information available in directories, you will probably have a list of foundations that may possibly fund you or your project. But directories give only basic information about granting agencies, foundations, and grant programs. How do you get more information to evaluate them, pursue the most likely ones first, and avoid wasted effort?

First, ruthlessly weed out all foundations for which you meet some of the application restrictions but not all. Foundations with published guidelines cannot ignore their application standards to accommodate you. Government agencies awarding fellowships are obliged by law to adhere to their published guidelines for application.

To find out more information about a particular foundation, look up its most recent IRS Forms 990-PF, which every private foundation must file every year with the Internal Revenue Service. Form 990-PF lists all grants paid by a foundation and the dollar amount received, which helps you evaluate what it is likely to fund in the future based on what it has funded in the past. These forms become part of the public record and all are available for inspection through the Foundation Center's New York and Washington, DC, reference library. Some local libraries in cooperation with the Foundation Center carry copies of 990-PFs for foundations within their states.

As you narrow the field of possible foundations, call the foundations' offices and ask them to describe their funding priorities. Ask to be sent any printed information, including annual reports, descriptions of their funding areas, brochures on grant programs, lists of past grants awarded by the foundation, application forms and application guidelines. Briefly describe your project concept to a knowledgeable person on the staff to find out if it falls within their area of interest and if they have any suggestions. If you can, visit the foundation office and become known to the staff.

This extra research should enable you to target the most likely foundations for your project.

Finally, faculty and graduate students can apply for project, travel, or research grants available at their universities, especially large research universities. With less competition, these grants are more likely to be funded than applications to foundations or government agencies. The granting programs vary from institution to institution, as do funding guidelines and amounts given. Request more information about grant programs at the graduate school, academic dean's office, provost, or university research office.

WRITING A GRANT APPLICATION

Government granting agencies usually provide application forms and guidelines to anyone applying for grants. They may also sponsor seminars instructing applicants on the kinds of projects likely to be funded and ways to structure an application. Some large foundations do the same. Gather as much information as possible before you begin. Get copies of the proper application forms and instructions and follow them rigorously. Be sure to answer all points and check to see that your project conforms to time frames and allowable cost. Submit the requested number of copies, and collect the mandatory signatures from sponsors. Many fellowships require slides of your work, which peer panels review when selecting fellowship recipients. It is absolutely essential that your slides be top quality and clear and adequately show your work.

Some foundations do not have application forms or detailed guidelines. If so, call the foundation for advice on grant applications. Use the following for suggestions to structure your proposal for such a foundation. Incorporate whatever is appropriate for your project.

Cover letter. This letter is not, strictly speaking, part of your proposal, but should name the grant for which you are applying, explain the purpose of your proposal, identify prominent persons if they recommended you to this foundation, and include necessary details such as where you can be reached.

Identification of the proposal. At the beginning of your proposal, or on a separate title page, indicate 1) the name of your proposal; 2) the foundation to which you are applying; 3) your name, address, and telephone number; and 4) the date.

Abstract or summary. For long proposals (in excess of six pages), prepare a one-page summary of all important points.

Objectives. This should be a brief description of the specific benefits to come from the particular research, project, or work you want to do.

Background information. Describe your background and competence in relation to this proposal. Why is your project stimulating, necessary, or beneficial? If others are doing work like it, how is yours different?

Project description. This section should answer the following questions: 1) Who will do the project? 2) What will be done? 3) For whom will the project be done? 4) Why will the project be done? 5) Where and when will the project be executed? You may use a combination of written descriptions, diagrams, drawings, photographs or other visual material. If applying to a foundation interested in enhancing social welfare through art, identify your host venue and anticipated audience and show how they will benefit from your project.

Technical support. This section should describe the equipment, personnel assistance, and facilities you already have for the project, and also what you still need in these areas.

Budget. Submit a total budget, listing every expense item and cost. Indicate which items will be covered by donations from other sources. Allow 10 percent extra for materials and supplies in case of cost increases. Any fee you intend to pay yourself for your time and talent is taxable income, so allow extra to ensure yourself fair pay after taxes.

Evaluation/conclusion. How will you evaluate whether or not your project is successful? Do you envision any follow-up projects to it?

Supporting documents. Include pertinent materials such as your resume, the resumes of other participants, a letter of support from the host venue, or letters from other donors to the project.

Your proposal should be as brief and concise as possible. Three to five pages is usually adequate. Avoid obscure jargon; your purpose is to explain your idea, not to mystify your reader. Equally important, avoid generalizations and platitudes. If you are proposing to paint a mural for a community center, "bringing culture to the masses" is too general an objective for your project, whereas "developing a design that reflects the unique architecture and history of the neighborhood" may be more pointed. Be positive, emphasizing the benefits to come from your project versus dwelling on inadequacies.

Presentation is important. Your proposal should be well packaged, on nice paper, with clean readable copy. Break up big blocks of solid type with indentations, titles, and subheadings. All visual materials should look professional. Have friends or art professionals review your proposal for content issues and proofread it for grammar and spelling errors before you submit it.

ARTIST-IN-RESIDENCE PROGRAMS

Residency programs give artists the opportunity to concentrate on their art while living in a situation conducive to working. Some residencies are like retreats, located in remote or rustic settings, while others enable artists to live and work in major art centers either in the United States or abroad. The following are the kinds of sponsors for residency programs:

- Art colonies or art communities are centers with living accommodations and work facilities that are often located in retreat-like settings. Some are devoted to the work and exchange of ideas among visual artists only, while others mix artists with writers, musicians, and so on.
- Institution-sponsored residencies are associated with art schools, universities, or museums. Some such residencies offer specific courses of study that residents can take.

- Government-sponsored residencies, usually state- or city-funded, place artists in schools or other tax-supported centers. Artists give demonstrations, lectures, or work in open studios as resources for students or citizens.
- Industry-sponsored residencies are offered by a few businesses that produce utilitarian or decorative items in a specific media, such as ceramics, or using a particular process, such as mold making or casting. With these residencies, artists have access to industrial-scale fabricating equipment.

Particular details of residency vary tremendously from program to program. While no program offers a complete range of benefits, all residencies offer some of the following:

Studios, either private or shared

Access to equipment or information, such as a sculpture shop, photography darkrooms, video equipment, printmaking facilities, libraries, or archives

Exhibition opportunity, sometimes with catalogs

Opportunity to work with other artists in residence

Artists' slide registries, maintained by some programs

Housing, sometimes with accommodations for families

Meals

Costs to artists vary even more. Some residency programs receive foundation, grant, or tax support, and thus not only pay the cost of residence but also provide artists a small to substantial monthly stipend while they are in residence. A few even give extra funds for art materials or for air fare to and from the residency. On the other hand, others charge for access to labs, housing, and/or meals. These fees range from minimal to considerable. Usually, government-sponsored residencies pay the artist, especially when teaching and/or open studio are required. Art colonies usually charge fees, but many offer options to offset costs. For example, some offer scholarships or fellowships, and some allow residents to work a certain number of hours a week in exchange for residency fees. In these cases, the benefits of the facilities and the advantage of working with other artists in residence must be weighed against the cost.

The sponsor sometimes fixes the length of residency. In other cases, the artist chooses a time period between a set minimum and maximum. The shortest residencies are two weeks long. Much more common are those that are one to six months in length. A few last as long as two years.

There may be media, content, geographic, or career-level restrictions on those who apply for residencies. Thus, some residencies are media-specific, for example, for photography, printmaking, or book arts only. Some focus on a particular theme. Some are open only to artists living in a certain geographic

area. Some are available only to students, to emerging artists, or to those in mid-career. Requirements on residents vary, with some programs mandating that artists-in-residence hold open studio days, give lectures, or teach courses, and others listing no specific requirements.

Listing of residency opportunities can be found in a number of periodicals and books:

- Artist resource books and publications list names, addresses, and brief descriptions of residency programs, for example, the previously mentioned *Money for Film and Video Artists, Money for Performing Artists* and *Money for Visual Artists*, all edited by Suzanne Niemeyer, and *Money to Work II: Funding for Visual Artists*, edited by Helen M. Brunner and Donald H. Russell.
- Directories, such as *Organizing Artists: A Document and Directory of the National Association of Artists' Organizations* and the *Directory of Research Grants* give names and addresses of residency programs.
- Professional publications, such as the *CAA News*, the bimonthly newsletter of the College Art Association, list names, addresses, and brief descriptions of some residencies when an application deadline is upcoming.
- National and regional art magazines also list some residencies in their announcement and classified sections when the application deadline is upcoming.
- On-line information sources, such as Arts Wire, list residencies when an application deadline is upcoming.
- The Visual Artist Information Hotline has information on colonies and residencies.
- Your state arts agency, local art agency, or city cultural affairs department will have information on residency programs they sponsor.
- College and university art departments often post advertisements for residency programs on their bulletin boards.

Most listings merely inform you where to write for complete descriptions and application forms. Once received, review all material carefully to evaluate which residency program suits you. If the residence site is unknown to you, request pictures or descriptions of available housing, equipment, and labs. Get a list of artists who have previously been in residence. Ask mentors and friends about the reputation of various programs.

Residencies usually require that applicants send written and visual materials that attest to their art-making, experience, and vision. For example, you may be required to submit some combination of resume, slides, statement, project proposal, or letters of recommendation. Some ask you to complete questionnaires or interview you by telephone. Competition for the best residency programs is very intense.

Lin Hixson
Photo by Ken Thompson

ARTIST INTERVIEW: LIN HIXSON

Lin Hixson is a performance artist who teaches time-based courses on sound, video, performance, film, and installation at the School of the Art Institute of Chicago. Topics discussed in her interview include sources of funding for artists in general, and particular problems facing performance artists.

You are part of the performance group, Goat Island. How is the group funded?

Goat Island is a nonprofit organization. We get NEA funding, Illinois Arts Council funding, and city funding. We get fees when we perform. Our total funding—this is for five people—probably equals somewhere between twenty and thirty thousand dollars a year. And we're considered to be doing pretty well. We had hoped we could hold just part-time jobs and do the company, but we all have full-time jobs to support ourselves. And there's no doubt in my mind that for each of us Goat Island is a full-time job in and of itself.

In the beginning we put our own money into it. We don't anymore but now our contribution is the time we put in. Right now the group

(continued)

Goat Island/Lin Hixson, director. Can't Take Johnny to the Funeral. 1991. Perfor-
mance featuring Timothy McCain (left), Karen Christopher (right).
Photo by Eileen Ryan

(continued from previous page)

usually gets paid a thousand dollars to twelve hundred a year above
expenses and that's for working three or four times a week and per-
forming. But we get to travel and our travel expenses are paid. The
first piece we did, we toured and didn't get paid. We borrowed a van
and did our work in five different places around the country. Then
the next year we got some funding because, of course, the work was
seen. So it really was worth the investment.

We are planning our fourth tour to England and we occasionally tour
around the States. Most of our support has come from the United
Kingdom. Our last piece was commissioned by England and we're
doing a little book which was commissioned by England. The U.K. is
bringing over a retrospective of our last three works.

How do you account for that support?

In the U.K., we were framed a specific way by our presenters and
the press. They took a lot of time putting us in a certain context, so

(continued)

(continued from previous page)

we always do well there with audiences. In the States, we do great in Chicago. But it's hard to place Goat Island. For some reason, here people have trouble marketing us and so it's very difficult for anyone to afford us. Our work is disconcerting because it is very physically demanding and the performers aren't trained dancers. It's not pretty work by any stretch of the imagination. But we're not interested in just touring our work. We want to develop ongoing relationships with different cities, communities.

As director, do you do the clerical and administrative work, write the grants, and do the booking?

After graduate school, one of the things I loved about performance was not being at the mercy of the gallery system. I presented my own work in a loft and people came and I could charge money at the door to cover my costs. I had control over what the program was, what the space was. Sometimes in a regressed state I wish that someone would just take care of all of this administrative stuff for me because it's truly exhausting. The other side, which I wouldn't trade, is making all the important decisions.

At first we all did grant writing but now Matthew, my partner and a member of the group, writes most of the grants. We have someone who does our typing, computer work and the mailing list for five hours a week at ten dollars an hour. We had an agent for a while but it didn't work out.

We were part of a pilot program the MacArthur Foundation did two years ago where they funded consultants to work with the nonprofit artists' organizations in Chicago. These consultants were very helpful in their views on the 1990s and the possibilities for the future. They felt strongly that the old nonprofit model was not working for a small art collective like Goat Island. That model centered on building a board that fund-raises. Today, most people are overextended and a fund-raising commitment is a lot to ask. With all of us holding full-time jobs, running our organization, and trying to make art, forming a large board and keeping it going was impossible.

They suggested that we stay small. So we have a board, because the government requires it to be a nonprofit. You have to have certain structures in place with a certain number of meetings. But our board is

(continued)

(continued from previous page)

us and a videographer and designer who now are part of Goat Island. There's nothing illegal about us being on our board. It just means that we don't get any corporate funding or foundation funding. But the likelihood of us getting that is slim anyway with the current situation. We want to put people on our board who we know are dedicated to the organization and its philosophy.

Do you approach corporations for things like in-kind donations for your projects?

Usually we work with other artists and theater groups for in-kind donations, like borrowing lights and risers. There's funding for specific projects from corporations. You don't have to be a nonprofit yourself. Individual artists can apply and have an already-established organization be a fiscal sponsor. Each corporation is different, and their guidelines are continually changing. There's an emphasis now on community and education. I have mixed feelings about it. Many artists excel as educators, but some have more introverted talents, and they must be supported as well. Community and education are important issues and are vital to expanding the idea of art. I object when they are used as boundaries and are reductive in their definition of art.

Most of Goat Island's grants are from governmental agencies.

Yes, we are all federally and locally funded. Which is a bad sign by the way, because government funding is diminishing. The whole restructuring of the NEA has affected us and our funding has declined. So it is even more important to build these communities in Portland, the U. K., and Chicago where we can continue doing our work.

A comparable performance group, mid-level in the U. K., similar to Goat Island, with five or six people, earns around $150,000 from government funding. And the government funding in the U. K. is considered abysmal. Although funding is diminishing there, many artists still assume their main activity will be art-making and this will be their means of support.

The Wooster group is another model. We're compared to them even though we're very different. They are a performance group in New York and luckily bought their space in the 1970s. They also developed

(continued)

(continued from previous page)

their corporate and foundation support. Willem Dafoe is a member of the group and works in Hollywood as an actor, giving them some support. Performance artists can try the entertainment route. For a while people were modelling themselves after Laurie Anderson, Anne Magnuson, Eric Bogosian, and Spalding Gray. Those artists go between Hollywood and performance.

What do you advise for performance artists who are starting out, who do not yet have a following or a reputation?

The minute you get into performance art you're talking about a form that's marginal. The reality is that artists will have to hold jobs, and do their performance work as well. The trick is to approach both creatively, to see that they are interconnected as all things are in life.

Emerging performance artists can get small grants here and there, but there is not an ongoing system of support. The most important things are to continue making your work and to continue your creative life. As long as you are doing this, you are creating possibilities for yourself.

Locating and developing a community around your work can be very helpful. And once you develop a solid core, it continues to grow and you will find people willing to support your work because it has become meaningful and valuable to that group. It is an ongoing process of interaction and interdependence—not only an art process but a life process as well.

Chapter 14

OTHER FINANCIAL SUPPORT

PUBLIC ART PROGRAMS

Public art programs are government-funded or governmentally legislated art acquisition programs for new construction or major renovation projects. The concept originated on the federal level, with the General Services Administration (GSA) Art-in-Architecture Program, which mandated that all new construction, newly purchased, or renovated federal buildings set aside .5 percent of the cost toward acquiring and installing art in or around the building. The GSA program is still in place, and in addition has been used as a model for many states and some cities that have also initiated a Percent for the Arts Program for all new state-funded building projects. Public art programs are not limited to building construction. Recently enacted legislation called for government-funded "enhancement" of all means of above-surface transportation, including highways, light rail systems, and bike paths. Each state is allowed to interpret how enhancement will be carried out within its borders, but many are interpreting it as installation of public art or as artists collaborating with designers and engineers in the design of these transportation systems. Also, waterways legislation has supported the concept that harbors and ports should be accessible to the public, the model for which is Battery Park in New York City. The opportunity for public art to be installed in these areas is thus increased.

The above programs represent tax monies spent to acquire art for federal, state, and local government projects. In addition, legislation for funding for public art has been expanded into the private sector. Each state, working with municipalities, can identify areas within its borders as community redevelopment zones, which means that private developers receive a tax break or incentives on any new construction or major renovation done within the zone. The redevelopment of the zone is managed by a community redevelopment agency (CRA). Developers in these zones must spend 1 percent of all construction costs on the acquisition and installation of public art. There are many ways that developers can satisfy that requirement. A piece of sculpture in front of a building is one example. A more complex example is the redevelopment of the Bunker Hill area in Los Angeles, where the various developers of adjacent high-rise residences and office buildings formed a business association and assessed themselves a tax to build the Museum of Contemporary Art amid their

structures. Other examples of massive redevelopment projects were Horten Plaza in San Diego and Battery Park in New York.

All of these government-funded and privately funded public art projects are associated with new building construction, renovation, or redevelopment. But there are also various community-based organizations that sponsor their own public art projects, both permanent or temporary, separate from any construction. Festivals bring art to certain city areas for short time periods by providing funding for artists to do performance art or temporary installations. On the more permanent side are publicly or privately funded mural programs. An example is Artmakers, Inc., an artist cooperative that painted murals in neighborhoods of New York far from the cultural centers in Manhattan. They worked with housing organizations to identify sites, develop themes, and seek grants, donations, and private and public funding for their projects.

Thus, every year, many public art projects are initiated across the country. Open competitions are held for all federal- and state-funded projects, where artists are invited to submit proposals for projects. Finalists are selected from among all proposals, and then the commission is awarded to one from this smaller group. For privately funded projects, the developers have the right to select artists of their choice. Some do choose their own, while others use private consultants, hold open competitons, or work with the CRA in their area.

There are a number of sources available to artists to find out about open competitions for public art projects:

- Architecture magazines and national and regional art magazines publish minimal information about competitions in their announcement or classified sections. You then can write to the sponsors for complete information.
- *Public Art Review,* issued twice a year, has short articles, results of recent competitions, and listings of new ones.
- State art agencies maintain mailing lists of artists interested in receiving notices about upcoming public art project competitions. Some state-funded public art projects are open only to state residents, but for many, any U.S. artist is eligible to submit a proposal. Listings of state art agencies can be found in *Organizing Artists: A Document and Directory of the National Association of Artists' Organizations,* or in the *Guide to the National Endowment for the Arts.* Call and ask to be added to the state art agency's mailing list.
- Cities' cultural affairs departments and CRAs also maintain mailing lists for those interested in notification about competitions. The telephone numbers can be found through directory assistance, through state art agencies, at libraries, and at city or county government offices. Some are administered through the Parks and Recreation offices. In addition, you can call the NEA's Office of Public Partnership for Local Art Agencies or the National Assembly of Local Art Agencies.
- The GSA Art-in-Architecture Program maintains a registry of slides and resumes of artists who wish to be considered for its public art commissions.

Call or write the GSA for information on current competitions and guidelines for appropriate visual and written material.

Generally the process of awarding a public art commission to an artist in an open competition is a two-step procedure. In round one, all artists who wish to enter the competition submit a cover letter, a short written concept statement for the project, a resume and ten to twenty slides of their artwork or of previous public projects. Three to five entries are selected as finalists by a panel of artists, art professionals, and representatives of the sponsoring entity. In round two, the finalists present to the panel their ideas, usually as in-depth oral presentations. If a consultant has been hired by a private developer, the consultant may make the presentation of all finalists' work to the developer. In either case, finalists almost always have to do substantial research of the site and of the local community to make an effective proposal. Finalists using fabricators to construct some or all of the work must gather cost estimates. For some second-round presentations, finalists must develop extensive written material and visual aids for their presentation, with models, architect's drawings, timetables, and detailed budgets. If such an elaborate preparation is required, finalists should receive an honorarium as partial compensation for their work, whether or not their ideas were chosen in the end.

While a public art commission may be very exciting and gratifying for an artist, there are some pitfalls. Developing a first-round proposal and then perhaps a second-round in-depth presentation can be very time-consuming, which may be frustrating if you end up without the commission. If novices to public art are awarded commissions, they frequently have great difficulty developing realistic timetables and budgets. Even those with experience have trouble anticipating the pace of major construction projects, not to mention the havoc that bad weather, labor disputes, and budget shortfalls can wreak. The cost can easily run up higher than expected.

If you are awarded a public art commission, you will be asked to sign a lengthy contract drafted by the sponsoring agency. Review this contract with a lawyer before you sign. You should realize that provisions within the contract may carry hidden obligations. For example, one artist who was awarded a public art project for a new light-rail train station was surprised when "supervising installation of the artwork," as stipulated in her contract, also meant that she had to attend a four-hour training session to learn how to emergency-stop a train.

Many artists have professional fabricators make most of a public art piece, because of the large scale of many such projects and also to meet building code standards. In such cases, artists then produce detailed maps, drawings, or plans for fabricators to follow. To expedite this process, some artists repeatedly employ the same fabricators, who then become familiar with the artists' aesthetic and way of working.

You should enter only those competitions for public art projects that play to your strengths as an artist. For example, if you produce freestanding sculpture, enter those competitions that request objects. On the other hand, for

projects with aspects of architecture, engineering, or urban planning, you may need professional experience to make an effective proposal. If a particular competition presents design problems and regulatory hurdles outside your expertise, you may try to join architects, engineers, or others with experience to create design teams for public art projects.

As a final note, some artists knowledgeable about public art projects have initiated their own projects, by identifying sites, developing the art, and applying for funding, much like Artmakers, Inc., in New York. In these cases, the artists act as producers in order to execute a project where they have more control, versus conforming to preset project descriptions and the ideas of sponsors.

COMMISSIONS

Another source of funding for artists are private commissions, when an artist agrees to produce a special work for a client. The prospect of working on a commissioned piece is exciting, but throughout the process artists and clients need to take certain precautions to avoid disappointment or dispute. When you sell an already-existing piece, the buyers see what they are getting and the transaction may be very simple. Commissions represent a more lengthy relationship between artist and clients where both parties must communicate and agree on a number of points, including the nature of the piece being made, the timetable for completion, approval procedures and payment schedule. Without this understanding, you run the risk of disappointment, failed expectations and alienating a potential backer. The following steps will greatly increase the probability of a happy conclusion to your commission: 1) artist and clients hold preliminary meetings to thoroughly discuss the potential commission; 2) the artist develops a commission proposal, including description, budgets, and preparatory sketches or models; and 3) all parties sign a written contract specifying the work to be done and approval procedures. For elaborate commissions, these steps are essential; for very simple work, you can eliminate unnecessary procedures.

Preliminary meetings should include all persons who need to be pleased with the final results of your work. Meeting with only some of the decision makers may waste time until you have a sense of the entire group's tastes. At these meetings, bring samples of your own work or reproductions that can be easily seen. Good quality color prints of your work, as large as 11″ × 14″, in a compact portfolio, make an effective presentation. Alternatives include 4″ × 5″ transparencies, black-and-white prints, or color reproductions from catalogs or announcements; 35mm slides are least desirable for immediate viewing, because holding a sheet of slides to a window will not give your clients an adequate idea of your work. If you must use slides, bring a portable viewer or projector. With all visual material, be prepared to describe your work verbally.

If at this point your prospective clients express enthusiasm or interest, try to elicit a description of the kind of artwork they desire. If your clients give you very little direction, they may be giving you artistic license or they may be terrible at knowing and expressing their ideas. A thorough discussion at this point will save you time and effort at later stages. Find out specifically what preexisting works of art they like, and why. Ask how they would like the commissioned piece to look, what qualities they want communicated, and whom they envision as the audience for the work. In your conversation, try to get specific meanings for casual remarks. For example, does "impressive" mean big or the use of expensive materials? Does "colorful" mean a few bold colors or the spectrum in pastels? If site-specific, visit the location where the piece will be installed. Does the site need to be modified, and who will be responsible for that work and expense? Ask them how much they are willing to spend, because you need to know the approximate budget for the project.

In some cases, you may never meet your clients, if they have hired art consultants or designers to oversee a project, including selecting artists for commission work. All communication may go through these intermediaries, for one of two reasons: 1) the clients do not have time to devote to the project, or 2) the intermediaries want to ensure that they receive their fee. Getting a sense of what the clients want may be more difficult in these circumstances.

Go no further than preliminary meetings if you are not qualified to do the work, not interested in making what the client wants, cannot get sufficient information from the clients to proceed, or feel that you would be drastically underpaid for the work requested. Do not proceed on the hope that they will change their minds or that things will work out in time. If you decide to proceed, develop a simple pencil sketch to indicate your ideas. If your client likes the general direction of the work and wants to proceed, you are ready to develop a full proposal and sign a contract.

The full proposal is a detailed written presentation of your idea for a commission, based on preliminary discussion. It consists of a project description, budget, and preparatory sketches or models. The entire proposal package should make clear the visual appearance of the piece, its content, and the cost of producing it.

The preparatory sketches or models are perhaps the most important part of the proposal, as they translate your preliminary discussions into concrete images. They should also indicate the scale of the piece and, if site-specific, its location when installed. Do not skip or skimp on your visual materials, especially if you have never worked with particular clients before or if you are working through a consultant or designer, because the visual materials enable you to know whether you and your clients really agree about the work. The purpose of the written description is to clarify any points that cannot be communicated visually, such as upkeep and maintenance that a particular piece may require, special lighting needs, or necessary modifications to the existing space.

The budget should list a short description and dollar amount for the following items:

- Your fee for the work, which compensates you for your time, ability, and efforts. Allow for income tax you will have to pay, and any fees to agents, consultants, or dealers who helped you get the commission.
- Estimated cost of materials, plus 10 percent for cost overruns and price increases, if your clients are paying for the materials
- Other expenses you will incur for which the client will pay, for example, rented scaffolding, rented vehicles for hauling, insurance, assistants' fees, fabricator's fees, and so on

In addition, list without estimates all the items for which the clients assume total responsibility, such as modifying the existing space to accommodate your work, so that there is no question later about these particular points.

Your proposal should be "packaged" well, that is, its appearance, presentation, organization, and thoroughness should be impressive to your clients, especially new clients. The general public often uses presentation and packaging to gauge how creative you are as an artist and how reliable you might be to deliver a satisfactory result. Also, you may be competing against other artists for the commission. Since your clients may show your sketches and models to associates, friends, and other professionals, you benefit when the work is well organized and complete. So while a scribble on a napkin may suffice for you and may clearly communicate your idea, its casual presentation may fail to excite your clients.

These proposals require your creative efforts and a considerable amount of time. Well-established artists with reputations can request fees for developing proposals because the demand for them is great. Emerging artists sometimes do not have sufficient clout to request a proposal fee, or may offer to apply it toward the total commission cost, if their proposal is accepted. However, you should definitely be paid separately for the proposal in the following cases: 1) The clients specifically request a substantial investment in time, effort or materials; or 2) the preparatory work will become part of the final commissioned piece, for example, if you are to produce a series of twenty-five photographs and complete three in advance as samples.

After reviewing your proposal, your clients may want some changes. Minor ones can probably be easily accommodated. You may request an additional fee if substantive changes will require you to make new drawings or models, to ensure that the clients are not just fishing around.

If you expect to be paid for developing a proposal, draft a short contract or letter of agreement specifying what you will deliver and how much you are to be paid, before you begin any work. Indicate also the charge for revisions. Specify that all materials for rejected proposals are to be returned to you and that you retain the copyright on the materials. Sample proposal contracts that you can modify for your own purposes are available at an affiliate office of Volunteer Lawyers for the Arts.

As soon as your proposal has received final approval, have a commission contract drafted and signed by both parties. The commission contract should specify the product to be made and the approval procedure to be followed. The primary reason for commission contracts is to avoid disputes. The process necessary to reach a written, signed contract ensures a more solid understanding than most oral agreements can. Sample commission contracts are available through local Volunteer Lawyers for the Arts. Consult a lawyer before entering into any agreement with substantial consequences.

Contracts on private commissions should cover the following points:

Parties to the agreement. Besides the artist, everyone with decision-making power should be named.

The artwork to be made. Describe fully what is to be made, in what medium, what size, and where installed, if site-specific. List the preparatory sketches and models that were approved by the clients, and when.

Obligations of each party. List what the artist and what the clients will contribute to the project, for example, if your client will provide insurance and will modify the site in a particular way.

Timetable. Specify starting and completion dates for the work. You may also want the right to extend the deadline if you become ill or temporarily disabled. Within the time frame, list dates when your clients will review and approve work-in-progress, to protect yourself both from interfering clients who kibitz all the time and also from preoccupied clients who never manage to see the piece and then do not like it in the end.

Pay and payment schedule. List the amount you will be paid and what the payment covers. Specify if you are to be reimbursed for expenses. Refer to the proposal budget which the clients approved. Receive one payment for the work up front, another partial payment every time your clients review and approve the work, and final payment upon delivery of the finished work. If at any time your clients fail to pay you, you should have the right to terminate the agreement and retain all prior payments and all completed work.

Procedures for changes or cancellation. You should limit the amount of revisions your clients may request on the work in progress. Your preparatory drawings and models serve as a benchmark in cases where clients waffle on what they want. Stipulate extra payment for substantial revisions, to cover redesign costs, added material costs, and extra time. Should your clients abandon the project once you have begun, retain all prior payments and also a kill fee to compensate you for having committed time on an aborted project when you could have been working on others. You also want to reserve the right to sell the rejected work to another buyer, if possible.

Copyright and moral rights. Even though artists have copyright and moral rights protection by law (see Chapter 15), the average client may not know or understand these laws. Spelling them out in your contract may avert future disputes.

Commissions for works in public locations may require more considerations than works in private residences. For example, if you are commissioned to paint a mural in a bank lobby, you may encounter added costs in legal liability, workmen's compensation insurance, or compliance with building codes. Again, consult a lawyer to find out how to deal with these points in a contract.

ARTS ORGANIZATIONS

Arts organizations can provide needed support to emerging artists who have a particular project they wish to implement. Alternative spaces, community organizations, and artist organization are all possible sponsors of artists' projects. Emerging artists lack a track record, a proven history of successful projects, and an established reputation. Therefore, trying to pull together a project as an individual may be frustrating and difficult. If you work through an established organization to realize your project, you borrow the reputation of the organization, which may give you added clout when dealing with:

Foundations, when applying for grants

Businesses, when requesting donations

Local government, when applying for permits and waivers

Communities and individuals, when asking for their cooperation or participation

Thus, association with an arts organization may enable you to garner outside financial backing while providing you with various forms of intangible support, and in some cases actually provide monetary support.

There are two ways to work through established organizations to realize your project. In a formal long-term relationship, the organization sponsors a regular program with you in charge, such as a series of exhibitions, a video project with public access cable television, a lecture series, or a group of performances. Your relationship with the organization might be as a regular volunteer, or as part-time or full-time staff.

A second way to work with established organizations is on a project basis. You present your concept to the organizations and ask them to sponsor you for the term of the project. Organizations have mission statements that articulate their long-term purpose and commitments. The mission statement is a permanent document, but the ways to realize the mission are variable. Your project should further the mission of the organization. To present your project, first prepare some written material: a summary of your project, its objectives, a complete project description, and budget, along with your resume tailored to emphasize your competence to complete the project. Make an appointment with the director of the organization. Give a summary of your project, indicate how it helps in realizing the mission of the organization, and ask specifically for the

support you want. If the director is interested in the project, it will probably be submitted to the board for approval. If not, ask why and request suggestions.

If your sponsoring organization is a nonprofit, you can request that it act as fiscal receiver for your project. This means that donations for your project would go directly to the nonprofit organization, which then reimburses you, and your donors receive a tax break because their contributions are tax-deductible. Because fiscal receivers' funds can comprise only a small percentage of their total budget, nonprofit organizations are reluctant to act very often as fiscal receivers. They usually agree to do so only in situations where the project coordinator is well known to the organizations, and where the purpose of the project fits closely with their stated mission. Usually, the board of the nonprofit must vote to act as fiscal receivers in any particular case. The fiscal receiver retains a percentage of all donations, usually 7 to 10 percent, to cover the cost of acting as treasurer for you. Therefore, you will need to raise funds in excess of the cost of your project to cover the fiscal receiver.

SUPPORT FROM BUSINESSES

The competition for grant money is fierce and foundation giving is often restricted. As a result many artists working on projects look to the business community for support. Small businesses and large corporations do contribute to artists' projects, especially those firms with executives who have a long record of art patronage. Even firms that have never donated to the arts may support your project, provided it meets one of the following criteria:

Publicity. Projects that are public in nature, reach a wide audience, or are likely to be widely publicized are attractive to businesses. Such projects must make a generally positive impression that can be associated with their backers. Examples include murals, public monuments, historic markers, playgrounds, educational programs, lectures, public installations or displays of artwork, and so on.

Community Relations. Businesses may support projects executed in the immediate area where the business is located or where its customers live.

"Research and Development." Your project may be attractive if you innovatively use a product or process provided by the firm, and there is further marketing potential in your application.

A note before preceding: some corporations have their own foundations as conduits for their philanthropic activities (applying for funding through foundations is covered in Chapter 13). However, such foundations are not necessarily the sole conduits for donations by any one corporation. A corporation may separately fund projects, even if it also sponsors a foundation.

Make lists of possible businesses to approach, paying particular attention to small companies. While their donations may be modest compared to the

corporate giants, they may be more likely to contribute if they identify with your community.

Start locally to find small businesses and corporations to support your project, as you are more likely to receive aid from them than from out-of-town firms, even those known to support the arts. If your project is aimed at a particular population, such as adolescents or freeway commuters, make a list of firms that supply goods or services to that population. Some businesses will be easy and obvious choices, but with some imagination you might uncover more, for example, their food suppliers, their insurance companies, their favorite radio stations.

If your project is site-specific, such as a mural, note the names of small businesses in the vicinity. Make lists not only of retail stores and service-oriented businesses, but also manufacturers, construction companies, warehouses, and wholesalers.

For leads on larger corporations, consult geographic directories of corporations. The most beneficial are those covering your area only, because most corporations donate primarily near their plants, headquarters, or their customers. Among these more local directories, some cover an entire state, while others cover regions or municipal areas. For example, if looking for corporations in Santa Monica, California, you might consult the *Southern California Business Directory* for a listing of businesses in the southern half of the state, the *California Manufacturers' Register* for manufacturing companies, the *California Service Register* for service companies, or most immediately the *Directory of the Santa Monica Chamber of Commerce*. Other states and cities have comparable publications. Less helpful are national directories of public and private corporations, because the scope of their coverage is too broad. *Ward's Directory*, Dun and Bradstreet's *Million Dollar Directory*, and Moody's *Manuals* list the corporation's name, address, the CEO, its worth, number of employees, and a few sentences about the company. *Standard and Poor's Register of Corporations* is a national listing of publicly held companies that gives more information including financial history. These corporate directories are available through local chambers of commerce or in reference sections of large public libraries.

Another strategy is to approach corporations with executives who are interested in the arts. Once you have a list of local corporations and their CEOs, check the *Who's Who* in large public libraries to find out if these executives have any connection to the arts or to the community where you will do your project. Also, check the annual reports, publications, or stationery of arts organizations, museums, or alternative spaces for the listing of their boards of directors. The businesspeople on these boards may work at or own corporations that are receptive to the arts. *The Guide to U.S. Foundations, Their Trustees, Officers and Donors*, published by the Foundation Center, lists the names of trustees and managers of more than thirty-four thousand foundations. Again, the trustees of foundations that fund the arts may also be executives of corporations that support the arts.

Businesses may donate any of the following for projects they choose to support:

Funding. Some will make outright gifts of money.

Materials and supplies. Businesses will make gifts of materials, either those needed for making an art object or for constructing an art space. Food suppliers or retailers may donate food or beverages as refreshments for receptions or fund-raisers. Some firms may lend needed supplies, such as tables, chairs, lighting, scaffolding, and so on.

Space. Realtors or landlords may give free use of vacant spaces for a limited period of time. Businesses or schools may make available meeting rooms, theaters, or lecture halls with seating and audiovisual equipment for lectures, workshops, or performances.

Access to equipment. A manufacturer may allow on-site use of some special fabricating equipment needed for a project.

Personnel assistance. Staff with special skills may spend time working for a project. Examples might include accountants or lawyers to help a nonprofit organization, electricians, events organizers, publicists, among others.

Concerning cash gifts, some businesses are willing to make modest donations without your exerting tremendous amounts of effort to woo them. Therefore, you might break down your needs into "bite-size pieces" and plan to ask several firms for support, rather than hoping for everything from one. Concerning materials and supplies, some businesses have policies against giving gifts out of inventory. So, while asking for a needed video camera from a video manufacturer or retailer may seem logical, some firms may refuse you because their existence depends on selling such equipment, not giving it away. When approaching such businesses, be prepared to ask for other gifts, such as cash donations, use of space, or assistance from their personnel.

Prepare complete written documentation of the project. Included in the written materials should be:

- Description of your project, including its purpose, the targeted audience, its duration, and expected impact. This part is the heart of your proposal. Emphasize your project's aesthetic merit, and social merit if applicable, to avoid the appearance that it is merely a ploy to get goods and services that you are not willing to buy.
- Timetable for the project
- Budget, with list of other donors, if any
- Visual materials
- Your resume, and the resume or information sheet for any other individual or organization involved in the project
- The manner by which your donors will be acknowledged, for example, plaques on public sculpture or murals, credits at the ends of videotapes, or donors' lists on performance programs

To a great extent, your success in soliciting business donations is dependent upon your own credibility and the impression you make. Mention past experience that indicates you are capable of the project. Already having donors helps when making subsequent requests. To increase your credibility, get sponsors for your project, such as art organizations, alternative spaces, colleges, civic groups, or churches. Ask for letters of introduction from all sponsors.

The actual request for support is almost always made during a person-to-person meeting. Make your proposal to someone within a company who has the authority to make donations or gifts. Get the name and background of that person, if possible, from your sponsoring organization. Or try calling the firm directly, and asking secretaries or receptionists for information. It never hurts to ask to speak to the president. Be extremely courteous to secretaries and receptionists, or your inquiries may go no further.

Set an appointment for a half hour, if possible; you absolutely need at least fifteen minutes. During that time you have fundamentally three tasks: 1) to convince your prospective donors of the worth of your project; 2) to explain the importance of their contribution; and 3) to show the long-term benefits for the business. You should prepare an oral presentation, in which you introduce yourself, concisely explain the purpose of your project, identify the audience it will reach, and ask explicitly for a donation of a specific cash amount or specific equipment and supplies. Conclude with how the business will gain by being associated with your project. This presentation may be accompanied by any visual materials that make your project more concrete. You leave a copy of the written documentation with the prospective donors for their future reference; they should not be reading this material while you are making your presentation. Give donors a chance to ask questions. If you get a positive response, ask them to recommend others who might support the project. If you get no for an answer, ask for suggestions to help you in future solicitations. After each meeting, write a thank-you note, regardless of the response you received.

When meeting prospective donors, be articulate and concise, make eye contact, and try to establish rapport. Ask for what you need without waffling. Naturally, your appearance, style of presentation, and the professionalism of your supporting materials are critical for your success. Friends and mentors can be particularly helpful as you work on these questions of style.

Jenny Holzer
Photo by Michaela Zeidler (Courtesy Barbara
Gladstone Gallery, New York)

ARTIST INTERVIEW: JENNY HOLZER

Jenny Holzer's public texts address issues such as power, abuse, war, greed, and death. She has used posters, stone benches, electronic signs, and television broadcasts as media. Holzer represented the United States at the 1990 Venice Biennale.

Will you describe your process in conceptualizing your work and communicating your ideas to fabricators?

I usually begin by closing my eyes, and when I'm lucky I can see how the piece should be. Once that happens, I sometimes will make a drawing, and other times, I go straight from whatever I've seen to a conversation with the person who will fabricate the piece. I have a great working relationship with an engineer who makes my electronic signs, and often I can take my image to a test model by talking to him.

Because most of the works are site-specific, we don't have a chance to fine tune until we are in the space. So, for instance, before the Dia Foundation show, we came to the site and I realized that all my

(continued)

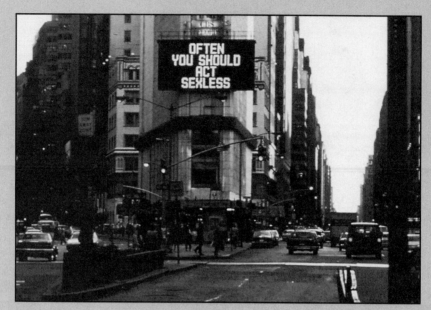

Jenny Holzer. Truisms. 1982. Installation, Spectacolor Board No. 1. Times Square, New York
(Courtesy Barbara Gladstone Gallery, New York)

(continued from previous page)

programming was wrong. My engineer had to synchronize the signs and I redid the programs.

For the installation at the Guggenheim, I went to the museum a number of times, and by standing there and walking around and staring, I decided where to place the spiral sign, and figured out where the benches should go. I did that in advance of the opening, but some of the essential stuff like making the sign work and doing the programming happened in the last twenty-four hours. It was a cliff-hanger! The sign didn't function immediately, and then we had to program in the few hours before the opening. I can look at this now and laugh, but it was unbelievable, because if the sign didn't work, then there was no show.

When you do site-specific pieces that are *really* specific—I don't happen to have a studio that is the size and shape of the Guggenheim—you do it when you have access.

(continued)

(continued from previous page)

What is your "studio time" like?

It's funny, not since I was in undergraduate school have I had much time, be it studio time, or whatever you want to call it. When I was in graduate school, I never had enough hours in the day because I had jobs. And then after I graduated, I was working x number of nights and days and it was hard to find peace. I thought this would be solved when I became a professional, but now I have no time because I do all kinds of things like being my own secretary. It is a machine that feeds on itself.

The equivalent to studio time for me is sitting at my desk and writing, and then I decide where the writing should go. Finally there's the administrative part about contracts and trips and site visits.

What kinds of agreements do you make with clients for commissioned work?

It really depends on the project. For some, it can be absolutely casual, and there is nothing in writing, and a handshake will do. Even a handshake is not always necessary. But, for example, if I work for a municipality, I need and want an elaborate contract to spell out who does what, who has what responsibilities and liabilities, when I am paid, you know, all that kind of stuff.

Responsibility for budget items, deadlines, insurance, publicity... Do you also specify protections like copyright and moral rights, even though they may be covered by law?

It's better to have that. Without being ridiculous, you try to put everything into the contract.

Who generates the contracts?

The all-new me generates the contracts, and lets the client modify it. Because then it's much closer to what I need. It's not a negotiating technique, it's that the city might not think of what I require. I perhaps am more familiar with what works best than they might be. You know, a contract is not always adversarial. It's just for clarity.

Do you get legal help in doing this?

Yep. And now that I've done a number of contracts and the attorneys have explained what they mean, I often can modify them myself.

(continued)

(continued from previous page)

I would say, get the most intelligent and knowledgeable attorney possible to make a first draft, and then read it until you understand (and not be embarrassed to ask questions until you do), and add whatever else might be desirable. Then realize that the other party may have different requirements, and that you'll have to go around a few times.

Do you find the process of working on a commissioned piece challenging or interesting?

More often than not, it is, but it's time consuming. It's a lot different than cooking up something at home and being autonomous—you know, being able to do exactly what you want when you want. It's laborious, sometimes frustrating, but usually, if both parties have goodwill and want the project to happen, it's fun. And often I learn something.

You started out making street posters. A cursory overview of your work may indicate that it is becoming more materialized, for example, the marble used for the installation at the Venice Biennale. Do you see your work that way?

Yes and no. Some of my stuff doesn't exist at all other than as an electronic impulse. Other things, like the installation for the Venice Biennale, did use materials that certainly are heavier and more baroque than street posters. But it's funny, even the museum installations have disappeared because they're up for a certain period of time and then they're broken into fragments. The Guggenheim piece probably is gone for good.

My career began in the streets for a number of reasons. The big one was that that's where I thought the work should be. Another reason was there were no galleries or museums interested in this sort of work.

Some things I do are nonexistent except when they are passing through a computer network. The museum and gallery installations indeed are clunkier than the street posters, but I'm not attached to tons of marble. I was trying to be site-specific in Venice which is the home of excess, but I don't foresee being in the stone business forever.

What process is involved in representing the United States in the Biennale?

As I understand it, and my understanding is imperfect, there is an international exhibitions committee that invites a number of curators

(continued)

(continued from previous page)

to submit proposals for a show of an artist or artists. And then, from those proposals, the committee picks a curator and his or her artist. For 1990, they selected Michael Auping. Auping was the curator at the Albright-Knox. I didn't know him, which was interesting. I think I met him once before.

Venice was funded a number of ways, and I don't know all of them. I'm not sure about government money. I believe the organizations in charge approached a number of foundations. I think the Pew Charitable Trust, and the Rockefeller Foundation gave money, and I could be forgetting some others. My gallery threw in money, I spent money. And Albright-Knox did, because they were the sponsoring institution.

You do take on provocative and difficult issues—war atrocities, AIDS, child abuse—and deal with these themes in public works.

I often write things on electronic signs that are considered unspeakable if I feel that these issues make the world turn, and in particular, turn for the worse. I'll broadcast something unmentionable if I feel it's a particularly bad brand of psychopathology harmful to people at large; I might try to hang that on the line so people can stare at it and recognize it for what it is. Sometimes I may talk about something tender and desirable that needs attention or recognition.

I concentrate on the horrific because I think, for the most part, good things take care of themselves. Occasionally, I celebrate something that I find wonderful.

Any advice for emerging artists?

My advice would be to make art only if you really must, and if you're prepared to have another job. It would be smart to acquire some kind of skill that's relatively high-paying so you can work half time, so you can fit art in.

Do it for love. Don't do it unless you feel compelled. If you're at all halfhearted, don't try. Go be a useful person of some other description, because art is such an odd thing, odd but wonderful. Do this if you're possessed, so that the work will be good enough, and you'll survive all the baloney you'll encounter.

Chapter 15

THE BUSINESS END

FINDING A STUDIO

Many artists look for the following qualities in studios:

Large work space

Low rent

Good lighting and/or high ceilings

Oversized doors or loading docks for moving materials or finished works

Convenient location for curators, critics, dealers, or collectors

Proximity to other artists

To meet these requirements, artists have gravitated to older industrial, manufacturing, and warehouse sections of large cities. Having outlived their usefulness as business structures, the buildings there can be recycled as studios because space is plentiful and cheap, and the amenities are adequate. When many artists live and work in the same area, a sense of community can develop, and the location becomes familiar to art professionals.

Finding such areas in large cities should be fairly easy, as they are well known to artists and art professionals. Ask around, or check the classified ads in regional art magazines or in alternative papers. In small towns without a comparable clumping of artists, you should investigate small vacant commercial or retail sites for possible studios.

The least expensive spaces are generally "day" studios, meaning that they are work-only spaces with minimal plumbing and possibly no heat. While some artists secretly live in day studios to save money; they risk eviction if discovered and conditions are often unappealing. More costly are live/work spaces, where the buildings have more amenities and meet local codes for residential dwellings or have received waivers to be used as artists' lofts.

When looking at a possible studio rental, check the space for adequate water, electricity, and heat. Try to meet other tenants if possible. Check the environment to determine whether your activities are likely to offend others, or theirs offend you. This includes whatever is next door or even across the street. Consider fumes, traffic, and noise pollution. Check building and parking security if in a marginal neighborhood.

When you find a studio that you want, both you and your new landlord should sign a lease for that space that spells out your agreement. Rent and the terms of the lease should be specified. If you are planning to use the space for a long time and rents in the area generally are rising, you should try to negotiate as low a rent for as many years as you can. If rents are falling, sign for as short a time as possible. Your lease agreement should cover when rent is due, what activities are permitted in the space, and any other important points. What utilities are provided and who pays for them? Who covers insurance? Can you sublease your space or get a roommate, if you choose? Are pets allowed? Who takes care of rodent and pest problems? If you want to use a loading dock or a storage area in the building, but they are located outside your space, add language to your lease to ensure your access to them. If you make considerable noise in the course of your work, make sure the lease reflects that you have permission to do so. Standard lease agreements are available in business supply stores, and can be modified to cover your agreement. Remember that all points are negotiable, so get the best deal possible for yourself.

Because many studios had been raw manufacturing spaces or warehouses, artists sometimes improve the spaces by adding sleeping lofts, storage racks, living areas, or finishing the walls. Any permanent improvements you make in a rented space becomes part of that space, and the landlord benefits from your labor and investment. If you envision adding a kitchen or installing a shower or whatever, negotiate with the landlord in advance for rent reduction or reimbursement for your expenses and a lengthy lease. Artists have sometimes paid the entire cost of improving rented spaces, only to find their rent raised when the lease expires because the space is now "nice." If you are contemplating renting a studio that has already been improved, you can expect to pay a higher monthly rent. In some areas of New York City, you might also have to pay a one-time-only fixture fee to the previous tenants as compensation for the improvements they have made. Fixture fees can be very modest or can be substantial, as much as several thousand dollars. In fact, the expense of studio space in any large city can be quite costly.

In some instances where artists have lived in and improved older manufacturing buildings, the areas become very chic and desirable to nonartists, whose demand for such spaces may raise the rent beyond what artists can afford. The end effect of this phenomenon, called gentrification, has been that artists have been driven out of areas where they have lived, worked, and built a community. Some cities have attempted legislative protections for artists' live/work spaces, but with limited success. The only ways to safeguard against gentrification are to take the risk of entering into a very long lease or of buying a structure, if you can manage the financial burden and can make that kind of long-term commitment.

Heather Becker, a figurative painter in Chicago, relates some of her experiences with studio/living situations:

> My husband and I have been living in lofts for about five years, which are plentiful in Chicago and offer the combination of finished and raw space.

My studio has always been in a completely raw space so I'm not hesitant as I am working. Usually we finish off the rest of the space by building lofts and walls as needed. The first build-out project we did was tedious, but it is much more economical to learn to do it yourself. Many times the work has been a loss for us because we were always renting, but at least we had an environment we enjoyed. We have never had too much problem with building permits or codes. The owners are generally thrilled with the up-grades because artists usually do a really nice job.

We recently bought a house on the west side. It needs a lot of work but the structure is in good condition and the taxes are reasonable. The mortgage pay-ments are considerably less than the rent we have been paying—around a third less. The house was affordable because a rough neighborhood is close by. We will probably tear it down to the bricks and rebuild the interior by our-selves—we enjoy doing it. It was important for us to get a house because over the years it is amazing how much money is wasted on renting. The biggest artists' community in Chicago, just ten blocks away, is getting too popular. It's becoming so congested that artists are going to get pushed out because they can't afford the rent anymore.

HEALTH AND SAFETY

As you move into a new studio, or continue to work in your old one, you must be constantly vigilant to protect your health. Certain art materials and processes pose hazards, so exposure to them should be minimized or totally avoided. The following illustrates ways materials and processes are dangerous to health:

Chemical threats. Solvents, dust, fumes, acids, and sprays can enter your body in one of three ways: 1) through your lungs, 2) through your diges-tive system, and 3) through your skin, especially broken skin. Dusts that are potentially harmful include dry pigment, ceramic clay dust, glaze dust, sawdust, fiberglass particles, metal particles, cloth fibers, and other fine airborne particles. After any instance of exposure you may feel fine or only feel minor discomfort, such as headaches, coughs, or skin irrita-tions. But long-term exposure can do severe skin and internal damage. Working in ceramics, drawing, fiber arts, painting, photography, print-making, and sculpture exposes you to these hazards.

Kinetic threats. Repetitive motions of all kinds stress the body. High noise levels damage the ears. Various postural problems can result from working long hours on a computer.

Radiation threats. Kilns and metalworking equipment pose threats to the eyes and skin.

Your own reaction to any particular material or process will be unique, based on a variety of factors. It could range from nothing at all to severe, depending upon the following:

Toxicity, or the relative degree of harmfulness of any one material

Exposure, or how often and how much you are exposed to a material or process. Can your body detoxify between exposures?

Age, because young children, older persons and pregnant or breast-feeding women are particularly at risk

General health and environment. Allergies, heredity, stress, smoking, and drinking may make you more susceptible to hazards. Industrial waste, smog, and other pollution may compound your reaction to a particular substance.

There are a number of books available on safe studio practices that contain lengthy descriptions of hazards and ways to avoid them, for example, *Artist Beware*, by Michael McCann, *Making Art Safely: Alternative Methods and Materials in Drawing, Painting, Printmaking, Graphic Design, and Photography*, by Merle Spandorfer, Deborah Curtiss and Jack Snyder, or *Safe Practices in the Arts and Crafts: A Studio Guide*, by Julian A. Waller. Read them and follow the rules. Another resource is the Center for Safety in the Arts, a national clearinghouse for research and education on hazards in the visual and performing arts. The Center publishes a newsletter, answers telephone queries, and provides educational materials both for free and for purchase.

Taking the following steps to improve your studio environment will help limit your exposure to harmful substances:

- Ensure adequate ventilation.
- Keep fumes and dust from your work area out of your living and eating area. Physically separate your living space from where you work.
- Make sure your studio can be wet-cleaned with a damp mop or wet cloths. Do not sweep or dry vacuum, which raises dust.
- Have sealed storage for all solvents, acids, dirty rags, and so on. Clean out toxic substances, and substitute less harmful ones whenever possible.
- Avoid loud places.

If you succumb to an unidentified malady, take note of your symptoms and inform your doctor of unusual materials or processes you have used recently, or the regular ones you use on a day-to-day basis.

INSURANCE

All self-employed persons or part-time employees are faced with the problem of finding medical insurance for themselves. While large medical insurance providers such as Blue Cross will write policies for individuals, the premiums are much more costly than similar coverage to persons on group plans. Professional organizations frequently offer group-rate medical insurance plans to their members. While membership is required, the cost of annual dues is offset many

times by the savings realized through group rates. Coverage varies from full medical insurance to major medical expenses only, and sometimes a very large deductible may be required. Art-related organizations that offer medical insurance include the College Art Association and National Artists Equity Association. Artists can join other non-art organizations that offer similar coverage, such as local professional groups. The Visual Artist Information Hotline provides information on and referrals to national organizations that provide insurance and health services.

Some artists without organizational affiliation have individual policies with health maintenance organizations (HMOs), and pay a monthly premium to avail themselves of the HMOs' services. The application forms for HMOs can be quite lengthy and the review process protracted, with delays up to a year between submitting your application and actually being enrolled.

Studio insurance is available through National Artists Equity Association.

Life insurance may be a priority if you have children or other dependents. Term life insurance covers you only during the years when you are likely to have dependents. It may be financially more feasible than "whole life," which pays benefits regardless of your age at death but carries higher premiums. Life insurance is available through many organizations, such as College Art Association and National Artists Equity Association, and through independent agents in any city.

KEEPING GOOD RECORDS

Artists must keep records for their business dealings and tax obligations. Specifical areas include:

Income and expense records

Income tax

Inventory records

Billing and collection

Income and expenses records must be kept for tax and budgeting purposes. Art-making income may include:

- Proceeds from the sale of your work, performance revenues, broadcast revenues, or income for rented work
- Wages or salary paid for work as an artist, including payment for commission work, honoraria, fees for demonstrations, stipends, and so on
- Copyright royalties for published works
- Advanced payment for work to be completed in the future, such as publications or public art commissions
- Prizes or awards
- Grant and fellowship monies

The following is a list of art-making expenses. It is not intended to be definitive, but includes the categories most likely to pertain to emerging artists.

- Mortgage interest or rent for studio, if separate from your residence. If you have a studio space within your home that is regularly and exclusively used for art-making only, and is your primary place of business, then your studio art expense is that portion of your rent or mortgage for a work space.
- Utilities for your studio, including electricity, gas, water
- Telephone costs for art activities, whether made from your studio or home phone
- Supplies and materials that are used for making art objects
- Car and truck expenses for your own vehicle when used for art-related activity, other than normal trips to and from your studio. Keep a logbook in your car to record the date, the art-related purpose, the beginning odometer reading and total mileage for such trips.
- Depreciation on work-related equipment
- Repairs and maintenance of work-related equipment
- Rent or lease of machines, vehicles, equipment, or other business property when used for your art activities
- Special clothing other than uniforms that is not adaptable to ordinary use. Examples would include costumes for performance only or protective clothing for welding.
- Insurance on art-related spaces or on art objects
- Taxes and licenses for art-related work
- Wages and other benefits paid to regular assistants or employees, or fees paid to other professionals, such as musicians for a performance
- Legal and professional services, for example, lawyers, accountants, or photographers who render services related to your art career
- Conferences, seminars, workshops, training sessions, and professional publications related to art
- Visual documentation of your work, including slides, 4″ × 5″ transparencies, and so on
- Advertising, including publicity photos, materials, and fees
- Office expenses, including postage
- Shipping costs
- Dues to professional organizations
- Travel, meals, and entertainment, when furthering your career

Your records must be "good" records, which means that they must be consistent, accurate, organized, and legible. They must be substantiated with receipts, cancelled checks, credit card statements, and/or notations in an appointment calendar or travel logbook. Art-making expenses and income should be kept separate from regular living expenses, and entered into a record dedicated to your art business. Ledgers or notebooks can be used, or computers with spreadsheet, tax-assistance, or financial-planner programs. Income items should be grouped together, with the following listed for each item:

The date

The amount

From whom received

The reason received

Indication of the check number or other form of payment

List expenses in a separate section of your record. Organize the corresponding receipts and keep them in labeled envelopes. These items should be directly related to your art career or your art-making activities, and not personal expenses. Each expense entry should include:

The date

The amount

To whom paid

The reason for the payment

Indication of the check number or other form of payment

These records are used directly when you file your *income tax* annually. Complete tax information is beyond the scope of this book, and there are already many publications that address your total tax picture. Since tax laws and tax forms change every year, this book cannot give up-to-the-minute comprehensive information about filing taxes, while tax guides available from January to April every year, in almost every bookstore, can. This section discusses tax issues specifically related to art-making for emerging artists. Only federal tax issues are covered, as laws differ for each state. However, state laws often follow the federal provisions.

For tax purposes, most artists consider themselves self-employed and their art making a business. Even if they hold another "regular" job, they are also self-employed in reference to their art career, unless their entire art output is for a regular employer who controls what they make and provides them with space, equipment, and materials. If you are a self-employed artist, the Internal Revenue Service allows you to deduct the "ordinary and necessary" expenses of a business and thus pay less taxes. However, the IRS limits the number of years that a small business can declare a loss. Check current IRS rules for these limitations. Use Schedule C, Profit or Loss from a Business, and current IRS guidelines for allowable deductions, to report art-related income and expense. You can substantiate the businesslike nature of your art activities by keeping good records, reviews of past exhibitions, and old appointment calendars showing meetings with art professionals and attendance at art events.

Artists may have to pay Self-Employment Tax and quarterly Estimated Tax on any year that they show a profit in their art business. Self-Employment Tax corresponds to the social security taxes that are normally levied on employers and withheld from employees' paychecks. If your net self-employment income is more than $400, you will have to pay this tax, even if you have another job

where social security taxes are withheld from your pay. Use Schedule SE to compute your Self-Employment Tax.

Estimated Tax is the means by which you pay your regular income tax on your profits as a self-employed artist. Estimated Tax is paid quarterly, on January 15, April 15, June 15 and September 15, so that self-employed persons do not have a large tax bill when they file their annual income tax report. You must pay quarterly Estimated Tax if you expect to owe more than $500 in income tax. Use Form 1040ES to pay Estimated Tax, with a worksheet for figuring your tax liability.

Self-employed artists may also be interested in establishing Individual Retirement Accounts (IRAs) for themselves as a means of lowering their taxes now and saving for retirement. Information on IRAs is available at commercial banks, investment planners, stock brokers, and savings associations.

Retaining records is necessary in case your tax returns are audited by the IRS. The IRS recommends that you keep records for three years after filing each return or two years from when you paid the taxes, whichever is later. This includes all records of the income, deductions, and credits shown on your return, all worksheets, W-2 Forms, 1099 Forms, and copies of your tax return. Some other tax advice books recommend keeping records at least seven years or longer, in case there is some dispute about unreported income in past years. While any taxpayer may be subject to an audit, certain items on artists' returns may increase artists' chances of an audit, including:

- Deduction for your studio in your home, called the "Home Office Deduction," when filing tax returns. The IRS often questions whether the space is used regularly and exclusively for business purposes, and often disallows this deduction because requirements were not met.
- Persistent or excessive losses, making your art career appear as less a business and more a hobby
- Excessive travel and entertainment expenses

When preparing your income tax, carefully read current IRS instructions and guidelines, because their rules change. For example, in 1986 and again in 1988, the IRS changed rules concerning how artists deduct the cost of materials and supplies necessary for their work. Also, regulations on charitable deductions for donated artwork have changed. With current rules, an artist can only deduct the cost of the raw materials and not the value of the work, unlike a collector who can deduct the value of the work. There has been some pressure to amend these guidelines. Every year, the IRS publishes booklets containing current information and tax guidelines that are available at local IRS offices or by calling 1-800-TAX-FORM (1-800-829-3676). These booklets will answer most questions if you take the time to plow through them. Publications that might be beneficial to emerging artists include:

Tax Guide for Small Business

Travel, Entertainment and Gift Expenses

Tax Withholding and Estimated Tax

Educational Expenses

Self-Employment Tax

Business Expenses

Accounting Periods and Methods

Record keeping for Individuals

Business Use of Your Home

Individual Retirement Accounts (IRAs)

Guide to Free Tax Services

Business Use of a Car

In addition to income, expense, and tax records, many artists need to keep records to track the art objects they have created. These *inventory records* indicate where the objects are at any one time and if payment has been received for sold work. If your work meets one of the following criteria, inventory records are especially important because you can easily confuse pieces, lose track of what is where, and forget what is owed to you:

- You have artwork consigned to more than one gallery or art consultant, and you often change what work is placed with which dealer.
- You consistently produce many works, or you work in multiples.
- Many of your works are untitled, or are similarly named.

Performance artists, video artists, or those whose works are few in number, large-scale, or site-specific, may not need an inventory record.

Keeping good inventory records requires that you accurately identify each art object visually and by name, and know its location if unsold, something that becomes increasingly difficult as years pass. Artists who produce many objects often use an identifying alphanumeric code written on the bottom or back of the art object. The same code is written on every slide or reproduction of the artwork, and also put on the object's inventory. Thus, when organized and filed, your slides becomes the visual inventory of your work. The written inventory, which you can cross-reference using the same alphanumeric code, should contain information such as:

Title of work

Name of series, if part of one

Completion date of work

Size

Medium. For flat work, note also the support—for example, canvas, paper, panel, and so on.

Identifying code

Dealer or consultant to whom the work has been consigned

Date consigned; if returned, the date returned

Final disposition of work, for example, if sold, rented, destroyed, lost, donated, and so on. Record the name of the person who has final possession, if applicable.

Any other information specific to your work that will help you track each piece

These records not only enable you to know where your work is at any time, but also help if someone wants more work in a particular series, or in a particular medium, or if you need several pieces of a particular size for a show.

Keeping the stack of consignment forms you get from dealers is not the same as keeping an inventory. Consignment forms, like receipts for banking transactions, show what you have "deposited" or "withdrawn" from a certain dealer. Your inventory record, like your total financial picture, needs to be much more detailed and organized. The inventory record is probably best kept on a computer using database software, similar to what you might use for your mailing list. Additions and deletions to computer inventories are easily made. You can quickly search the entire computer inventory by any entry; for example, by dealer to find everything that is consigned to one person, by series to list all unsold pieces in a particular group wherever they are, or by date to have a record of all pieces finished in a particular year. Doing such searches in a ledger or notebook inventory would be much more tedious and time-consuming.

Artists who sell their work need to establish methods of *billing and collection*. Like any self-employed person, you want to be paid promptly for the work you have done, and you want to avoid the grief, hassles, and headaches of trying to collect money from someone who owes you.

When you sell work directly "from your studio" to individual buyers, you should retain the purchased work until full payment is received. Exceptions can be made if the buyer is someone you know well and trust. While you should provide a bill of sale (see below), no billing should be necessary as long as you hold the work until completely paid. If the buyer is paying in installments, you should receive partial payment immediately. Never hold a work without money down. Without some commitment, buyers may experience a change of heart, and you may miss the opportunity to sell the work to another person.

When selling through an agent, such as a gallery or an art consultant, artists should be notified shortly after the sale of their work, and paid in full within thirty days. In theory, artists have no need to send bills, although some art consultants may request an invoice from the artist. Galleries do not request invoices.

Unfortunately, financial difficulties sometimes beset dealers and consultants, and they may neglect to notify you of sales, or you may not be paid for sold work in a timely manner. The situation is difficult to remedy, because the artwork is already out of your possession; a sale was made, and suddenly you have neither the work nor the payment. If you are uncertain about the disposition of work

you have consigned to a dealer or consultant, or believe work has been sold for which you have not been paid, try the following steps:

- Keep in regular contact with the dealer or consultant, asking about any recent sales or interest in your work.
- From your inventory records, make a list of all pieces consigned to the person in question. Call to schedule a convenient time to check your list against the actual pieces. Use the excuse that you are updating your entire inventory records, or that you are looking to exchange work for which there has been no interest. Be tactful and nonconfrontational, in person and on the telephone, unless you do not mind burning bridges.
- Take paperwork to the gallery when you check your work. The computer is particularly helpful here because inventory printouts look more impressive and carry more authority than handwritten lists, even though both may be equally accurate.
- Request payment, verbally and in writing, for all sold work. If excuses are made, persist in your requests for the next few months, citing your financial need. If they promise to mail a check, offer to pick it up in person.

Polite persistence is often sufficient to receive payment. If you find that it has not worked and want to apply more pressure, contact your lawyer or call the local chapter of the Volunteer Lawyers for the Arts to find out what legal options you have. Several states have consignment laws that require a dealer or consultant to pay you within thirty days of a sale; in these cases, withholding payment is illegal. Additionally, if you have a written contract with your dealer or consultant, you can sue for breach of contract (see below). You should bear in mind that legal remedies may be time-consuming and expensive. However, if a dealer or consultant owes you less than $2,500, you can press your claim against them in Small Claims Court, and avoid the cost of a lawyer to represent you. In some cases, legal remedies may be ineffective. For example, if your dealer or consultant has kept the entire proceeds from your sales and then declares bankruptcy, you have no remedy if you are an unsecured creditor.

Try to avoid bad situations with dealers and consultants by starting slowly with someone you have not worked with before. Check regularly on your work and make sure you are paid in a timely fashion.

LEGAL ISSUES

Contracts, Consignments, and Other Agreements

As an artist, you do business with dealers, clients, collectors, promoters, or producers. To keep these dealings smooth and satisfactory, you and the other party must agree upon some exchanges or some actions that each will do, and these agreements constitute contracts. Legally, a contract is a binding agreement between two or more persons or parties, where 1) all parties

BILL OF SALE
[Your name]
[Your studio address or place of business]
[Your telephone number]

Date: _____

ARTWORK
Name: _____
Date: _____
Size: _____
Medium: _____

SOLD TO
Name: _____
Address: _____

Telephone: _____

PRICE: _____
TERMS OF PAYMENT:

All copyright and reproduction rights are reserved by the artist.

(Signature of Purchaser)

(Signature of Seller/Artist)

FIGURE 15.1
Sample bill of sale

are competent to enter into the agreement; 2) the agreement in no way breaks the law; 3) all parties concur beforehand on the terms of the agreement; and finally, 4) an exchange of money, services or articles of value is to occur. Contracts may be oral or written.

This kind of language may sound oppressive to many artists, but in fact it describes the many agreements they make regularly in their careers, including selling a piece, being represented by a gallery, leaving work on consignment, or exhibiting work at any existing art venue. In the art world, these agreements

CONSIGNMENT AGREEMENT

Date: _____

1. _____ [Gallery, Dealer or Consultant] acknowledges receipt of
the following consigned artworks:
a. Title: _____

 Size: _____ Series: _____

 Date: _____ Condition: _____

 Retail Price: _____ Framed: Yes/No

b. Title: _____

 Size: _____ Series: _____

 Date: _____ Condition: _____

 Retail Price: _____ Framed: Yes/No

c. Title: _____

 Size: _____ Series: _____

 Date: _____ Condition: _____

 Retail Price: _____ Framed: Yes/No

d. Title: _____

 Size: _____ Series: _____

 Date: _____ Condition: _____

 Retail Price: _____ Framed: Yes/No

2. This agreement is applicable only to the above artworks. The
gallery/dealer/consultant is not a general agent for any other works.

3. Term of consignment is _____ months.

4. Commission to gallery/dealer/consultant is _____%.

5. Discounts may not exceed 15% of the retail price. Discounts shall be split
between the artist and the gallery/dealer/consultant.

6. Copyright and reproduction rights to these works are reserved by the artist.
No works may be copied or reproduced without consent of the artist. All
purchasers will be informed that the artist retains copyright.

7. Artist shall be paid within 30 days of the sale of a work. Artist retains title to
works until paid in full. Gallery/dealer/consultant will provide the artist a
quarterly statement documenting all transactions.

8. Gallery/dealer/consultant will provide the artist with the names and
addresses of all purchasers of the artist's works.

9. Gallery/dealer/consultant is responsible for any lost, stolen or damaged
work. Consigned works are held in trust for the artist and are not subject to
claim by creditors of the gallery.

10. This agreement may be terminated with thirty (30) days notice by either
party. All consigned artwork will be returned to the artist within 2 weeks (14
days) of termination at the expense of the gallery/dealer/consultant.

Agreed: _____ _____

 Gallery/dealer/consultant Date

 _____ _____

 Artist Date

FIGURE 15.2

**Sample consignment form containing clauses that artists may find beneficial;
clauses may be added or dropped to suit your particular needs and interests.**

are often oral only, and they work smoothly much of the time. However, oral contracts are not binding in the same way as written ones, and may be harder to have recognized in court. Formalizing your agreements in writing can avert disputes, or protect you should one occur.

When you sell a piece of artwork directly "from your studio" to a buyer, without a dealer or consultant as intermediary, you should have ready and always use a bill of sale (see sample in Figure 15.1), specifying what was sold to whom, when, and for how much. List terms of payment if the work is not purchased outright. Although legally you retain reproduction rights unless you specifically transfer them to someone in writing, the general public may not know that, so including such language on a bill of sale notifies your buyers. Make two copies of the bill of sale, one for yourself and one for your buyer.

Some artists use their own consignment forms for all sellable work left with any gallery or institution. Although galleries generally provide their own consignment forms (see Chapter 8), the information contained on each one varies tremendously. By using your own standardized form, you can better track your inventory. In addition, you can add terms that protect you in your dealings with the gallery. If for any situation you and your dealer decide to waive part of the consignment agreement, simply cross through that part and have all parties initial it. Make two copies, one for the dealer and one for yourself. When removing unsold work from a gallery, bring and mark all relevant consignment forms so that you and the dealer have an accurate record of what has been consigned. A sample consignment form that is artist-friendly is shown in Figure 15.2.

Both the bill of sale and the consignment form are contracts. They are fairly straightforward and usually sufficient to cover basic monetary transactions. More complex contracts are needed for long-term artist-dealer relationships that include exclusivity, territory, stipends, expectations of future exhibitions, future catalogs, or other major commitments. These contracts specify services to be rendered in addition to covering monetary matters. Both dealers and artists profit when a contract is signed between them. Vague or tentative commitments are made firm, and the possibility of misunderstandings is greatly reduced. The relationship is given a definite time frame, with procedures for evaluating, continuing, or breaking off at that time. Dealers gain because their efforts to build an artist's career will not be undermined by lack of exclusivity or by the artist's leaving for another gallery while the contract is in force. Artists gain because they are assured regular exhibits, promotion for their work, timely payment, regular accountings, and can seek another gallery after a specified period of time if they choose. In addition, other issues such as shipping costs, insurance, discounts to collectors, commissions on studio sales, and so on, can be worked out to the satisfaction of both parties.

A sample artist-dealer contract is reproduced in Figure 15.3. Another source for sample contracts is your local Volunteer Lawyers for the Arts. Sample documents should be modified to reflect the terms of your agreement with your gallery. Before signing any long-term agreement such as this, consult a lawyer familiar with contracts or with the arts. Again, the local volunteer lawyers can review contracts for you.

SAMPLE ARTIST-DEALER CONTRACT

AGREEMENT made the ____ day of _____, 19__, between _____, a [Corporation] with principal offices at _____ (the "Gallery") and _____ (the "Artist"), presently residing at _____.

WHEREAS, the Gallery desires exclusive representation of the Artist and the Artist's work under the terms and conditions specified in this Agreement; and

WHEREAS, the Artist desires to be represented by the Gallery under such specified terms:

NOW THEREFORE, in consideration of the foregoing premises and mutual covenants hereinafter set forth, the parties agree as follows:

1. TERRITORY. The Gallery shall be the exclusive representative and agent for the sale and exhibition of the Artist's work in _____ [city, country, continents, the world].

2. TERM. The term of this Agreement shall be for a period of _____ years [one/two/three years; two years preferred], beginning on _____, 199__ and ending on _____, 199__. This Agreement will renew itself for additional periods of _____ year(s) [one or two] each with a new Agreement to be signed by the parties for each additional term, unless either party gives the other notice of an intention not to continue within sixty (60) days prior to the expiration of this contract. During the additional periods, if the parties do not confirm new contract terms in writing, either party can terminate the Agreement as of the end of any month, on a minimum of sixty (60) days prior written notice to the other party.

3. EXHIBITIONS. The Gallery agrees to hold at least one one-person exhibition of the Artist's work at the Gallery during the initial _____ year term of the Agreement. If the Agreement is renewed, the Gallery agrees to hold at least one one-person exhibition of the Artist's work during that term. The Gallery may choose from time to time to include the Artist in group shows at the Gallery and, as the Artist's exclusive agent and representative, shall use its best efforts to obtain both one-person exhibitions elsewhere and have the Artist's work included in group shows in other galleries, museums, and alternative spaces.

4. CONSIGNMENT. The Artist will consign to the Gallery and the Gallery will accept consignment of certain works mutually selected by the parties, and upon receipt, the Gallery shall set forth in writing such acceptance in a consignment letter, in the format of Addendum A (see p. 14), which specifies the title, medium, size, date, and agreed selling price of each work consigned and the length of consignment. If the letter of consignment does not specify the length of consignment, the consigned works may be retained by the Gallery for the initial term of _____ [six (6) months/one (1) year/through the first one-person exhibition], unless this Agreement is terminated, in which case the Artist's works will be returned according to the terms set forth in Paragraph 15. At the end of the term of consignment, the works may be individually removed, if so desired by either party, on five (5) days prior written notice. Those works by the Artist that both parties agree shall remain at the Gallery for an extended period of consignment and all new works consigned to the Gallery shall be set forth in an amended or newly executed letter of consignment setting forth the title, medium, size, date, and agreed selling price of each work on consignment. These letters of consignment shall be annexed to this Agreement and considered a part of this Agreement.

5. COMMISSIONS. The Gallery shall receive a commission of fifty percent (50%) of the selling price of each sold work. In the case of discount sales, the Artist and Gallery shall split the discount up to _____ percent [10%, 15%, 20%—20% is common] of the agreed selling price. Any discount in excess of _____ (above specified percentage) percent of the agreed selling price shall be deducted from the Gallery's commission, unless the Gallery obtains written approval by the Artist. Discounts shall only be given to

FIGURE 15.3

Sample artist-dealer contract. (Reprinted with permission of Laurie Ziegler.)

given to museums, foundations, curators, galleries, private dealers, and good clients of the Gallery. Any other discounts may only be given with the Artist's written approval. In the event of studio sales by the Artist that fall within the scope of the Gallery's exclusive territory, the Gallery shall receive a commission of _____% [*30%, 40%, 50%—40% is common*] of the agreed selling price for each work sold in the Artist's studio, unless other arrangements have been agreed upon in writing or, if the Gallery has acted as the Artist's agent and representative and arranged for the sale, the Gallery shall receive a commission of fifty percent (50%). The Gallery shall not receive a commission on the sale of the Artist's work sold to family members or close friends. Works done on a commissioned basis by the Artist shall be considered studio sales in which the Gallery may be entitled to fifty percent (50%) commission, unless the commissioned work was arranged by the Artist's agent and representative from a territory not covered by this Agreement, in which case the Gallery agrees to no commission. If the commissioned work was arranged by a nonexclusive agent, who works with the Artist to obtain such private and public commissions, the Gallery agrees to accept a commission of _____% [*10%, 20%*], unless other terms and conditions are agreed upon between the Artist, agent, and the Gallery and such terms and conditions are set forth in a writing signed by the parties. The Artist may make gifts or donations of his/her artwork as he/she chooses without any interference or commission to the Gallery. The Artist may also exchange his/her works for other Artists' works or barter without the Gallery receiving any commission. The Gallery may not make a gift, donation, or barter of the Artist's work without the Artist's written approval. The Gallery may purchase, on occasion, the Artist's work at fifty percent (50%) of the agreed selling price. The Gallery may not resell such work for _____ [*one, two*] year(s) without written approval from the Artist.

6. PROMOTION. The Gallery shall make good faith efforts to promote and sell the Artist's works at the expense of the Gallery. The Gallery agrees to advertise and publicize the Artist's work, to arrange for other exhibitions that feature the Artist's work, and to work with other galleries to promote the work. [*Optional: to produce a catalogue for at least one of the Artist's one-person exhibitions during the term of this Agreement (depends on such factors as the Gallery's financial ability to produce a catalogue and the Artist's status—first show versus established artist)*]. The Artist agrees to cooperate with and to assist the Gallery in promoting and publicizing the Artist's works, including the furnishing of names and addresses and other data regarding existing collectors of the Artist's work.

7. AGREED SELLING PRICE. The Gallery shall set the retail price on each work and will give the Artist a list of the prices for the Artist's approval. The Artist shall have the right to object to any prices. If the Artist objects to any prices, the Gallery and the Artist shall discuss and reach agreement on the price and upon the reaching of such agreement, the Gallery shall set forth the agreed selling price for each consigned work in a letter of consignment, including the terms specified in Paragraph 4. The Gallery and Artist shall re-evaluate the agreed selling price of the Artist's work at the end of each year, unless either party deems it necessary to do so on other occasions to dictate to the conditions of the market. All such changes shall be set forth in an amended or newly executed letter of consignment.

8. PAYMENTS. The Gallery shall pay the Artist all proceeds due to the Artist within thirty (30) days of payment by the purchaser to the Gallery or, in the event the Gallery is the purchaser, within twenty-one (21) days of such purchase. No sales on approval or credit shall be made without the written consent of the Artist and in such cases, the first proceeds received by the Gallery shall be paid to the Artist until the Artist has been paid all proceeds due, as required in the consignment statute of the state whose laws govern this Agreement. All works are considered consigned until the Artist has been fully paid for the sale of the sold work and no works of art will be released by the Gallery to the purchaser until fully paid for, unless the Artist has given his/her written consent.

FIGURE 15.3 (Continued)

9. ADVANCE PAYMENTS. The Gallery may, in its discretion, make advance or stipend payments to the Artist in advance of the sale of the Artist's work. Such stipend payments shall be set off against future sales and amounts due to the Artist. If this Agreement is terminated and the Gallery is entitled to repayment of advances in excess of the amount otherwise owed to the Artist as a result of sales of the Artist's work, Artist agrees to repay the Gallery said excess, unless both parties agree, in an informal writing, that the Gallery shall accept an exchange of the Artist's work in lieu of cash to cover the amount owed to the Gallery.

10. SECURITY INTEREST. The Artist reserves title to and a security interest in any and all works by the Artist consigned to the Gallery or proceeds of sale under this Agreement. If the Gallery defaults in making any payment due to the Artist, in accordance with Paragraph 8 above, the Artist shall have all the rights of a secured party under the Uniform Commercial Code. The Artist's works shall not be subject to claims by the Gallery's creditors. The Gallery agrees to secure the artist at the time of consignment by signing and delivering to the Artist a financing statement, Form UCC-1, and such other documents as the Artist may require to perfect his/her security interest in the works. The Gallery agrees to sign the financing statement, Form UCC-1, and return it to the artist for recording promptly after the Artist submits the UCC-1 forms to the Gallery. The Artist agrees to sign and file a Form UCC-3 termination statement for each of the Artist's works sold by the Gallery, after the Artist receives full payment for the work. The Artist shall retain title to all of the works consigned to the Gallery until the Artist is paid in full by the Gallery. The Gallery agrees not to pledge or encumber any of the Artist's works in its possession and not to incur any charge or obligation in connection therewith for which the Artist may be liable.

11. ACCOUNTINGS. The Gallery shall furnish the Artist with a quarterly accounting listing all sales made during that period; the name of the purchaser of each work sold, including the address of the purchaser; the date of purchase; the selling price and the discount given, if any; the allocation of the proceeds between the Artist and the Gallery; the amounts paid to the Artist during the said accounting period; and the amounts, if any, remaining due to the Artist.

12. INSPECTION OF THE BOOKS AND RECORDS. The Gallery shall be responsible for the maintenance of accurate books and records with respect to all transactions entered into by or on behalf of the Artist. The Gallery will permit the Artist or, on the Artist's written request, the Artist's authorized representative, to inspect these books and records during normal Gallery business hours.

13. DOCUMENTATION. The Gallery shall document all of the Artist's work consigned to the Gallery. Such documentation shall include, but not be limited to, photographs and slide transparencies of each consigned work. The Artist shall receive at least one color slide transparency of each consigned work at the expense of the Gallery. The Gallery shall provide the Artist access to and permit him/her to have extra copies of all photographs, transparencies, catalogues, and other materials pertaining to the Artist's work at any time during this Agreement, at the Artist's expense, unless otherwise provided for in an informal writing between the parties. At the termination of this Agreement, the Gallery must provide the Artist with any and all documentation of the Artist's Work at the expense of the _____ [*Gallery/Artist*].

14. CRATING, SHIPPING, INSURANCE. The Gallery shall pay all crating and shipping expenses of the Artist's works from the Artist's studio to the Gallery and from the Gallery back to the Artist's studio or storage. The Gallery shall be responsible for arranging for the crating and shipping of any and all the Artist's work to be sent to other exhibitions arranged by the Gallery. The Gallery shall be responsible for loss or damage to the consigned work at the gallery and work by the Artist that may be forwarded to other exhibitions arranged by or through the Gallery, unless the third-party gallery has assumed responsibility for any loss or damage while the Artist's work is in transit to, at, or being transported from its Gallery and such responsibility has been set forth in a writing between the _____ [*Artist—if the third-party gallery represents the Artist in other territories;*

FIGURE 15.3 (Continued)

Gallery—if the Gallery arranged the show at the third-party gallery] and this third-party gallery. The Gallery shall insure each of the consigned works for at least fifty percent (50%) of the agreed selling price. Such insurance will protect the work from the moment the Artist's work leaves the Artist's studio until the work is sold and paid for in full or returned to the Artist's studio. In the event of loss or if the Artist's work is damaged and the restoration is not an unreasonable expense to or request of the Artist, the Artist shall receive the same amount from the Gallery or the Gallery's insurance carrier as if the work had been sold at its agreed selling price. The Gallery shall insure the Artist's work with an insurance carrier in the State of _____ and rated "A" or higher by _____ [*a reputable insurance company*] or its equivalent.

15. TERMINATION. This Agreement shall be terminated at the end of the specified period, unless both parties enter into a new written Agreement extending or amending the terms of this Agreement. This Agreement may be terminated with sixty (60) days written notice to the other party if the Gallery fails to make prompt payments under the terms of this Agreement; or the Gallery changes its ownership, location, or identity; or if either party fails to act in good faith and/or use reasonable efforts to promote the sale of the Artist's work at the Gallery. Upon the event of such termination, the gallery shall have the sixty (60) days above specified to settle and transfer to the Artist the balance due to the Artist and to return all unsold works to the Artist. This Agreement may be terminated immediately if either party dies or the Gallery becomes bankrupt or insolvent and all works by the Artist shall be returned at the expense of the Gallery, unless it can be proven that the Artist has acted in bad faith and payments due to either party shall be paid within _____ [*7, 14*] days of said termination. In the event the Gallery becomes bankrupt or insolvent, payments due the Artist will be made before other creditors are paid and the Artist's works consigned to the Gallery shall not be subject to the claims of other creditors.

16. COPYRIGHT. The Gallery shall take all steps necessary to ensure that the Artist's copyright to the Artist's works is protected and shall inform all purchasers of the Artist's works that the Artist has retained the copyright and the copyright is not being transferred with purchase.

17. ASSIGNMENT. This Agreement shall not be assignable by either party hereto, provided, however, that the Artist shall have the right to assign money due him/her hereunder.

18. ARBITRATION. Any controversy or claim arising out of this Agreement or of a breach thereof, in excess of the jurisdiction of the Small Claims Court, shall be settled in arbitration in _____ [*city, borough, county*], in the state of _____, by and in accordance with the rules of the American Arbitration Association, and in accordance with the laws of the state of _____. The arbitrators' award shall be final, and judgment may be entered upon it in any court having jurisdiction thereof.

19. GOVERNING LAW. This Agreement shall be governed by the laws of the state of _____ .

20. ENTIRE AGREEMENT. This Agreement represents the entire Agreement between the Gallery and the Artist and supersedes all prior negotiations, representations, and Agreements, whether oral or written. This Agreement may not be modified in whole or in part except by written instrument signed by both parties.

IN WITNESS WHEREOF, the parties hereto have executed this Agreement on the day and the year first written above.

[*NAME OF GALLERY*]

By: _____
[*Gallery Owner or Director with contract-signing capacity*]

By: _____
[*Artist*]

FIGURE 15.3 (Continued)

In fact, artist-dealer contracts are not commonly written and signed. Any one or more of the following reasons are factors for this: The relationship started casually and slipped into something more serious; the artist-gallery relationship is seen as a sensitive understanding between sensitive persons and a written document codifying it would be crude and unnecessary; the artist feels powerless to ask for one for fear of offending the dealer; contracts are not the custom in the art world; or one or both parties want the relationship to remain vague so that the commitments on each side are more slippery and fluid.

Since "contract" may be a word that causes both artist and dealer to flinch, a letter of agreement may be a viable, if less satisfactory, alternative. You draft a letter of agreement after a conversation with your dealer where future exhibitions or other business is discussed. Send a copy of the letter to the dealer and retain one for yourself. A sample is shown in Figure 15.4. After a week, call the dealer to confirm receipt of the letter.

Artists may become dissatisfied with the services their dealers provide and decide to end their association. In some cases, artists have had difficulty collecting money due them for sold work or regaining their work left on consignment. Some dealers have felt that they have been cheated out of the future profits they would have realized from the efforts they have put into an artist's career. The results can be bitterness and in some cases lawsuits. A recent well-known example is the dispute arising around the artist Peter Halley's decision to leave Sonnabend Gallery in New York, to be represented by Gagosian Gallery. Sonnabend sought an injunction to stop Halley from showing at Gagosian, claiming that although there was no written contract, Sonnabend Gallery had built Halley's career and was entitled to profits from current and future work. Although the injunction was denied, Sonnabend is still pursuing the possibility of a lawsuit against Halley and Gagosian, in addition to all parties negotiating.

Many of the difficulties in the Sonnabend/Halley/Gagosian dispute arose from the lack of a written contract between Sonnabend and Halley, defining the nature of their agreement, the obligations of each party, the duration of their relationship, and procedures for termination. Sonnabend and Halley disagreed on exactly what services the gallery was providing to further his career. In general, with written contracts, both parties are better able to perform to expectations. If one party fails to fulfill its obligations in a written contract, a lawyer representing the other can write a letter threatening to sue, which may sufficiently persuade the offending party. If threats are ineffective, then sue. Remember, however, that contracts do not make lawsuits more common! The process of constructing a written agreement that both parties can sign works out potential problems and misunderstandings before they happen.

Oral agreements are theoretically as binding and enforceable by law as written contracts, but you may have difficulty establishing the exact nature of the agreement. Another possible legal remedy where there is no contract is unjust enrichment, where someone cannot unjustly profit at your expense.

May 12, 1995

(Dealer)
(Gallery)
(Address)

Dear (Dealer);

This letter confirms the agreement we made in our meeting of May 9, 1995, at your gallery.

Specifically, you will mount a solo exhibition of my sculpture in your main gallery from February 27, 1996, to March 30, 1996. My drawings will be displayed in the back gallery.

You will receive a 50% commission on all sales of work. Discounts of up to 15% may be given, and the discount split between us. We will mutually agree upon and set retail prices for work. All drawings will be framed by the gallery's regular framer.

While you will pay for the designing, printing, and mailing of an announcement with a color image of my work, the image used and the design of the announcement will be approved by both you and by myself. The announcement will be sent to the entire gallery mailing list and to 200 persons on my mailing list. In addition, you will provide me with 75 extra announcements for my own use.

You will prepare and pay for all publicity for the exhibition, including a quarter-page black-and-white ad in *Art/Talk* magazine. You will also provide refreshments for a reception on the evening of March 2, 1996.

I will presume that this letter accurately reflects our agreement unless I hear from you within five working days. If your thinking is substantially different, please call me so that we can come to an understanding.

Sincerely,

(Artist)

FIGURE 15.4

This is a fictional letter of agreement, showing how a hypothetical artist can verify an oral agreement when a gallery will not enter into a written contract. Of course, the letter of agreement you write will reflect the terms of your particular situation.

Thus, someone cannot commission you to produce an artwork, keep the work, and then refuse to pay you, whether or not there was a contract.

Copyright

Copyright is the legal right to copy, publish, display, or sell copies of an artistic, literary, or musical work. Three aspects of copyright are of particular interest to artists:

- Using the reproduction rights outlined in the Copyright Act to protect your own original work from being copied illicitly by someone else
- Avoiding infringing on someone else's copyright if you use appropriated imagery as the basis or part of your work
- Using copyright protection to ensure the integrity of your work by preventing unwarranted distortions, mutilations, or modifications

Reproduction rights to their work are critically important to artists. Whoever holds a copyright to a work has exclusive legal control over the reproduction of the work and the sale of those reproductions. The Copyright Act protects "original works of authorship fixed in any tangible medium of expression. . . ." Thus, to be eligible for protection, your work must be an uncopied and unplagiarized pictorial, graphic or sculptural work, film, audiovisual work, dramatic work, or sound recording. It must exhibit a degree of creativity ("authorship") and be "fixed" in some material form. Ideas, procedures, processes, systems, principles, discoveries, and concepts do not fall under the Copyright Act, but the unique concrete expression of ideas may. Names, titles, and short phrases cannot be copyrighted, but if used in commerce as trademarks may be protected by the Lanham Act and the Trademark Law Revision Act. Utilitarian objects are covered by patent legislation.

The copyright owner has specific rights under Section 106 of the Copyright Act. They are:

Reproduction. The copyright owner is the only person who legally can make copies of an artwork in any medium at all, or who can give permission for another person to do so.

Adaptation. The copyright owner can prepare derivative works of the original, where the work is translated, reformed, or recast in a different medium, and the derivative does not duplicate the original.

Distribution. This is the sole right to sell, rent, lend, or distribute copies of the original work.

Performance. This is the right to perform a piece publicly, which includes recitation, display, or live staging of a work. This provision applies to performance, video, and film.

Display. This is the right to publicly display copyrighted work. The right is extended to the copyright owner and to any person who owns a lawful copy of the work. In copyright legislation, the word "copy" can mean both the original work of art and a reproduction of it.

Copyright protects any creative artistic work as it is being made and when finished. At the time of creation, the copyright generally belongs to the artist(s) who made the work. Exceptions to the artist-owned copyright are 1) when the art was created as "work for hire," or produced by regular employees in the normal course of their job while under the direction and control of an employer; or 2) when an independent artist makes a specially commissioned work for which there is a written "work for hire" contract and where the work is part of a larger collective work. In these cases, the copyright is owned by whoever commissioned the work.

The duration of copyright protection is as follows for all works created after January 1, 1978:

Lifetime of the artist, plus fifty years, for works created by one artist

Lifetime plus fifty years after last artist's death, for works created jointly by two or more artists

Seventy-five years after date of first "publication," or one hundred years after date of creation, whichever expires first, for anonymous or pseudonymous works.

For copyright purposes, "publication" has a particular meaning. In this case, publication generally means the distribution of copies or phonorecords of a work to the public through sale, rent, or loan. For works of art that exist in only one copy, selling or offering it for sale through a dealer or from your studio does not constitute publication. A work of art is considered published only when reproduced in multiple copies that are publicly distributed through sale, rent, or loan.

An artist, or any other copyright owner, may choose to transfer the entire bundle of rights for a specific work to another person, like any other personal property. The copyright can be sold, licensed, or donated. Also, the copyright owner may make only a partial, or "nonexclusive," transfer of right to others. For example, the owner could grant permission for many persons to simultaneously reproduce a work. Or rights might be granted geographically, so that one person might have North American reproduction rights while another has European. The transfer of rights could be for a limited time, for example, for one time only or for ten years, or the transfer may be applicable in one medium only, such as either photographic or lithographic reproductions. With the exception of granting nonexclusive license, you must sign a written document to transfer your copyright ownership to another person specifically, as an oral agreement is not legally binding in this case.

The physical artwork is distinct from the copyright to it. Artists can sell works of art they have created, but they retain the copyright to them unless

they also in writing sell the copyrights. Conversely, artists may sell the copyrights to works while retaining the original objects.

While the Copyright Act protects all your work from being illegally copied, you must follow certain procedures to secure the complete copyright protection for your work, specifically, by *copyright registration*. Copyright registration involves affixing a proper notice to each artwork and by submitting certain forms, fees, and materials to the U.S. Copyright Office. The basic form for a copyright notice is "© [date] [your name]." For sound recordings on formats such as cassette tapes, CDs, or LPs, the formula is the same, except the letter "P" (for phonorecord) is used inside the circle, instead of "C." Examples of acceptable notices are as follows:

"© 1995 Maria Rodriguez" or "Copr. 1995 Maria Rodriguez" or "Copyright 1995 Maria Rodriguez." These notices are for works created by an individual artist. You may use an abbreviation or alternate designation of your name, if you are known by and can be identified by it.

© 1995 Maria Rodriguez and John Lee. This notice is for joint owners of a copyright, used when artists collaborate on a work.

© 1993, 1995 Maria Rodriguez. This notice is used for published works in more than one edition.

© 1995 Maria Rodriguez (lithographs) © 1995 John Lee (photographs). This double notice is fixed to single works where artists have made separate contributions.

The notice must be legible and visible on the work. It may appear on the front or back of a painting or drawing, but not on a removable frame. For a sculptural work, the notice cannot be placed inside the work or on the bottom of a large, heavy piece. Notice may be placed at the beginning of a video.

The U.S. Copyright office provides a number of free circulars and publications to explain copyright law and procedures. These helpful publications are clearly written, informative, and instructive.

Circular 1: Copyright Basics, briefly covering many aspects of copyright protection

Circular 3: Copyright Notice, which discusses the proper placement and use of the copyright notice

Circular 7d: Mandatory Deposit of Copies or Phonorecords for the Library of Congress

Circular 92: Copyright Law of the United States of America. Unlike other circulars which are modestly sized between two and four pages, this 140+ page book presents the Copyright Law with Amendments that provides copyright protection for visual arts and for many other "original works of authorship," including musical compositions, literary texts, computer programs and cable-TV programs.

The following forms are used when you wish to register a specific work with the U.S. Copyright Office:

Form VA, with instructions, for visual artworks. You should also request Circulars 40 and 40a for complete information.

Form PA, with instructions, for performing arts including all performance, film, and audiovisual works; also Circular 55

Form TX, with instructions, for nondramatic written works, such as exhibition catalogs, directories, theses, or articles

Form SR, with instructions, for sound recordings including dramatic recordings or lectures; also Circular 56

Complete the copyright application form, enclose a $20 fee for each registration, and include deposit copies of the work or "identifying materials," and return to the Register of Copyrights, Library of Congress, Washington, DC 20559. All forms, fees and deposit materials for each copyright registration must be in one package. Registration fees are due to increase after July 1995.

Copies of the work must accompany your copyright application in order to identify accurately what is being protected. For most published material in print format, the deposit consists of two complete copies of the work. For a computer program, deposit one visually perceptible copy of the source code for the first and last twenty-five pages of the program (request Circular 61 for more information). For works on CD-ROM, the deposit consists of one CD-ROM copy, a copy of the operating software, plus any documentation or users' guides. For sound recordings, the deposit must include two complete phonorecords and any accompanying text or pictorial matter published with the sound recording. For a work in video or film, the deposit must include one complete copy plus a separate description or synopsis.

When copyrighting a work of visual art, identifying materials are used as documentation when a copy cannot be deposited with the U.S. Copyright Office. Thus, two copies of a book can be deposited, but actual copies of art objects would be impractical. Circular 40a gives in-depth instruction on what identifying materials need to be deposited for various categories of art objects. Generally, identifying material should show the actual work as completely as possible, including the color of a piece, multiple views of sculpture, and the location of the copyright notice on the work. This material must be at least 3″ × 3″ and no larger than 9″ × 12;″ however, 8″ × 10″ is the preferred size. If using 35mm slides, affix them to a larger piece of matboard. Include your name, the name of the work, the exact measurement of one or more dimensions, and date of the work on the documentation.

For full copyright protection, you must affix a proper notice to each copy of your work and register it within three months of publication, as publication is defined in reference to copyright law. If someone illegally copies your fully protected work, Sections 501 through 506 of the Copyright Law allow you to seek the following:

- Court-ordered injunction to cease the infringement
- Impoundment of the actual articles that infringe on your copyright
- Awards for damages and/or profits from the infringement
- Reimbursement of your costs and attorney fees
- Criminal penalties against the infringer for willfully copying your work and/or removing your copyright notice. Most such cases, however, are settled between the involved parties without criminal procedings.

If your copyright was not registered within three months of the publication of your work, you cannot be awarded statutory damages or attorney's fees in case of infringement.

If a work of yours has been illegally copied, get legal advice to investigate your options, for example, with the local Volunteer Lawyers for the Arts.

What happens if you did not register a work with the Copyright Office, did not affix a copyright notice to your work, and discover that someone has copied it? If you had the work reproduced in large numbers, published, and widely circulated without notice, it will likely fall into the public domain, unless you take steps outlined by the Copyright Office in Circular 3 to remedy the situation within five years. Works in the public domain have no copyright, belong to the community at large, and can be used by anyone at will.

On the other hand, unique artworks or artworks produced in multiples of less than two hundred copies, created after March 1, 1989, are covered by copyright protection even if you do not affix a copyright notice or register the work. Reproducing an image of your artwork on exhibition announcements without a copyright notice does not void your copyright. The copyright remains yours until you transfer it in writing. Someone copying your work without your permission infringes on your copyright. However, without the copyright notice on a piece, the copying is likely to constitute "innocent infringement," and the offender likely to receive only a token fine because the infringement was the result of ignorance rather than willful intent. For full protection, register the work and affix a notice to all copies. Because registration fees can be expensive for artists who produce many works, some affix the copyright notice to their work without registering it. Since registration is not mandated for copyright protection, this is perfectly legal, and some artists are willing to live with the fact that they will not be entitled to the full range of remedies provided by law in case of infringement.

For any work published in more than 200 copies in the United States after March 1, 1989, you must deposit two copies of the work with the Library of Congress, whether or not you actually register the work with the Copyright Office. This is called the Mandatory Deposit Requirement for published work. Refer to Circular 7d for more information.

Another area of concern for many artists is *avoiding infringement on someone else's copyright*. With the proliferation of copying machines, scanners, and cameras, making copies of existing work is easy and common. Many artists use existing artwork as raw materials for their own work. However, the

copy you make of any copyrighted work or image is illegal unless you have the copyright owner's permission. Making copies can violate the copyright owner's right to make, use, and profit from reproductions. The exception to this is "fair use," which are limited circumstances where you can copy a copyrighted work without permission. Section 107 of the Copyright Act lists four factors to be used in determining whether a specific act of copying constitutes "fair use":

- "Purpose and character of the use, including whether such use is of a commercial nature or is for non-profit educational purposes." The more commercial in purpose your copying is, the less likely it falls under fair use. Criticism, news reporting, teaching, or research may constitute valid reasons for copying a work without permission.
- "Nature of the copyrighted work." For example, copying an image in an out-of-print book for research purposes may constitute fair use.
- "Amount and substantiality used in relation to the copyrighted work as a whole." The more of the original work you copy, the less likely the copying constitutes fair use.
- "Effect of the use on the potential market for or value of the copyrighted work." Your copying is unlikely to be fair use if it competes with or undermines the copyright owner's market for the work.

None of these factors exonerates copying without permission, but merely outlines circumstances when such copying may be excused.

Parody is an instance of fair use of copyrighted material without permission. A parody imitates some aspect of an original work for comic effect or ridicule. While a parody is a separate creative work, it heavily references the original for its effect, and that original may be copyrighted. The distinction between a parody and a derivative work may be fuzzy, and derivative works are covered by copyright protection. A general guideline is that the parody should contain as little copyrighted material as possible to make the reference clear and the parody effective.

For the most part, "fair use" cannot be used to condone appropriation in visual art. Appropriation, where existing imagery is taken intact and incorporated into new works created by another artist, became popular in the 1980s and continues to be common. The proliferation of new technologies makes incorporating another's work into your own easily accomplished. Appropriated imagery adds increased layers of meaning to a new work, as both bring with them their unique subject matter, context, and social associations. Appropriation can be very effective in deconstructing or critiquing aesthetic or social standards.

If you are interested in appropriation and want to incorporate existing imagery in your own work, you could limit yourself to images in the public domain. This would include all material without a copyright, everything published more than seventy-five years ago, or anything published prior to January 1, 1978, for which the copyright has lapsed. The records of the Copyright Office are open to public inspection, and searches can be made

by name of copyright owner or by the name of the work in question. The Copyright Office will conduct a search for you, charging an hourly fee and costs (request Circulars 22 and 23 for more information). Documents created by employees of the federal government as part of their official duties may be freely copied. If you wish to appropriate copyrighted imagery, you must get written permission of the copyright owner.

Some artists take existing imagery, copyrighted or not, as a basis for their own artwork but transform it to create a new work that is obviously not the original copyrighted work. However, if a jury were to decide that your new work was substantially similar to the original, your new work might still infringe on the original's copyright. "Substantial similarity" is not precisely defined, but represents a judgment call.

A recent famous copyright suit was brought against the artist Jeff Koons who had a copyrighted image by the photographer Art Rogers made into a sculpture. Rogers sued for copyright infringement and won. Defenses for Koons included parody and the creative transformation of source material; Koons turned the photograph into a sculpture, changed the color and altered some details. None of these arguments was effective. In 1992, the court decided that Koons was motivated by profit rather than parody and there was "substantial similarity" between the Rogers photograph and the Koons sculpture. Rogers sought $2.8 million in damages.

There are no fixed guidelines or set of conditions that stand as absolute criteria for copyright infringement. If a case is contested in court, a jury will be presented with arguments and evidence and use their collective judgment. However, legal suits generally do not arise unless money can be made or in circumstances with high visibility.

A final area covered by copyright law is that of *moral rights*. These protections cover issues of attribution and integrity. Attribution is the right of artists to be credited for the works they have created and not to be identified with works made by others. Integrity is the right of artists to protect works "of recognized stature" from being mutilated, modified, or destroyed when these acts negatively affect their honor or reputations. The law covers only willful and intentional mutilations, and exempts modifications that result from the passage of time. Moral rights are covered in Section 106A of the Copyright Law, and are limited to unique works of visual art and artworks reproduced in limited numbered editions of two hundred or less. When a work of visual art is incorporated into a building and the building owner wants it removed, the owner must grant the artist the opportunity to remove the work rather than simply destroy it.

Moral rights are not like the other copyrights that are concerned with personal property. Generally these rights have no financial considerations attached directly to them, and in fact are somewhat antagonistic to the concept of personal property, which allows property owners to do as they choose with their possessions. The person who owns a work of art "of recognized stature" is obliged to respect the integrity of that work as long as its

creator lives. These rights belong to the artists for the extents of their life-times and cannot be bought or sold, even when the original work and its copyright have been transferred. Artists can waive the rights in writing, but they cannot belong to anyone else.

While these and other moral rights have been long recognized in other countries, notably France, they are relatively new in the United States, having been incorporated into the federal Copyright Law only in 1990. Thus the actual interpretation of terms and the implementation of the law itself has been little tested by courts. Moral rights are covered more thoroughly in state laws, such as the California Art Preservation Act and the New York Artists' Authorship Rights Act. Other states protecting the moral right of integrity include Connecticut, Louisiana, Maine, Massachusetts, Nevada, New Mexico, Pennsylvania, Rhode Island, and Utah.

For more information on all aspects of the Copyright Law and copyright registration, consult the helpful and easily readable publications from the U.S. Copyright Office. The *Artist's Friendly Legal Guide*, by Conner, et al., also discusses copyright issues and procedures. Additionally, an informative book on copyright and a host of other legal issues surrounding art is *Art Law in a Nutshell*, by Leonard D. DuBoff.

Freedom of Expression Issues

Artists have always used their artwork as vehicles to express ideas. Sometimes these ideas have run afoul of certain U.S. social or legal standards. Segments of the population or of the government have sought to repress art that they considered subversive, obscene, or religiously offensive. Recent examples have included withdrawn funding for Robert Mapplethorpe photographs based on accusations of obscenity, Andres Serrano's "Piss Christ" for offending a number of Christians, and several examples of U.S. flag desecration in artwork as a form of political protest.

While freedom of speech is often cited as a defense in these situations, the speech protected by the First Amendment is "pure speech," or verbal or written communication. The courts extend this protection to other forms of expression, including artwork and conduct, as they approach "pure speech," but exact extent of the protected categories is not clear. Although freedom of speech is a constitutional right, the government always has the overriding right to outlaw advocacy that may incite a lawless action. In addition, the courts may classify some material as outside the protection of the First Amendment, such as child pornography or hate speech. Also, commercial speech used in advertising is not protected because it is not "pure speech."

There have been recent cases of artwork being removed from an exhibit for having offended someone or some group; often the removal is met with protest. A recent example occurred when some city council members removed an unflattering painting of Chicago Mayor Harold Washington from a public exhibition. More stifling to freedom of expression is the behind-the-

scene censorship imposed by some art professionals and community leaders who opt to not show some work because they fear possible reactions to it. They simply skirt the issue by showing something else. Artists have sometimes practiced self-imposed censorship, in some cases never creating or showing work they would have otherwise done, for fear of closed doors, pressures, or reprisals. Social pressures can be great, but artists and art professionals need not succumb to it. For a more detailed discussion of the legal issues surrounding freedom of expression, see *Art Law in a Nutshell*, by Leonard D. DuBoff. Organizations that may be helpful on this issue are the American Civil Liberties Union's Art Censorship Project and the National Campaign for Freedom of Expression.

John Baldessari, 1991
Photo © Luciano Perna

ARTIST INTERVIEW: JOHN BALDESSARI

John Baldessari is a conceptual artist, photographer, maker of books, and filmmaker, whose work has been widely shown throughout the United States and Europe. He taught for many years at California Institute for the Arts. He discusses here his own use of imagery and issues of intellectual property.

I'm not sure if this is the language you would use, but you recycle images in your work.

Well, when you say "recycle" that does make me a little bit uncomfortable. If recycling is like somebody writing using words that some other writer has used . . . yeah, of course. . . .

I'm perfectly willing to go out and shoot a photograph. But my attitude is that unless you need an image of a particular house, why go shoot another house? For me images are just stuff out there in the world. What makes it art is how they're put together. I think I go at my own work very much like a writer. But all artists are doing that. They are drawing from bits of memory here, from that painting or this prior experience or what have you. It's all cooking in there.

(continued)

John Baldessari. Sea Creature: Cyclist/Obscured
Situation/Telephone/Money/Drinkers/Boxer/Passerby.
1992. Color photography, crayon on masonite, 95.75" X 94".
Photo © Lawrence Beck. (Courtesy of Sonnabend Gallery, New York)

(continued from previous page)

Do you keep a lot of source material? How do you organize and access it? Where does the imagery come from?

Over the years I've used various kinds of systems: alphabetized, color-coded, file folders and so on. Now I think that my vocabulary of images has grown, like one's vocabulary of words, to the point where you don't have to use a dictionary. I sort of know where things are. My imagery comes from anyplace, I guess. I use a lot of film stills. If I find a snapshot in the street that somebody's thrown away and there's something there I think I can use, I'll use that.

Technology has made it increasingly easy to use existing images and at the same time we are experiencing increased legal efforts to protect intellectual property rights in reference to images.

(continued)

(continued from previous page)

In terms of intellectual property, I could go either way on that. In one way it seems preposterous, like owning a dictionary and no one can use those words anymore. But if someone were just going to completely lift a whole book or a whole painting I could see some problem with that.

But art couldn't happen without borrowing from the history of art. I just think it should be all free flowing, somehow, because I don't know where it ends, you see. I talked about using a photograph of a house. Does somebody own that? And if another photograph of the house had been taken a minute later, would it be a different picture? Or move the camera a millimeter, would it be a different picture? Yes, in fact it would, but at what point does somebody own an image? I don't know.

The legal system has attempted to define intellectual ownership but actually when there is a dispute in court, the jury makes a judgment call. And one jury may decide one way, and another. . . .

There are interesting implications in some music sampling. There was an article in the *New York Times* where a rap group had used "Pretty Woman," and the estate of Roy Orbison sued. The rap group won. The decision was that it was parody. So now I guess if we say that things are a parody, then it's okay. I don't know what the implication of this is going to be.

I understand that Jeff Koons used parody as a defense in the lawsuit Art Rogers brought against him. And Koons lost.

I wasn't there but I understand that he lost because he had a pretty arrogant attitude when in fact he shouldn't have lost.

Your feeling is that his taking was legitimate. . . .

My god, the two things were so different. It gets pretty bizarre.

You said before that you don't check the copyright status of works that you use, but then you really change them substantially anyway.

It used to be in years back that the rule of thumb in the advertising world was that you just flip-flopped the image and that would make it

(continued)

(continued from previous page)

okay to use. I don't know if that was true or not; that was just the conventional wisdom that was around. It gets ludicrous. I just did a piece for the Museum of Modern Art where I'm photographing elements from their collection and I used a very small detail from a Disney film, the "Three Little Pigs"—one frame of the film!—and there was a two-page contract just to use this.

I understand that Disney is exceedingly vigilant in protecting their copyrighted materials.

I have heard, but don't know if it's true or not, that any photograph taken at DisneyWorld is copyrighted. I don't know if it's ever been tested or what.

You have been careful in the past when you used appropriated images of nonpublic persons in your work. Placing the dots over their faces solved both conceptual and potentially legal problems.

That's my own summation; I don't know if in fact that it does.

All this fits with your interest in populist approaches to art.

I don't think that art has to be defined by money.

And it fits with your emphasis on accessibility. You mentioned in other interviews that one reason you made artist books was that your students could afford them.

I just used students as an example because that was my social milieu. I still do things for magazines, or posters or billboards or what have you. What is so great about books, in terms of literature, is that anyone can have a great work of art in their hands. Why can't the same thing apply to visual art?

I think art making can be reduced to simple communication. Essentially, it's one person trying to get something across to another person.

You are quoted as saying, "Every artist should have a cheap line: it keeps art ordinary and away from being overblown." Is that perhaps even more important now?

That is another populist notion of mine, tied with ideas of accessibility. But if you mean that maybe cheaper things sell better now—it

(continued)

(continued from previous page)

doesn't matter. It's not that money isn't out there. I think people feel a little ashamed in using it in a conspicuous way and art gets included somehow as something that one really doesn't need, like having a yacht or a second home or what have you. It's not seen by too many people as really necessary. And actually I think I resisted the idea of art for a long time because I didn't think it helped anybody. But then it seems like it does in some way I can't quite figure out.

It's absolutely imperative that the art one does is the art one believes in. That sounds pretty maudlin but quite often we do the art we think the world wants to see, for whatever reasons, and it may not really. The art that you might really want to do but don't do because people would think you were bonkers, that's going to come out eventually, so you might as well attend to it right away.

SECTION FIVE

Graduate School

For the majority of artists, a college education has been essential to their development. At the undergraduate level, art education speeds your growth technically and conceptually as an artist, while general education expands the range of related topics for your art. The educational environment provides you with a community of people who will help and support each other. You have the opportunity to study the work of other contemporary and historical artists. However, you do not absolutely need a college degree to be an artist, much less advanced study in graduate school. There are examples of artists of distinction who have had no formal art schooling at all.

Should you get a Master of Fine Arts degree? While the M.F.A. will likely aid your career, whether or not to go to graduate school is a complex decision to make. Chapter 16 provides guidelines for making that decision, and methods for choosing graduate schools.

Chapter 16

THE MASTER OF FINE ARTS DEGREE

The Master of Fine Arts is the advanced degree for studio art making, earned upon completion of graduate school. Most M.F.A. programs are either two or three years in length. The Master of Fine Arts is a relatively new degree in academia. First offered by a few schools in the late 1940s, the number of M.F.A. programs and students ballooned during the late 1960s and 1970s. Few artists who began their professional careers in the 1950s and even early 1960s had an M.F.A. Now, the M.F.A. is quite common among artists.

The first major benefit of working for your M.F.A. degree is the opportunity to concentrate intensely for a few years to develop a personal body of work. In the Master of Fine Arts program, your own ideas, momentum, and enthusiasm dictate your art making within an environment that should challenge you. Graduate study is much more focused and self-directed, versus the generalized and instructor-directed undergraduate experience. Undergraduate programs require a mix of art courses in various media and general education courses. Undergraduates often do not have the time or direction to produce a coherent body of work.

In graduate school, you make artwork that springs from your own ideas and learn contemporary theoretical and conceptual issues surrounding art making. Art making now is considered a critical activity, and artists must understand how their art responds to or develops from others' art and how it fits with major art developments, social changes or political issues. The M.F.A. curriculum will help you develop the conceptual framework and language you need to relate these issues to your own art making.

On the practical side, you can use the M.F.A. to place yourself in the professional art world. In addition to the education you receive, the M.F.A. helps validate you in the art market, provides you with personal recommendations, and leads to professional contacts. This process begins even while you are still in graduate school, as you make connections with curators, gallery directors, and writers. You work closely with faculty members who may become friends or mentors, and may assist you in your career even after you finish your degree. You can form alliances with your fellow graduate students, and join art cooperatives and organizations. All this is especially beneficial if you are studying someplace other than where you went to undergraduate school. You can "learn the ropes" in an art center in a new city.

An M.F.A. program also provides material benefits. These may include a free studio for you, access to metal-fabricating and woodwork shops, access

to photography darkrooms, computer labs, painting facilities or drawing studios with figure models. If you study at a college or university rather than at an art institute, you may also take courses in other excellent academic departments related to art, such as history, critical theory, urban planning or film studies. A good art school or department should have an extensive library.

The M.F.A. is the highest degree, or "terminal degree," offered in academia for art making. Thus an M.F.A. qualifies you for a college-level teaching job, which may help your career as an artist, and give you enough free time to pursue your art making. Most college instructors teach 15 to 18 contact hours per week plus committee work, and have summers off, while still earning a full-time salary with benefits. College teaching jobs are scarce and the competition is stiff. While on rare occasions prominent artists without degrees may be hired to teach, almost all universities, colleges and junior colleges require the M.F.A. of all studio art instructors.

Artists frequently take other art-related jobs, such as curator, art writer, arts administrator, gallery worker, designer or fabricator. While not necessary, the M.F.A. nonetheless provides good background training for any of these positions.

On the downside, an M.F.A. degree carries some false expectations about what it means and what it can do for an artist. While the M.F.A. does help to validate you as an artist, too many students graduate with M.F.A. degrees each year to find college teaching positions, or to be absorbed into the mainstream commercial gallery system. Teaching jobs at four-year colleges and universities are especially hard to get, although part-time teaching positions at junior colleges are more plentiful and more available to recent M.F.A. graduates, especially in large cities with extensive junior college systems. Nonetheless, the odds against your finding a tenure-track teaching job or financial success in a commercial gallery are still very high. Recent graduates often have to deal with financial hardship, especially if they are burdened with school debts and are without a regular job for several years after finishing the M.F.A.

Do not go to graduate school with the expectation that you will be able immediately to find a teaching, curatorial or writing job upon graduation. Do not go to graduate school if it means incurring massive debts. Graduate school is a good choice for you if you want to spend a few years intensively making art, honing your intellectual and technical skills, studying critical theory, building alliances, and beginning to develop long-term involvement in the art world.

A note about Master of Arts degrees: Some colleges and universities offer Master of Arts degrees in Studio Art. These are sometimes one-year programs, but more often take eighteen months or two years to complete. The M.A. usually requires half or two-thirds the credit hours of an M.F.A. degree. Studying for an M.A. in Studio Art provides you with many of the benefits of the M.F.A. degree, such as the opportunity to focus on your work, interact with faculty, and use the resources of the institution. However, the M.A. is not the terminal degree in the field of art making, and therefore does not qualify you for college-level teaching jobs in studio art. The effort required to earn the M.A. degree

may not be much less than for an M.F.A. Graduate school expenses may be comparable for an M.A. and an M.F.A. degree. If you decide you want an M.F.A. after completing an M.A., you may find that many schools will not count your M.A. studio credits towards your M.F.A. requirements. Essentially, you would have to start over. Therefore, enroll in an M.F.A. rather than an M.A. program. Note: this caveat applies only to Studio Art programs, not to M.A. programs in other areas of study.

WHEN TO CONSIDER GRADUATE SCHOOL

Some students apply for graduate school during their undergraduate senior year, and begin graduate school the following September. However, more students take a break before graduate school. Graduate students in studio art are often in their late twenties or thirties; students in their forties are less common but certainly not rare.

There are several advantages of waiting a few years before going to graduate school. You can use the time to work in a professional art-related job, to better understand the professional art world before returning to school. Hopefully, the job will put you in good financial shape; graduate school can be very expensive, even with scholarships, assistantships, and living stipends. During the intervening years, you can develop and focus your artwork. More mature, coherent work gives you a better chance to get into graduate school than the best of your undergraduate work, which is likely be somewhat disjointed, having been produced in different classes, in a wide range of media, exploring disparate themes. In the extra years, you can more thoroughly research graduate schools, a task that can at times feel almost like a part-time job!

Finally, a few extra years' maturity helps as you begin school. Graduate school can be intense, with teachers challenging you and other students competing against you. You can lose your way or become discouraged. With more art-making background and professional experience, you may be less buffeted by the rigors of school than younger persons just out of undergraduate school.

If you decide to go to graduate school, you need to start working toward it almost a full year before you plan to attend. Each school has its own timetable for admission applications. Some schools admit students in September only, while others admit at the beginning of any semester or quarter. For September admissions, the majority of better-known schools have deadlines of February 1 through April 1 of the same year; some are earlier or later. For January admission, the deadline is often November 1 of the previous year. Some schools have "rolling admission," which means you can apply at any time, and if accepted, you may enter at the beginning of the next semester/quarter in which there is room for you.

Even before the application deadlines, which are several months before you begin attending school, you will need about five months to research schools and prepare your applications. Use the first three months to research

schools, reading directories, writing for catalogs and visiting schools. Take any necessary standardized tests at this time. The last two months will be devoted to collecting letters of recommendation, ordering transcripts, preparing slides, and working on application forms, statements, and financial aid forms. A single application, with slides, application fee, test fee, and postage, will probably cost between $40 and $85.

MAKING PRELIMINARY CHOICES

How do you choose among the 180 M.F.A. programs currently offered in the United States? You might simply pick the one nearest to you. But with some research, you are likely to find programs that would better challenge you, with faculty more suited to help you with your specific art concerns, with favorable financial aid packages, in cities with thriving art communities, and so on.

Investigating M.F.A. programs is serious, time-consuming research. Ask your undergraduate teachers, your mentors, or other artists for suggestions on universities with good M.F.A. programs, where they studied for an M.F.A., or if they know any particularly strong programs. Talking to those who know your work and know about various M.F.A. programs is the best way to find a program appropriate for you. Ask them to name artists whose work has an affinity to yours, with whom you should study, and where these artists are currently teaching. A strong faculty can make your graduate studies exciting and beneficial even if other factors are less than ideal. Studying with the "right" persons is more important than where you study or how many labs you can use. Also, ask mentors and other artists about the cultural life in areas surrounding the school and about the facilities available to graduate students. Your mentors' recommendations can greatly decrease the amount of research you have to do to find a good school. Word of mouth is often the most effective way to find the best program for what you want to do.

Where do you want to live while you study? If you plan to stay in the United States, choosing a region that appeals to you is another step in narrowing the scope of your research into M.F.A. programs. The Northeast and the West Coast have the greatest concentration of art centers. Beyond that, the decision is a matter of personal choice, based on factors like weather, political climate, local culture, and so on. Choose an area where you believe you would be happy.

Do you want to live in a big city? Again, this is a personal decision. The largest art centers in this country are in New York City, Los Angeles, and Chicago. However, other large U.S. cities have art communities and distinct political and cultural scenes, including Boston, Miami, Minneapolis/St. Paul, Philadelphia, Washington (D.C.), Baltimore, New Orleans, Pittsburgh, Houston, Dallas, Seattle, San Francisco, San Diego, and others. Before deciding on a particular city, investigate its art community. Size alone will not always be the best indication. The following are some important signs:

- Look for a good museum, several galleries, and alternative spaces. The *Annual Guide to Museums, Galleries and Artists*, published every year by *Art in America* magazine, will quickly provide you with this information.
- Look for at least two good colleges/universities in the city. It is not absolutely necessary that both have strong M.F.A. programs, but both should have good art departments.
- Look for other social, cultural, and political events that represent diverse life-styles and points of view. Check the daily and alternative newspapers for signs of thriving local scenes, especially checking the calendar sections. You can find newspapers from other cities in almost all university and large public libraries.
- Look for good sources for art supplies and for raw and industrial materials, by checking that city's telephone directories, which are usually available at large public libraries.

At the other end of the spectrum, you may choose to pursue your M.F.A. at an isolated university, outside of any major city, where there are few distractions to keep you from concentrating full-time on your work. Choose major universities with many cultural resources, to help overcome the limited urban opportunities. Small colleges in small towns have limited resources and few art faculty.

There are cost implications in your choices. Living in large cities is likely to be more expensive than in small towns. A private university in a major metropolitan area will probably entail the highest tuition and highest cost of living. A state-supported public university will be less expensive if you establish residency in that state, but nonresident fees may be as high as private university tuition. In fact, private university tuition offset by financial aid may end up costing you less than paying nonresident fees at public institutions.

If you study in a foreign university, you will not be working towards an M.F.A. An advanced degree in art from a foreign institution is not equivalent to the M.F.A. and will not be honored by U.S. colleges and universities. The only exceptions are the M.F.A.s offered by some Canadian institutions. If you want to study overseas for enrichment as part of your M.F.A. studies, enroll in an M.F.A.-granting U.S. university that has "study abroad" programs.

Avoid trying to transfer credits from one institution to another, because most schools want students to take studio courses in residence. Therefore, studio credits from foreign institutions will probably not count toward an M.F.A. degree, and studio credits from other U.S. schools may not transfer either. If you do try to transfer credits, you will have to meet the criteria established by the school granting your degree. Ask about accreditation requirements, comparability of courses, and time limitations for any course you hope to transfer.

RESEARCHING GRADUATE SCHOOLS

Once you have asked mentors to recommend M.F.A. programs and have made your geographical decisions, your next task is to research and evaluate the available M.F.A. programs. There are several directories providing up-to-date information on M.F.A. programs, which will give you enough preliminary information to make a short list of schools to which to apply.

The National Association of Schools of Art and Design (NASAD) is the only national accrediting agency for art programs in this country, recognized by the U.S. Department of Education and the Council on Postsecondary Accreditation. Art schools that want to be accredited by NASAD submit to an extensive review of their curriculum, faculty, facilities and administration, to determine if they meet NASAD standards. If so, they are listed in NASAD's annual "Directory of Member Institutions," which lists the names and addresses of accredited schools and the degrees offered (B.A., B.F.A., M.A., M.F.A., etc.).

NASAD evaluates and recommends only certain schools and M.F.A. programs. Any NASAD-approved program is likely to be reputable and stable. However, other excellent M.F.A. programs are not NASAD-approved and therefore not listed in its directory. Accreditation is not necessary for a program to be recognized as reputable. Some schools have never chosen to submit to the time-consuming and costly NASAD evaluation process. In addition, NASAD's standards promote a curriculum that is heavily weighted towards studio courses. NASAD-accredited schools may require that you take more studio hours than other institutions, which may not interest you if you want a program with more humanities, critical studies, or art theory seminars.

Other directories that list all schools offering the M.F.A. degree are available in college or large public libraries. These directories are compiled from information provided by the listed schools and thus make no evaluation about the quality of the programs offered, unlike the NASAD directory. In some cases, the information about the schools and programs is quite extensive and very valuable, while others contain only brief listings. Consult only recently published directories so that the information is current.

M.F.A.: Directory of Programs in the Visual Arts contains the most extensive listings about M.F.A. programs in the United States, identifying all 180 institutions offering the degree. In addition to the factual information such as the institutions' addresses whether they are private or public, *M.F.A.: Directory of Programs in the Visual Arts* lists admission requirements and application materials, faculty names and areas of expertise, and numbers of students, indicating gender breakdown of both faculty and students. As for the curriculum, it lists minimum, maximum, and average length of study time, areas of concentration, requirements for graduation, and opportunities to study abroad if available. A resource list (studio, labs, exhibition spaces, etc.) and breakdown of financial aid are also provided. *M.F.A.: Directory of Programs in the Visual*

Arts is updated every five years and is published by and available through the College Art Association.

Peterson's Annual Guides to Graduate Studies is a six-volume publication updated yearly. Book 2, entitled *Peterson's Guide to Graduate Programs in the Humanities and Social Sciences*, lists all M.A.- and M.F.A.-granting institutions in the United States, U.S. territories, and Canada under "Section 4: Art and Art History." In addition to the school's address, telephone number, unit head, and application contact, the directory lists possible media areas of concentration, accreditation status, availability of part-time programs, number of faculty with gender breakdown, number of students with gender and ethnic breakdown, degree requirements, entrance requirements, application deadline and fees, tuition and fees, and available financial aid. All of this information is abbreviated and condensed into one paragraph of small type. Some schools have opted to purchase two-page advertisements in *Peterson's* that cover the same points about the program and faculty, but in a much more expanded format.

American Art Directory contains a list of 1,667 art schools, colleges, and universities offering graduate and undergraduate degrees in studio art, art history, and architecture in the United States and Canada. Because it covers so many degrees, you have to dig to find those schools offering M.F.A.'s, and its entries are fairly brief. For each school, the *American Art Directory* lists its address, name of dean or department chair, degrees awarded, tuition, and in some cases the names of its faculty members.

How do you turn these directories' orgies of facts into useful information as you select M.F.A. programs? First, evaluate the faculty. There should be more than one working in your medium or area of interest, so that you will be exposed to broad input and criticism about your work. While they are unlikely to be the hottest new names in the contemporary national art scene, the faculty should be actively producing artists, with recent exhibitions or publications. To determine their degree of activity, look up art faculty in the *Art Index,* a bibliographic listing of articles from 235 different art publications, to see if their work has been recently reviewed, to find any recently published reproductions of their work, or to read any articles they may have written. Check for them also in *Who's Who in American Art*, a compilation of short biographies of artists, art historians, administrators, librarians, collectors, critics, and curators. In very condensed form, you can read about the faculty's vital statistics, education, training, works in public collections, commissions, exhibitions, positions held, honors and awards, media, and dealers. While *Who's Who in American Art* provides much valuable information, unfortunately it is not totally inclusive. It leaves out some significant persons because of the somewhat random process by which artists are nominated to be included.

Check the school's curriculum in these directories. What is the average completion time for the degree? Two-year and three-year programs are standard. What suits your own timetable? How much time and tuition can you afford? What are the requirements for graduation? You should expect to have a solo exhibit of your work in a quality gallery space and write a thesis about

your work or about some contemporary art issue. To require much less indicates a program that is not as rigorous and challenging as it could be. Check the list of resources. A well-equipped department should be able to provide a metal shop, wood shop, photo lab, private studios, and computer facilities for image manipulation (not simply word-processing labs). While they are important considerations, facilities and curricula are lesser priorities than the quality of the faculty when choosing graduate schools, because facilities and curricular lists alone do not always indicate what goes on in the school.

After examining the faculty, facilities, and program as presented in these general directories, you should be able to compile a list of five to ten schools that seem promising to you. Write to their admissions offices and request catalogs, application forms, financial aid information, and more information on their M.F.A. programs. Read the catalogs thoroughly to find out about the institutions as a whole, and their resources. Carefully study the curricula and number of courses required, the number of years in the program, and other writing or exhibition requirements to complete the M.F.A. Read about available financial aid and note admissions requirements and application deadlines. Check again on the faculty, their areas of expertise and their professional accomplishments. Look at the curricula in other departments for related courses that will expand the scope of your studies.

If possible, visit your top choices of schools to which you intend to apply. Before you go, set up appointments in advance with faculty and admissions counselors. Take a set of your slides with you and talk to the faculty about your work. Try to determine whether you want to work with this faculty, how accessible they are, how interested they are in students in general and you in particular, and what they think about your work.

Look at studios, labs, and other facilities for available equipment, technical assistance, and access. Does the equipment work? Are the studios large enough, well-lit and ventilated, and secure? Are the studios on or close to campus? Many schools may not be able to provide pristine facilities with new equipment. But do the facilities meet your art-making needs?

Visit the library, look over the periodicals available, and the size of the art book collections. The collection should include contemporary theoretical books and scholarly publications, in addition to books with good reproductions. Visit and evaluate the university museum, gallery, or student exhibition space.

Talk to students currently enrolled in the M.F.A. program. What do they think of the faculty, the quality of the teaching, the curriculum, and the facilities. Is the program working well? What are the topics discussed in seminars? Are the faculty members available for individual critiques? Does the student work seem strong? Does the work look the same from student to student, or is there variety?

Admissions counselors can be a great source of information about the school, financial aid, and admissions procedures. Since they are salespersons for the school, they are likely to lean toward the positive when answering your

questions. But pointed questions can elicit a fairly accurate picture of the school. Even if you cannot afford to visit the school in person before applying, you should ask the admissions counselor these questions by phone:

The faculty

- Can they guarantee that prominent faculty will be available to work with students? Well-known artists may be listed among the faculty, but at some schools they are rarely on campus due to career commitments.

The facilities

- Are studios provided for graduate students?
- Are they private or communal studios?
- Can they be locked and are they secure?
- Do graduate students have twenty-four hour access to studios and labs?

The curriculum

- How long will it take to complete the M.F.A.?
- How many hours and what specific courses are required to complete the M.F.A.?
- Do graduate students take specific courses of instruction, such as painting, or do they work independently in their studios?
- Can graduate students easily cross media areas? For example, could a photography student choose also to work in another medium, or are they restricted to photography only in pursuing their degree?
- What is the philosophy of the art institution? Do the faculty members promote a particular conceptual, critical, social, or political agenda?
- What other resources are available to students at this institution? For example, if at a university, can graduate students also take courses in other departments?

Financial Aid

- What kinds of financial aid does the school offer?
- Does a teaching assistantship provide tuition remission, a stipend, or both?
- What are the responsibilities and obligations of a teaching assistant?
- What does a fellowship provide, and in return for what?
- What loans or work-study programs are available?
- How many teaching assistantships are available?
- How many teaching assistantships are given to first-year graduate students?

The Admissions Process

- What does the school want to see in a slide portfolio for admission?
- What is the basis for choosing students to receive a teaching assistantship?
- How many people do they accept, out of how large a pool of candidates?
- When are applicants notified about whether they have been admitted and if they have received a teaching assistantship?

ADMISSIONS APPLICATIONS, FINANCIAL AID, AND OTHER REQUIREMENTS

All schools require that you have a certain amount of background preparation before you can apply to graduate school, but schools vary from institution to institution in their basic requirements.

To apply for an M.F.A. program, you need an undergraduate degree, although a few places indicate that they would accept "comparable experience." A number of schools require that the undergraduate degree be either a Bachelor of Fine Arts degree, a Bachelor of Arts degree with at least sixty hours of studio credits, or "the equivalent." You must have your undergraduate school send your transcripts directly to the graduate schools to which you are applying. Some schools require that you score at a certain level on the Graduate Record Exam (GRE) and others require the Test of English as a Foreign Language (TOEFL) for international students. Test scores must be sent to the schools to which you are applying. Further information is available through your undergraduate student advisor, graduate school admissions counselor, or by contacting GRE or TOEFL directly.

Once you have met the basic requirements, you must provide written and visual material upon which you will be evaluated for admission. The first step is to complete an application form provided by the school. University-based art schools usually require that you complete two application forms, one to the graduate school and one to the art department. You must send a slide portfolio of your work, usually with twenty slides. The slides are almost always the most important criteria for admission. Make sure your work is as strong as possible and that your slides are well framed, properly exposed, and clearly labeled. Read the application form carefully to find out how each school wants the slides presented. Schools may request slides in carousels, in plastic sheets, or in boxes. Some want a printed list of slides, while others request some particular labeling. Include a self-addressed stamped envelope if you want your slides returned.

Almost all schools require three letters of recommendation (see Chapter 12 for advice on soliciting letters of recommendation). Most require a typed essay, which could be a brief version of your artist's statement, with reasons why you are interested in graduate school and your long- and short-term goals. Have your mentor read your essay and make suggestions before you send it. A few schools require a personal interview with you.

Most schools charge an application fee, ranging between $15 and $50. If you cannot afford the application fee for each school, you can request a fee waiver based on limited financial circumstances. Either write a personal letter requesting the waiver, or ask your current department counselor to write one, if you are still in school.

Apply for all possible financial aid packages to receive as much assistance as possible while in school. Tuition, art supplies, raw materials, and living expenses

can be tremendous, and you want to incur as few debts as possible while in graduate school. These are the general categories of financial aid:

- Scholarships defray or wipe out the cost of tuition, and are based on merit. Scholarships generally carry no work obligation with them. Recipients usually must maintain a high grade point average.
- Grants defray or wipe out the cost of tuition, but are based on need, with generally no work obligation, but often a GPA level to maintain.
- Fellowships provide money to graduate students for tuition and also stipends for living expenses. There is generally no associated work obligation.
- Assistantships provide stipends that help defray the cost of living and/or provide tuition remission, which is a cancellation of or release from paying tuition. In exchange, students work a number of hours for the school. Most are teaching assistantships, in which graduate students work with undergraduate classes for ten to twenty hours per week. In some schools, teaching assistants are completely responsible for a class; at other institutions, regular faculty are in the classroom with TAs. Much less common in art are research assistantships, where graduate students assist faculty in their research.
- Work-study programs pay students to work a limited number of hours weekly on campus, usually doing clerical tasks or maintenance.
- Student loans are monies lent at low interest rates, but must be repaid. Loans should be the last resort financial aid; borrow only what you absolutely need to keep your debt to a minimum.

Often, there are sources of aid for underrepresented, minority, disadvantaged, and disabled groups. If you belong to one of these groups, identify yourself as such to the financial aid officer at the schools to which you are applying to find out if special funding exist.

Most schools offer a range of financial aid, and often students are provided aid from various categories, making up their particular financial aid package. It is impossible here to give specific information about financial aid that covers all institutions, because each school has its own resources and application procedures. Read the instructions from each institution, fill out and return all forms well in advance of their deadline if possible. Keep copies of all forms, because most institutions ask for similar information, and some require you to reapply for financial aid every year you are enrolled in their program.

Apply to six to eight schools if possible. This gives you a better chance of being admitted at one school at least, and at best, lets you choose the most favorable offer if several institutions admit you. Call the schools to make sure that all materials and letters of recommendation have been received.

Most schools use something like the following admissions screening process. After the application deadline, admissions counselors review all applications for completeness. Then, the faculty review the slides, letters of

recommendation, and statements to choose whom to admit to the program. Teaching assistantships, scholarships and other financial aid are awarded to students who seem the most promising, plus a list of runners-up is compiled. Letters are then sent to applicants, informing them that 1) they are admitted to the program with financial aid; 2) they are admitted to the program and on a waiting list for financial aid; 3) they are admitted to the program; 4) they are on a waiting list to be admitted to the program; or 5) they have not been accepted into the program.

If you were unable to visit a school before applying, try to see it before you accept admission, to make sure the program will work for you. Once a school has admitted you, you have a limited amount of time either to accept or refuse admission and pay a deposit to hold your place in the program. You will be receiving responses from the various schools over a period of weeks or even months, because each school's application deadline is different. This may put you in the difficult position of having to decide to accept one school's offer before you have even heard from other schools. Or you may be on the waiting list for admission or financial aid at your preferred institution and wonder whether to accept a firm offer from another school. You definitely should accept the one best offer you have received at any point in time. If a better offer comes later from another school, go for it and then decline your first acceptance. Of course, you should never accept the offers of two or more schools simultaneously. Take your best choice, and free your space at your second choice for others who are on the waiting list at that institution.

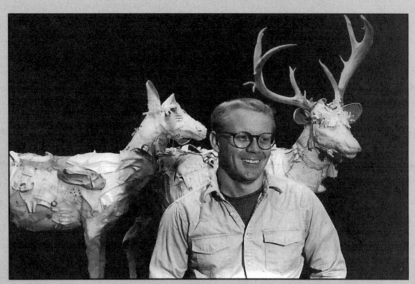

Ken Little (shown with Wish, 1982, Collection of Nelson Gallery, University of California, Davis.)
(Photo courtesy of artist)

ARTIST INTERVIEW: KEN LITTLE

Ken Little is a sculptor who teaches at University of Texas at San Antonio, who has also lived in Montana and Utah. He has opened an alternative exhibition space in the warehouse he purchased and renovated into artists' studios. In his interview, he discusses practical problems and philosophical issues facing some students after they finish graduate school.

You've worked a number of years as a sculptor, but never had consistent gallery representation.

I grew up in places where you only saw art in museums, so I figured that's what you made it for. I didn't really ever think about trying to sell through a commercial gallery. Some artists focus on making a living off their work. But I just assumed I never would, but that I would do something else, and do my work. And I've been really pretty fortunate in having teaching jobs and grants.

In the 1970s when I was a student, I started entering slide-entry shows where you paid five dollars. They are more expensive now. My work wasn't insured and I had to pay shipping both ways. And

(continued)

Ken Little, Henry Stein. Bible Houses (detail of the installation Scenic Loop). 1993. Mixed media, Each house: 12" X 14" X 9". Art Gallery, California State University at San Bernardino.
(Photo courtesy of artist)

(continued from previous page)

they weren't responsible for damage or anything. These competitions were like "artist rodeos"; everyone showed up, paid an entry fee and someone won a prize! But through those kinds of shows, I made some contacts with people who were running small art centers and who later went on to other places. They'd sometimes give me a show five years later.

Away from major cultural centers, there is a whole level of smaller art museums and art communities that basically don't have very good budgets and need to get art to show. I encourage my students to contact these art museums and university galleries in towns anywhere from 40,000 to 250,000 people. They may go for contemporary art, depending on the curators or directors there, who are just starting out themselves. Eventually some of those people are going to be at the bigger museums. It helps when you have networked with these people starting their careers also, and then over the

(continued)

(continued from previous page)

years maintain your connection with them. Things will work out if you keep working and the work is good.

I've tried really hard to show in places like San Francisco and New York, and have had some success doing that. However, being a sculptor particularly makes it very difficult to maintain those long-distance connections. The galleries I work with have no shipping budgets to speak of, so I'd drive the work out there myself, because I couldn't pay to have it shipped out. And it's just not practical for galleries either. They would say, "Look, logistically our problem is first of all we can't store it. We won't sell it in the show, because we usually make our sales six months after the show. We can't keep the sculpture around that long." They can stack many more paintings in the back. And also, let's face it, they can't sell as many sculptures as they can sell paintings.

Do you have any advice for sculptors?

Learn to survive as an artist. Focus on the long haul—your life's work. And if you're an M.F.A. student in a university, you've got at your disposal probably a $300,000 or $400,000 shop full of tools and all kinds of power. Walking away from all that stuff can kill artists when they get out of school. They don't know what to do. So I really try to wean my students away from lots of equipment and process. "O.K., let's say you don't have a fancy welder or table saw or whatever. Is not having that going to make you stop making your art?"

Students solve these problems in different ways. Some of them buy tools and continue at whatever level they can maintain financially. I've also known students who get together, rent a building, and co-op tools they can all use. But you have to have insurance, because there could be real problems with liabilities. Some go for lower tech processes or learn ways to build things without all that stuff. Painters usually don't have that kind of problem. That doesn't say it's not expensive to buy paint, but they don't have to lug around all this gear.

Sculptors really need to figure out if their resources are going to hold out. If your work is all invested in processes, then you've got a real problem when you don't have access to that process. So to survive, conceptually you have to orient yourself towards a more self-sufficient sustainable direction.

If you are any kind of artist working outside the major art markets, I think that the hardest thing psychologically is the fact that there's

(continued)

(continued from previous page)

no recognition that what you're doing is a profession. Even in San Antonio, but particularly in smaller places that I've lived, your art is perceived as a hobby, or it's your creative activity that you do after your other job, putting it on the second tier in the eyes of the public. People generally don't understand art as a serious cultural endeavor. There's a recognition that it's sort of eccentric behavior, and sometimes it is, but there's plenty of pretty eccentric behavior in normal life, if you look at it. A lot of really creative great artists are regular people. But the way they plug into ordinary life is extraordinary.

Two big things that are missing when you're away from cultural centers are critical public dialog and press. Without them, art really does not have a profile in the community and thus there is no recognition of the artists. Critical public dialog and art critics are as important as collectors and museums and galleries. So find sustainable work without compromising quality, work for the long haul, network with art professionals and writers your age, and think about addressing the place where you live.

What has been your experience with teaching and being an artist?

Being an artist is a pretty hard thing to be. It's easy to lose the discipline of going to the studio. And when you've got a nice little paycheck coming in off a teaching job, and you buy a house, and then you decide you want to do some gardening work, or you get interested in cooking, or have a kid . . . I'm not saying that you can't do those things, but I think that if you want to survive as an artist, you have to keep your work as a high priority. The time you have free goes in the studio. And you need a space that's your own. And not a space that eventually you'll start storing boxes in. You go in there. It's your studio. Close the door and stay with the discipline.

My creativity is not usually robbed by teaching. I've had good jobs and I've worked on making them "good." But when I teach, I don't lug in all the staging, all the sets, all the lights and put on the play too. I make the students bring something to it, because teachers who do everything are going to be pretty well used up by the end of the day. I'm continually amazed at the students who come through my classes—wave after wave of these people, sometimes from nonart backgrounds, sincere, hard-working and very talented—who do things that are just great.

(continued)

(continued from previous page)

If someone teaches the same class every semester, and they just erase "spring semester" and put "fall semester" on the syllabus, have it copied, hand it out, and do it again and again and again . . . I think they're doing themselves and the students a disservice. If you don't like what you're doing, if you don't like teaching, if you can't grow through the process, if you don't like making your work, then you have to do something to change that. It's not the students' responsibility, it's not your work's responsibility, it's not the art world's responsibility, it's your responsibility.

You've just bought a building.

Yes, it was a warehouse, two stories, interior wooden structure, vacant for twelve years. For modern industry, it's an antique. All warehouses now are one story, so you don't have to move anything up and down, and are all steel on concrete slabs. So this piece of property was not really worth anything to anybody, except artists. It's in a pretty marginal neighborhood where you have to worry about security. Not terribly, but enough. Anyway, it makes the price right. I got really tired of renting spaces from people and doing a lot of work on them. Then when the space looked good, either the rent was going up, or someone else wanted to rent it for a lot more money, and then I'd be asked to match their rent.

So I just decided I'd do it for myself. I was fortunate enough to have money from the sale of a piece. And now it's got my studio, seven other artists, and an exhibiting space that will be open only by appointment. I really don't have the money to hire staff or do all that.

Do you have any particular advice for emerging artists?

Artists have to work through discouragement, they have to work through lack of resources, lack of funds, lack of time, lack of inspiration, lack of support, or whatever. But maintaining a discipline to work through, that is probably what makes people survive. When opportunity knocks you have to have the work.

You have to make your work and make sure it's good. Keep the best pieces in a safe place. And get a more practical kind of everyday pleasure and affirmation of who you are from your work, rather than thinking that's not enough, that you need to have a one-person show like such and such, or reviews, or a coffee-table book. It's

(continued)

(continued from previous page)

easy advice to give, and it's hard advice to live by. I'm forty-six and I live in the middle of the country. There's not much here unless you make it yourself. Once you've done it, there's a lot of power there.

Admittedly, many times I feel like I'm in an antique profession, making these things that hang around and that have no apparent function. But in the long run I think they have a deep spiritual, intellectual function in the culture. Artists are constantly judged by economic, political, and business standards rather than humanist, spiritual, or intellectual standards. And we as artists let that happen to us all the time. We're not very good at projecting our own image about the things that are important.

I've had to deal with the fact that my contemporaries who live in San Francisco or New York now have big galleries, coffee-table books, and catalogues. I have to sit down and tell myself that that is nice, but I have chosen not to live there. I could be living there, but I'm not. So I have to get something else out of my work, and that is the sense that what I'm doing is very worthwhile and that's making some sort of progress towards me being a full, enlightened person. And things will work out. They always do.

APPENDIX:

ORGANIZATIONS, AGENICIES AND SERVICES FOR ARTISTS

Accountants for the Public Interest
1012 14th Street NW
Suite 906
Washington, DC 20005
(202) 347-1668
 API is a national nonprofit organization that provides volunteer accounting services through a national network of API Affiliates, to nonprofits, individuals, and small businesses that need but cannot afford these services.

American Association of Museums
1225 Eye Street, NW
Suite 200
Washington, DC 20005
(202) 289-1818
 The AAM's monthly newsletter, *Aviso,* lists entry-level and higher job openings in museums.

American Civil Liberties Union's Arts
Censorship Project
132 West 43rd Street
New York, NY 10036
(212) 944-9800.
 The ACLU's Arts Censorship Project is dedicated to litigation, advocacy and public education concerning censorship in the arts. The Project provides legal assistance to individual artists and organizations threatened with censorship by government, private organizations, or pressure groups.

Art Libraries Society of North Americ
3900 East Timrod Street
Tucson, AZ 85711
(602) 881-8479
 ARLIS promotes the profession of art librarianship and visual resources curatorship. Its newsletter, *Art Documentation,* lists job openings in art libraries.

Arts Wire
c/o New York Foundation for the Arts
155 Avenue of the Americas
New York, NY 10013
(212) 366-6900
 Arts Wire is an arts computer network providing news, information, and on-line discussions on matters concerning artists.

Association of Independent Video and
Filmmakers
625 Broadway, 9th Floor
New York, NY 10012
(212) 473-3400
 AIVF is a national service organization for independent media producers. It publishes the monthly magazine, the *Independent,* and also the *AIVF Festival Guide,* important resources for video artists.

Business Volunteers for the Arts
Arts and Business Council, Inc.
25 West 45th Street, Suite 707
New York, NY 10036
(212) 819-9287.
 BVA assists arts organizations in managing areas such as marketing, strategic planning, and financial systems.

Center for Safety in the Arts
5 Beekman Street, Suite 820
New York, NY 10038
(212) 227-6220
 CSA is a national information resource on health and safety in the performing and visual arts. The center maintains an Art Hazard Information Center for written and telephone inquiries, and distributes over one hundred publications on hazards in the arts.

College Art Association
275 Seventh Avenue
New York, NY 10001
(212) 691-1051.

The College Art Association is an organization dedicated to high standards in the teaching and practice of art and art history. Important publications include 1) the *CAA News,* a bimonthly newsletter with articles and information about grants, residencies, and other opportunities for artists; 2) *Careers,* a listing of college-level teaching and teaching-support jobs; and 3) *MFA: Directory of Programs in the Visual Arts,* a comprehensive listing of MFA programs in the United States. Group-rate insurance is available to CAA members.

Foundation Center
79 Fifth Avenue
New York, NY 10003-3076
(212) 620-4230

The Foundation Center provides information on private foundations by publishing a number of foundation directories, which can be purchased directly from the Center, but most are quite costly. The directories can be accessed through the Center's four libraries and at numerous cooperating libraries, located by calling (800) 424-9836. Cooperating libraries usually also carry their state's directory of foundations and other grant directories. In addition, the Foundation Center publications are available on-line through the DIALOG Information Services; call DIALOG at (415) 858-2700 for more information.

General Services Administration
Art-in-Architecture Program
GSA Public Buildings Service — PGA
18th and F Streets, NW, Room 1300
Washington, DC 20405
(202) 501-1219

The GSA commissions public art projects for new federal buildings. Write for guidelines.

Graduate Record Examinations
Educational Testing Service
P. O. Box 6000
Princeton, NJ 08541-6000
(609) 771-7670 or (510) 654-1200.
Call or write for information about GRE test sites and dates, if applying to graduate schools requiring GRE scores for admission.

National Alliance of Media Arts Centers
655 13th Street, Suite 201
Oakland, CA 94612
(510) 451-2717.

NAMAC is a national association of organizations and individuals dedicated to promoting media arts, including film, video, audio, and multimedia production. Its monthly newletter, *MAIN,* reprints articles and lists jobs and calls for entry to competitions.

National Art Education Association
1916 Association Drive
Reston, VA 22091-1590
(703) 860-8000

The association publishes *National Arts Placement* newsletter listing grant, fellowship, and teaching opportunities in the arts.

National Artists Equity Association, Inc.
Central Station, PO Box 28068
Washington, DC 20038-8068
(202) 628-9633

Artists Equity is a national organization of artists dedicated to working collectively to address the concerns of the profession. It also provides group rates on insurance to members.

National Assembly of Local Arts Agencies
927 15th Street, NW
Washington, DC 20005
(202) 371-2830

The National Assembly of Local Arts Agencies represents local arts in U.S. communities.

National Assembly of State Arts Agencies
1010 Vermont Avenue, NW
Washington, DC 20005
(202) 347-6352

NASAA is a membership organization representing the fifty-six art agencies of the fifty states and six special U.S. jurisdictions.

National Association of Artists Organizations
918 F Street, NW
Washington, DC 20004
(202) 347-6350

NAAO supports and serves artists' organizations, the primary sites for the presentation of new art work. It publishes *Organizing Artists: A Document and Directory of the National Association of Artists' Organizations.*

National Association of Schools of Art and Design.
11250 Roger Bacon Drive, Suite 21
Reston, VA 22090
(703) 437-0700
NASAD is the only accrediting organization of M.F.A. programs in the United States. The *Directory of Member Institutions* lists M.F.A. programs they accredit.

National Campaign for Freedom of Expression
1402 Third Avenue, Suite 421
Seattle, WA 98101
(800) 477-NCFE
NCFE is an educational and advocacy network of artists, organizations and concerned citizens for freedom of artistic expression.

National Endowment for the Arts
The Nancy Hanks Center
1100 Pennsylvania Avenue NW
Washington, DC 20506
(202) 682-5400
The NEA is the federal agency that supports visual, literary, and performing arts. The *Guide to the National Endowment for the Arts* provides an overview of NEA services, grant categories, and listings of regional, state, and local art agencies. The telephone number for the Office of Public Partnership for State and Regional Art Agencies is (202) 682-5429; for the Office of Public Partnership for Local Art Agencies, call (202) 682-5431.

Test of English as a Foreign Language
PO Box 6151
Princeton, NJ 08541-6151
(609) 951-1100.
Call or write for TOEFL test sites and dates if required for graduate school applications.

U. S. Copyright Office
Information and Publications Section, LM-455
Library of Congress
Washington, DC 20559
Information: (202) 707-3000
To place an order for publications or forms:
(202) 707-9100
The federal office for the registration of copy protection for original artistic, literary or musical works. For information on copyright legislation and procedures, or to fully protect work from illicit copying, contact the U.S. Copyright Office.

The Visual Artist Information Hotline
c/o The American Council for the Arts
1 East 53rd Street
New York, NY 10022
(212) 223-2787
Hotline: (800) 232-2789
The Visual Artist Information Hotline provides information on funding organizations, artist colonies, residencies, and artist organizations and services. The Hotline is staffed between 2:00 and 5:00 P.M. Eastern Time, Monday through Friday.

Volunteer Lawyers for the Arts
1285 Avenue of the Americas, Third Floor
New York, NY 10019
(212) 977-4514
A national network of over forty VLAs throughout the United States and Canada provides legal services, assistance, and educational programs for artists and arts organizations. Most VLAs publish state-specific educational material, such as tax and legal guides for artists. Addresses and telephone numbers of all affiliates are available at the office of the New York VLA.

Women's Caucus for Art
Moore College of Art
20th & the Parkway
Philadelphia, PA 19103
(215) 854-0922
WCA is a nonprofit women's professional and service organization for visual artists. Twenty chapters operate across the United States.

ANNOTATED BIBLIOGRAPHY

American Art Directory 1993-1994. 54th ed. New Providence, NJ: R. R. Bowker, A Reed Reference Publishing Company.

Extensive listings of art organizations, art publications, art institutions, and art schools, colleges and universities offering graduate and undergraduate degrees.

Apple, Jacki. *Doing It Right in L. A.: Self-producing for the Performing Artist.* Los Angeles: Astro Artz and Fringe Festival, 1990.

A practical guide to performance spaces, publicity, directing, and other issues facing artists who self-produce their work, available through Community Arts Resources, 1653 18th Street, Suite 1, Santa Monica, California 90404; (310) 315-9444.

Arntson, Amy E. *Graphic Design Basics.* Fort Worth, TX: Harcourt Brace Jovanovich College Publishers, 1993.

A discussion of the visual decisions to make when designing exhibition announcements and performance programs.

Art Index. New York: The H. W. Wilson Company.

A periodical that indexes the articles that appear in 268 art magazines; available in art libraries.

Art in America. "Annual Guide to Museums, Galleries and Arts." New York: Art in America, 1993.

A comprehensive, state-by-state, alphabetical listing of U. S. museums, commercial galleries, alternative spaces, university galleries, and the directors, dealers, and artists associated with them. The guide, published every August, is available through <u>*Art in America,*</u> 575 Broadway, New York, 10012, (212) 941-2800.

Bolton, Richard, ed. *Culture Wars: Documents from the Recent Controversies in the Arts.* New York: The New Press, 1992.

Discussions on contemporary cultural controversies.

Brunner, Helen M. and Donald H. Russell, eds. *Money to Work II: Funding for Visual Artists.* Rev. and expanded ed. Washington, DC: Art Resources International, 1992.

A listing of private foundation and governmental funding sources available to individual artists. Order directly from Art Resources International, 5813 Nevada Avenue, NW, Washington, DC 20015-2544; (202) 363-6806.

Caplin, Lee. *The Business of Art.* 2nd ed. Englewood Cliffs, NJ: Prentice-Hall, 1989.

A general guide to an artist's studio practices and the mainstream museum/gallery system.

Cochrane, Diane. *This Business of Art.* Rev. ed. New York: Watson-Guptill, 1988.

A guide to an artist's studio practice that emphasizes contracts, letter writing, and other aspects of record-keeping.

Cohen, Herb. *You Can Negotiate Anything.* New York: Bantam Books, 1980.

Negotiating strategies for individuals.

College Art Association. *MFA: Directory of Programs in the Visual Arts.* New York: College Art Association, 1992.

An in-depth listing of Master of Fine Arts programs in the United States, with information on admissions, financial aid, curricula, facilities, faculty, and students. The directory is updated every five years, and is available in many university libraries, and through the College Art Association.

Conner, Floyd, Roger Gilcrest, Peter Karlen, Jean Perwin, and David Spatt. *The Artist's Friendly Legal Guide*. Revised and updated edition, Cincinnati, OH: North Light Books, 1991.

Information on copyright, moral rights, contracts, record-keeping, and taxes. Written in an easily readable style.

Cruikshank, Jeffrey L. and Pam Korza. *Going Public: A Field Guide to Developments in Art in Public Places*. Amherst, MA: Arts Extension Service, 1988.

A helpful introduction to public arts for artists, covering topics such as developing projects, contracts, insurance, maintenance, and preservation. Available through AES Publications, Arts Extension Service, Division of Continuing Education, 604 Goodell Building, University of Massachusetts, Amherst, MA 01003; (413) 545-2360.

Dickinson, Eleanor. "Statistics: Gender Discrimination in the Art Field." Washington, DC: National Artists Equity Association, Inc., 1990.

A gender breakdown of artists, art faculty, art reviews, and exhibitions in the United States, suggesting discriminatory patterns in galleries and museums. The study is available through National Artists Equity Association.

Directory of Research Grants. 18th ed. Phoenix, AZ: The Oryx Press, 1993.

Brief listings of some of the art-related research grants, state art agency grants, public art programs, and foundation grants in the United States.

DuBoff, Leonard D. *Art Law in a Nutshell*. 2nd ed. St. Paul, MN: West Publishing Company, 1993.

An accessible, informative, and often entertaining guide to art law, including tax law, copyright, trademarks, moral and economic rights, and freedom of expression issues. Available only in law libraries and at legal bookstores.

Gablik, Suzy. *The Reenchantment of Art*. New York: Thames and Hudson, 1991.

A discussion of art-making outside of profit and fame motivations, that attempts to reintegrate art and life in meaningful ways.

Hoover, Deborah. *Supporting Yourself As an Artist*. 2nd ed. New York: Oxford University Press, 1989.

A guide to grants and corporate giving for visual artists, media artists, performing artists, and writers.

Kahn, Si. *Organizing, A Guide for Grass Roots Leaders*. New York: McGraw-Hill Book Company, 1982.

Tips on organization and communication for people who find themselves in leadership positions.

Laing, John, ed. *Do-It-Yourself Graphic Design*. New York: Collier Books, Macmillan Publishing Company, 1984.

Information on production problems facing artists designing exhibition announcements and performance programs.

Lippard, Lucy. *Mixed Blessings*. New York: Pantheon, 1990.

A cross-cultural survey of contemporary artists from many different ethnic backgrounds.

Mancuso, Anthony. *How to Form a Nonprofit Corporation*. Berkeley, CA: Nolo Press, 1994.

Step-by-step information on procedures and papers necessary to form a nonprofit corporation.

McCann, Cecile Nelken. "Guerrilla Talk: A Conversation with a Member of Guerrilla Girls West." *Artweek,* Vol. 22, no. 22, June 20, 1991: 1+.

A discussion from the inside of a guerrilla art group.

McCann, Michael. *Artist Beware*. New York: Lyons and Burford, 1992.

Health hazards from art materials and unsafe studio practices.

Mills, Carlotta R., ed. *Foundation Grants to Individuals*. 8th ed. New York: The Foundation Center, 1993.

A listing of some of the residencies and foundation grants to individual artists.

Murphy, C. Edward, ed. and Joan Seabourne, asst. ed. *Guide to U.S. Foundations, Their Trustees, Officers and Donors.* Volumes 1 and 2. New York: The Foundation Center, 1993.

A beneficial fund-raising tool for arts organizations. Introductory material contains a bibliography of local and state foundation directories.

National Association of Artists' Organizations. *Organizing Artists: A Document and Directory of the National Association of Artists' Organizations.* Washington, DC: National Association of Artists' Organizations, 1992.

A very helpful resource with listings for local, national, and regional art organizations, government art agencies, service organizations, residencies/colonies, and alternative spaces.

National Association of Schools of Art and Design. *Directory of Member Institutions.* Reston, VA: National Association of Schools of Art and Design (NASAD), 1993–1994.

A brief directory of MFA programs accredited by NASAD, available only through NASAD.

National Endowment for the Arts. *Guide to the National Endowment for the Arts.* Washington, DC: The National Endowment for the Arts, 1993.

An overview of programs, procedures, grant categories, and regional agencies within the NEA.

Niemeyer, Suzanne, ed. *Money for Film and Video Artists.* New York: American Council for the Arts and Allworth Press, 1991.

Niemeyer, Suzanne, ed. *Money for Performing Artists.* New York: American Council for the Arts and Allworth Press, 1991.

Niemeyer, Suzanne, ed. *Money for Visual Artists.* New York: American Council for the Arts and Allworth Press, 1991.

Three guides for residencies, foundation support, corporate and governmental funding sources for individual artists in various disciplines.

Olson, Stan, ed., and Margaret Mary Feczko, asst ed. *The Foundation Directory.* Volumes 1 and 2. 15th ed. New York: The Foundation Center, 1993.

Helpful fund-raising information for arts organizations.

Peterson's Guide to Graduate Programs in the Humanities and Social Sciences 1993, Peterson's Annual Guides to Graduate Study: Book 2, 27th ed. Princeton, NJ: Peterson's Guides, 1992.

A very condensed listing of all M.A.– and M.F.A.–granting institutions in the United States, U.S. territories, and Canada under "Section 4: Art and Art History," with information on admissions, financial aid, faculty, media areas offered, entrance, and degree requirements. The guide is available at university libraries and in large public library collections.

Pindell, Howardena. "Artworld Racism: A Documentation." *New Art Examiner,* March 1989: 32–36.

Survey results indicating underrepresentation of African-American, Latino, Asian, and Native-American artists in museums and galleries.

Pinkerton, Linda F. and John T. Guardalabene. *The Art Law Primer: A Manual for Visual Artists.* New York: Nick Lyons Books, 1988.

An introduction to U.S. art law for visual artists, including copyright, contracts, leases, and the artist–dealer relationship.

Public Art Review. St. Paul, MN: Forecast.

Public Art Review is a biannual publication on public art programs and current competitions, published by Forecast, 2324 University Avenue West, St. Paul, MN 55114; (612) 641-1128.

Society for Photographic Education. "Survey of Women and Persons of Color in Post-Secondary Photographic Education." Albuquerque, NM: Society for Photographic Education, Judith Thorpe, Executive Director, P.O. Box BBB, Alburquerque, NM 87196.

Gender and racial breakdown of the art faculties of U.S. colleges and universities.

Spandorfer, Merle, Deborah Curtis, and Jack Snyder, M.D. *Making Art Safely: Alternative Methods and Materials in Drawing, Painting, Printmaking, Graphic Design and Photography.* New York: Van Nostrand Reinhold, 1993.

A guide to safe studio practices.

Waller, Julian A., M.D., M.P.H. *Safe Practices in the Arts and Crafts: A Studio Guide,* 2nd ed. New York: The College Art Association, 1985.
Listings of hazardous materials and studio practices.

Who's Who in American Art 1993–1994. 20th ed. New Providence, NJ: R. R. Bowker, A Reed Reference Publishing Company.
Brief biographies of U.S. artists and art professionals.

Ziegler, Laurie. "The Ties That Bind: The Importance of Artist-Dealer Contracts." *New Art Examiner,* Vol. 20, No. 10. Summer 1993: 12–17.
A discussion of troubled artist–dealer relationships, and the necessity for written agreements.

INDEX